UMBERTO ECO
THE BOOK OF
LEGENDARY LANDS

Translated by Alastair McEwen

First published in the United States of America in 2013
by Rizzoli Ex Libris, an imprint of
Rizzoli International Publications, Inc.
300 Park Avenue South
New York, N.Y. 10010
www.rizzoliusa.com

2013 2014 2015 2016 / 10 9 8 7 6 5 4 3 2 1

Distributed in the U.S. trade by Random House, New York

Printed in Italy

ISBN-13: 978-0-8478-4121-9

Library of Congress Catalog Control Number:
2013936600

Printed and bound in October 2013 in Italy by Errestampa S.r.L. – Orio al Serio (BG)

Editorial Director – Elisabetta Sgarbi
Editorial Coordination – Annamaria Lorusso, Alessandra Lusardi
Editing – Federica Matteoli, Katharina Bielenberg, Ilaria Fusina
Picture Research – Ilaria Fabrizio
Graphic Design – Polystudio, Francesco Messina, Francesca Zucchi, Giard Bettio, Anna Pinatto
Picture Research – Silvia Borghesi
Production – Sergio Danotti

UMBERTO ECO

THE BOOK OF
LEGENDARY LANDS

Translated by Alastair McEwen

Rizzoli
ex libris

CONTENTS

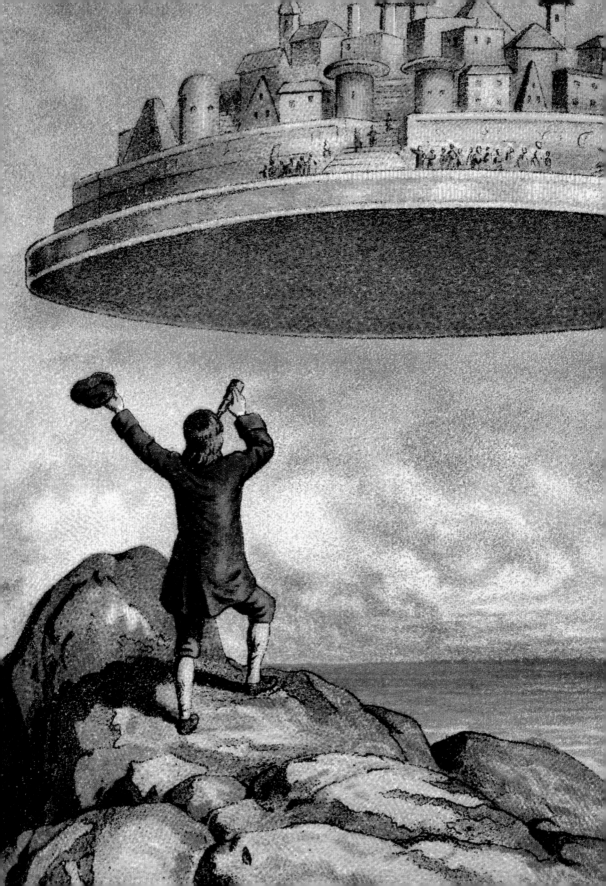

INTRODUCTION

Gulliver discovers Laputa, illustration from an edition of *Gulliver's Travels* by Jonathan Swift (Leipzig, c. 1910)

This book is concerned with the lands and places of legend: lands and places because sometimes they are continents, such as Atlantis, other times towns and castles or, in the case of Baker Street and Sherlock Holmes, apartments.

There are many dictionaries of fantastic and fictional places (and the most complete is the excellent *Dictionary of Imaginary Places* by Alberto Manguel and Gianni Guadalupi), but here we shall not be dealing with invented places because we would have to include Madame Bovary's house, Fagin's lair in Oliver Twist, or the Bastiani Fortress in The Tartar Steppe. These are places found in novels, which fanatical readers sometimes try to find, without great success. Other times they are fictional places inspired by real places, where readers try to find the traces of the books they have loved, just as every 16th of June in Dublin readers of Ulysses try to identify Leopold Bloom's house on Eccles Street, visit the Martello Tower—now a Joyce museum—or attempt to buy in a certain chemist's shop the lemon soap purchased by Bloom in 1904.

It even happens that fictional places have been identified with real places, such as Nero Wolfe's brownstone in Manhattan.

But here we are interested in lands and places that, now or in the past, have created chimeras, utopias, and illusions because a lot of people really thought they existed or had existed somewhere.

That said, there are still many distinctions to be taken into account. There are legends about lands that certainly no longer exist, whereas it cannot be ruled out that they may have existed in ancient times, and this is the case with Atlantis, the last traces of which many perfectly sane people have tried to find. There are lands men-

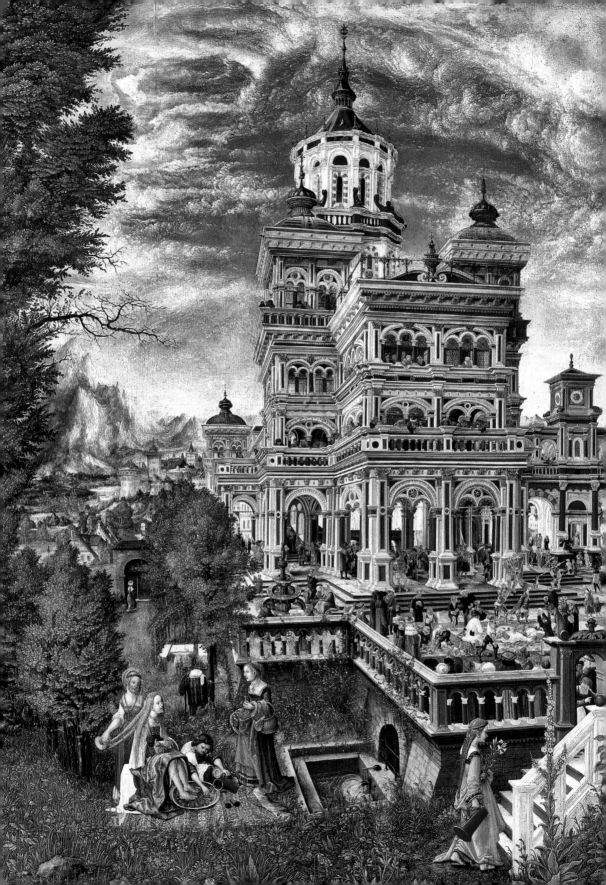

tioned in many legends and whose existence (albeit remotely possible) is doubtful, such as Shambhala, to which some people attribute a purely "spiritual" existence, and others that are undoubtedly the effect of narrative fiction, such as Shangri-La, but imitations of which are constantly produced for gullible tourists. There are lands whose existence is asserted only in biblical texts, such as the Earthly Paradise or the country of the Queen of Sheba, but it was belief in such places that prompted many, Christopher Columbus included, to discover lands that really did exist. There are lands created by a false document, such as the land of Prester John, which nonetheless persuaded explorers to travel through both Africa and Asia. Finally, there are places that really exist to this day, even though sometimes in the form of ruins, but around which a mythology has grown up, such as El Alamūt, over which hovers the legendary shadow of the Assassins, or Glastonbury, now associated with the myth of the Grail, or Rennes-le-Château, or Gisors, which have been made legendary by very recent commercial speculation.

In short, legendary lands and places are of various kinds and have only one characteristic in common: whether they depend on ancient legends whose origins are lost in the mists of time or whether they are an effect of a modern invention, they have created flows of belief.

The reality of these illusions is the subject of this book.

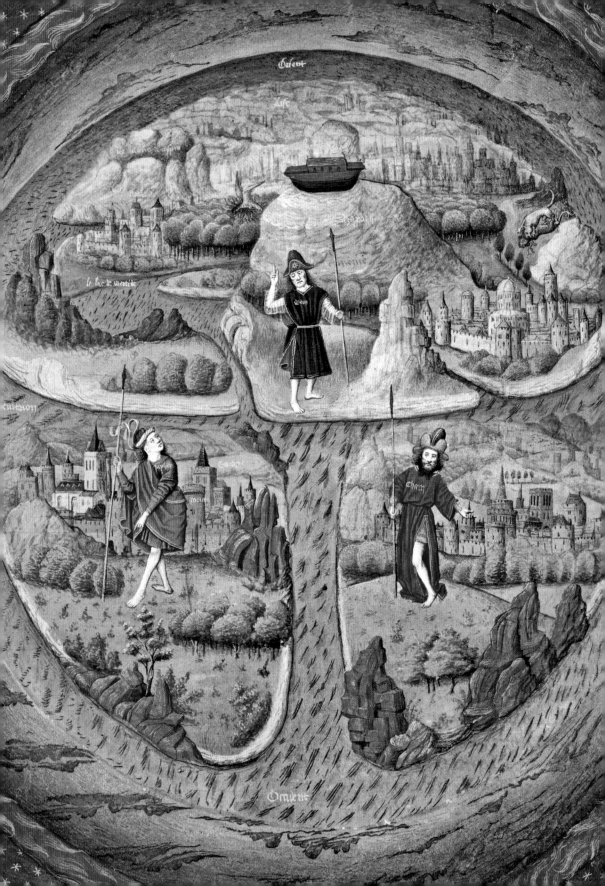

1

THE FLAT EARTH
AND THE ANTIPODES

T and O map,
Mappa mundi
in *La fleur des histoires*
(1459–1463), Paris,
Bibliothèque nationale
de France

In various mythologies, the Earth assumes poetic, often anthropomorphic forms, such as the Greek Gaia. An Asian legend maintained that the Earth lay on the back of a whale, held up in its turn by a bull, which stood on a rock, and the rock was held up by dust, beneath which no one knew what lay, if not the great sea of the infinite. In other versions, the Earth rested on the back of a <u>turtle</u>.

THE FLAT EARTH When people began to reflect "scientifically" about the form of the Earth, it was fairly realistic for the ancients to maintain that it was in the form of a disk. Homer thought the disk was surrounded by the ocean and covered by the dome of the heavens, and—judging by fragments of the <u>pre-Socratics</u>, sometimes imprecise and contradictory, depending on the sources—Thales believed it was a flat disk; Anaximander thought it was cylindrical in form; and Anaximenes talked about a flat surface surrounded by the ocean, which floated on a kind of compressed-air cushion.

Only Parmenides seems to have guessed its spherical nature, while Pythagoras held that it was spherical for mystical-mathematical reasons. But subsequent demonstrations of the roundness of the Earth were based on empirical observations: see the texts by <u>Plato</u> and <u>Aristotle</u>.

Doubts about sphericity linger in Democritus and Epicurus, and Lucretius denies the existence of the Antipodes, but in general for all of late antiquity, the spherical form of the Earth was no longer debated. Naturally, Ptolemy knew the Earth was round; otherwise he would not have been able to divide it into 360 degrees. Eratosthenes also knew this, because in the third century BC, he had made a pretty

good calculation of the length of the terrestrial meridian by consider-
ing the different inclination of the sun at midday on the summer sol-
stice as it was reflected in the bottoms of wells in Alexandria and
Syene, the distance between which he knew.

Despite many legends, which still circulate on the Internet,
all medieval scholars knew that the world was round. Even a first-year
high school student can easily deduce that, if Dante enters the funnel
of the Inferno and emerges on the other side to see unknown stars at
the foot of the mountain of Purgatory, this means that he knew per-
fectly well that the Earth was a sphere. The same opinion was held by
Origen and Ambrose, Albertus Magnus and Thomas Aquinas, and
Roger Bacon and John of Holywood, just to name a few.

In the seventh century, Isidore of Seville (despite the fact
that he was not a model of scientific accuracy) calculated the length of
the equator as eighty thousand stadia. Whoever poses the question of
the length of the equator obviously knows and believes that the world
is spherical. What's more, Isidore's measurement, albeit approximate,
does not diverge that much from modern ones.

So why has it long been believed, and why do many still be-
lieve to this day, even authors of various serious books on the history
of science, that the original Christian world had abandoned Greek sci-
ence and returned to the idea of the flat Earth?

Try to make an experiment and ask a person, even a cultivat-
ed one, what Christopher Columbus wanted to demonstrate when he
intended to reach the East via the West and what was it that the doctors
of Salamanca stubbornly denied. The answer, in most cases, will be
that Columbus believed that the world was round, whereas the doctors
of Salamanca maintained that the Earth was flat and that, after a brief
stretch, the three caravels would plunge into the cosmic abyss.

Nineteenth-century secular thinkers, irritated by the fact
that various religious confessions were opposing evolutionism, attrib-
uted the idea of the flat Earth to the whole of Christian thinking (both
patristic and scholastic). It was a matter of demonstrating that, just as
they had been wrong about the spherical form of the Earth, so the
churches could be wrong about the origin of species. So they exploited

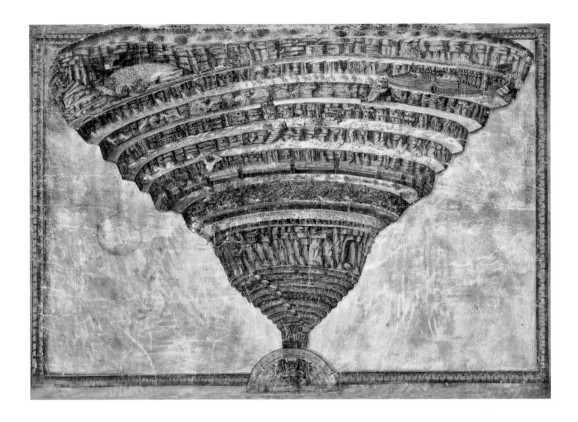

Sandro Botticelli,
The Abyss of Hell,
illustration for the
The Divine Comedy
(c. 1480),Vatican City,
Biblioteca Apostolica
Vaticana

a Christian author of the fourth century, Lactantius (in his *Institutiones divinae*). Because the Bible describes the universe in the form of the Tabernacle, and hence in a quadrangular shape, Lactantius opposed the pagan theories about the roundness of the Earth, also because he could not accept the idea of the existence of the Antipodes, where men would have had to walk with their heads downward.

Then, in his *Christian Topography*, Cosmas Indicopleustes, a Byzantine geographer of the sixth century, still thinking of the biblical tabernacle, maintained that the cosmos was rectangular with an arch that rose above the flat surface of the Earth. In Cosmas' model, the curved vault was hidden to our eyes by the stereoma, in other words the veil of the firmament. Below this lies the ecumene, or the whole world in which we live, which rests on the ocean and imperceptibly rises constantly toward the northwest, where there stands a mountain so high that its presence eludes our sight and its summit merges with the clouds. The sun, moved by the angels—to whom we

also owe the rains, earthquakes, and all other atmospheric phenom-
ena—passes in the morning from the east toward the south, in front of
the mountain, and lights up the world, and in the evening it climbs up
to the west and disappears behind the mountain. The moon and the
stars follow the opposite cycle.

As was demonstrated by Jeffrey Burton Russell (1991),
many authoritative histories of astronomy, still studied in schools,
maintain that the works of Ptolemy remained unknown throughout
the Middle Ages (which is historically untrue) and that Cosmas' the-
ory became prevalent opinion un-
til the discovery of America. But
Cosmas' text, written in Greek
(a language that the Christian
Middle Ages knew only through a
handful of translators interested
in Aristotelian philosophy), did
not become known to the Western
world until 1706 and was pub-
lished in English in 1897. No me-
dieval author knew it.

Cosmas Indicopleustes,
The Rectangular Cosmos,
Ms. Plut. 9.28, c.95v,
Florence, Biblioteca
Medicea Laurenziana

How was it possible to maintain that the Middle Ages consid-
ered the Earth a flat disk? In the manuscripts of Isidore of Seville (who,
as we have seen, also talked of the equator) there appears the so-called
T and O map, wherein the upper part represents Asia, at the top, be-
cause according to legend the Earthly Paradise lay in Asia; one side of
the horizontal bar represents the Black Sea and the other the Nile,
while the vertical one represents the Mediterranean; and so the quar-
ter circle on the left represents Europe and the one on the right repre-
sents Africa. All around lies the great circle of the ocean.

The impression that the Earth was seen as a disk is also giv-
en by the maps that appear in the commentaries on the Apocalypse by
the *Beatus of Liébana,* a text written in the eighth century but one
that, illustrated by Mozarabic miniaturists in the following centuries,
largely influenced the art of the Romanesque abbeys and the Gothic
cathedrals—and the model is found over and over in countless other

T and O map, Bartholomaeus Anglicus,
Le livre des propriétés des choses (1372)

Pages 16–17:
Saint-Sever World Map, from the *Saint-Sever Beatus* (1086), Paris, Bibliothèque nationale de France

illuminated manuscripts. How was it possible that people who believed the world was round made maps in which the Earth is seen as flat? The first explanation is that we do this too. To criticize the flatness of these maps would be like criticizing the flatness of a contemporary atlas. It was a matter of a naive and conventional form of cartographic projection.

But we have to consider other elements. The first is suggested to us by Saint Augustine, who was well aware of the debate opened

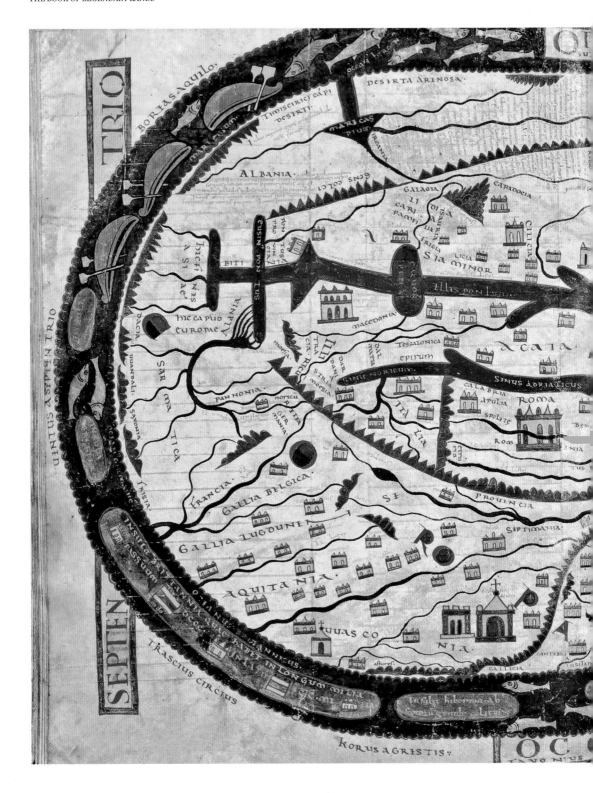

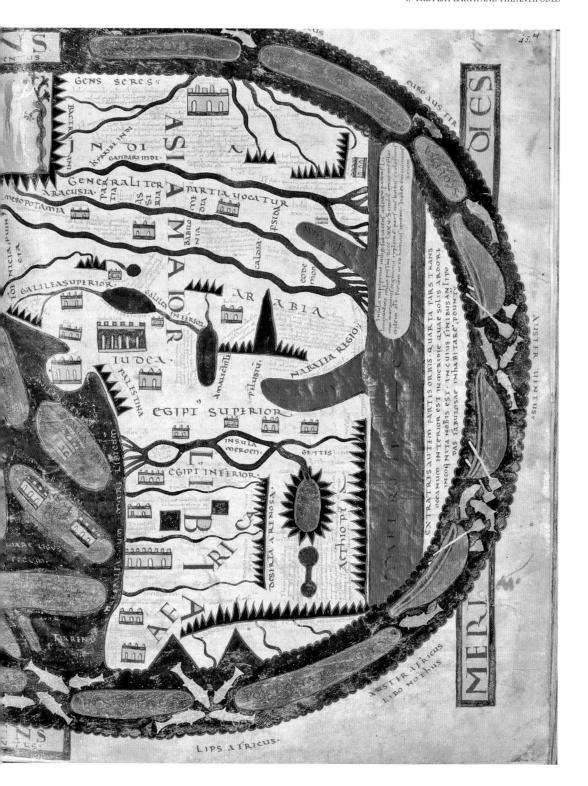

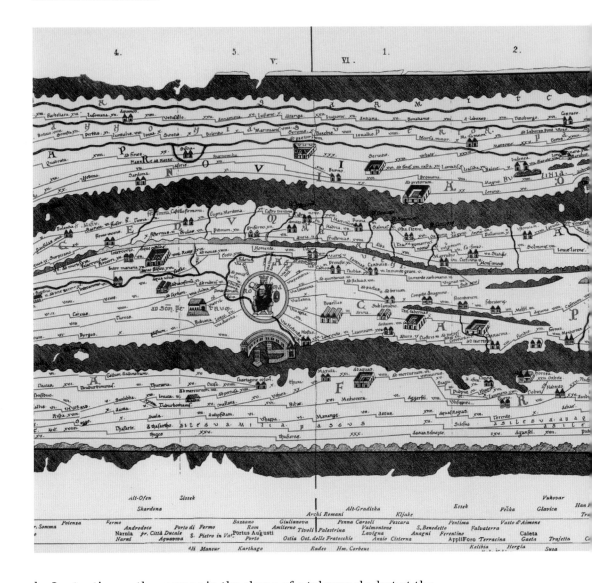

by Lactantius on the cosmos in the shape of a tabernacle, but at the same time knew about the opinions of the ancients regarding the sphericity of the world. Augustine's conclusion is that there is no need to worry about the description of the biblical tabernacle because, as one knows, holy writ often speaks in metaphors, and perhaps the Earth is round. However, because knowing that it is spherical or not does not serve to save the soul, we can ignore the question.

This does not mean, as has often been insinuated, that there was no medieval astronomy. In the twelfth and thirteenth centuries,

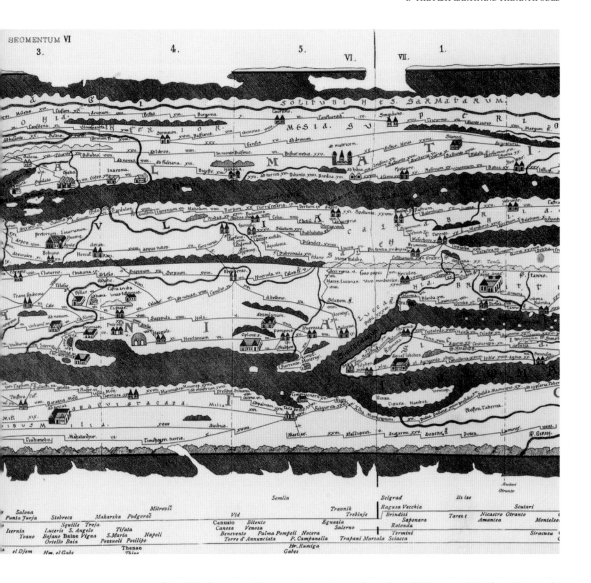

Section of the *Tabula Peutingeriana* (twelfth-century copy)

first Ptolemy's *Almagest* was translated and then Aristotle's *De caelo* (*On the Heavens*). As some may know, one of the subjects of the Quadrivium taught in medieval schools was astronomy, and in the thirteenth century it was John of Holywood's *Tractatus de sphaera mundi* that, following Ptolemy, constituted an unquestioned authority for some centuries to come.

The Middle Ages was a period of great voyages, but what with bad roads, forests, and stretches of sea to be crossed trusting in some boatman of the day, there was no possibility of making accurate

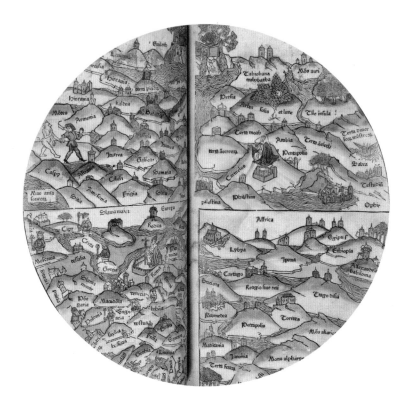

Map from *Rudimentum novitiorum*, Lucas Brandis, Lübeck (1475), Oxford, Oriel College Library

maps. They were purely indicative, like the instructions in the pilgrims' guide to Santiago de Compostela, which said more or less: "If you wish to go from Rome to Jerusalem, proceed southward and ask directions on the way." Now try to think of the maps you find in old railway timetables. That series of junctions is very clear if you need to take a train from Milan to Livorno (and you find out it is necessary to pass through Genoa), but no one could use it to extrapolate the exact shape of Italy. The exact shape of Italy is of no interest for someone who has to go to the station. The Romans mapped a series of roads that connected every city in the known world, but here's how these roads were represented in the map known as the *Tabula Peutingeriana*, named after the person who rediscovered it in the fifteenth century. The upper part represents Europe, and the lower part Africa, but this leaves us exactly where we were with the railway map. From this map we can see the roads, where they begin and where they end, but we cannot guess the shape of Europe, the Mediterranean, or Africa.

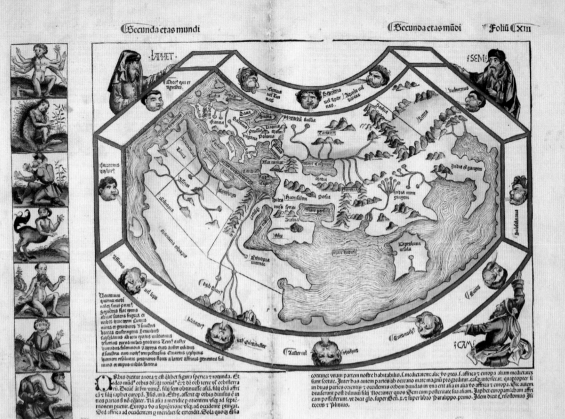

Map of the world according to Hartmann Schedel, in *Liber chronicarum* (*Nuremberg Chronicle*), Nuremberg (1493)

Certainly the Romans must have had far more accurate geographical notions, because they sailed all over the Mediterranean, but in drawing that map, the cartographers were not interested in the distance between Marseilles and Carthage but in giving the information that Marseilles and Genoa were connected by a road.

Otherwise, medieval journeys were imaginary. The Middle Ages produced encyclopedias, *imagines mundi* that mainly sought to satisfy a taste for the marvelous, telling of distant and inaccessible countries, and these books were all written by people who had never seen the places they talked about, because in those days the power of tradition counted for more than experience. A map was not intended to represent the shape of the Earth but to list the cities and the peoples you could come across.

Again, symbolic representation counted for more than empirical representation. In the map *Rudimentum novitiorum* of 1475, the illuminator was more concerned about showing Jerusalem at the cen-

ter of the Earth than how to get there. And all this when maps from the same period already represented Italy and the Mediterranean rather well.

One final consideration: medieval maps had no scientific function, but were a response to a demand for the fabulous from the public—I'd like to say in the same way as today's glossy magazines show us the existence of flying saucers and television tells us that the pyramids were constructed by an extraterrestrial civilization. The map in the *Nuremberg Chronicle,* which dates from 1493 and has a car- tographically acceptable representation, also shows the mysterious monsters that were thought to inhabit those lands.

On the other hand, the history of astronomy is curious. A great materialist, Epicurus, cultivated an idea that survived for a long time, so much so that Gassendi was still discussing it in the sev- enteenth century, and which in any event is mentioned in Lucretius' *On the Nature of Things*: the sun, the moon, and the stars (for many very serious reasons) cannot be either greater or smaller than they appear to our eyes. As a result, Epicurus judged that the diameter of the sun was about thirty centimeters.

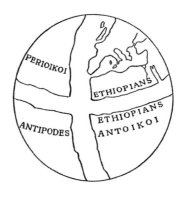

The Antipodes according to Crates of Mallus, from Konrad Miller, *Mappae Mundi,* Stuttgart (1895)

And this is how, while some very ancient cultures really be- lieved in a flat Earth, many of our contemporaries, despite the current state of our historical knowledge, still think that the ancients and me- dievals believed in a flat Earth. Which lets us see that the propensity for legend is more on the part of moderns than on that of their forefa- thers. Not to mention the moderns and the contemporaries, and more of them than you would think (see Blavier 1982 and Justafré, undated, for an exhilarating bibliography) are still writing books against the Copernican hypothesis or, as in the case of <u>Voliva</u>, have maintained that the Earth is a flat disk.

THE ANTIPODES The Pythagoreans had worked out a complex planetary system in which the Earth was not even at the center of the universe. The sun was also on the outskirts, and all the spheres of the planets orbited around a central fire. Moreover, in rotating, each sphere produced a sound on the musical scale, and in order to establish an exact correspondence between sound phenomena and astronomical phenomena, they even introduced a nonexistent planet, the Anti-Earth. This Anti-Earth, invisible from our hemisphere, could be seen only from the Antipodes.

In Plato's *Phaedo*, it is suggested that the Earth is very large and that we occupy only a small part of it, so that other peoples might be living in other parts of its surface. The idea was picked up again in the second century BC by Crates of Mallus, according to whom there existed two inhabited lands in the Northern Hemisphere and two in the Southern one, separated by oceanic channels arranged to form a cross. Crates presumed that the southern continents were inhabited but not accessible from our side. In the first century AD, Pomponius Mela hazarded the guess that the island of Taprobane (about which we shall talk later) represented a kind of promontory of the unknown southern land. References to the existence of the Antipodes appear in Virgil's *Georgics*, in Lucan's *Pharsalia*, in Manilius' *Astronomica*, and in Pliny's *Natural History*.

But talking about this land obviously led to the problem of how its inhabitants could live with their heads pointing downward and their feet upward, without falling into the void.[1] This hypothesis had already been opposed by Lucretius.

Obviously, the most determined adversaries of the Antipodes were those who denied the sphericity of the globe, such as Lactantius and Cosmas Indicopleustes. But even a sensible person, such as Augustine, could not stand the idea of men with heads pointing downward. This was also because, by presuming the existence of human beings at the Antipodes, one would have had to think of creatures who were not descended from Adam and had not been affected by redemption.

Nonetheless, already in the fifth century AD, Macrobius had put forward a reasonable argument to show that there was nothing

1. *A complete treatment of the Antipodes is in Moretti (1994). See also Broc (1980).*

Lambert of Saint-Omer, "Octavianus Augustus," in *Liber floridus*, Man. Lat. 8865, Folio 45r, Paris, Bibliothèque nationale de France. The globe in the emperor's hand represents a T and O map

irrational about the belief that beings could live on the other side of the planet. The same position was taken by <u>Lucius Ampelius</u>, <u>Marcus Manilius</u>, and even <u>Luigi Pulci</u> (who was very sensitive to the course of the debate in ancient times) in his *Morgante*.

The diffidence with regard to the Antipodes, precisely because they could not explain the universality of redemption, was protracted even after Macrobius, whose position had been considered heretical by Pope Zacharias, who in 748 called it a "perverse and iniquitous doctrine," and it was violently challenged in the twelfth century by <u>Manegold of Lautenbach</u>. Nevertheless, in general the Middle Ages accepted the idea of the Antipodes, from William of Conches to Albertus Magnus, from Gervase of Tilbury to Pietro d'Abano, and from Cecco d'Ascoli to (with some hesitation) Pierre d'Ailly, whose *Imago mundi* was to inspire Columbus's voyage.

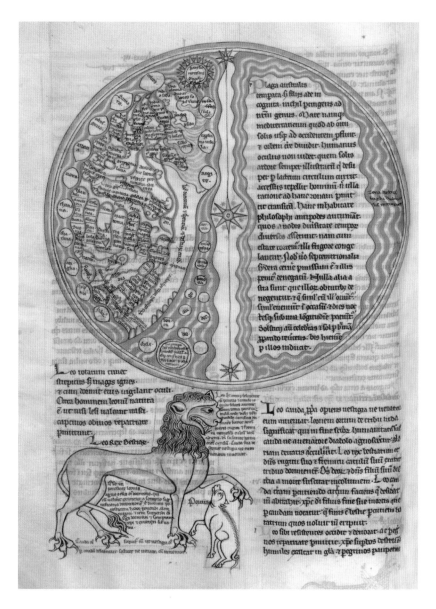

Lambert of Saint-Omer, "Octavianus Augustus," in *Liber floridus*, Man. Lat. 8865, Folio 35r, Paris, Bibliothèque nationale de France. At right the *zona australis*, or the Antipodes

Naturally, Dante Alighieri also believed in the Antipodes if he located the mountain of Purgatory on the other side of the globe and could climb it without falling head down into the abyss and even arrive in the Earthly Paradise.

The Antipodes had served in Roman times to justify expansion toward unknown lands, and this idea returned with the geographical explorations of the modern era. At least from Columbus on-

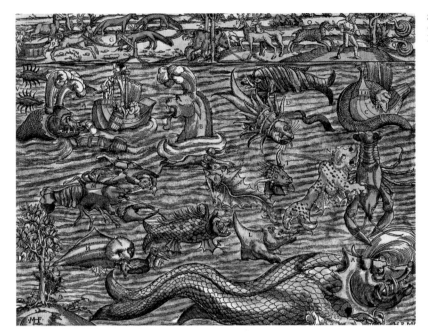

Sea monsters, from
Cosmographia, Sebastian
Münster, Basel (1550)

ward, their existence was no longer in doubt because people began to know lands in the Southern Hemisphere previously considered inaccessible, and those—such as Vespucci—who visited them talked about them with nonchalance. If anything, another idea began to make headway, one that was to survive until the eighteenth century, that of an unknown land, Terra Australis, which lay in the extreme south of the globe. But we will talk about that in another chapter.

Nevertheless, even when the Antipodes were reachable, another aspect of the legend—of ancient origins—lingered on. We find evidence of this (among many other sources) in Isidore of Seville: the Antipodes, if they are not home to human beings, are in any case lands of monsters. And even after the Middle Ages, explorers (Antonio Pigafetta included) were always prepared to find in the course of their voyages the frightful and deformed, or benign but odd creatures of legend—and even today, having to exclude them from an Earth whose every detail is now known, science fiction narratives put them on other planets in the guise of "bug-eyed monsters" or the lovable ET.

The Turtle

STEPHEN HAWKING
A Brief History of Time (1988), I

A well-known scientist (some say it was Bertrand Russell) once gave a public lecture on astronomy. He described how the earth orbits around the sun and how the sun, in turn, orbits around the center of a vast collection of stars called our galaxy. At the end of the lecture, a little old lady at the back of the room got up and said: "What you have told us is rubbish. The world is really a flat plate supported on the back of a giant tortoise." The scientist gave a superior smile before replying, "What is the tortoise standing on?" "You're very clever, young man, very clever," said the old lady. "But it's turtles all the way down!"

The Flat Earth
of the Pre-Socratics

ARISTOTLE (384–322 BC)
On the Heavens, II, 13.3

There are similar disputes about the shape of the earth. Some think it is spherical, others that it is flat and drum-shaped. For evidence they bring the fact that, as the sun rises and sets, the part concealed by the earth shows a straight and not a curved edge. . . .
Others say the earth rests upon water. This, indeed, is the oldest theory that has been preserved, and is attributed to Thales of Miletus. It was supposed to stay still because it floated like wood and other similar substances, which are so constituted as to rest upon water but not upon air.

HIPPOLYTUS (C. 170–C. 236)
The Refutation of all Heresies, I, 5–7

[For Anaximander maintained that] the earth is poised aloft, upheld by nothing . . . and that the figure of it is curved, circular, similar to a column of stone. And one of the surfaces we tread upon, but the other is opposite.

And [Anaximenes] that the expanded earth is wafted along upon the air, and in like manner both sun and moon and the rest of the stars; for all things being of the nature of fire, are wafted about through the expanse of space, upon the air. . . . And he says that the stars do not move under the earth, as some have supposed, but around the earth, just as a cap is turned round our head; and that the sun is hid, not by being under the earth, but because covered by the higher portions of the earth. . . .

And [Anaxagoras] that the earth is in figure plane; and that it continues suspended aloft. . . .

The Spherical Earth

PLATO (428–348 BC)
Phaedo, 99b, 108e–109a

And thus one man makes a vortex all round and steadies the earth by the heaven; another gives the air as a support to the earth, which is a sort of broad trough. . . .
Well, then, he said, my conviction is, that the earth is a round body in the center of the heavens, and therefore has no need of air or any similar force to be a support, but is kept there and hindered from falling or inclining

any way by the equability of the surrounding heaven and by her own equipoise. For that which, being in equipoise, is in the center of that which is equably diffused, will not incline any way in any degree, but will always remain in the same state and not deviate.

ARISTOTLE (384–322 BC)
On the Heavens, II, 14

Again, our observations of the stars make it evident, not only that the earth is circular, but also that it is a circle of no great size. For quite a small change of position to south or north causes a manifest alteration of the horizon. There is much change, I mean, in the stars which are overhead, and the stars seen are different, as one moves northward or southward. Indeed there are some stars seen in Egypt and in the neighborhood of Cyprus which are not seen in the northerly regions; and stars, which in the north are never
beyond the range of observation, in those regions rise and set. All of which goes to show not only that the earth is circular in shape, but also that it is a sphere of no great size: for otherwise the effect of so slight a change of place would not be quickly apparent.

DIOGENES LAERTIUS
(SECOND–THIRD CENTURY)
Lives and Opinions of Eminent Philosophers, IX, 3, 21, and VII, 1, 24–26

[Parmenides] was the first to declare that the earth is spherical and is situated in the center of the universe.

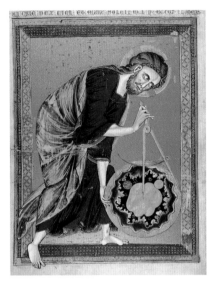

Spherical Earth in an image of God measuring the world with a compass, from a *Bible moralisée* (c. 1250)

Alexander in his *Successions of Philosophers* says that he found in the Pythagorean memoirs the following tenets as well . . . [the] universe [is] animate, intelligent, spherical, with the earth at its center, the earth itself too being spherical and inhabited round about. There are also antipodes, and our "down" is their "up." Light and darkness have equal part. . . .

The World Is a Tabernacle

COSMAS INDICOPLEUSTES
(SIXTH CENTURY)
Christian Topography, III

When men at first after the Deluge were high up in the air, building the tower in their warfare with God, they suspected from their constantly observing the heavenly bodies, but erroneously, that the heaven was spherical. . . .
He then afterward directed [Moses] to construct the Tabernacle according to the pattern which he had seen [on

Mt. Sinai]—being a pattern, so to say, of the whole world. [Moses] therefore made the Tabernacle, designing that as far as possible it should be a copy of the figure of the world, and thus he gave it a length of thirty cubits and a breadth of ten. Then, by interposing inside a veil in the middle of the Tabernacle, he divided it into two compartments, of which the first was called the Holy Place, and the second behind the veil the Holy of Holies. Now the outer was a pattern of this visible world which, according to the divine Apostle, extends from the earth to the firmament, and in which at its northern side was a table, on which were twelve loaves, the table thus presenting a symbol of the earth which supplies all manner of fruits, twelve namely, one as it were for each month of the year. The table was all round wreathed with a waved moulding symbolic of the sea which is called the ocean, and all round this again was a border of a palm's breadth emblematic of the earth beyond the ocean, where lies Paradise away in the East, and where also the extremities of the first heaven, which is like a vaulted chamber, are everywhere supported on the extremities of the earth. Then at the south side he placed the candlestick which shines upon the earth from the south to the north. In this candlestick,

symbolic of the week of seven days, he set seven lamps, and these lamps are symbolic of all the luminaries.

The Flat Earth of Voliva

L. SPRAGUE DE CAMP
AND WILLY LEY
Lands Beyond (1952)

While the thinkers of the time prior to the great voyages of discovery still had some reason on their side–usually adherence to Scripture, or their interpretation of it–all the later revivals of the flat earth have been strictly screwball antics. The most recent and certainly the most notorious of them was that of Wilbur Glen Voliva, ruler of the Christian Catholic Apostolic Church of Zion, Illinois, from 1906 to his death in 1942.

The founder of this cult was a noisy little Scot named John Alexander Dowie who left his Congregationalist ministry in Australia to found a faith-healing society. In 1888 he set out for England to organize a branch, but in passing through the United Sates he sensed greener pastures and presently set up his church in Chicago. Persecution caused him to move to Zion, thirty-five miles north, where he reigned for nearly two decades by virtue of oratory gifts, commercial shrewdness, and adamantine opposition to all vices, in which he included tobacco, oysters, medicine, and life insurance.

Dowie's downfall began when he proclaimed himself Elijah III (that is, the second reincarnation of Elijah, the first having been John Baptist) and tried to take New York City by storm. He descended upon the sinful metropolis with eight trainloads of followers

Cosmas Indicopleustes,
The Rectangular Cosmos,
Ms. Plut. 9.28, c.95v,
Florence, Biblioteca
Medicea Laurenziana

and rented Madison Square Garden for a week. The New Yorkers came to see the wonder man, but found somebody who looked like Santa Claus mouthing a tedious spate of vituperation in rich Edinburgh brogue. They got bored and trooped out in droves, leaving the prophet screaming threats and insults.

To seal his doom Dowie had been selling "stock" (actually promissory notes bearing 10% interest) to pay interest on stock already sold. Inevitably the laws of arithmetic caught up with him. While Dowie was away in Mexico buying an estate to which he intended to retire, Wilbur Voliva, using the power of attorney with which Dowie had imprudently trusted him, led a revolt of the cult's officials and at one stroke stripped Dowie of power and pelf. Elijah III died soon after.

The bushy-browed and austerely handsome Voliva had started as an Indiana farm boy, gone into the ministry of the Christian Church, and deserted that for Dowieism. Under his rule Zion's formidable blue laws were screwed even tighter, so that anybody caught smoking or chewing gum on the muddy streets was liable to be thrown in the hoosegow. After his coup he reorganized the bankrupt community so successfully that by 1930 he was making $6,000,000 a year from Zion's industries, which included not only Dowie's original lace factory, but also a paint factory, a candy-bar factory, and other establishments Voliva's cosmogony comprised a disk earth with the North Pole at the center and a wall of ice around the edge. Those who traveled around the earth (as Voliva himself did several times) were merely following a circular path around the center disk. When asked what lay

beyond the ring-wall of ice that corresponded to the Antarctica of the wicked, he retorted that: "it is not necessary that we know," and when taxed with the fact that on his map the Antarctic circle (and with it the coastline of Antarctica) would be 43,000 miles long whereas those who did circumnavigate Antarctica found much smaller figures, he simply changed the subject.

The Antipodes

ARISTOTLE (384–322 BC)
Metaphysics I, 5

. . . as the number 10 is thought to be perfect and to comprise the whole nature of numbers, they say that the bodies which move through the heavens are ten, but as the visible bodies are only nine, to meet this they invent a tenth—the "counter-earth."

ARISTOTLE
On the Heavens II, 13, 1

Pythagoreans take the contrary view. At the centre, they say, is fire, and the earth is one of the stars, creating night and day by its circular motion about the centre. They further construct another earth in opposition to ours to which they give the name counter-earth.

MARCUS MANILIUS
(FIRST CENTURY BC–
FIRST CENTURY AD)
Astronomica, I, 236–246, 377–381

Around the earth live various races
 of men and animals

The Antipodes according
to Cosmas Indicopleustes

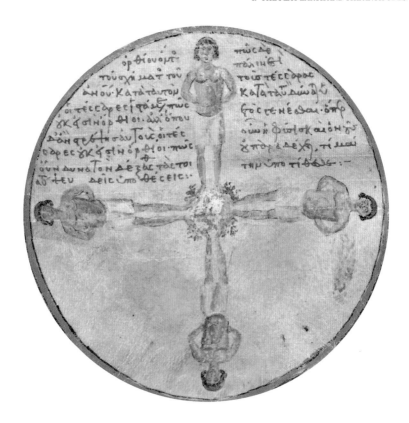

And the birds of the sky. One part
 stretches up to the Bears
And the other habitable part extends
 into the austral regions:
It lies beneath our feet, but it seems
 to them that they are above,
Because the earth hides its curvature
And the surface of the globe both rises
 and falls.
When the Sun, as it sets on us, looks
 upon these regions,
The new day reawakens the sleeping
 cities there,
And its light brings back activity and
 toil to those lands;
We are plunged into night and aban-
 don our limbs to sleep:
The sea divides one side from the oth-
 er but unites us with its waves.
 . . .
Beneath them [the southern constella-
tions] lies another part of the
 world,
That we cannot reach,
And unknown races of men, and king-
 doms never crossed
That receive light from the same sun
 as us,
And shadows opposite to ours, with
 stars that set to the left
And rise to the right, in a sky the re-
 verse of our own.

LUCRETIUS (C. 96–C. 55 BC)
On the Nature of Things, I, 1050ff

And in these problems, shrink, my
 Memmius, far
From yielding faith to that notorious
 talk:
That all things inward to the center
 press;

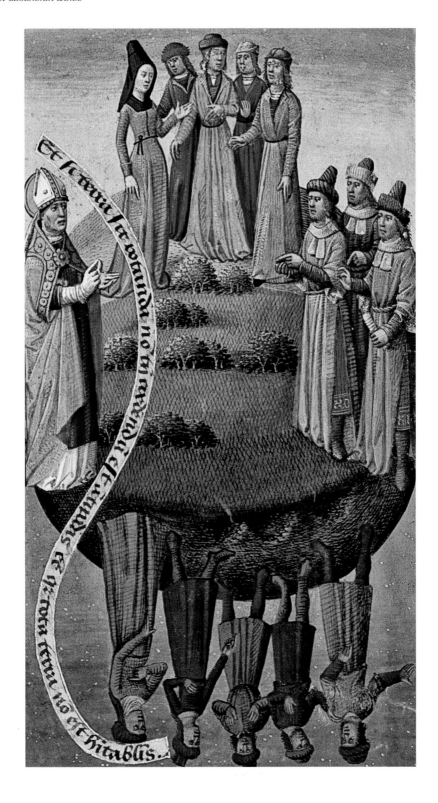

And thus the nature of the world
 stands firm
With never blows from outward, nor
 can be
Nowhere disparted—since all height
 and depth
Have always inward to the center
 pressed
(If thou art ready to believe that aught
Itself can rest upon itself); or that
The ponderous bodies which be under
 earth
Do all press upward and do come to
 rest
Upon the earth, in some way upside
 down,
Like to those images of things we see
At present through the waters. They
 contend,
With like procedure, that all breath-
 ing things
Head downward roam about, and yet
 cannot
Tumble from earth to realms of sky
 below,
No more than these our bodies wing
 away
Spontaneously to vaults of sky above;
That, when those creatures look upon
 the sun,
We view the constellations of the
 night;
And that with us the seasons of the sky
They thus alternately divide, and thus
Do pass the night coequal to our days,
But a vain error has given these
 dreams to fools,
What they've embraced with reason-
 ing perverse. . . .

LACTANTIUS (C. 240–320)
The Divine Institutes III, 24, 467–470

How is it with those who imagine that
there are antipodes opposite to our
footsteps? Do they say anything to the
purpose? Or is there any one so sense-
less as to believe that there are men
whose footsteps are higher than their
heads? Or that the things which with
us are in a recumbent position, with
them hang in an inverted direction?
That the crops and trees grow down-
ward? That the rains, and snow, and
hail fall upward to the earth? And does
any one wonder that hanging gardens
are mentioned among the seven won-
ders of the world, when philosophers
make hanging fields, and seas, and cit-
ies, and mountains? . . .
What course of argument, therefore,
led them to the idea of the antipodes?
They saw the courses of the stars trav-
elling toward the west; they saw that
the sun and the moon always set to-
ward the same quarter, and rise from
the same. But since they did not per-
ceive what contrivance regulated their
courses, nor how they returned from
the west to the east, but supposed that
the heaven itself sloped downward in
every direction . . . they thought that
the world is round like a ball, and they
fancied that the heaven revolves in
accordance with the motion of the
heavenly bodies; and thus that the
stars and sun, when they have set, by
the very rapidity of the motion of the
world are borne back to the east.

COSMAS INDICOPLEUSTES
(SIXTH CENTURY)
Christian Topography I, 14 and 20

Thus they do their best to prevent
anyone surpassing them in their ef-
frontery—or rather, let me say, in im-
piety, since they do not blush to affirm
that there are people who live on the
under surface of the earth. What then,

should some one question them and say: Is the sun to no purpose carried under the earth? these absurd persons will, on the spur of the moment, without thinking, reply that the people of the Antipodes are there—men carrying their heads downward, and rivers having a position opposite to the rivers here! thus taking in hand to turn every thing upside down rather than to follow the doctrines of the truth, in which there are no futile sophisms, but which are plain and easy and full of godliness, while they procure salvation for those who reverently consult them. . . .

But should one wish to examine more elaborately the question of the Antipodes, he would easily find them to be old wives' fables. For if two men on opposite sides placed the soles of their feet each against each, whether they chose to stand on earth, or water, or air, or fire, or any other kind of body, how could both be found standing upright? The one would assuredly be found in the natural upright position, and the other, contrary to nature, head downward. Such notions are opposed to reason, and alien to our nature and condition. And how, again, when it rains upon both of them, is it possible to say that the rain falls down upon the two, and not that it falls down to the one and falls up to the other, or falls against them, or toward them, or away from them. For to think that there are Antipodes compels us to think also that rain falls on them from an opposite direction to ours; and any one will, with good reason, deride these ludicrous theories, which set forth principles incongruous, ill-adjusted, and contrary to nature.

SAINT AUGUSTINE (354–430)
City of God, XVI, 9, 315–316

But as to the fable that there are Antipodes, that is to say, men on the opposite side of the earth, where the sun rises when it sets to us, men who walk with their feet opposite ours, that is on no ground credible. And, indeed, it is not affirmed that this has been learned by historical knowledge, but by scientific conjecture, on the ground that the earth is suspended within the concavity of the sky, and that it has as much room on the one side of it as on the other: hence they say that the part which is beneath must also be inhabited. But they do not remark that, although it be supposed or scientifically demonstrated that the world is of a round and spherical form, yet it does not follow that the other side of the earth is bare of water; nor even, though it be bare, does it immediately follow that it is peopled. For Scripture, which proves the truth of its historical statements by the accomplishment of its prophecies, gives no false information; and it is too absurd to say, that some men might have taken ship and traversed the whole wide ocean, and crossed from this side of the world to the other, and that thus even the inhabitants of that distant region are descended from that one first man.

MACROBIUS
Commentary on the Dream of Scipio, I, 5, 23–26

This same reasoning leaves us in no doubt that, for the part of the earth's surface that we reckon to be below us, the entire circumference of the temperate zones on that side must also be

De exiguitate oceani, from a sixteenth-century edition of Macrobius' *Commentary on the Dream of Scipio*, II, 9. Past the ocean floor is the land of the Antipodes, "unknown to us."

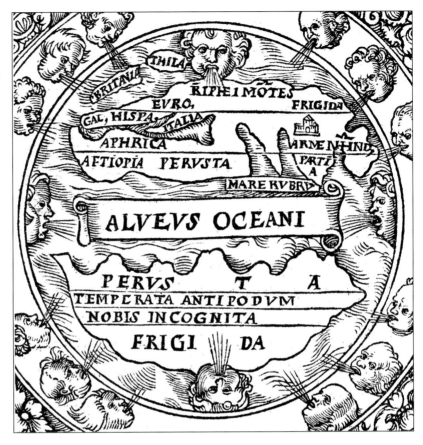

considered temperate following the same arrangement; and in consequence, that two zones exist down there, lying at a distance from each other, and equally inhabited.

Or if there is anyone who prefers to oppose this conviction, then let them tell us what leads them to reject our affirmation. Indeed, if we are able to exist on this part of the earth in which we live, because when treading upon the ground we see the sky above our heads, because the sun rises and sets for us, because we enjoy the air surrounding us and inhale it as we breathe, why should we not believe that other inhabitants exist down there who still enjoy the same conditions?

Indeed, we must reckon that the aforementioned inhabitants of those places below breathe the same air, because the same temperate climate reigns in their zones along the whole length of the same circumference: they have the same sun, which will be said to be setting for them when it rises for us and which will rise when it must set for them; like us they will tread the earth and still see the sky above their heads; nor will they be fearful of falling from the earth into the sky, because nothing can ever fall upward. Indeed, if where we are, we think of down as the direction of the earth and up as the direction of the sky (something that for us is ridicu-

lous even to mention), to them as well, upward will be the direction toward which they raise their eyes from below, nor will they ever be able to fall into regions lying above them. I could even state that the least educated amongst them think the same about us and cannot believe that we can live in the place where we are, convinced that a person would fall if he were to attempt to stand up in the region below them. In spite of this, none of us has ever been frightened of falling into the sky: therefore neither will anyone in their region fall upward; because toward the earth "all masses are attracted by their own force" (Cicero, *Somnium Scipionis* 4,3).

LUCIUS AMPELIUS
(THIRD CENTURY)
Liber memorialis, VI

The terrestrial globe lies beneath the heavens and is divided into four inhabited regions. The first is inhabited by us, and in the second—which lies opposite—the inhabitants are called Antichthones. The other two regions lie opposite the first two and their inhabitants are called Antipodes.

LUIGI PULCI
Morgante, XXV, 230–233

1. Rinaldo, having recognized the place, because he had seen it once before, then said to Astarotte: Tell me a little of the purpose this sign has served. Said Astaròt: A dim and distant error, for many centuries unrecognized, has made men talk of "the Pillars of Hercules" and claim that many have perished beyond.

2. I tell you that this belief is false, as it is possible to sail further on, because the water is flat all around, though the earth has the form of a wheel. The human race was cruder then, such that Hercules might blush at having left those signs, which vessels now will leave behind.

3. And the other hemisphere may be reached, since all things are drawn toward the center, so that the earth by divine mystery is suspended between the stars sublime, and down there are cities, castles and empires; but those earlier people did not know: see how the sun is hastening to go in that direction, as they await down there.

4. . . . Those people are named Antipodes; they worship the sun and Jupiter and Mars, they have plants and animals, just like you, and often fight great battles too.

5. Said Rinaldo: As we are speaking of this, tell me, Astaròt, another thing besides: if these people are of the race of Adam; and, since false things are worshipped there, whether they can attain salvation as we can. Said Astarotte: Ask me no further, because more than this I cannot say, and it seems your questioning is crude.

6. So would He have been biased your Redeemer, toward this side, so that Adam was formed for you up here, and He was crucified for love of you? I tell you that all men by the cross are saved; and even having erred so long, perhaps, you will all adore the truth in harmony, and find mercy one and all.

The Antipodes,
relief by the Master
of the Metope, Modena,
Museo lapidario del Duomo

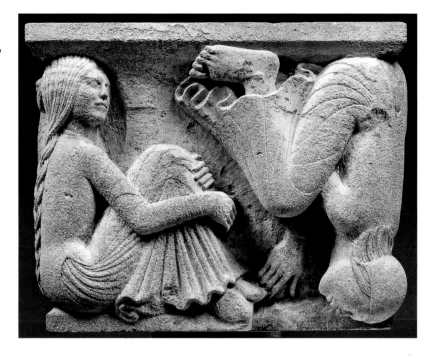

MANEGOLD OF LAUTENBACH (C. 1040–C. 1119)
Opusculum contra Wolfelmum Coloniensem (1103; *Patrologia Latina,* vol. 155, col. 153–155)

And once you accept that there are four regions inhabited by men, and that no travel whatsoever between them is possible on account of the barriers erected by nature, you must explain—tell me, I beg you!—how the confession of the holy and apostolic Church is true and can reasonably be fulfilled: that the Savior came for the salvation of the entire human race. . . . But how might this be if three races of men, as the aforesaid Macrobius argues, can exist apart, beyond this habitable region in which the temperate climate of the zones of heaven and earth permit us to dwell—three races to whom the news of our salvation cannot reach?

ANTONIO PIGAFETTA
Magellan's Voyage around the World (1523)

Our old pilot from Maluco told us that there was an island nearby called Arucheto, the men and women of which are not taller than one cubit, but who have ears as long as themselves. With one of them they make their bed and with the other they cover themselves. They go shaven close and quite naked, run swiftly, and have shrill voices. They live in caves underground, and subsist on fish and a substance which grows between the wood and the bark [of a tree], which is white and round like preserved coriander, which is called ambulon. However, we did not go there because of the strong currents in the water, and the numerous shoals.

2

BIBLICAL LANDS

THE LOST TRIBES Nothing is better known to us than the geography of biblical Palestine and the neighboring lands. Jericho and Bethlehem exist to this day, as does the Sinai, the Sea of Galilee, and the Red Sea crossed by Moses and his people. Yet the biblical account also mentions some places whose geography is plunged deep in legend.

Let us take the matter of the twelve tribes of Israel. Their names are known: they were the tribes of Reuben, Simeon, Levi, Judah, Dan, Naphtali, Gad, Asher, Issachar, Zebulun, Joseph, and Benjamin. When the people of Israel, led by Joshua, re-settled the land of Israel (around 1200 BC), the country was subdivided into eleven parts, in each of which one tribe stayed. The tribe of Levi, whose members performed priestly duties, was assigned no land.

The tribe of Judah, the most numerous, lived in the southern part of the country, and there were two realms, that of Judah and that of Israel, inhabited by ten of the original tribes. But the kingdom of Israel was conquered by the Assyrians in 721 BC, and its inhabitants were deported to other regions of the empire, where the members of the ten tribes gradually merged with the natives and all certain traces of them were lost. But for many Jews, the reintegration of those lost co-religionists has remained a project to be realized, an ideal connected with the expectation of the Messianic era.

According to one tradition, the lost tribes could not return to Israel because the Lord had surrounded their path with a legendary river, the Sambatyon. Throughout the week the waters of the Sambatyon boiled; enormous rocks broke away from its bed, flew up into the air, and fell back on those who tried to find a ford. The

Jean Fouquet, illustration, *The Building of the Temple of Solomon*, in *Les Antiquités judaïques* (c. 1470), Flavius Josèphe, Ms. Fr. 247 f.153v, Paris, Bibliothèque nationale de France. The temple is seen as a gothic cathedral

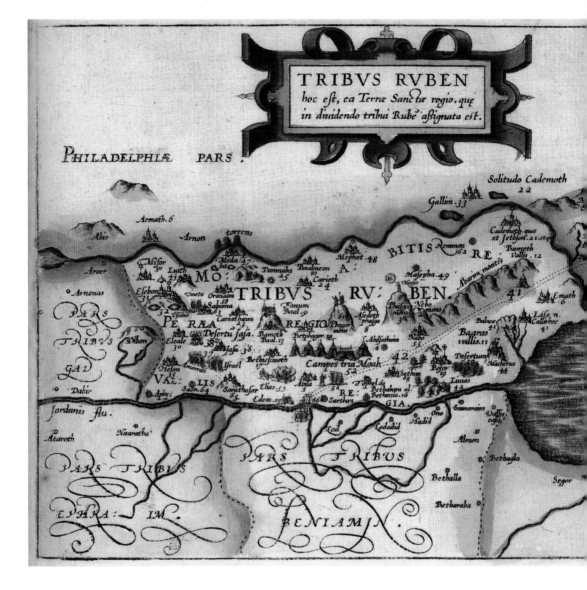

Sambatyon rested only on Saturdays, but no Jew would have dared violate the Sabbath by trying to cross that calm watercourse. Another tradition had it that the Sambatyon was a river made only of rocks and sand, a tumultuous chaos of boulders and earth, which flowed ceaselessly, and those who observed that sight from the banks had to cover their faces to keep them from being gashed.

 In the Middle Ages, information about the lost tribes comes to us from a Jewish traveller of the ninth century, Eldad ha-Dani, who

Christian van Adrichom, *The Twelve Tribes of Israel*, in *Situs terrae promissionis* (1628)

Pages 42–43: Tintoretto, *The Fall of Manna* (sixteenth century), Venice, presbytery of the Basilica di San Giorgio Maggiore

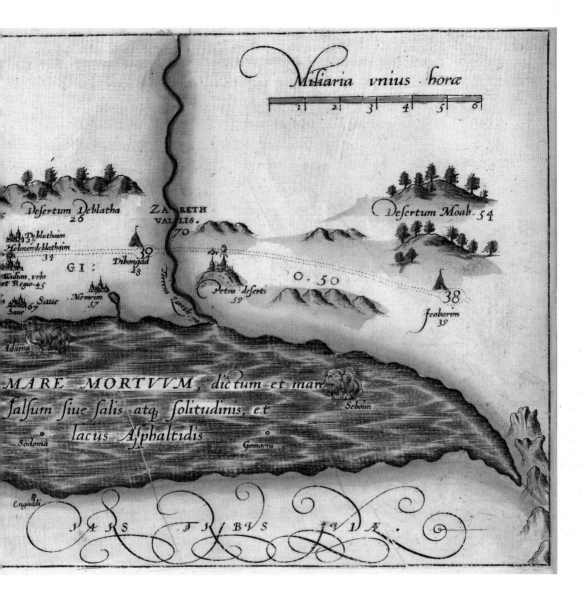

believed the ten tribes were on the other side of the rivers of Abyssinia, or in fact on the banks of the Sambatyon. In 1165 Benjamin of Tudela, describing one of his journeys to Persia and the Arabian peninsula, tells of how he came across some tribes of Jewish origin. But the lost tribes have been sought in other, less conceivable places. For example, in the sixteenth century, Bartolomeo de Las Casas, in defending the Indians of America from the oppression of the Spanish conquistadores, presented them as the descendants of the ten lost

41

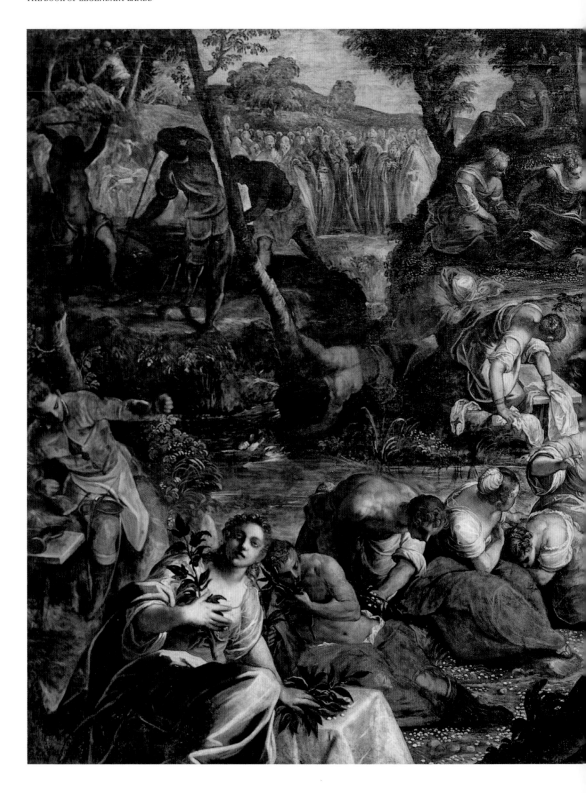

tribes. In the seventeenth century, the realization of the Messianic era and hence the return of the ten tribes had been announced by the followers of a singular mystic, prophet and kabbalist, Shabbetai Tzevi, who had allegedly crossed the Sambatyon. Unfortunately Tzevi's announcement was not very efficacious, because shortly afterward he decided to convert to Islam and became less credible as far as the Jewish community was concerned.

In various periods, the lost tribes have been identified in Kashmir, on the basis of possible Jewish etymologies of some place names or local tribal groups; among the Tartars of central Asia; in the Caucasus; in Afghanistan; and in the empire of the Khazars (which was a Turkic kingdom whose inhabitants converted to Judaism in the eighth century). Not to mention other identifications that have involved the Zulus, the Japanese, the Malaysians, and so on.

The most bizarre hypothesis, which has associated the ten tribes with the British Isles since the eighteenth century, was the work of Richard Brothers, a supposed prophet who had spent many years in a psychiatric institution and who (defining himself as Nephew of the Almighty) had founded a millenaristic movement. Brothers believed that the descendants of the lost tribes were the inhabitants of the British Isles. In the following century, an Irishman, John Wilson, started up the British Israelism movement—according to which the Jews who survived the deportations had migrated from Central Asia to the Black Sea and thence to England (where the royal family allegedly descended from the house of David); in this process, they purportedly acquired blonde hair and blue eyes, and there were some who, with huge disregard for the etymological sciences, took the *Saxons* as *Isaac's sons*. The movement enjoyed a certain diffusion in English-speaking countries, where some followers exist to this day, and publications in support of this lineage still appear.

As usual, legends are always born on the basis of a historical truth. The idea that, in the course of deportations and diasporas, there formed between Asia and Africa pockets of Jewish origin is far from unbelievable. And so we know of tribes of Ethiopian Jews, the *falashas*, the

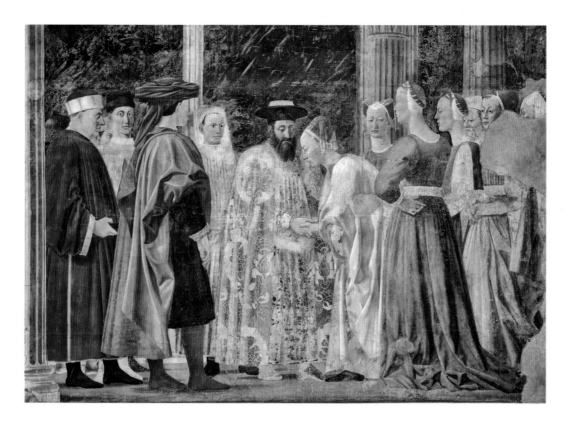

Piero della Francesca,
*The Meeting of Solomon
and the Queen of Sheba*
(1452–1466), Arezzo,
Basilica di San Francesco

"migrants," who according to one of their traditions, had moved to Abyssinia after the destruction of Solomon's Temple—and today very many of them have been welcomed to Israel as descendants of the tribe of Dan. But while the *falashas* really exist, the legends that associate them with the search for the Ark of the Covenant, allegedly kept in Axum (Ethiopia), are more or less utter nonsense.

SOLOMON, THE QUEEN OF SHEBA, OPHIR, AND THE TEMPLE The Bible tells us that the Queen of Sheba had come to meet Solomon, attracted by the fame of his wisdom and the splendor of his palace; and among the countless masterpieces inspired by that visit, the fresco by Piero della Francesca in Arezzo is still renowned. We know where Solomon was: in Jerusalem. But where did the queen come from? Here legend prevails over history; as for history, the most complete document we possess is in the Old Testament, in the first book of Kings.

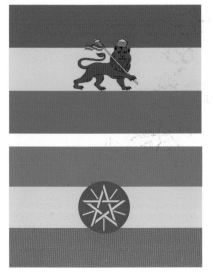

Later it became known that the Arabs knew her as Queen Bilqis, the Ethiopians called her Makeda, a Persian version of the story exists, and we also find her mentioned in the Koran. But it is in Ethiopia that she is considered a national myth, and there she is cited in the *Kebra Nagast* (The Glory of the King), written in Ethiopia in the fourteenth century.

The Bible, while speaking enthusiastically of that visit, does not tell us whether or not there was something more than a diplomatic relationship between Solomon and the queen. But in the *Kebra Nagast*, it is said, on the one hand, that after her visit the queen decided she would no longer worship the Sun but the God of Israel; and on the other, it is said that the couple had had a complete sexual relationship, from which was born Menelik, whose name means more or less "Son of the wise man," and who would be the primogenitor of a Solomonic lineage; hence the symbol of the Lion of Judah, which characterized the Ethiopian empire, and Solomon's seal in the center of the current flag, signifying the proud claim to direct descent from the great king. Naturally, since in biblical legends (as the Indiana Jones films tell us), the Ark of the Covenant is always around somewhere, it supposedly arrived in Axum, after various trials and tribulations, precisely because Menelik had called on his father one day and stole it from him, leaving a wooden copy in exchange.

Let us try to draw a few conclusions: one tradition has it that the queen came from Ethiopia, but Sheba lay at the meeting point where caravans carried incense in the direction of the Red Sea, in Arabia Felix, which corresponds more or less with the modern Yemen, and this tells us that in those days the very notion of Ethiopia was rather confused (and, as we shall see, it was no accident that, in an equally legendary Ethiopia, the realm of Prester John had been trans-

ported from the Far East). But the fact that Ethiopia has engendered so many legends tell us that it must have been a fairly rich and powerful kingdom.

Yet in Second Chronicles (9:1–12), in narrating the episode of the Queen of Sheba, it is also said, regarding the gifts she made to Solomon, that "the servants also of Huram, and the servants of Solomon, which brought gold from Ophir." Where was Ophir? It is mentioned various times in the Bible, and it was certainly a port. Three Arabic and Ethiopian pre-Islamic sources say that the Queen of Sheba had annexed it to her realm and had built it with gold stones, a wealth of which lay in the surrounding mountains. In his *Jewish Antiquities* (1.6.4), Flavius Josephus maintained that Ophir was in Afghanistan; Tomé Lopes, Vasco da Gama's companion, had suggested that it was the ancient name of Zimbabwe, which was the principal trading center in gold during the Renaissance, but its ruins date only from the Middle Ages. In 1568 Álvaro de Mendaña de Neira—of whom we shall be talking with regard to Terra Australis—when he had discovered the Solomon Islands, declared that he had discovered Ophir; in *Paradise Lost* (11.399–401), Milton talks of Mozambique; the theologian Benito Arias Montano (in the sixteenth century) had proposed Peru; in the nineteenth century, various scholars had identified Ophir with Abhira, at the mouth of the Indus, in modern Pakistan. Others again brought it back to Yemen, where we find ourselves back in Sheba without having concluded anything.

When, in 1970, Israel occupied Sharm el-Sheikh in the Sinai (now a flourishing Egyptian tourist resort), it named the locality Ofira, which means "toward Ophir," seeing in it one of the routes followed by Solomon's fleets to load the riches that the Bible talks about. We find Ophir in the novel *King Solomon's Mines* by H. Rider Haggard, but in that text, the place is located in South Africa, while the mysterious Opar, a city in the African jungle that appears in the Tarzan stories, is inspired by Ophir.

And so even the place of the Queen of Sheba fades into the confused geography of myth and cannot be found, like many of the lost islands that this book will be dealing with.

Solomon had amazed the Queen of Sheba with the splendor of the temple of Jerusalem, commonly known as the First Temple, which he is said to have built in the tenth century BC and which was destroyed by Nebuchadnezzar II in 586 BC. The Second Temple was built on the return from exile in Babylon starting from 536 BC, and was then enlarged by Herod the Great around 19 BC and destroyed by Titus in AD 70. But the First Temple was certainly the subject of a great many legends.

In the Bible we find two descriptions of the First Temple, in First Kings (6–8) and in Ezekiel (40–41). The description in Kings is more precise than Ezekiel's version and describes the temple according to measures that are comprehensible at first sight. This is not the case in Ezekiel, which nonetheless, precisely because of its apparent incoherence, has led exegetes over the centuries to make the rashest of exercises in visual interpretation.

It is interesting to see the efforts medieval allegorists make to *see* the Temple as it appears in Ezekiel's version; in order to see it they even try to provide instructions for its ideal reconstruction. Naturally, it would have been enough to read that text as the account of a vision, the memory of a dream, where forms appear, become deformed, and vanish, and from the literary point of view, it would even be interesting to surmise that the prophet was writing under the effect of some hallucinogen. On the other hand, Ezekiel himself does not say he saw an authentic construction but a *"quasi* aedificium." The same Jewish tradition admitted the impossibility of a coherent architectural interpretation, and in the twelfth century, Rabbi Solomon ben Isaac recognized that no one could understand anything about the layout of the northern rooms, where they began in the west and how far they extended to the east, and where they began on the inside and how far they extended on the outside (cf. Rosenau 1979)—and the Fathers of the Church said that, for example, if one wished to understand the measurements of the building in physical terms, the doors would have had to be wider than the walls.

But for the men of the Middle Ages, it was necessary to interpret Ezekiel literally, because they accepted the exegetical principle (de-

Raphael,
The Vision of Ezekiel
(c. 1518), Florence,
Galleria Palatina,
Palazzo Pitti

rived from Augustine) that, when Scripture contains apparently overly detailed and basically useless expressions, as for example numbers and measurements, they had to glimpse an allegorical meaning. And so if a reed was six cubits long, this was not only a verbal statement, but a *fact* that had been truly verified and that God had thus predisposed so that we could interpret it allegorically. Consequently, the temple *had to be* reconstructed realistically, otherwise this would have meant that Scripture had lied to us.

Now try, with a ruler, a measurement-conversion table, the biblical text in front of you, to construct a model of the temple. Medieval authors, who had tried this, did not possess measurement conversion tables, apart from distorted data that could have come to them from many translations and transcriptions of translations. But even a modern architect would find it difficult to transform these verbal instructions into a drawn plan.

In his *In visionem Ezechielis*, Richard of Saint Victor, in an attempt to make visible the "quasi" edifice described by the prophet, took pains to redo the calculations and reenvision planes and cross sections, deciding that when two measurements did not coincide, one reference must have been to the entire building and the other to only one of its parts, and he carried out the desperate (and destined to be unsuccessful) attempt to reduce the "quasi" edifice to something that a medieval master stonemason could have constructed. And all this is not to mention the exuberant proto-Baroque reinterpretations in Jerome de Prado and Juan Bautista Villalpando (1596).

From an archaeological standpoint, they were all reconstructions doomed to failure, and other commentators resigned themselves to talking about the Temple only with reference to its mystical significance, and by doing so, they could indulge in speculation without having to take into account realizable architectural plans. Or they could give free rein to their imaginations, as did certain medieval illuminators, who saw it as a Gothic cathedral, as did all the Masonic literature that sprang up around the myth of Hiram, the builder of the Temple, murdered by his workers, who wanted to extort from him the secrets of a master stonemason; or around the legend of the Templars, who came into being as knights of the Temple of Jerusalem but had simply taken possession of the Al-Aqsa Mosque because they believed it stood on the same ground as the First Temple.

In all these cases, Solomon's Temple, which certainly was a real place to a certain extent, became legendary, and all the efforts in the following centuries were aimed at reconstructing it, at least in the imagination, but not at finding it. To this day, devotees of three religions go to the Temple Mount in Jerusalem as if the Temple were still there: the Jews pray along the Wailing Wall, the last remains of

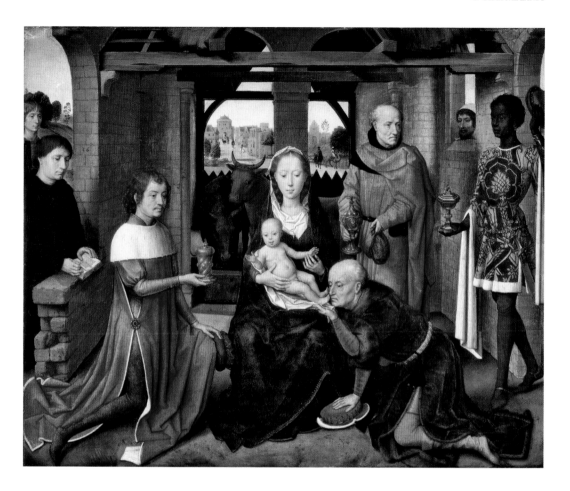

Hans Memling, *Floreins Triptych* (1474–79), central panel with adoration of the Magi, Bruges, Memling Museum

Herod's Temple destroyed by Titus; Christians turn their attention to the Holy Sepulchre; and Muslims go to the Mosque of Omar, still whole, but built in the seventh century AD, as the Dome of the Rock. But the First Temple remains lost forever.

WHERE DID THE MAGI COME FROM (AND WHERE DID THEY GO)? No legend is closer to us than that of the Three Magi. It has inspired countless artistic masterpieces and at the same infinite childish dreams—so that no one wonders anymore if the Magi really existed; but this is a question for historians, Bible scholars, or mythographers. In any case, their fleeting appearance in history is set between two legendary places, that of their origin and that of their sepulchre.

As for historical documents, the Gospel according to Matthew is the only canonical Christian source to describe the episode of the Magi. And Matthew does not say that there were three of them; in fact, he does not even say that they were kings. All he does is mention a journey from the east following a star, the offering of gold, frankincense, and myrrh, and the fact that the Magi refused to tell Herod the whereabouts of the child. At most, from Matthew we can deduce that there were three Magi because they had brought the child three gifts.

It was only the successive tradition that saw the Magi as kings and tried to fix their origin in some precise Eastern country, and there is mention of the Magi in the apocryphal gospels. A reference to the three kings also appears in Arab sources (for example, in the ninth century, the encyclopedist al-Tabari referred to gifts brought by the Magi, quoting as his source the seventh-century writer Wahb ibn Munabbih).

On the other hand, the author of the Gospel according to Matthew wrote toward the end of the first century, and therefore Matthew, or whoever wrote in his stead, was not yet born at the time of Jesus' birth and therefore could not talk from firsthand experience. So even before the evangelical text, information about the Magi was circulating in some way, even in pre-Christian society. John of Hildesheim (a late biographer of the Magi of the fourteenth century) says the origin of their journey began with astronomical research carried out on the Hill of Vaws, or the Hill of Victory, identifiable with Sabalān, the highest peak in Azerbaijan in the ancient Armenian empire. Tradition has it that the peak was climbed by Zoroastrian priests and astrologers, who waited for the appearance of a star that prophecies linked to the coming of a divinity on the Earth. In fact, *magi* comes from the Greek *magos, magoi*, which probably referred to the priests of Persian Zoroastrianism, as for example in Herodotus—and as we are led to think by the evangelical mention of the observation of the stars—but it could also mean wise men, although in other New Testament texts, such as the Acts of the Apostles, the term also means a wizard (like Simon Magus). The Magi probably came from Persia,

but they might also have come from Chaldea, and John of Hildesheim says they came from the Indies, but between the Indies he also puts Nubia, and so the area of their origin widens disconcertingly—also because John had connected the tale of their journey with the realm of Prester John,[1] which brings us back to some part of the Far East, as tradition still had it at the time when the hagiographer was writing. What has remained almost constant in the tradition is that one was presumably white, one Arab, and the other black, to suggest the universality of Redemption.

As for their number, tradition runs riot, sometimes there is talk of two, other times twelve, namely Hormizd, Jazdegerd, Peroz, Hor, Basander, Karundas, Melkon, Gaspar, Balthazar, Fadizzarda, Bithisarea, Melchior, and Gastapha. In the western tradition, the idea that won the day in the end was that there were three of them, Gaspar, Melchior, and Balthazar; but for the Ethiopian Catholic Church, they were called Hor, Basander, and Karundas; Syrian Christians knew them as Larvandad, Hormisdas, and Gushnasaph; in Zacharias Chrysopolitanus's *Concordia evangelistarum* (1150), they had become Appelius, Amerius, and Damascus, or, in the Hebrew forms, Magalath, Galgalath, and Tharath.

The regal grandeur of the Magi (and see further ahead in this book the close fusion of kingship and priesthood with regard to Melchizedek) was later confirmed in the liturgical tradition when the Feast of the Epiphany was connected with the prophecy in Psalm 72:10–11: "The kings of Tarshish and of the isles shall bring presents: the kings of Sheba and Seba shall offer gifts. Yea, all kings shall fall down before him: all nations shall serve him."

But perhaps the story of their burial is more interesting. Marco Polo says he visited the tombs of the Magi in the city of Sheba. But we have historical evidence dating from a century before Marco Polo. When Frederick Barbarossa conquered and razed Milan in 1162, in the Basilica of Saint Eustorgius there was a sarcophagus (which still exists but is empty), which was supposed to contain the bodies of the three kings. Tradition had it that in the fourth century, Bishop Eustorgius, wishing one day to be buried together with the Magi, had

1. *See chapter 4 on the wonders of the East.*

their remains brought from the basilica of Hagia Sophia in Constantinople (where they had been taken by Saint Helen, who had found them during her pilgrimage to the Holy Land). At an even earlier date, it was said that they had been buried in Persia, where Marco Polo said he had found them.

On having found them in Milan instead, Frederick's minister, Reinald von Dassel, who knew how much a relic could be worth in economic terms because it made a city the destination of constant pilgrimages, ordered the bodies to be removed to Cologne cathedral, where you can see the Ark of the Magi to this day. The Milanese had long lamented that theft (see the recriminations of <u>Bonvesin de la Riva</u>) and tried vainly to recover the precious remains. It was only in 1904 that the archbishop of Milan solemnly relocated some fragments of bone from those venerated remains (two fibulas, a tibia, and a vertebra) offered by the archbishop of Cologne. But many places boast that they obtained fragments of the relics during their removal from Milan to Germany, and so the tombs of the Magi (a bone or a piece of cartilage each) have multiplied. Pilgrims in life, the three kings have become vagabonds post mortem, engendering their multifarious cenotaphs.

Paolo Veronese,
detail from *The Queen
of Sheba* (1580–1588),
Turin, Galleria Sabauda

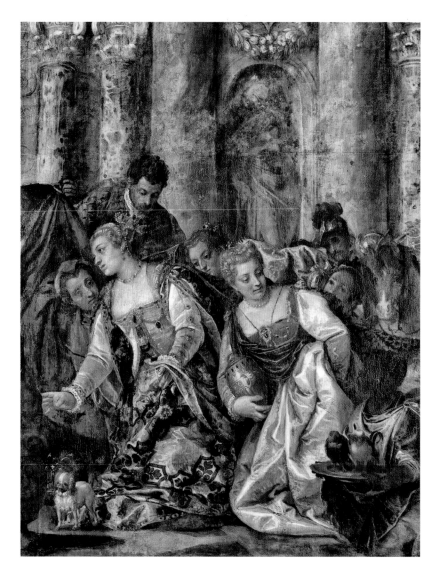

The Queen of Sheba

First Kings, X, 1–25,
King James Version

And when the queen of Sheba heard of the fame of Solomon concerning the name of the Lord, she came to prove him with hard questions. And she came to Jerusalem with a very great train, with camels that bare spices, and very much gold, and precious stones: and when she was come to Solomon, she communed with him of all that was in her heart. And Solomon told her all her questions: there was not any thing hid from the king, which he told her not. And when the queen of Sheba had seen all Solomon's wisdom, and the house that he had built, and the meat of his table, and the sitting of his servants, and the at-

tendance of his ministers, and their apparel, and his cupbearers, and his ascent by which he went up unto the house of the Lord; there was no more spirit in her. And she said to the king, It was a true report that I heard in mine own land of thy acts and of thy wisdom. Howbeit I believed not the words, until I came, and mine eyes had seen it: and, behold, the half was not told me: thy wisdom and prosperity exceedeth the fame which I heard. Happy are thy men, happy are these thy servants, which stand continually before thee, and that hear thy wisdom. Blessed be the Lord thy God, which delighted in thee, to set thee on the throne of Israel: because the Lord loved Israel for ever, therefore made he thee king, to do judgment and justice. And she gave the king an hundred and twenty talents of gold, and of spices very great store, and precious stones: there came no more such abundance of spices as these which the queen of Sheba gave to king Solomon. And the navy also of Hiram, that brought gold from Ophir, brought in from Ophir great plenty of almug trees, and precious stones. And the king made of the almug trees pillars for the house of the Lord, and for the king's house, harps also and psalteries for singers: there came no such almug trees, nor were seen unto this day. And king Solomon gave unto the queen of Sheba all her desire, whatsoever she asked, beside that which Solomon gave her of his royal bounty. So she turned and went to her own country, she and her servants. Now the weight of gold that came to Solomon in one year was six hundred threescore and six talents of gold, beside that he had of the merchantmen, and of the traffick of the spice mer-

chants, and of all the kings of Arabia, and of the governors of the country. And king Solomon made two hundred targets of beaten gold: six hundred shekels of gold went to one target. And he made three hundred shields of beaten gold; three pound of gold went to one shield: and the king put them in the house of the forest of Lebanon. Moreover the king made a great throne of ivory, and overlaid it with the best gold. The throne had six steps, and the top of the throne was round behind: and there were stays on either side on the place of the seat, and two lions stood beside the stays. And twelve lions stood there on the one side and on the other upon the six steps: there was not the like made in any kingdom. And all king Solomon's drinking vessels were of gold, and all the vessels of the house of the forest of Lebanon were of pure gold; none were of silver: it was nothing accounted of in the days of Solomon. For the king had at sea a navy of Tharshish with the navy of Hiram: once in three years came the navy of Tharshish, bringing gold, and silver, ivory, and apes, and peacocks. So king Solomon exceeded all the kings of the earth for riches and for wisdom.

The Measurements of the Temple

Ezekiel, XL, 1–31, and XLI, 1–26, King James Version

In the five and twentieth year of our captivity, in the beginning of the year, in the tenth day of the month, in the fourteenth year after that the city was smitten, in the selfsame day the hand of the Lord was upon me, and brought

Santi di Tito,
*Solomon Directing
the Building of the Temple*
(sixteenth century),
Florence, Cappella
della Compagnia
di San Luca, Basilica
della Santissima Annunziata

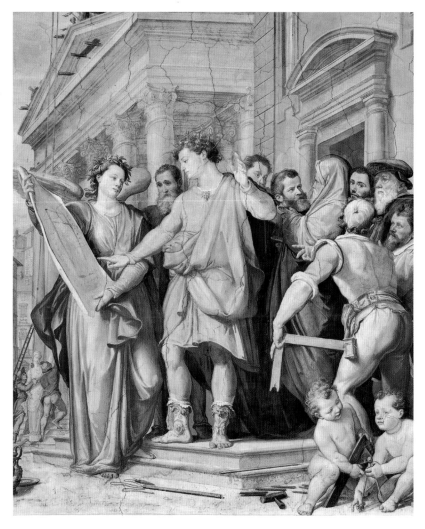

me thither. In the visions of God brought he me into the land of Israel, and set me upon a very high mountain, by which was as the frame of a city on the south. And he brought me thither, and, behold, there was a man, whose appearance was like the appearance of brass, with a line of flax in his hand, and a measuring reed. . . . And the little chambers of the gate eastward were three on this side, and three on that side; they three were of one measure: and the posts had one measure on this side and on that side. And he measured the breadth of the entry of the gate, ten cubits; and the length of the gate, thirteen cubits. The space also before the little chambers was one cubit on this side, and the space was one cubit on that side: and the little chambers were six cubits on this side, and six cubits on that side. He measured then the gate from the roof of one little chamber to the roof of another: the breadth was five and twenty cubits, door against door. He made also posts

of threescore cubits, even unto the post of the court round about the gate. And from the face of the gate of the entrance unto the face of the porch of the inner gate were fifty cubits. And there were narrow windows to the little chambers, and to their posts within the gate round about, and likewise to the arches: and windows were round about inward: and upon each post were palm trees. Then brought he me into the outward court, and, lo, there were chambers, and a pavement made for the court round about: thirty chambers were upon the pavement. And the pavement by the side of the gates over against the length of the gates was the lower pavement. Then he measured the breadth from the forefront of the lower gate unto the forefront of the inner court without, an hundred cubits eastward and northward.

And the gate of the outward court that looked toward the north, he measured the length thereof, and the breadth thereof. And the little chambers thereof were three on this side and three on that side; and the posts thereof and the arches thereof were after the measure of the first gate: the length thereof was fifty cubits, and the breadth five and twenty cubits. And their windows, and their arches, and their palm trees, were after the measure of the gate that looketh toward the east; and they went up unto it by seven steps; and the arches thereof were before them. And the gate of the inner court was over against the gate toward the north, and toward the east; and he measured from gate to gate an hundred cubits. . . .

And there was a gate in the inner court toward the south: and he measured from gate to gate toward the south an hundred cubits. And he brought me to the inner court by the south gate: and he measured the south gate according to these measures; and the little chambers thereof, and the posts thereof, and the arches thereof, according to these measures: and there were windows in it and in the arches thereof round about: it was fifty cubits long, and five and twenty cubits broad. And the arches round about were five and twenty cubits long, and five cubits broad. And the arches thereof were toward the utter court; and palm trees were upon the posts thereof: and the going up to it had eight steps.

Afterward he brought me to the temple, and measured the posts, six cubits broad on the one side, and six cubits broad on the other side, which was the breadth of the tabernacle. And the breadth of the door was ten cubits; and the sides of the door were five cubits on the one side, and five cubits on the other side: and he measured the length thereof, forty cubits: and the breadth, twenty cubits. Then went he inward, and measured the post of the door, two cubits; and the door, six cubits; and the breadth of the door, seven cubits. So he measured the length thereof, twenty cubits; and the breadth, twenty cubits, before the temple: and he said unto me, This is the most holy place. After he measured the wall of the house, six cubits; and the breadth of every side chamber, four cubits, round about the house on every side. And the side chambers were three, one over another, and thirty in order; and they entered into the wall which was of the house for the side chambers round about, that they might have

hold, but they had not hold in the wall of the house. And there was an enlarging, and a winding about still upward to the side chambers: for the winding about of the house went still upward round about the house: therefore the breadth of the house was still upward, and so increased from the lowest chamber to the highest by the midst. I saw also the height of the house round about: the foundations of the side chambers were a full reed of six great cubits. The thickness of the wall, which was for the side chamber without, was five cubits: and that which was left was the place of the side chambers that were within. And between the chambers was the wideness of twenty cubits round about the house on every side. . . . Now the building that was before the separate place at the end toward the west was seventy cubits broad; and the wall of the building was five cubits thick round about, and the length thereof ninety cubits. So he measured the house, an hundred cubits long; and the separate place, and the building, with the walls thereof, an hundred cubits long; also the breadth of the face of the house, and of the separate place toward the east, an hundred cubits. And he measured the length of the building over against the separate place which was behind it, and the galleries thereof on the one side and on the other side, an hundred cubits, with the inner temple, and the porches of the court; the door posts, and the narrow windows, and the galleries round about on their three stories, over against the door, cieled with wood round about, and from the ground up to the windows, and the windows were covered; to that above the door, even unto the inner house, and without, and by all the wall round about within and without, by measure. And it was made with cherubims and palm trees, so that a palm tree was between a cherub and a cherub; and every cherub had two faces; so that the face of a man was toward the palm tree on the one side, and the face of a young lion toward the palm tree on the other side: it was made through all the house round about. . . . The altar of wood was three cubits high, and the length thereof two cubits; and the corners thereof, and the length thereof, and the walls thereof, were of wood: and he said unto me, This is the table that is before the Lord. And the temple and the sanctuary had two doors. And the doors had two leaves apiece, two turning leaves; two leaves for the one door, and two leaves for the other door. And there were made on them, on the doors of the temple, cherubims and palm trees, like as were made upon the walls; and there were thick planks upon the face of the porch without. And there were narrow windows and palm trees on the one side and on the other side, on the sides of the porch, and upon the side chambers of the house, and thick planks.

Where the Wise Men Came From

Gospel according to Saint Matthew, II, 1–14, King James Version

Now when Jesus was born in Bethlehem of Judaea in the days of Herod the king, behold, there came wise men from the east to Jerusalem, saying, Where is he that is born King of the Jews? for we have seen his star

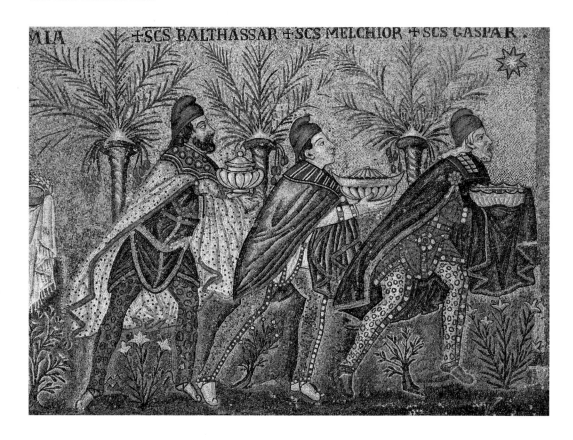

+SCS BALTHASSAR +SCS MELCHIOR +SCS GASPAR

in the east, and are come to worship him. When Herod the king had heard these things, he was troubled, and all Jerusalem with him. And when he had gathered all the chief priests and scribes of the people together, he demanded of them where Christ should be born. And they said unto him, In Bethlehem of Judaea: for thus it is written by the prophet, And thou Bethlehem, in the land of Juda, art not the least among the princes of Juda: for out of thee shall come a Governor, that shall rule my people Israel. Then Herod, when he had privily called the wise men, enquired of them diligently what time the star appeared. And he sent them to Bethlehem, and said, Go and search diligently for the young child; and when ye have found him, bring me word again, that I may come and worship him also. When they had heard the king, they departed; and, lo, the star, which they saw in the east, went before them, till it came and stood over where the young child was. When they saw the star, they rejoiced with exceeding great joy.

And when they were come into the house, they saw the young child with Mary his mother, and fell down, and worshipped him: and when they had opened their treasures, they presented unto him gifts; gold, and frankincense, and myrrh. And being warned of God in a dream that they should not return to Herod, they departed into their own country another way.

The Three Magi
(sixth century), Ravenna, Basilica di Sant'Apollinare Nuovo

JOHN OF HILDESHEIM
Historia de gestis et translatione trium regum (1477)

Now, around the kingdoms and lands of these Three Kings it must be understood that there lie the Indies, and that all their territories are made up, for the most part, of islands, full of terrible swamps, in which grow canes so sturdy that houses and ships are built of them. And in these lands and islands grow plants and beasts unlike any others, so that it costs much trouble and danger to travel from one island to the other.... So in the first India lies the Kingdom of Nubia, over which Melchior reigned. And he also possessed Arabia, where we find Mount Sinai and the Red Sea, across which it is easy to sail from Syria and Egypt to India. The Sultan, however, does not permit any letter from the Christian kings to reach Prester John, the lord of the Indies, so as to prevent them from hatching conspiracies between them. For the same reason, Prester John makes sure that no one crosses his territories to reach the Sultan. Consequently, those travelling to India are forced to make a long and laborious detour through Persia. Those who have crossed the Red Sea relate that the sea bed is colored red, so that the water, on the surface, resembles red wine, even though in itself it is the color of any other water. It is also salt, and so clear that you can see stones and fishes on the far depths of the seabed. It is roughly four or five miles wide, triangular in shape, and flows out of the Ocean. It is at its broadest where the Children of Israel set out to cross the sea on dry land. Another river then branches off from it, which is navigable for the journey to Egypt from India.

The whole land of Arabia is also colored red, and the rocks, timbers and all the products of the region are for the most part red in color. Excellent gold is to be found there in slender veins, and also, upon a mountain, there is a seam of emeralds which is mined with great effort and ingenuity. This land of Arabia once belonged in its entirety to Prester John, but now it is almost entirely under the dominion of the Sultan. Nevertheless, the Sultan continues to pay tribute for it to Prester John, so that he may be permitted to transport goods from India without disruption....

The second India was the kingdom of Godolia, ruled by Balthazar, who gave incense to the Lord. He also ruled over the kingdom of Saba, the land where in particular many noble spices grow, and the incense that exudes from certain trees in the manner of gum. The third India is the kingdom of Tharsis, which was ruled by Gaspar, who brought a gift of myrrh, and under his dominion was also the island of Egriseula, where the body of St. Thomas rests. This is the land where more than any other, myrrh grows in great quantity, on plants that resemble parched ears of grain. The Three Kings of these three kingdoms brought gifts to the Lord obtained from the produce of their lands, and so we read in the words of David: "The Kings of Tharsis and the island shall offer presents, the Kings of the Arabs and Saba shall bring gifts." In this passage, the names of the largest kingdoms are not mentioned, since each of the three Kings possesses two kingdoms. Melchior is king of Nubia and Arabia, Balthazar is king of Godolia and Saba, and Gaspar king of Tharsis and the island of Egriseula.

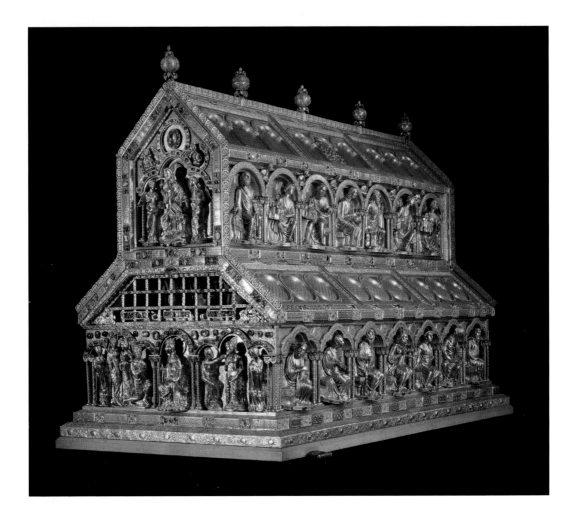

Marco Polo and the Tomb of the Wise Men

MARCO POLO
The Travels of Marco Polo (1298),
I, 13–14

In Persia is the city of Saba, from which the Three Magi set out when they went to worship Jesus Christ; and in this city they are buried, in three very large and beautiful monuments, side by side.... One of these was called Jaspar, the second Melchior, and the third Balthasar. Messer Marco Polo asked a great many questions of the people of that city as to those Three Magi, but never one could he find that knew aught of the matter, except that these were three kings who were buried there in days of old.... He found a village there which goes by the name of Cala Ataperistan, which is as much as to say, "The Castle of the Fire-worshippers."

They relate that in old times three kings of that country went away to worship a Prophet that was born, and they carried with them three manner of offerings, Gold, and Frankincense, and Myrrh; in order to ascertain

Nicholas of Verdun,
Ark of the Magi (1181),
Cologne Cathedral

whether that Prophet were God,
or an earthly King, or a Physician.
So it came to pass when they had come
to the place where the Child was born,
the youngest of the Three Kings went in
first, [then the middle one and the el-
dest], and [each] found the Child appar-
ently just of his own age. And when the
three had rejoined one another, each
told what he had seen. . . . So they agreed
to go in all three together, and on doing
so they beheld the Child with the ap-
pearance of its actual age, to wit, some
thirteen days. Then they adored, and
presented their Gold and Incense and
Myrrh. And the Child took all the three
offerings, and then gave them a small
closed box; whereupon the Kings de-
parted to return into their own land.

And when they had ridden many days
they said they would see what the Child
had given them. So they opened the lit-
tle box, and inside it they found a stone.
They had no understanding at of the sig-
nification of the gift of the stone; so they
cast it into a well. Then straightway a
fire from Heaven descended into that
well wherein the stone had been cast.
And when the Three Kings beheld this
marvel they were sore amazed, and it
greatly repented them that they had
cast away the stone... so they took of that
fire, and carried it into their own coun-
try... and there the people keep it contin-
ually burning, and worship it as a god,
and all the sacrifices they offer are kin-
dled with that fire. And if ever the fire
becomes extinct they go to other cities
round about where the same faith is
held, and obtain of that fire from them.
Such then was the story told by the
people of that Castle to Messer Marco
Polo; they declared to him for a truth
that such was their history, and that
one of the three kings was of the city
called Saba, and the second of Ava,

and the third of that very Castle
where they still worship fire.

The Theft of the Wise Men

BONVESIN DE LA RIVA
(C. 1240–C. 1313)
On the Marvels of the City of Milan, VI

From her [Milan], after her walls were
destroyed by Frederick I, also in pun-
ishment for her fidelity—Oh shame! Oh
suffering!—for the same reason, the en-
emies of the church stole the remains
of the Three Magi, which had been
brought to our city by St. Eustorgius in
the year 314. This was the reward for
our labors: for having faithfully fought
against the rebels of the church, we suf-
fer the loss of such a treasure! Woe be-
tide the citizens of this land who, in
spite of being despoiled of such a great
treasure, prefer to engage in mutual de-
struction, rather than seeking a way in
which they might remedy their shame
and gloriously reclaim the wealth of
which they have been deprived, by as-
serting the rule of canon law! And if
I were permitted to speak against my
lords, the pastors of this city, I would
rather say: "Woe betide the archbishops
of this land, for whose disinterest the
relics have not yet been recovered by
bringing to bear the sword of the
church, these relics which were lost not
through the fault of our citizens, but for
the defense of the church by virtue of an
absolute and unshakeable faith!" Since
the day that this city was founded, in
other words—according to what is writ-
ten—since the year 504 before the birth
of our Savior, two hundred years after
the foundation of Rome, in my opinion,
it has not been deprived of any greater
honor.

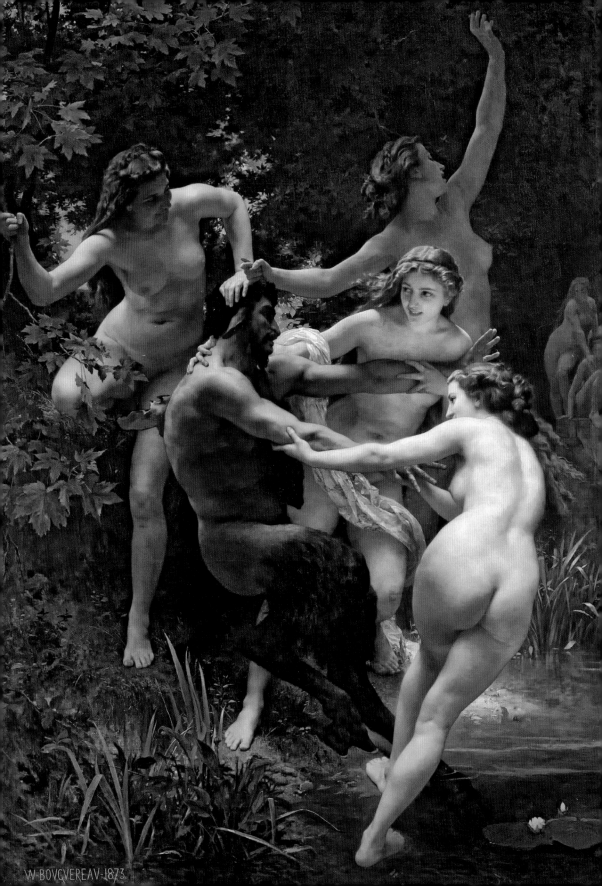

W·BOVGVEREAV·1873

3

THE LANDS OF HOMER
AND THE SEVEN WONDERS

Left:
William-Adolphe
Bouguereau,
Nymphs and Satyr
(c. 1873), Williamstown,
Massachusetts, Sterling and
Francine Clark Art Institute

Right:
Andrea Mantegna,
Parnassus (1497),
Paris, Louvre

We know the entire universe of Greek mythology: Attica, Olympus, the rivers, lakes, forests, and the sea. Yet the Greek imagination continuously transformed every aspect of the world it knew into a legendary place. It envisaged Olympus as inhabited by the gods, stretches of water and mountains populated by nymphs: the Oreads, the mountain nymphs; the Dryads, who lived in trees; the Hydrads, the water nymphs; the Nereids, the sea nymphs; the Crenaeae and the Pegaeae, the nymphs of fountains; and sky nymphs, such as the Pleiades.

Not to mention the satyrs, the heroes, and many minor divinities associated with a place . . . Hence the entire Greek universe

Annibale, Agostino, and Ludovico Carracci, *Jason Captures the Golden Fleece* (sixteenth century), Bologna, Palazzo Fava

Annibale, Agostino, and Ludovico Carracci, *Building the Argo* (sixteenth century), Bologna, Palazzo Fava

could give rise to research on legendary lands, if most of these lands were not known to us, even though they have now been abandoned by the divinities of long ago. When it comes to the places where Troy or Agamemnon's palace stood, there is little for the imagination to work on, and we have pretty clear ideas about the location of Colchis, reached by Jason in his search for the Golden Fleece. Lots of tourists go to Argos and Mycenae, yet these places have a life of their own in our minds and have the same properties as nonexistent lands.

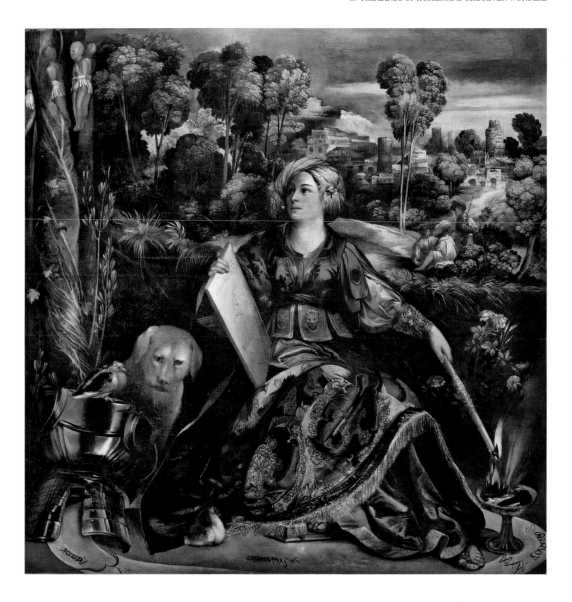

Dosso Dossi, *Circe*
(sixteenth century),
Rome, Galleria Borghese

So we are still arguing about the whereabouts of the places visited by Ulysses in the course of his wanderings. It is known that they should be fairly close to hand, so to speak, between the Ionian Sea and the Straits of Gibraltar, but there is still debate about which real places correspond to those mentioned in the *Odyssey*.

THE WORLD OF ULYSSES Let us retrace Ulysses' voyage, trying to locate the places of his vicissitudes as an encyclopedia

identifies them today. After seven years on the island of Ogygia, a prisoner of the nymph Calypso, the hero escapes and, after a storm, lands on the island of the Phaeacians, Scheria. This ought to be Corfu, which is not far distant from modern Ithaca. Here, Ulysses tells Alcinous about all his previous adventures, his encounter with the Lotus-Eaters, perhaps on the Libyan coast, the story of Polyphemus, who probably lived in Sicily, his stay on the island of Aeolus, his arrival in the lands of the Laestrygonians, monstrous cannibals who lived on the coast of Campania, his arrival on the island of Circe, now known as Mount Circeo in Lazio, where he stayed for a year, his arrival in the sunless land of the Cimmerians overlooking the entrance to the underworld, the passage near the island of the Sirens in the Bay of Naples and then between Scylla and Charybdis (the straits of Messina) to Trinacria, where the oxen of the sun grazed, his rescue after a terrible shipwreck on Ogygia, on the Moroccan coast, where he remained for a long time as the lover and prisoner of the nymph Calypso, and finally his landing on the island of the Phaeacians and his return to Ithaca.

Pier Francesco Cittadini, il Milanese, *Circe and Ulysses* (seventeenth century), Galleria Fondantico di Tiziana Sassòli

This was a voyage that we can reconstruct on a contemporary map. But were these places really the ones of Ulysses' journey? Tourists sailing toward Greece and seeing Ithaca from afar may experience a "Homeric" emotion. But is today's Ithaca really that of Ulysses? Even though the geographer Strabo identified it as such in the first century AD, many modern scholars claim that the Homeric descriptions do not correspond to modern Ithaca, which the poet described as flat, whereas it is mountainous. And so it has been suggested that Ulysses' island was more likely Levkás (ancient Leucadia).

Arnold Böcklin, *Ulysses and Calypso* (1882), Basel, Kunstmuseum

If we have not managed to identify the hero's homeland, then what chance do we have with the other lands mentioned by the author of the *Odyssey*?

If we follow the reconstruction of the eighty most bizarre theories regarding Ulysses' wanderings (Wolf 1990), probably the first map that tried to portray them was the one that appears in Abraham Ortelius's *Parergon* in the sixteenth century. And right away you can say that in Ortelius's view Ulysses' journeyings were far more limited

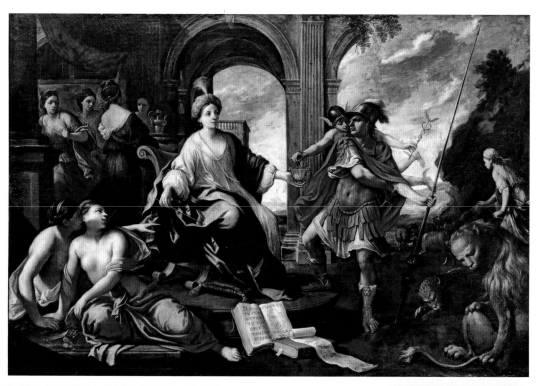

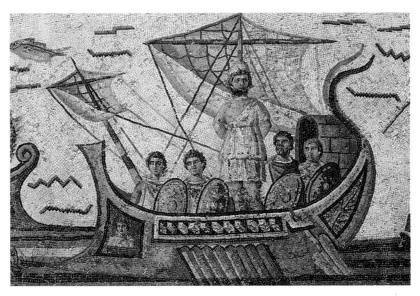

The Boat with Ulysses and His Companions (third century), mosaic, Tunisia, Bardo National Museum

and he would not have ventured beyond Sicily (where the Lotus-Eaters lived too) and the Italian peninsula, which also contained the land of the Cimmerians and Calypso's island; not to mention Ogygia, which is moved from the Moroccan coast to more or less what would today be the Gulf of Taranto, which would explain how a lost sailor could land at Scheria sooner or later. And in this sense Ortelius followed directions that might refer to ancient sources that located Ogygia near Crotone in Calabria.

But in 1667 Pierre Duval had drawn a map in which the Lotus-Eaters were on the African coast. If we then move on to various nineteenth-century reconstructions, we find Ogygia in the Balkans and the land of the Cimmerians and Calypso in the Black Sea. Samuel Butler (1897), as well as suggesting that Homer had been a woman, placed Ithaca in Sicily, in Trapani, and a pseudo-Eumaius (1898) asserted that Ulysses had circumnavigated Africa and discovered America—but it is believed that this suggestion had parodistic intentions.

The reconstruction of the travels is still going on, and mention should be made of Hans Steuerwald (1978), who has Ulysses arrive in Cornwall and in Scotland, and so the wine produced on Circe's island would be pure Scotch whiskey. The sinologist Hubert Daunicht

Eumaios, *Ulysses
as Circumnavigator
of Africa and Discoverer
of America* (1898), Paris,
Bibliothèque nationale
de France

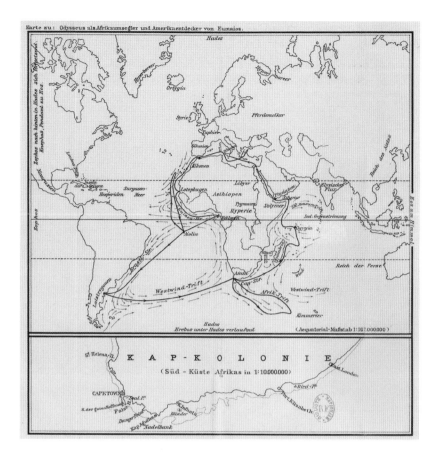

(1971) who, on noting some analogies between the *Odyssey* and some Chinese stories, extended Ulysses' wanderings to China, Japan, and Korea. Then there is Christine Pellech (1983) who maintained that Ulysses had discovered the Straits of Magellan and Australia. Recently, Felice Vinci (1995) shifted all of Ulysses' travels from the Mediterranean basin to the Baltic.

If there really are eighty theories, we could stop here and limit ourselves to mentioning the most quoted one (which even inspired Joyce for his *Ulysses*, which reconstructs the entire journey in the space of a single day in Dublin): this is one of the various books written by Victor Bérard, also the French translator of the *Odyssey*, of whose work we shall mention at least *Les navigations d'Ulysse*.

Bérard maintained that the Homeric account is based on the Mediterranean voyages made by the Phoenicians, but his reconstruc-

tion has been criticized because, although he had actually sailed along the routes he describes, he had done so aboard a modern boat that did not make it possible to know how much time it would have taken Ulysses to go from one place to the next. In any case, Bérard placed the Lotus-Eaters on the Tunisian coast, the Cyclops around Vesuvius, the island of Aeolus on Stromboli, the Laestrygonians north of Sardinia, Circe's abode near Mount Circeo, Scylla and Charybdis in the Straits of Messina, Calypso in Gibraltar, and the island of the Phaeacians as

Anonymous Master
of the Johnson Collection
of the Philadelphia Museum
of Art (best known for
*The Assumption of Saint
Mary Magdalene*),
*The Adventures of Ulysses:
The Contest with the
Laestrygonians*
(thirteenth–fourteenth
centuries), Frances Lehman
Loeb Art Center, Vassar
College, Poughkeepsie,
New York

Corfu; he also identified the island of the sun with Sicily, and Ithaca as the island of Thiaki in the Gulf of Corinth.

The most contentious overturning of perspective came with Sergio Frau's book (2002), which on the basis of a rereading of the classical texts, challenges the idea that the author of the *Odyssey* believed that the Pillars of Hercules were the Strait of Gibraltar. This localization is allegedly from the Hellenistic age, the result of an attempt to extend toward the west the world that Alexander's expedi-

*The Laestrygonians
Attacking Ulysses' Ships*
(40–30 BC), Bibliotheca
Apostolica Vaticana

tion had extended to the east. In ancient times, the perception of the navigable Mediterranean was far narrower; the entire western part was held by the Phoenicians and unknown to the Greeks, and the Pillars of Hercules would have been identified with the Sicilian Strait, between the island and the African coast. All of Ulysses' travels would have taken place in the eastern Mediterranean, and Sardinia would have been the legendary Atlantis (and see the chapter dedicated to this "vanished" continent).

But while in Frau's view the world of Ulysses was smaller than what had once been thought, here is another hypothesis, that of Vinci (1995) for whom the Homeric navigator's journey ought to be seen in the Far North.[1] In fact, through a painstaking reconstruction of the description of events and the names of places, Vinci concludes that all the adventures narrated by Homer (or someone in his stead) occurred in the

1. *Felice Vinci,
Homer in the Baltic:
The Nordic Origins
of the Odyssey
and the Iliad, 4th ed.*
(Rome: Palombi, 2003).

Baltic and Scandinavia. The hypothesis derives from the theory, expounded on various occasions, whereby during the Bronze Age the Nordic peoples had immigrated to the Aegean; these populations supposedly then changed their ancient legends into Mediterranean terms.

This book is not intended to establish Ulysses' true periplus. The poet (or poets) later made things up on the basis of legendary information. The *Odyssey* is a beautiful legend, and all attempts to reconstruct it on a modern map have created just as many legends. One of those we have mentioned is perhaps true or plausible, but what fascinates us is the fact that over the centuries we have been entranced by a journey that never happened. Wherever Calypso lived, a great many men have dreamed of spending a few years in her sweetest of captivities.

THE SEVEN WONDERS Among the legendary places of the ancient world, we should again record its seven wonders, in other words the <u>Hanging Gardens of Babylon</u>, where it is said that Queen Semiramis gathered fresh roses in every season; the <u>Colossus of Rhodes</u>, an enormous bronze statue standing in the island's harbor; the <u>Mausoleum at Halicarnassus</u>; the <u>Temple of Artemis in Ephesus</u>; the <u>Lighthouse of Alexandria in Egypt</u>; the <u>Statue of Zeus at Olympia</u>, the work of Phidias; and the <u>Great Pyramid of Giza</u>. And we have texts by <u>Pausanias</u>, <u>Pliny</u>, <u>Valerius Maximus</u>, <u>Aulus Gellius</u> and—among others—even <u>Julius Caesar</u>, who mention and describe each of these wonders, which leads us to believe that, even if they were not as wonderful as tradition would have it, they really did exist.

The most talked about wonder is the Temple of Artemis, given that legend says that a certain Herostratus set it on fire in order to acquire eternal fame; it has to be said that the wretch succeeded in his intention, even though the posthumous fame he enjoys is dubious.

The only surviving wonder is the Great Pyramid of Cheops. And although it has survived, the Great Pyramid is the one that has led to most legends, in modern times too. So the real pyramid still exists today, and you can visit it, but so-called "<u>pyramidologists</u>" have created its legend, fantasizing about a kind of parallel pyramid that exists only in the imaginations of mystery hunters.

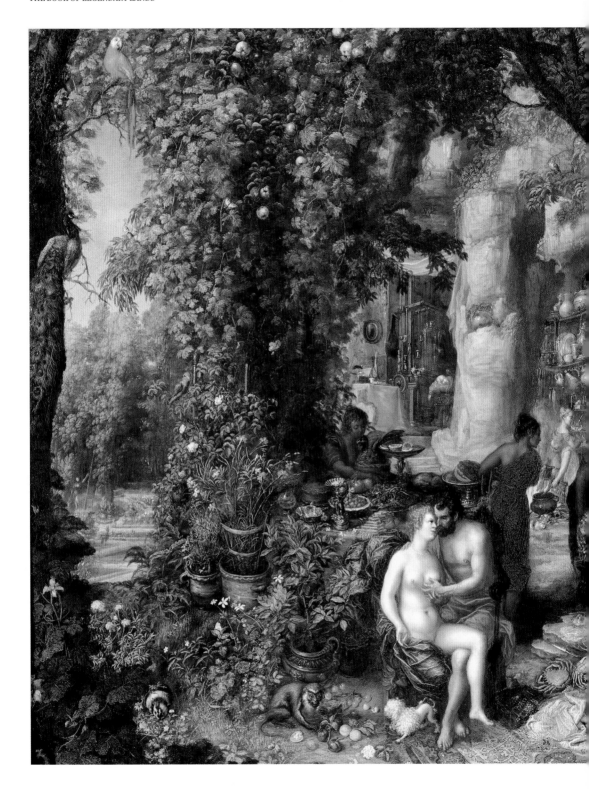

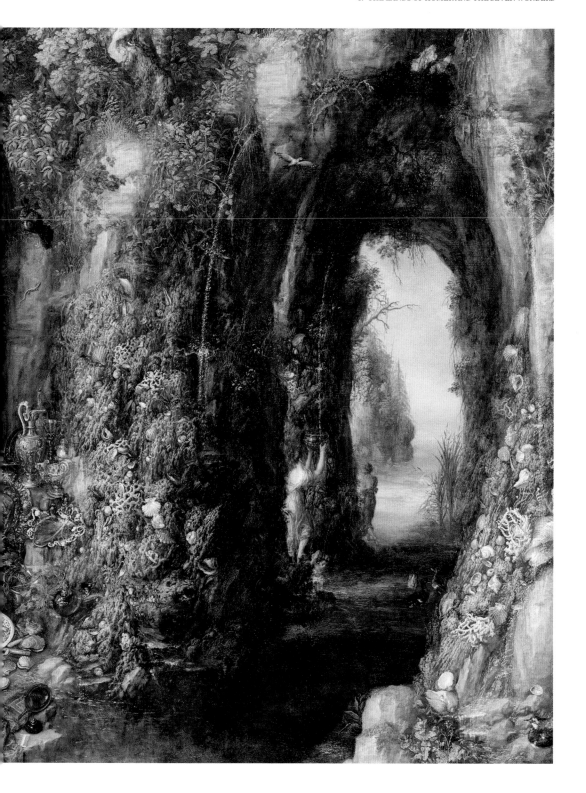

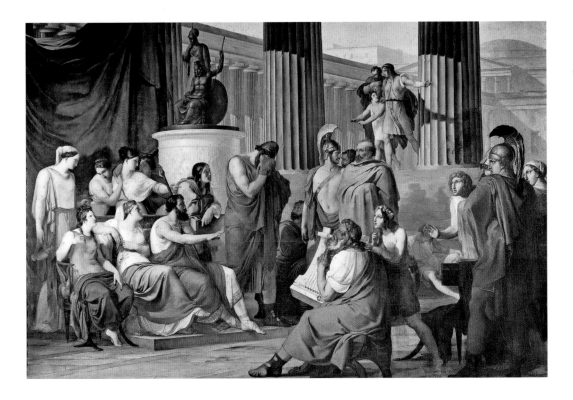

The Palace of Alcinous

H O M E R (C. EIGHTH CENTURY BC)
The *Odyssey*, VII, 81–132

... Ulysses went on to the house of Alcinous, and he pondered much as he paused a while before reaching the threshold of bronze, for the splendor of the palace was like that of the sun or moon. The walls on either side were of bronze from end to end, and the cornice was of blue enamel. The doors were gold, and hung on pillars of silver that rose from a floor of bronze, while the lintel was silver and the hook of the door was of gold.

On either side there stood gold and silver mastiffs which Vulcan, with his consummate skill, had fashioned expressly to keep watch over the palace of king Alcinous; so they were immortal and could never grow old. Seats were ranged all along the wall, here and there from one end to the other, with coverings of fine woven work which the women of the house had made. Here the chief persons of the Phaeacians used to sit and eat and drink, for there was abundance at all seasons; and there were golden figures of young men with lighted torches in their hands, raised on pedestals, to give light by night to those who were at table. There are fifty maid servants in the house, some of whom are always grinding rich yellow grain at the mill, while others work at the loom, or sit and spin, and their shuttles go backward and forward like the fluttering of aspen leaves, while the linen is so closely woven that it will turn oil. As the Phaeacians are the best sailors in the world, so their women excel all others in weaving, for Minerva has

Francesco Hayez, *Ulysses at the Court of Alcinous* (c. 1814), Naples, National Museum of Capodimonte

taught them all manner of useful arts, and they are very intelligent.

Outside the gate of the outer court there is a large garden of about four acres with a wall all round it. It is full of beautiful trees—pears, pomegranates, and the most delicious apples. There are luscious figs also, and olives in full growth. The fruits never rot nor fail all the year round, neither winter nor summer, for the air is so soft that a new crop ripens before the old has dropped. Pear grows on pear, apple on apple, and fig on fig, and so also with the grapes, for there is an excellent vineyard: on the level ground of a part of this, the grapes are being made into raisins; in another part they are being gathered; some are being trodden in the wine tubs, others further on have shed their blossom and are beginning to show fruit, others again are just changing color. In the furthest part of the ground there are beautifully arranged beds of flowers that are in bloom all the year round. Two streams go through it, the one turned in ducts throughout the whole garden, while the other is carried under the ground of the outer court to the house itself, and the town's people draw water from it. Such, then, were the splendors with which the gods had endowed the house of king Alcinous.

Ulysses' Journey
Was Close to Home

SERGIO FRAU
The Columns of Hercules:
An Investigation (2002)

Who placed the Pillars of Hercules at Gibraltar, and when? Did the Far West of the ancient Greeks really only begin out there? And could the straits be-

tween Malta, Sicily, and Tunisia—that secret, underwater canyon surrounded by rocks and sand banks waiting in ambush, by then just beneath the water's surface—be a possible alternative?

Or what about Reggio and the Strait of Messina? Things are no better there, with the terrifying sea monsters Scylla and Charybdis standing guard. . . .

The more you read, in fact, the more terrors you find lurking in the Strait: a part of the Mediterranean where some of the highest concentrations of monsters, tragedies, and shipwrecks have been imagined and described. All fantasies? . . . But then, when it comes to monsters, terrors, and risks, all located around the Strait of Sicily, Homer goes all out. He makes free use of the stories that must have filled the evenings in the Mediterranean ports at the time. . . .

Back then, in Homer's time, when they heard these things, everyone thought of just one place: the Sea of Sicily. . . . And so if all these scholars—who know a lot about the Greeks, after all—are right, what was the use of those clamoring sons and daughters of Oceanus, placed out there, beyond Gibraltar where they would have been no use to anyone? That great hubbub with their tangled sequence of difficult names, what use could they be? And above all, to whom? Why on earth would you think about Moroccan rivers, gulfs in Senegal, or the Hesperides on the Atlantic, given that people never went there? And were frightened even of crossing the Strait of Otranto. . . . In short, where did Homer's terrible Ocean really begin? Could it be beyond Gibraltar? Unthinkable. And in fact, no one thinks it did.

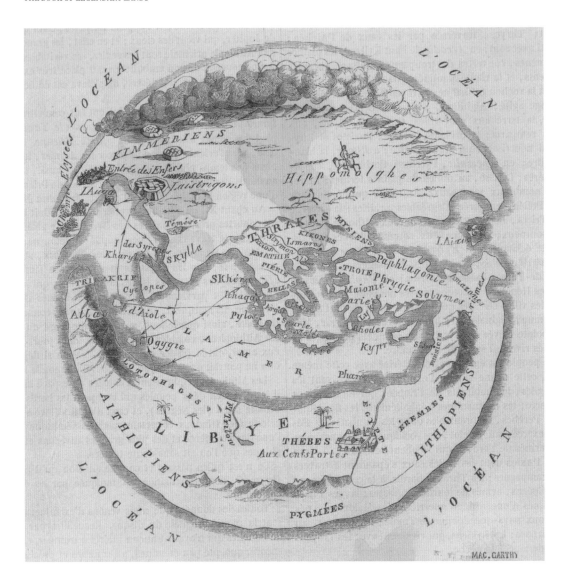

M. O. Mac Carthy, *Carte du monde d'Homère* (1849), New York, Public Library

Ulysses' Journey Was Far from Home

FELICE VINCI
Homer in the Baltic (1998)

After the end of the last glacial age, several climatic phases occurred in succession in northern Europe, as summarized below according to their main distinctive features, with a particular focus on vegetation:

—Recent Pre-Boreal (8000–7000 BC). The climate is still cold, continental; red fir, alder and hazel trees begin to spread.

—Boreal (7000–5500 BC). Summers are warm and winters are relatively mild.

—Atlantic (5500–2000 BC). The

climate is warmer than that of the Boreal phase; summers are warm, winters are mild and humid. Oak woods spread.

—Sub-Boreal (2000–500 BC). The climate becomes more continental and grows cooler. Beech and fir trees prevail.

We are most interested here in the Atlantic phase . . . corresponding to the *post-glacial climatic optimum*, which peaked around 2500 BC and lasted until around 2000 BC—and the subsequent cooler period. According to Professor Pia Laviosa Zambotti, this *climatic optimum* was the best climatic period Scandinavian countries have ever known, which justifies the high cultural level achieved in Scandinavia around 2500 BC. . . .

In these circumstances, it is not difficult to imagine that the highly skilled seafarers of the Bronze Age, taking advantage of the exceptionally favorable conditions offered by the high point of this *climatic optimum* (which, as we have stated, reached its peak at around the mid-point of the third millennium BC), were able to travel even very long distances by sea. . . .

The real backdrop to the *Iliad* and the *Odyssey* can be identified not in the Mediterranean but in northern Europe. The sagas that gave rise to the two poems come from the Baltic and Scandinavia, where the Bronze Age was flourishing in the second millennium BC and where many places mentioned by Homer can still be recognized today, including Troy and Ithaca. Following the breakdown of the *climatic optimum*, these sagas were taken to Greece by the great seafarers who founded the Mycenaean civilization in the sixteenth century BC. In the Mediterranean, they rebuilt their original world, in which the Trojan

War and other events in Greek mythology had taken place, and from generation to generation, they kept alive the memory of the heroic age and deeds of their ancestors from their lost homeland, which they then passed down to subsequent eras.

Put very briefly, these are the conclusions of our research, which—having taken on board the absurdities resulting from a Mediterranean setting for Homer's poems, their problematic relationships to Mycenaean geography, their European-barbarian dimension (Piggou) and the probable Nordic origin of the Mycenaean civilization (Nilsson)—took its starting point from Plutarch's account of the northern location of the island of Ogygia: this was the key that opened up the doors of Homer's world to us, allowing us to embark upon a painstaking reconstruction, the results of which demonstrate the legitimacy of the initial assumption.

Such an view—which abides by the Popperian criterion of "falsifiability"—as well as finally providing adequate answers to the questions of the ancients, disproving the old belief that "Homer was a poet but not a geographer," can be integrated in an entirely natural way with the recent discoveries made through study of Homer's works and Mycenaean civilization, making it possible to bring them together into a coherent, unitary vision and so create a synthesis that would otherwise have been impossible.

The reconstruction of the places mentioned by Homer is particularly significant for the areas of both Troy and Ithaca, for which we have a large body of evidence, as they provide the settings for the *Iliad* and the *Odyssey* respectively: and the mere fact of having discovered Dulichio, the mysterious "long

island" so often mentioned by Homer—correctly situated opposite the low-lying "Peloponnese" and a group of islands that are completely consistent with the accounts in both poems—could in itself constitute a not insignificant justification of the validity of the theory. We have also noted that the two poems extend into different areas that are nevertheless complementary in a certain sense: one, through the *Catalog of Ships*, allowed us to fully reconstruct the Achaean outposts along the Baltic coast during the early Bronze Age; the other, through Ulysses' travels, delivers an extraordinarily vivid and coherent picture of the knowledge that those ancient peoples possessed of the "outside world," which was fascinating but also full of hidden dangers, such as the powerful Atlantic tide (which Homer introduces on two occasions, in entirely different guises: menacing in the case of the terrifying channel guarded by Charybdis, and benevolent when it helps the hero to reach the safety of land, carrying him into the mouth of the river Scheria), as well as unusual phenomena, such as the extremely long summer days in the land of the Laestrygonians, which in turn anticipate the arctic dimension of the island of Circe, even further to the north, where the sun never sets in the summer and the "dances of the aurora" can be seen.

In short, the geographical information that can be gleaned from the whole of Homer's world can be cataloged into a number of large "groupings": the world of Ithaca (in the islands of Denmark), the adventures of Ulysses (in the North Atlantic), the world of Troy (in southern Finland) and world of the Achaeans (along the Baltic coasts). Each of these presents extraordinary correlations with the respective areas of northern Europe we have identified, supported by the incongruities of the traditional Mediterranean location; and the meteorological conditions that can be identified for each are systematically cold, foggy and unsettled, which is completely consistent with the Nordic context. Furthermore, the light nights of the northerly latitudes allow us to resolve the issue of the two days of uninterrupted battle between the Achaeans and the Trojans, as well as the fact that they coincide with the full flood of the rivers Scamander and Simoeis, which fits perfectly with the seasonal patterns of the Nordic rivers.

Anonymous, *The Hanging Gardens of Babylon* (c. 1886), lithograph, private collection

The Hanging Gardens of Babylon

PSEUDO-PHILO OF BYZANTIUM
(C. SIXTH CENTURY)
Seven Wonders of the Ancient World

Louis de Caullery, *The Colossus of Rhodes* (seventeenth century), Paris, Louvre

The Hanging Gardens [is so-called because it] has plants cultivated at a height above ground level, and the roots of the trees are embedded in an upper terrace rather than in the earth. This is the technique of its construction. The whole mass is supported on stone columns, so that the entire underlying space is occupied by carved column bases. The columns carry beams set at very narrow intervals. The beams are palm trunks, for this type of wood—unlike all others—does not rot and, when it is damp and subjected to heavy pressure, it curves upward. Moreover it does itself give nourishment to the root branches and fibers, since it admits extraneous matter into its folds and crevices. This

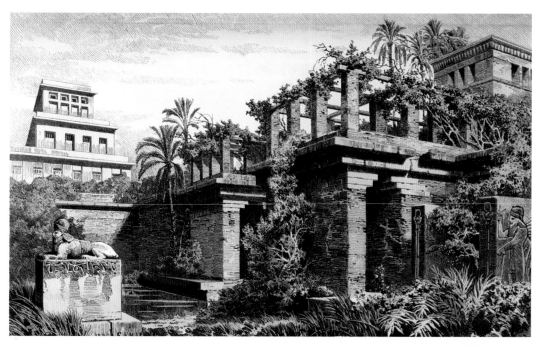

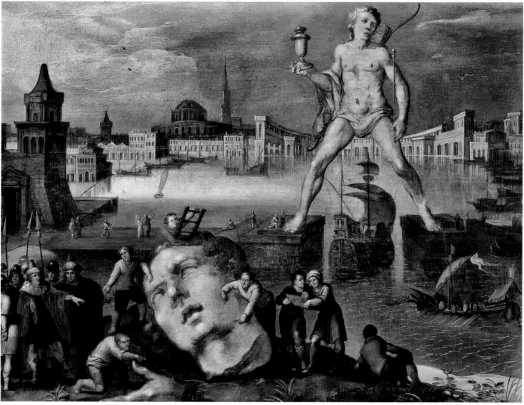

structure supports an extensive and deep mass of earth, in which are planted broad-leaved trees of the sort that are commonly found in gardens, a wide variety of flowers of all species and, in brief, everything that is most agreeable to the eye and conducive to the enjoyment of pleasure. The whole area is ploughed in just the same way as solid ground, and is just as suitable as other soil for grafting and propagation. Thus it happens that a ploughed field lies above the heads of those who walk between the columns below. Yet while the upper surface of the earth is trampled underfoot, the lower and denser soil closest to the supporting framework remains undisturbed and virgin. Streams of water emerging from elevated sources flow partly in a straight line down sloping channels, and are partly forced upward through bends and spirals to gush out higher up, being impelled through the twists of these devices by mechanical forces. So, brought together in frequent and plentiful outlets at a high level, these waters irrigate the whole garden, saturating the deep roots of the plants and keeping the whole area of cultivation continually moist. Hence the grass is permanently green, and the leaves of trees grow firmly attached to supple branches, and increasing in size and succulence with the constant humidity. For the root [system] is kept saturated and sucks up the all-pervading supply of water, wandering in interlaced channels beneath the ground, and securely maintaining the well-established and excellent quality of trees. This is a work of art of royal luxury [lit. "riotous living"], and its most striking feature is that the labor of cultivation is suspended above the heads of the spectators.

The Colossus of Rhodes

PLINY THE ELDER (23–79)
Natural History, XXXIV, 18

But calling for admiration before all others was the colossal Statue of the Sun at Rhodes made by Chares of Lindus, the pupil of Lysippus mentioned above. This statue was 105 ft. high; and, 66 years after its erection, was overthrown by an earthquake, but even lying on the ground it is a marvel. Few people can make their arms meet round the thumb of the figure, and the fingers are larger than most statues; and where the limbs have been broken off enormous cavities yawn, while inside are seen great masses of rock with the weight of which the artist steadied it when he erected it. It is recorded that it took twelve years to complete and cost 300 talents, money realized from the engines of war belonging to King Demetrius which he had abandoned when he got tired of the protracted siege of Rhodes. There are a hundred other colossal statues in the same city, which though smaller than this one would have each of them brought fame to any place where it might have stood alone; and besides these there were five colossal statues of gods, made by Bryaxis.

The Mausoleum of Halicarnassus

AULUS GELLIUS
Attic Nights, X, 18

Artemisia is said to have loved her husband Mausolus with a love surpassing all the tales of passion and beyond one's conception of human

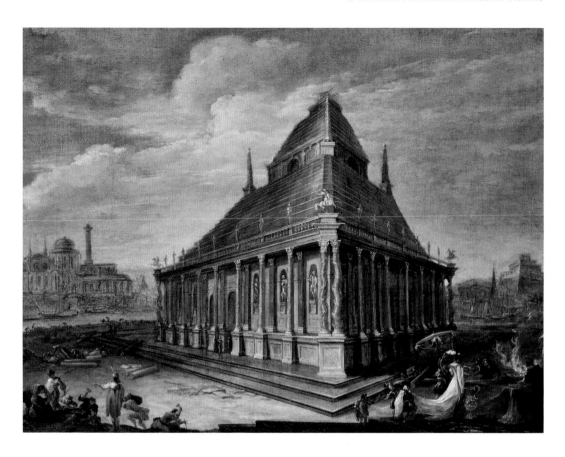

Wilhelm van Ehrenberg, *The Seven Wonders of the World: The Mausoleum at Halicarnassus* (seventeenth century), Saint-Omer, Musée de l'Hôtel Sandelin

affection. Now Mausolus, as Marcus Tullius tells us, was king of the land of Caria; according to some Greek historians he was governor of a province, the official whom the Greeks term a satrap. When this Mausolus had met his end amid the lamentations and in the arms of his wife [in 353 BC] and had been buried with a magnificent funeral, Artemisia, inflamed with grief and with longing for her spouse, mingled his bones and ashes with spices, ground them into the form of a powder, put them in water, and drank them; and she is said to have given many other proofs of the violence of her passion. For perpetuating the memory of her husband, she also erected, with great expenditure of labor, that highly celebrated tomb, which has been deemed worthy of being numbered among the seven wonders of the world. When Artemisia dedicated this monument, consecrated to the deified shades of Mausolus, she instituted an *agon*, that is to say, a contest in celebrating his praises, offering magnificent prizes of money and other valuables. Three men distinguished for their eminent talent and eloquence are said to have come to contend in this eulogy, Theopompus, Theodectes and Naucrates; some have even written that Isocrates himself entered the lists with them. But Theopompus was adjudged the victor in that contest. He was a pupil of Isocrates.

The Construction of the Temple of Artemis at Ephesus

PLINY THE ELDER (23–79)
Natural History, XXXVI, 21, 95

Of grandeur as conceived by the Greeks a real and remarkable example still survives, namely the Temple of Diana at Ephesus, the building of which occupied all Asia Minor for 120 years. It was built on marshy soil so that it might not be subject to earthquakes or be threatened by subsidences. On the other hand, to ensure that the foundations of so massive a building would not be laid on shifting, unstable ground, they were underpinned with a layer of closely trodden charcoal, and then with another of sheepskins with their fleeces unshorn. The length of the temple overall is 425 feet, and its breadth 225 feet. There are 127 columns, each constructed by a different king and 60 feet in height. Of these, 36 were carved with reliefs, one of them by Scopas. The architect in charge of the work was Chersiphron. The crowning marvel was his success in lifting the architraves of this massive building a into place. This he achieved by filling bags of plaited reed with sand and constructing a gently graded ramp which reached the upper surfaces of the capitals of the columns. Then, little by little, he emptied the lowest layer of bags, so that the fabric gradually settled into its right position. But the greatest difficulty was encountered with the lintel itself when he was trying to place it over the door; for this was the largest block, and it would not settle on its bed. The architect was in anguish as he debated whether sui-

cide should be his final decision. The story goes that in the course of his reflections he became weary, and that while he slept at night he saw before him the goddess for whom the temple was being built: she was urging him to live because, as she said, she herself had laid the stone. And on the next day this was seen to be the case. The stone appeared to have been adjusted merely by dint of its own weight. The other embellishments of the building are enough to fill many volumes, since they are in no way related to natural forms.

The Temple on Fire

VALERIUS MAXIMUS
(FIRST CENTURY BC–FIRST CENTURY AD)
Memorable Deeds and Sayings, VIII, 14

The lust for fame can even reach the point of sacrilege. There was once, for example, a certain individual who wanted to burn down the temple of Artemis in Ephesus, so that the destruction of that work of art might spread his name all across the earth: a folly to which he confessed under torture. The Ephesians had wisely decided to cancel out the evil man's memory by decree; but Theopompus, in his inordinate eloquence, mentioned him in his *Histories.*

The Lighthouse of Alexandria

JULIUS CAESAR (100–44 BC)
The Civil Wars, III, 112

On the island there is a tower called Pharos, of great height, a work of won-

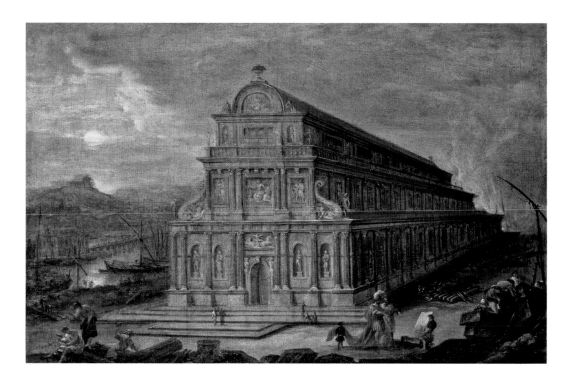

Wilhelm van Ehrenberg,
*The Seven Wonders
of the World: The Temple
of Diana at Ephesus*
(seventeenth century),
private collection

derful construction, which took its
name from the island. This island,
lying over against Alexandria, makes
a harbor, but it is connected with the
town by a narrow roadway like a
bridge, piers nine hundred feet in
length having been thrown out
seaward by former kings. On this
island there are dwelling-houses
of Egyptians and a settlement the
size of a town, and any ships that
went a little out of their course there
through carelessness or rough
weather they were in the habit of
plundering like pirates. Moreover,
on account of the narrowness of the
passage there can be no entry for
ships into the harbor without the
consent of those who are in occupa-
tion of Pharos.

The Statue of Zeus at Olympia

PAUSANIAS (C. 110–180)
Periegesis, V, 1–4, 7–10

The god sits on a throne, and he is
made of gold and ivory. On his head
lies a garland which is a copy of olive
shoots. In his right hand he carries a
Victory, which, like the statue, is of
ivory and gold; she wears a ribbon
and—on her head—a garland. In the
left hand of the god is a scepter, orna-
mented with every kind of metal, and
the bird sitting on the scepter is the
eagle. The sandals also of the god are
of gold, as is likewise his robe. On the
robe are embroidered figures of ani-
mals and the flowers of the lily.
The throne is adorned with gold and
with jewels, to say nothing of ebony
and ivory. Upon it are painted figures

87

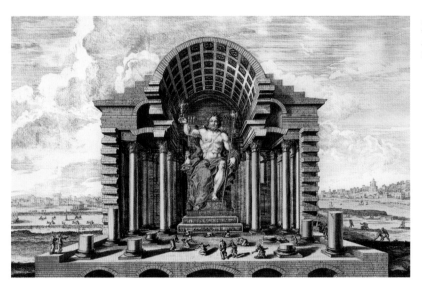

Johann Bernhard Fischer von Erlach, *The Statue of Zeus at Olympia* (1721), print, private collection

and wrought images. There are four Victories, represented as dancing women, one at each foot of the throne, and two others at the base of each foot. On each of the two front feet are set Theban children ravished by sphinxes, while under the sphinxes Apollo and Artemis are shooting down the children of Niobe.

Between the feet of the throne are four rods, each one stretching from foot to foot. The rod straight opposite the entrance has on it seven images; how the eighth of them disappeared nobody knows. These must be intended to be copies of obsolete contests, since in the time of Pheidias contests for boys had not yet been introduced. The figure of one binding his own head with a ribbon is said to resemble in appearance Pantarces, a stripling of Elis said to have been the love of Pheidias. Pantarces too won the wrestling-bout for boys at the eighty-sixth Festival.

On the other rods is the band that with Heracles fights against the Amazons. The number of figures in the two parties is twenty-nine, and Theseus too is ranged among the allies of Heracles....

On the uppermost parts of the throne Pheidias has made, above the head of the image, three Graces on one side and three Seasons on the other. These in epic poetry are included among the daughters of Zeus. Homer too in the *Iliad* says that the Seasons have been entrusted with the sky, just like guards of a king's court. The footstool of Zeus, called by the Athenians thranion, has golden lions and, in relief, the fight of Theseus against the Amazons, the first brave deed of the Athenians against foreigners.

On the pedestal supporting the throne and Zeus with all his adornments are works in gold: the Sun mounted on a chariot, Zeus and Hera, Hephaestus, and by his side Grace. Close to her comes Hermes, and close to Hermes Hestia. After Hestia is Eros receiving Aphrodite as she rises from the sea, and Aphrodite is being crowned by Persuasion. There are also reliefs of Apollo with Artemis, of Athena and of

Heracles; and near the end of the pedestal Amphitrite and Poseidon, while the Moon is driving what I think is a horse. Some have said that the steed of the goddess is a mule not a horse, and they tell a silly story about the mule. I know that the height and breadth of the Olympic Zeus have been measured and recorded; but I shall not praise those who made the measurements, for even their records fall far short of the impression made by a sight of the image. Nay, the god himself according to legend bore witness to the artistic skill of Pheidias. For when the image was quite finished Pheidias prayed the god to show by a sign whether the work was to his liking. Immediately, runs the legend, a thunderbolt fell on that part of the floor where down to the present day the bronze jar stood to cover the place.

All the floor in front of the image is paved, not with white, but with black tiles.

The Pyramidologists

UMBERTO ECO
"On Perverse Uses of Mathematics" (2011)

The Napoleonic expedition to Egypt had made the pyramids more accessible to scientists, and a series of reconstructions and measurements were begun, focusing particularly on the Pyramid of Cheops, in which the King's Chamber was found to contain no mummy of a pharaoh (nor any treasure). Even though it was more reasonable to believe that since the arrival of the Muslims the pyramids had been the target of looting, people began to imagine that the Pyramid of Cheops was not a tomb at all, or at any rate not only a tomb, but rather a vast mathematical and astronomical laboratory whose measurements were intended convey scientific knowledge to future generations, which was possessed by the ancient builders of the pyramid and then lost. In fact this knowledge was perhaps unknown even to the Egyptians, since according to some pyramidologists, the original builders came from much further afield in time and space, and perhaps from another planet.

According to our current knowledge, the pyramid of Cheops measures around 755 feet along each side (with slight differences between the different sides, due in part to erosion of the stones and the fact that it is no longer faced with smooth casing stones, which were taken by the Muslims to build mosques) and stands 479 feet tall. Undoubtedly, the pyramid's orientation appears to follow the four points of the compass (to within less than a tenth of a degree) and it seems that the pole star at the time of its construction was visible through one of its entrance corridors. This should in no way surprise us, since the ancients were attentive observers of the skies and, from Stonehenge to the Christian cathedrals, issues of orientation have been the focus of much attention. The problem, however, was to determine which units of measurement were used by the Egyptians, because if it were to turn out that in current units a certain length equated to 666 feet or inches, it would be extremely rash to suggest that the Egyptians wanted to express the apocalyptic number of the Beast, given that the same length expressed in ancient cubits would not have signified anything.

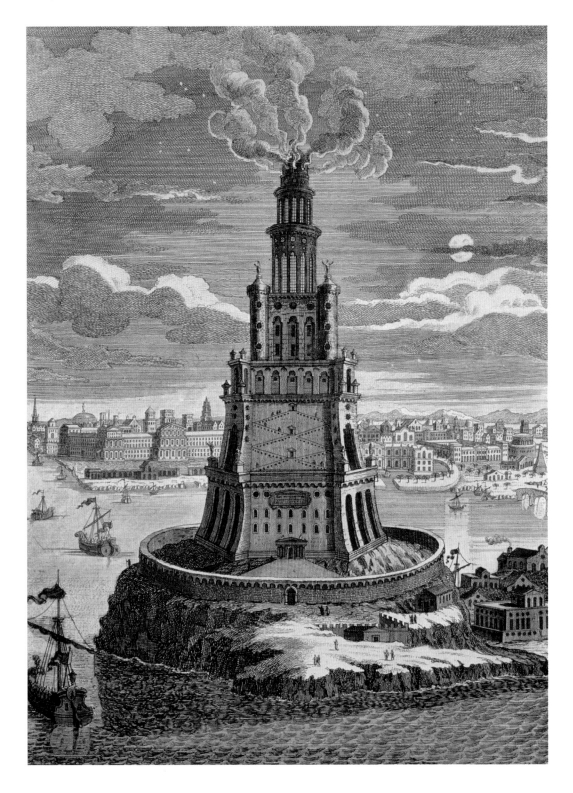

In the early nineteenth century, a certain John Taylor, who incidentally had never seen the pyramids and was referring to other people's drawings, had discovered that dividing the perimeter of the Pyramid by double its height (or dividing the length of its base by its height and multiplying the result by 2) gave a result very similar to pi. With this discovery Taylor had calculated that the relationship of the pyramid's height to its perimeter was the same as the relationship between the earth's polar radius and its circumference. Taylor's discoveries had a very great influence in around 1865 on the Scottish astronomer Charles Piazzi Smyth, who in fact dedicated his work *Our Inheritance in the Great Pyramid* to Taylor. Smyth had calculated, on what basis it is unclear, that the sacred Egyptian cubit (roughly 24.8 inches) was made up of 25 "pyramid inches," which corresponded admirably to English inches. Indeed, Piazzi Smyth devotes a chapter of his book to criticism of the republican and anti-Christian artificiality of the French decimal metric system, while celebrating the naturalness of the English system in accordance with divine laws.

The overall length of the perimeter, in pyramid inches, was 36,506. By inserting a decimal point, God knows why, you arrive at the exact number of days in the solar year (365.06). A follower of Piazzi, Flinders Petrie (even though it seems he later insinuated he had once seen the master filing down the cornerstones of a gallery to make his calculations add up), confirmed the pi calculation, discovering that the King's Chamber also contains the number pi in the relationship between its length and its perimeter. By multiplying the length of the King's Chamber (measured in pyramid inches) by 3.14, you once again arrive at 365.242, more or less the number of days in the year.

As a map drawn by Piazzi shows, the lines of latitude and longitude that intersect at the pyramid (30° north and 31° east) would cross more dry land than any others, as if the Egyptians had wanted to position the pyramid at the center of the inhabited world. The results obtained by Piazzi and subsequent pyramidologists include assertions that the height of the pyramid, multiplied by 1,000,000,000, equates to the minimum distance between the Earth and the Sun (that is to say 90.7 million rather than 91.3 million miles). The weight of the pyramid, multiplied by 1,000,000,000, comes to a good approximation of the weight of the earth. By doubling the length of the four sides of the pyramid, we obtain a figure almost exactly equal to a sixtieth of a degree at the latitude of the equator. Finally, the curvature of the walls (imperceptible to the naked eye) is identical to that of the Earth. In conclusion, the Pyramid of Cheops, otherwise known as the Great Pyramid, is a 1:43,200 scale model of the earth. . . .

Piazzi Smyth was an astronomer but not an Egyptologist, nor did he have sufficient notions of the history of science. If truth be told, he also lacked common sense. Take the theory that the pyramid occupied a position at the center of the landmasses above sea level, for example: you would need to presume that the Egyptians had the same maps as us at their disposal and knew exactly where the United States and Siberia were, even then excluding

the existence of Greenland and Australia—and in any case, there has been no discovery to suggest that the Egyptians ever drew a reliable map. In the same way, they could not have known the average height of the continents above sea level. Although the idea that the earth was spherical had already gained popularity by the time of the pre-Socratics (but still many centuries after the pyramids were built), it is doubtful whether the Egyptians had clear ideas about the real curvature of the earth's surface and the circumference of the globe, given that it was not until the third century BC that Eratosthenes calculated a good approximation of the length of the earth's meridian.... Piazzi writes at a certain point that "from apex point to base, the contents of the Great Pyramid in Pyramid cubic inches are near 161,000,000,000. How many human souls, then, have lived on the earth from Adam to the present day? Somewhere between 153,000,000,000 and 171,000,000,000" (*Our Inheritance*, London, 1880, p. 583). If the pyramid was to predict the number of the earth's inhabitants in centuries to come, why should it have stopped at the time in which Piazzi Smyth lived and not allowed, to be on the safe side, for another millennium or thereabouts?

Following these scientific principles, Piazzi Smyth discovered linear and volumetric correspondences among the sarcophagus discovered in the King's Chamber, Noah's Ark, and the Ark of the Covenant (which as far as I know has been seen only by Indiana Jones), because he took the Biblical measurements at face value and translated Hebrew cubits into Egyptian cubits without any hesitation.

Not only this, but the relationships between the lengths of the pyramid's corridors even revealed certain fateful dates, such as the future date of the Exodus (1533 BC), and given that the length of time separating the Exodus and the crucifixion was apparently 1485 years, also the date of Jesus's death. Other calculations performed by the progeny of Piazzi Smyth reveal that the sum of the lengths of the two passages to the King's Chamber gives the number of fish caught by Jesus's disciples. Furthermore, since the Greek word for fish (*ichthys*) is assigned the numeric value 1224, it is easy to deduce that 1224 is 153 times 8. Why eight? Naturally because it is the number by which you can divide 1224 to give a result of 153 (after having tried the sum with the 7 preceding numbers). And what if 1224 was not divisible by any number to give a result of 153? Obviously this example would then not have been deemed relevant and would not have been mentioned. In the same way, pyramidologists have calculated that the exact number of days that Jesus lived on earth was 12,240 and that this number is the product of 10 × 8 × 153. Here it was simply a question of multiplying 1224 by ten then dividing it by eighty: the solution lay only in establishing that 12,240 was the number of days that Jesus lived, a calculation that is not even remotely suggested by any biblical text—also because if Christ lived for 33 years, multiplying 33 by 365 makes 12,045, and even if we calculate that Jesus was born in a leap year, in 33 years we will have nine

Pages 92–93:
Anonymous,
The Pyramids of Giza
(1837), print, Florence,
Archivi Alinari

Calculations regarding
the perfect position
of the Great Pyramid
from Charles Piazzi Smyth,
*Our Inheritance in
the Great Pyramid,*
London (1880)

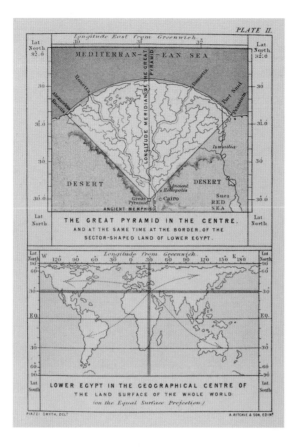

leap years, and the figure would rise to a maximum of 12,054 (but since the last year of his life stopped at Easter, the figure would actually be lower).

The fact is that you can do whatever you want with numbers. With reference to the discoveries made by the pyramidologists, an architect by the name of Jean-Pierre Adam conducted an experiment on a kiosk selling lottery tickets close to his house. The length of the counter was 149 centimeters, in other words one hundred billionth of the distance from Earth to the sun. The height at the rear divided by the width of the window was $176 \div 56 = 3.14$. The height of the front was 19 decimeters, in other words equal to the number of years in the Greek lunar cycle. The sum of the heights of the two front corners and the two rear corners was $190 \times 2 + 176 \times 2 = 732$, which is the date of the victory at the Battle of Poitiers. The thickness of the counter was 3.10 centimeters and the width of the window frame 8.8 centimeters. By substituting the whole numbers with the corresponding letter of the alphabet, we arrive at $C_{10}H_8$, which is the formula for naphthalene.

4.

THE WONDERS OF THE EAST, FROM ALEXANDER TO PRESTER JOHN

THE ORIENT OF THE ANCIENTS The Greek world was always fascinated by the Orient. Already in Herodotus's day (around 475 BC), Persia was connected by trade routes to India and central Asia, and new roads were opened to the Greeks with the conquests of Alexander the Great, as far as the Indus valley (beyond today's Afghanistan). Nearchus, Alexander's admiral, had opened up a route from the Indus delta to the Persian Gulf, and subsequently the Hellenistic influence extended even further. But heaven knows what merchants and soldiers recounted on their return. Although these lands had been visited by that time, their exploration had been preceded by many legends that continued to survive for centuries, even when more credible travellers, such as Giovanni da Pian del Carpini (John of Plano Carpini) and Marco Polo had written huge reports of their travels in the Middle Ages. In short, reports on the wonders, or *mirabilia*, of the Orient from antiquity until the end of the Middle Ages had become a literary genre that survived every geographical discovery.

The wonders of India had been described by Ctesias of Cnidus in the fourth century BC; his work has been lost, but there is a wealth of extraordinary creatures in Pliny's *Natural History* (first century AD), which then inspired a myriad successive compendia, from the *Collectanea rerum memorabilium* (Collection of Memorable Things) by Solinus in the third century to the book on the liberal arts in the *De nuptiis Philologiae et Mercurii* (On the Marriage of Philology and Mercury, i.e., Learning and Commerce) by Martianus Capella, in the late fourth or early fifth century.

In the second century AD, Lucian of Samosata, in his *True History*, albeit in order to parody traditional credulity, featured hip-

Left:
Rabanus Maurus,
detail from *De universo,
seu de rerum natura*
(On the Universe; or,
On the Nature of Things,
eleventh century)

Right:
*Alexander the Great
on his flying machine*,
from the *Roman d'Alexandre*
(1486), Ms. 651, Chantilly,
Musée Condé

pogryphs, birds with lettuce-leaf wings, Minotaurs, and flea-archers the size of twelve elephants.[1]

Whatever Alexander the Great had seen, fantastic accounts of his travels continued to fascinate medieval man, and you can see how in the <u>*Romance of Alexander*</u> (which circulated in various Latin versions from the fourth century onward but sprang from Greek sources that go back before pseudo-Callisthenes of the third century AD) the Macedonian conqueror visited amazing lands and found himself having to face frightening peoples.

Through the various tales about Alexander, there thus developed a subgenre of Oriental *mirabilia*, which was the list or the description of the monsters that could be encountered there, and we also find descriptions of this kind in Augustine, <u>Isidore of Seville</u>, and Mandeville.

The same fabulous beings, animals, or humanoids were to populate the medieval encyclopedias, through the influence of the *Physiologus*, written in Greek between the second and third centuries of our era and then translated into Latin as well as various Asian languages, which lists about forty of them, including animals, trees, and stones. After having described these beings, the *Physiologus* shows how and why each of them is the vehicle of ethical and theological teachings. For example, the lion, which according to legend wipes away its tracks with its tail to elude hunters, becomes a symbol of Christ, who wipes away the sins of men.

This explains to us why the description of these creatures

1. *On medieval* mirabilia, *see Le Goff 1985, Tardiola 1991, and Zaganelli 1990 and 1993.*

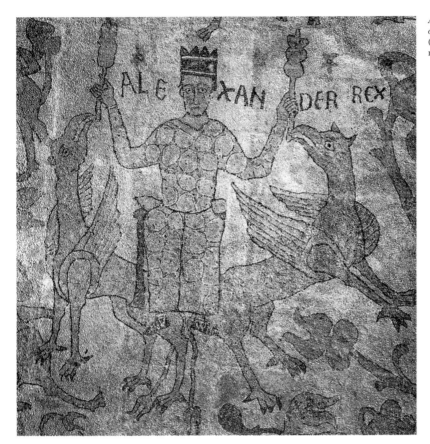

Alexander the Great Sitting on Two Griffins (1163–1166), mosaic, central nave of Otranto Cathedral

continued throughout the Middle Ages in the various bestiaries, lapidaries, herbals, and the "encyclopedias" conceived on Pliny's model, from the *Liber monstruorum de diversis generibus* (Book of Monsters of Various Origins, eighth century) or *On the Nature of Things* by Rabanus Maurus (ninth century) to the great compilations of the twelfth and thirteenth centuries, such as, for example, *De imagine mundi* (Image of the World) by Honorius of Autun, the *Book of the Nature of Things* by Thomas of Cantinpré, *The Nature of Things* by Alexander Neckam, *On the Properties of Things* by Bartholomaeus Anglicus, and the *Speculum majus* (The Great Mirror) by Vincent of Beauvais, down to the *Li livres dou Trésor* (The Book of the Treasure) by Brunetto Latini. For medieval man, convinced that the world was a great book written by the finger of God and that every living creature, animal and vegetable, and every stone was the vehicle of a supe-

rior meaning, it was necessary to populate the universe with beings equipped with the most disparate properties in order to glimpse an allegorical significance through these characteristics. And Alain de Lille in the twelfth century warned that "every creature in the universe—almost as if it were a book or a painting—is like a mirror: of our life, of our death, of our condition, of our fate—a true symbol" (from *Rhythmus alter* [Another Harmonization]).

The notions of the Orient and India, however, were very vague, because on the one hand, you arrived at the eastern extremity of Asia, where the maps located the Earthly Paradise (see the chapter on this), and on the other, one of the first texts on the *mirabilia* (written perhaps in Greek in the sixth century and then translated into Latin in the seventh), known as the *Letter to Emperor Hadrian* or *De rebus in Oriente mirabilibus* or again *The Wonders of India*, describes a journey made to Persia, Armenia, Mesopotamia, Arabia, and Egypt. And we shall see later the nonchalance with which legend shifted the realm of Prester John from the Far East to Ethiopia.

THE REALM OF PRESTER JOHN The *Chronica de duabus civitatibus* (Chronicle of the Two Cities) of Otto von Freising narrates that in 1145, during a visit to Pope Eugene III, in the course of an Armenian embassy, Hugh, Bishop of Jabala, had talked to him in the presence of the pope about a certain John, a Nestorian Christian *rex et sacerdos*, a descendant of the Magi, urging Eugene to call for a second crusade against the infidels.

In 1165 there began to circulate what was to become known as the *Letter of Prester John*, in which the prester (an old form of *priest* or *presbyter*) wrote to Manuel I Komnenos, the Byzantine emperor. But the letter also reached Pope Alexander III and Frederick Barbarossa, and it certainly made an impression on its recipients if Alexander III, in 1177, sent—through his physician Filippo—a missive to the mythical monarch exhorting him to abandon the Nestorian heresy and to submit to the Church of Rome. Little is known about this Filippo, or if he reached Prester John, or if the latter replied, but the whole episode reveals the interest that the letter had aroused on a political as well as a religious level.

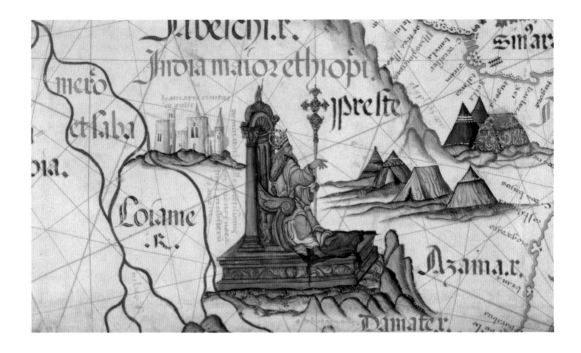

The letter said that in the Far East, beyond the regions occupied by the Muslims, and beyond those lands that the crusaders had tried to free from the dominion of the infidels but under whose dominion they had returned, there flourished a Christian realm, governed by a fabulous Presbyter Johannes, *rex potentia et virtute dei et domini nostri Iesu Christi.*

Prester John, from Hartmann Schedel, *Nuremberg Chronicle* (1493)

If there existed a Christian realm beyond the lands controlled by the Muslims, it was possible to think of a reunion between the Roman Church of the West and the Far East, and this legitimized all enterprises of expansion and exploration. And so, translated and paraphrased several times in the course of the following centuries in various languages and versions, the letter had decisive importance for the expansion of the Christian West. In 1221 a letter from Jacques de Vitry to Pope Honorius III mentions Prester John as a quasi-messianic ally capable of turning the military situation in favor of the crusaders, whereas in the course of the seventh crusade, Louis IX (according to Jean de Joinville's *Life of Saint Louis*) saw him rather as a possible adversary while he hoped for an alliance with the Tartars. In the sixteenth century in Bologna, at the time of the coronation of Charles V,

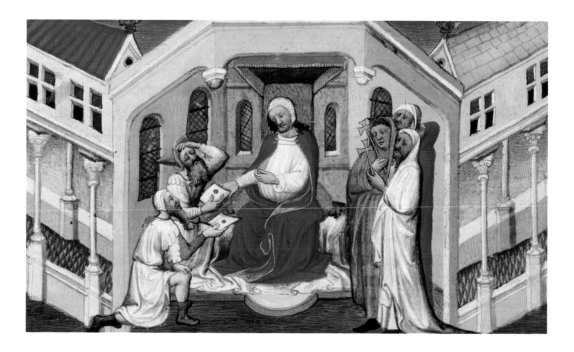

*Genghis Khan's
Messenger asks Prester John
for his Daughter's Hand,
Livre des merveilles
du monde
(fifteenth century),
Ms. Fr.2810, fol. 26r, Paris,
Bibliothèque nationale
de France*

there was talk of John as a possible ally for the reconquest of the Holy Sepulchre.

The legend of Prester John was constantly picked up by those who cited the letter without asking themselves about its authenticity. John Mandeville (who wrote *The Travels of Sir John Mandeville* or a *Treatise on the Most Wonderful and Remarkable Things to Be Found in the World*) talked about the realm of Prester John. This author had never left his own home, and he wrote almost sixty years after Marco Polo had ventured as far as Cathay. But for Mandeville, talking about geography still meant talking about creatures that *had to be*, irrespective of whether they actually existed, even though some of his pages lead one to think that his sources included eyewitness accounts by Marco Polo. It is not that Mandeville writes nothing but cock-and-bull stories: for example, he talks of the chameleon as an animal that changes color, even though he adds that it looks like a goat.

It is interesting to compare Mandeville's Sumatra, southern China, and India with those of Marco Polo. There is a nucleus that remains largely identical, except that Mandeville still populates these lands with animals and humanoid creatures he found in earlier books.

Around the middle of the fourteenth century, the realm of Prester John moved from a vague Far East toward Africa, and certainly the utopia of John's realm encouraged the exploration and conquest of the continent. In fact the Portuguese identified his kingdom with Ethiopia, which was in fact a Christian empire, even though less rich and fabulous than the one described in the notorious letter. See, for example, a report by <u>Francisco Alvarez</u> (*A True Relation of the Lands of Prester John of the Indies*, 1540), who between 1520 and 1526 had been in Ethiopia as a member of a Portuguese diplomatic mission.

How did Prester John's letter come about, and what was its goal? Perhaps it was an anti-Byzantine propaganda document, produced in the *scriptoria* of Frederick I (given that it contains fairly disparaging expressions about the Eastern emperor), or one of the rhetorical exercises so beloved of the learned of the period, not much worried whether what they passed off as true really was so. The problem, however, is not so much that of its origin but the way it was received. A political project was gradually reinforced through this geographical fantasizing. In other words, the phantasm called up by some imaginative scribe served as a pretext for the expansion of the Christian world toward Africa and Asia, a friendly prop for the white man's burden. What had contributed to its success was the description of a land inhabited by all kinds of monsters, rich in precious materials, splendid palaces, and other marvels, an idea of which can be had from the passages published in the anthology. Whoever wrote the letter was familiar with all the ancient literature on the wonders of the Orient and was capable of exploiting with rhetorical and narrative skill a legendary tradition that was more than 1,500 years old. But above all he wrote for a public for whom the Orient held a particular appeal, owing to the unheard-of riches it guarded, a mirage of abundance in the eyes of a world dominated largely by poverty.[2]

Was the priest's letter entirely false? It certainly brought together all the stereotypes of the fabulous Orient, but it said something true about the existence, if not of a realm, of many Christian communities between the Middle East and Asia. These were the Nestorian communities. The Nestorians adhered to the doctrine of Nestorius

2. *For the various versions of the letter and its success, see Zaganelli (1990).*

(c. 381–451), the patriarch of Constantinople, who maintained that two distinct persons coexisted in Jesus Christ, the man and the god, and that Mary was the mother only of the human person, thereby refusing her the title of Mother of God. The doctrine had been condemned as heretical, but the Nestorian church was already widespread in Asia, from Persia to Malabar and China.

As we shall see, when the great medieval travellers pushed on as far as Mongolia and Cathay, in the course of their journeying, they heard from the local populations about a certain Prester John. Certainly those distant peoples had never read the prester's letter, but equally certainly his letter was at the very least a legend that circulated among the Nestorian communities which, in support of their identity, boasted of that descent as an aristocratic title to show their pride in being Christians in pagan lands.

The last element of fascination in the letter was that John proclaimed himself *rex et sacerdos*, king and priest. The fusion of kingship and priesthood is fundamental in the Judeo-Christian tradition, going back to Melchizedek, king of Salem and priest of the Almighty, to whom Abraham himself rendered homage. Melchizedek appears above all in Genesis 14:17–20: "And the king of Sodom went out to meet him, after his return from the slaughter of Chedorlaomer and of the kings that were with him, at the valley of Shaveh, which is the king's dale. And Melchizedek king of Salem brought forth bread and wine: and he was the priest of the most high God. And he blessed him, and said, Blessed be Abram of the most high God, possessor of heaven and earth: And blessed be the most high God which hath delivered thine enemies into thy hand. And he gave them tithes of all."[3]

Insofar as he offers bread and wine, Melchizedek immediately appears as a Christlike figure, and as such he is mentioned in numerous passages in the *Gospel according to Paul*, which, in defining Jesus as "Priest in eternity according to the Order of Melchizedek" announces his return as King of Kings. And to come to our own times, John Paul II, during the General Audience of February 18, 1987, said, "The name Christ that, as we know, is the Greek equivalent of the term Messiah, that is to say the Anointed, as well as its 'regal' character, of

3. *From the King James Version.*

which we have spoken in the previous catechesis, also includes, according to the Old Testament tradition, a priestly character. . . . This unity has its first expression, almost a prototype and a harbinger, in Melchizedek, king of Salem, a mysterious contemporary of Abraham."

Whoever wrote the *Letter of Prester John* was also aware of this idea of priestly kingship and kingly priesthood—and this explains why this distant emperor was known as *presbyter* or priest.

LEGENDS AND TRAVELLERS Prester John was talked about, albeit vaguely and with reference to information acquired in the course of their itinerary, by the first travellers who pushed on toward the Orient and wrote accounts of their journeys.

John of Plano Carpini made his first voyage in 1245 toward the Mongol Empire (through Poland and then Russia), and in his *History of the Mongols* (5.12), he recounts how Genghis Khan sent one of his sons to conquer Lesser India, whose inhabitants were dark-skinned Saracens, known as Ethiopians. But then he moved toward Greater India, where he was opposed by the king of that land "commonly called Prester John," who had constructed copper dummies with fire inside them and put them on horseback, placing men with bellows at their backs. Once they clashed with the enemy, his men worked their bellows so that the adversaries' horses were burned by Greek fire.

William of Rubruck made his journey to Mongolia in 1253 and often betrays a certain skepticism about the legends he heard ("they have also told me that beyond Cathay there is a region where people do not grow old . . . they have assured me that this is true, but I don't believe it," 29.49). He, too, heard talk of a Nestorian King John who ruled over the Nayman people, and he supposed that accounts of him were "things ten times greater than reality," because it is typical of Nestorians (he says) to make up sensational rumors from nothing. He admits that he passed through their lands "but no one knew anything about him, except for some Nestorians" (17.2). Probably Marco Polo also drew on that same tradition; he visited the Orient as far as China between 1271 and 1310 and mentions Prester John in at least two chapters of the *Travels*. He does not boast that he entered his kingdom

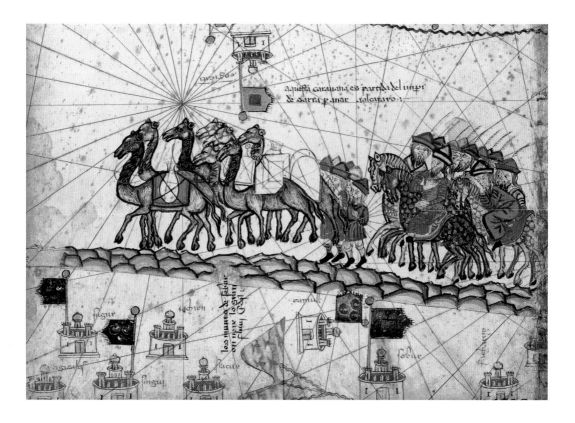

Marco Polo Travelling along the Silk Road, Catalan map (fourteenth century), Paris, Bibliothèque nationale de France

but reports tales heard during his journey. On the subject of Tenduc, he says that this province is toward the east, by then under the dominion of Genghis Khan, and ruled by the descendants of Prester John. But of the battles fought by these descendants, he limits himself to a mention. Hence in Polo's view, Prester John was yesterday's news.

Another skeptic was Odoric of Pordenone, who made his journey in 1330, and in his *Sulle cose sconosciute* (On Unknown Things) he notes: "We left Cathay going westward . . . we sailed for about a month, and we reached the land of Prester John, which is not all that it is said to be. The main city is Casan, and the country is small and disorderly; and what makes this Prester John known is that he is related by marriage to the Great Khan, one of whose daughters he has taken as a wife. To the best of my knowledge, this was not a very important thing, and so we stayed there for a short time only."

Nonetheless, the persistence of the legend in Asiatic countries tells us that the *Letter of Prester John*, false as it was, had tapped

The Lady and the Unicorn (1484–1500), tapestry, Musée national du Moyen Âge (formerly Musée de Cluny)

some exotic knowledge and bears witness to Eastern traditions still unknown to the West.

One might think that those who had actually visited those lands about which people had once merely told fantastic tales would have given a faithful account of what they really saw and not of what they would have liked to see. But even these credible travellers often failed to elude the influence of the legends they knew about before their departure.

In Marco Polo there is a kind of conflict between what tradition suggested to him and what he really saw. A typical case is that of

Albrecht Dürer,
Rhinoceros (1515),
woodcut, private collection

the unicorn, which he saw on Java. Now, when it comes to the existence of unicorns, medieval man had no doubts, and later, in 1567 (see Shepard 1930), the Elizabethan traveller Edward Webbe saw them in the Sultan's seraglio, in India, and even in the Escorial in Madrid, while the seventeenth-century Jesuit missionary Francisco Rodrigues Lobo saw some in Abyssinia, and another unicorn was seen by John Bell in 1713. Polo knew that according to legend, the unicorn was an animal, obviously with a long horn on its forehead; it was white and gentle and attracted to virgins. And in fact in order to catch one it was said to be necessary to sit a virgin under a tree, and the animal would come and lay its head in her lap, so that the hunters could catch it. According to Brunetto Latini, when the unicorn sees the maiden, it cannot resist going to her and laying its proud head in her lap.

Could Marco Polo not look for unicorns? He looked for them, and he found them, because he was led to look at things through the eyes of tradition. But once he had looked and seen, on the basis of past culture, he began to reflect like a veracious witness, capable of criticizing the stereotypes of exoticism. In fact he admits that the unicorns he saw were a bit different from those pretty, white, deer-like creatures with a spiral horn that appear on the English royal coat of arms.

Blemmyes,
sciapods and monocoli,
from the Boucicaut
Master, *Livre
des merveilles
du monde* (fifteenth
century), Paris,
Bibliothèque nationale
de France

What he had seen were rhinoceroses, and so he confesses that uni-corns have "hair like a buffalo and feet like those an elephant," their horn is large and black, the tongue is spiny, the head looks like that of a boar, and all in all, "it is a most foul beast to see. It is not, as they say here, that it lets itself be taken by the maiden, but the opposite." The fact is that the *Travels* is dominated by curiosity but never by a fren-zied wonder, and far less by alarm.

Of course, Polo heard mysterious voices in the Lop Desert, as might anyone riding on horseback for weeks on end.[4] He took croco-diles for big snakes with only front paws, but you can't expect him to have got too close in order to observe them. That said, he does tell us in a plausible manner about petroleum and fossil carbon.

Sometimes it really seems as though he is inventing legends, as his predecessors and successors did, as when he tells us about musk, an exquisite scent found below the navel in a "postuma," or abscess, of an animal like a cat. Yet the animal does exist in Asia, and it is *Moscus moschiferus*, the musk deer, which has teeth just as Polo describes them and which in the skin of its abdomen, above the preputial aper-ture, secretes musk with a highly penetrating perfume. Moreover, it is the Tuscan version of the *Travels* that says it is like "a cat," because the original French correctly says that it is like a gazelle. Polo talks of the salamander but points out that it is a fabric made of asbestos, not the animal of the bestiaries that lives and basks in fire. "And these are sal-amanders, and the others are fables."

Polo tries, therefore, to curb his imagination. But in a later version of the *Travels*, the *Livre des merveilles du monde*, now in the Bibliothèque Nationale in Paris, when he describes the kingdom of Coilu, on the Malabar coast, and tells of a people who gather pepper and, in the Tuscan version, the *mirabolani emblici* (which were kinds of plums used as spices or as medicinal drugs), how does the illumina-tor portray the inhabitants of Malabar? One is a Blemmy, namely one of those fabulous creatures with no head and a mouth on the stomach; another is a Sciapod, which lies in the shade of its single foot; and the third is a Monocolus, a one-eyed creature—exactly what the reader of the manuscript expected to find in that region. In Polo's text, these

4. *Cf. Geiger (2009): when in an "extreme environment" (such as mountain peaks or deserts), even normal people can sense the presence of mysterious beings or have visual or auditory hallucinations.*

three monsters are not mentioned at all. At most, Polo says that the inhabitants of Coilu are black, go around naked, that the area has many black lions, white parrots with red beaks, and peacocks, and with the fine coldness that distinguishes him when he reports on customs a little unusual for good Christians, he notes that they have a scant sense of morality and wed their cousins, stepmothers, or their brother's widow.

Why did the illuminator permit himself to insert these three beings that do not exist in the world of the *Travels*? Because he, like his readers, was still bound to the legend of Oriental *mirabilia*.

On the other hand, it has been noted (see Olschki 1937) that many of the descriptions of Oriental palaces given by the great travellers seem to be copied from those of Prester John's royal palace. Naturally, the prevailing feature of such descriptions is an abundance of precious stones, gold, and crystal, but Marco Polo's depiction of the imperial palace corresponds to Chinese sources as far as the exterior is concerned, but not the interior, of which the traveller probably only caught a fleeting glimpse and so he had to make up for this with the literary models that he, or his scribe Rustichello da Pisa, had in mind. Regarding the great hall of the palace, Odoric of Pordenone talks of twenty-four golden columns, while fifty of these were mentioned in the *Letter of Prester John*, but William of Rubruck, in his description of the palace of Khan Mongke, talks of two rows of columns without mentioning gold. Probably they were made of wood with some gilding. So it must have been those that had struck Odoric, but he had Prester John in mind.

THE AUTOMATA One of the wonders of which travellers often spoke were automata. Hellenistic culture boasted a wealth of automata, and the machines described by Hero of Alexandria (first to second century AD) in his *Spiritalia seu pneumatica* bear witness to the interest that people of those days had in self-operating objects that combined natural motive power (descending weights and falling water) and artificial ones (the expansion of heated air), as for example happened on an altar where a fire heated a container full of water to produce steam that flowed underground to activate another mechanism that opened the

doors of a temple. Realized or only planned, these products of Alexandrian culture went on to inspire the Byzantine world on the one hand and the Islamic one on the other.

From the Byzantine period, there is a record of a monumental clock that stood in the market of Gaza (described in the sixth century by Procopius of Gaza), whose tympanum was decorated with a Gorgon's head that rolled its eyes when the hour struck. Below that there were twelve windows that marked the nighttime hours, and twelve doors that opened every hour when a statue of the sun god passed by and Hercules would emerge to be crowned by a flying eagle. For Western medieval man, Byzantium was part of the Orient, as is witnessed by an amazed description written by Liutprand of Cremona in the tenth century. In his *Antapodosis,* Liutprand, who as imperial ambassador to Constantinople— and despite his once having described with some sourness Emperor Nicephorus II and his court—talks in admiring tones of the wonderful throne that, on the roaring of two great golden lions on the steps, rose mechanically while the emperor donned new clothes on its upward course.

There are numerous accounts of Muslim interest in automata, from Arabic translations of the work of Hero to the memory of a self-operating silver-and-gold tree that belonged to the caliph of Baghdad, al-Ma'mūn and the hydraulic clock that Hārūn ar-Rashīd sent as a gift to Charlemagne, with metal balls that sounded the hours as they fell into a basin and topped by twelve windows from which twelve figures of knights emerged.

Between 1204 and 1206, an Arab scientist expert in mechanics, al-Jazari, wrote the *Book of Knowledge of Ingenious Mechanical Devices*, of which we still have some drawings that bear witness to the progress achieved in the construction of automata.

In the West, too, there was no lack of artisans able to construct automata, and legend has it that Pope Sylvester II (who reigned 999–1003) was attributed with the creation of a golden talking head that murmured secret advice.

According to the *Otia imperialia* (Recreation for an Emperor) by Gervase of Tilbury (thirteenth century) a certain Virgilius, bishop of Naples, apparently invented a mechanical fly that protected the

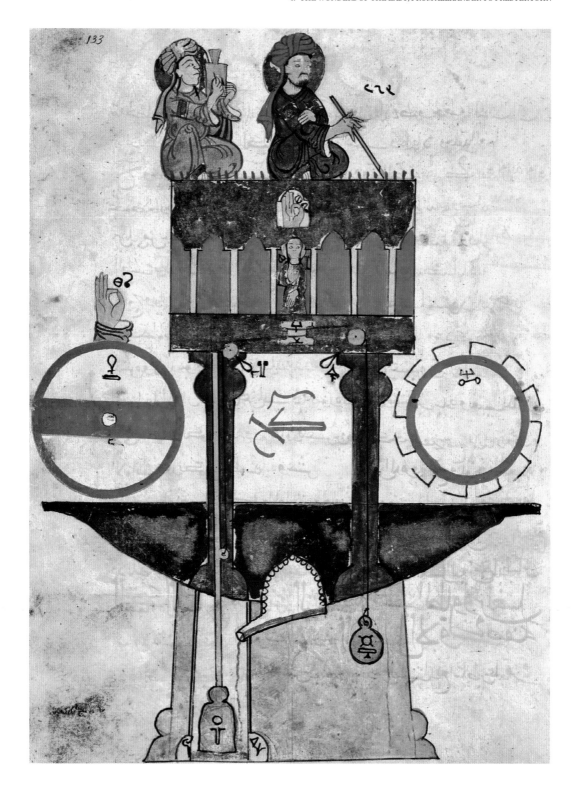

Left:
Water clock, from al-Jazari,
*The Book of Knowledge
of Ingenious Mechanical
Devices* (1206), Istanbul,
Topkapi Palace Museum

Right:
Villard de Honnecourt, *Livre
de portraiture*
(c. 1230), Paris, Bibliothèque
nationale
de France

stands of Neapolitan butchers from insects, and it was said that Albertus Magnus had constructed a kind of iron robot that opened the door for guests. In his *Livre de portraiture*, Villard de Honnecourt (thirteenth century) had designed various automatic contrivances. In Strasbourg Cathedral, a clock made in the fourteenth century showed the Magi bowing before the Virgin and Child, while various kinds of automata are mentioned in the knightly romances.

If this was the fascination exercised by automata, all the more reason to find them in the fabulous Orient, also because extraordinary ones were promised in the *Letter of Prester John*. Odoric of Pordenone saw a jade pine cone, surrounded by gold wires, from which emerged four serpents also made of gold, from whose mouths ran dif-

ferent kinds of liquid; and he saw golden peacocks that seemed alive and beat their wings when someone clapped his hands (and he wondered whether this was a result of diabolical arts or of some subterranean engine). Perhaps not self-moving but very similar to the Byzantine throne described by Liutprand was the object seen by John of Plano Carpini at the court of the Tartar emperor Güyük Khan, all in ivory and decorated with gold, precious stones, and pearls (*History of the Mongols*, 9.35).

At the court of Khan Mongke in Karakorum, William of Rubruck saw a silver tree whose roots were formed by four silver lions, from each of whose mouths poured mare's milk. From the top of the tree, there emerged four golden serpents whose tails wound around the trunk. One serpent spouted wine; another, milk; the third, a beverage made from honey; and the fourth, rice beer. Amid the serpents on the top of the tree, there rose an angel holding a trumpet. When the drinks were finished, the head cupbearer ordered the angel to sound the trumpet, and a man concealed in a niche blew into a secret tube that led to the angel, which then sounded the trumpet; at this point, servants poured the right beverage into each of the four tubes that led to the serpents, and the cupbearers collected the liquids that flowed out to offer them to the guests. An Oriental marvel, certainly, but William knew that the creator of this wonder was a French goldsmith, one Guillaume Boucher. A sign that many Oriental marvels came from the West, which was not unaware of them, but it matters little: the excitement consisted in discovering them in distant lands about which one could fantasize.

TAPROBANE In order to give an idea of ancient and medieval confusion about how things were in the mysterious East, here is the story of the island of Taprobane.

Taprobane had been discussed by Eratosthenes, Strabo, Pliny, Ptolemy, and Cosmas Indicopleustes. According to Pliny, Taprobane was discovered in Alexander's day, whereas before that, it was generally represented as the land of the Antichthons (natives of the Southern Hemisphere) and considered "another world." Pliny's island

Puppeteers, bishop, antipope, and the king in his bed, from an eighteenth-century copy of *Hortus deliciarum* by Herrad of Landsberg (1169–1175), Bibliothèque municipale de Versailles

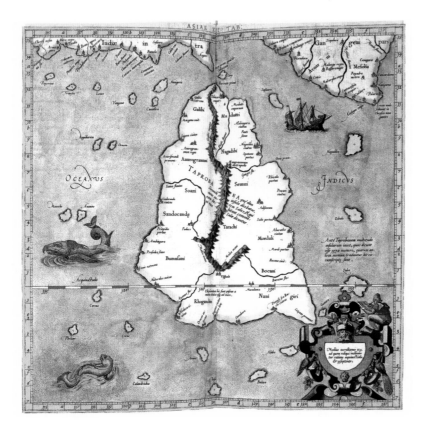

The island of Taprobane, from Gerardus Mercator's *Universalis tabula iuxta Ptolemeum* (Universal Chart in the Style of Ptolemy, 1578), London Geographical Society

Sebastian Münster, *The Island of Taprobane* (1574)

could be identified with Ceylon, and this can be deduced from Ptolemy's maps, at least in the sixteenth-century editions. In his *De situ orbis* (On the Layout of the Globe), Pomponius Mela wondered if it was an island or an extension of another world, as Pliny had suggested, while mentions of the island are found in Asian authors.

Isidore of Seville, too, located it south of India and limited himself to saying that it possessed a wealth of precious stones and that it had two summers and two winters. But in a map said to be by pseudo-Isidore, we find Taprobane at the eastern extremity of the globe, in the exact position of the Earthly Paradise. And in fact, as can be seen from a reconstruction by Arturo Graf, in "Ceylan"—according to legend—there lay Adam's tomb.

The problem is that Taprobane and Ceylon were thought to be two different islands, and this duplication appears clearly in Mandeville, who talks about it in two chapters of his *Travels*. He does

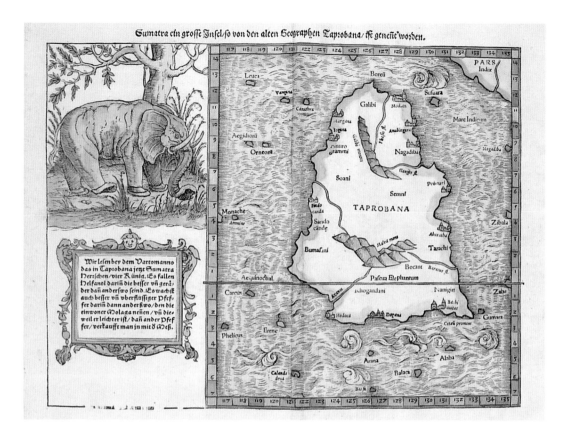

Sumatra ein grosse Insel/so von den alten Geographen Taprobana/ist genent worden.

Wir lesen bey dem Vartomanno das in Taprobana jetz Sumatra Herrschen/vier König. Es fallen Helfanté darin die besser vñ gerð/ der dañ anderswo seind. Es wachßt auch besser vñ vberflüssiger Pfef/ fer darin dann anderswo/den die einwoner Molaga nennen/vñ die weil er leichter ist/ dañ ander Pfef fer/ verkaufft man jn mit ð Moeß.

not say exactly where Ceylon lay but specifies that it measured a good eight hundred miles around, and the territory "is so full of serpents, dragons, and crocodiles, that no man dares to live there. The crocodiles are a kind of serpent with a yellow rayed back, with four legs and short buttocks and large nails like talons or spurs. Some are five ells long, others six, eight, or even ten."

Mandeville believed that Taprobane was in the area of the realm of Prester John; it had two summers and two winters, and on it there rose enormous mountains of gold guarded by gigantic ants.

From this point onward from one cartographer to the next, Taprobane spun like a top from one point to another of the Indian Ocean, sometimes alone and sometimes in tandem with Ceylon. In the fifteenth century, the traveller Niccolò de' Conti identified it with Sumatra, but sometimes we find it located between Sumatra and Indochina, near Borneo.

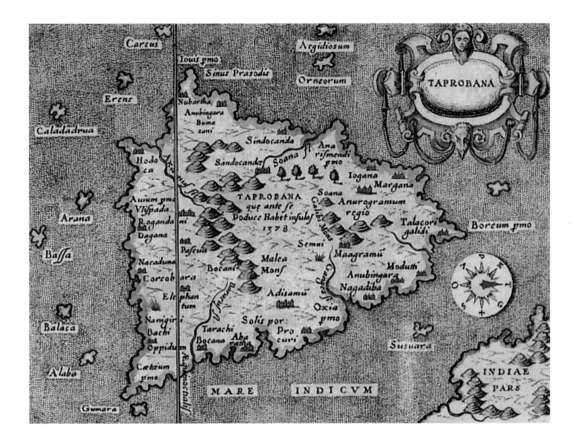

In his *L'isole più famose del mondo* (The Most Famous Islands of the World) of 1590, Tommaso Porcacchi tells us of a Taprobane full of riches, of its elephants and immense tortoises, as well as the characteristic attributed to its inhabitants by Diodorus Siculus. These were supposed to have a kind of forked tongue ("with one side they speak to one person, and with the other they speak to someone else").

After having related various traditional notions, Porcacchi nonetheless apologizes to his readers because he had found no exact mention of its geographical location anywhere, and he concludes: "Despite the fact that many ancient and modern authors have dealt with this island, I cannot find anyone who assigns its boundaries: so I too must be excused, if in this I fall short of my customary order." As for its identification with Ceylon, he was still doubtful: "First (according to Ptolemy) it was called Simondi, and then Salike, and finally Taprobane; but the moderns conclude that it is Sumatra, even though

Tommaso Porcacchi,
The Island of Taprobane
(c. 1590), Venice

there is no lack of those who believe that Taprobane is not Sumatra but the island of Zeylan But some moderns believe that none of the Ancients located Taprobane correctly: on the contrary, they hold that there is no island that can be believed to be Taprobane in the places in which it has been located."

Hence, from an island in excess, Taprobane slowly became an island that did not exist, and as such it was treated by Thomas More, who situated his Utopia "between Ceylon and America," while Tommaso Campanella located his City of the Sun in Taprobane.

The East of Herodotus

HERODOTUS (484–425 BC)
The History, III

Eastward of these Indians are another tribe, called Padaeans, who are wanderers, and live on raw flesh. This tribe is said to have the following customs:—If one of their number be ill, man or woman, they take the sick person, and if he be a man, the men of his acquaintance proceed to put him to death, because, they say, his flesh would be spoilt for them if he pined and wasted away with sickness. The man protests he is not ill in the least; but his friends will not accept his denial—in spite of all he can say, they kill him, and feast themselves on his body. So also if a woman be sick, the women, who are her friends, take her and do with her exactly the same as the men. If one of them reaches to old age, about which there is seldom any question, as commonly before that time they have had some disease or other, and so have been put to death—but if a man, notwithstanding, comes to be old, then they offer him in sacrifice to their gods, and afterward eat his flesh. There is another set of Indians whose customs are very different. They refuse to put any live animal to death, they sow no corn, and have no dwelling-houses. Vegetables are their only food. There is a plant which grows wild in their country, bearing seed, about the size of millet-seed, in a calyx: their wont is to gather this seed and having boiled it, calyx and all, to use it for food.…
All the tribes which I have mentioned live together like the brute beasts: they have also all the same tint of skin, which approaches that of the Ethiopians.…

Here, in this desert, there live amid the sand great ants, in size somewhat less than dogs, but bigger than foxes. The Persian king has a number of them, which have been caught by the hunters in the land whereof we are speaking. These ants make their dwellings underground, and like the Greek ants, which they very much resemble in shape, throw up sand-heaps as they burrow. Now the sand which they throw up is full of gold. The Indians, when they go into the desert to collect this sand, take three camels and harness them together, a female in the middle and a male on either side, in a leading-rein. The rider sits on the female, and they are particular to choose for the purpose one that has but just dropped her young; for their female camels can run as fast as horses, while they bear burthens very much better.…
When the Indians therefore have thus equipped themselves they set off in quest of the gold, calculating the time so that they may be engaged in seizing it during the most sultry part of the day, when the ants hide themselves to escape the heat.…
When the Indians reach the place where the gold is, they fill their bags with the sand, and ride away at their best speed: the ants, however, scenting them, as the Persians say, rush forth in pursuit. Now these animals are, they declare, so swift, that there is nothing in the world like them: if it were not, therefore, that the Indians get a start while the ants are mustering, not a single gold-gatherer could escape. During the flight the male camels, which are not so fleet as the females, grow tired, and begin to drag, first one, and then the other; but the females recollect the young which they have left behind, and

Monsters, from Ulisse Aldrovandi, *Monstrorum historia* (1698), Bologna, Ferroni

Dragon, from Pol de Limbourg, *Les très riches heures* (detail), fifteenth century, Chantilly, Musée Condé

never give way or flag. Such, according to the Persians, is the manner in which the Indians get the greater part of their gold; some is dug out of the earth, but of this the supply is more scanty. . . . Arabia is the last of inhabited lands toward the south, and it is the only country which produces frankincense, myrrh, cassia, cinnamon, and ladanum. The Arabians do not get any of these, except the myrrh, without trouble. The frankincense they procure by means of the gum styrax, which the Greeks obtain from the Phoenicians; this they burn, and thereby obtain the spice. For the trees which bear the frankincense are guarded by winged serpents, small in size, and of varied colors, whereof vast numbers hang about every tree. They are of the same kind as the serpents that invade Egypt; and there is nothing but the smoke of the styrax which will drive them from the trees.

The Arabians say that the whole world would swarm with these serpents, if they were not kept in check in the way

in which I know that vipers are. Of a truth Divine Providence does appear to be, as indeed one might expect beforehand, a wise contriver. For timid animals which are a prey to others are all made to produce young abundantly, that so the species may not be entirely eaten up and lost; while savage and noxious creatures are made very unfruitful.

Many Things Unbelievable to Many

PLINY THE ELDER (23–79)
Natural History, VII, 1–2

. . . some things among which I doubt not will appear portentous and incredible to many. For who ever believed in the Ethiopians before actually seeing them? or what is not deemed miraculous when first it comes into knowledge? how many things are judged impossible before they actually occur? Indeed the power and majesty

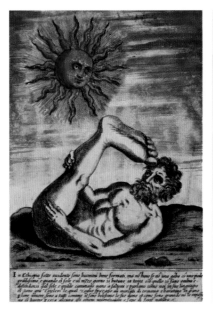

Sciapod and other
monstrous creatures,
from Ulisse Aldrovandi,
Monstrorum historia
(1698), Bologna, Ferroni

Monsters, from Konrad von
Megenberg, *The Book of
Nature* (1482), Augsburg

of the nature of the universe at every
turn lacks credence if one's mind em-
braces parts of it only and not the
whole. Not to mention peacocks, or
the spotted skins of tigers and pan-
thers and the colorings of so many an-
imals, a small matter to tell of but one
of measureless extent if pondered on
is the number of national languages
and dialects and varieties of speech, so
numerous that a foreigner scarcely
counts as a human being for someone
of another race! Again though our
physiognomy contains ten features or
only a few more, to think that among
all the thousands of human beings
there exist no two countenances that
are not distinct—a thing that no art
could supply by counterfeit in so small
a number of specimens! ...
We have pointed out that some Scythian
tribes, and in fact a good many, feed on
human bodies—a statement that per-
haps may seem incredible if we do not
reflect that races of this portentous
character have existed in the central re-

gion of the world, named Cyclopes and
Laestrygones, and that quite recently
the tribes of the parts beyond the Alps
habitually practised human sacrifice,
which is not far removed from eating
human flesh. But also a tribe is reported
next to these, toward the North, not far
from the actual quarter whence the
North Wind rises and the cave that
bears its name, the place called the
Earth's Doorbolt—the Arimaspi whom
we have spoken of already, people re-
markable for having one eye in the cen-
tre of the forehead. Many authorities,
the most distinguished being Herodotus
and Aristeas of Proconnesus, write that
these people wage continual war around
their mines with the griffins, a kind of
wild beast with wings, as commonly re-
ported, that digs gold out of mines,
which the creatures guard and the
Arimaspi try to take from them, both
with remarkable covetousness.
But beyond the other Scythian canni-
bals, in a certain large valley in the
Himalayas, there is a region called

Abarimon where are some people dwelling in forests who have their feet turned backward behind their legs, who run extremely fast and range abroad over the country with the wild animals. . . .

India and parts of Ethiopia especially teem with marvels. The biggest animals grow in India: for instance Indian dogs are bigger than any others. Indeed the trees are said to be so lofty that it is not possible to shoot an arrow over them, and [the richness of the soil, temperate climate and abundance of springs bring it about] that, if one is willing to believe it, squadrons of cavalry are able to shelter beneath a single fig tree; while it is said that reeds are of such height that sometimes a single section between two knots will make a canoe that will carry three people. It is known that many of the inhabitants are more than seven feet six inches high, never spit, do not suffer from headache or toothache or pain in the eyes, and very rarely have a pain in any other part of the body—so hardy are they made by the temperate heat of the sun; and that the sages of their race, whom they call Gymnosophists, stay standing from sunrise to sunset, gazing at the sun with eyes unmoving, and continue all day long standing first on one foot and then on the other in the glowing sand. Megasthenes states that on the mountain named Nulus there are people with their feet turned backward and with eight toes on each foot, while on many of the mountains there is a tribe of human beings with dogs' heads, who wear a covering of wild beasts' skins, whose speech is a bark and who live on the produce of hunting and fowling, for which they use their nails as weapons; he says that they numbered more than 120,000 when he

published his work. Ctesias writes that also among a certain race of India the women bear children only once in their lifetime, and the children begin to turn grey directly after birth; he also describes a tribe of men called the Monocolia who have only one leg, and who move in jumps with surprising speed; the same are called the Umbrella-foot tribe, because in the hotter weather they lie on their backs on the ground and protect themselves with the shadow of their feet; and that they are not far away from the Cave-dwellers; and again westward from these there are some people without necks, having their eyes in their shoulders. There are also satyrs [doubtless a kind of monkey] in the mountains in the east of India (it is called the district of the Catarcludi); this is an extremely swift animal, sometimes going on all fours and sometimes standing upright as they run, like human beings; because of their speed only the old ones or the sick are caught. Tauron gives the name of Choromandae to a forest tribe that has no speech but a horrible scream, hairy bodies, keen grey eyes and the teeth of a dog. . . .

Megasthenes tells of a race among the Nomads of India that has only holes in the place of nostrils, like snakes, and bandy-legged; they are called the Sciritae. At the extreme boundary of India to the East, near the source of the Ganges, he puts the Astomi tribe, that has no mouth and a body hairy all over; they dress in cotton-wool and live only on the air they breathe and the scent they inhale through their nostrils; they have no food or drink except the different odors of the roots and flowers and wild apples, which they carry with them on their longer journeys so as not to lack a supply of scent; he says they

can easily be killed by a rather stronger odor than usual. Beyond these in the most outlying mountain region we are told of the Three-span men and Pygmies, who do not exceed three spans, *i.e.* twenty-seven inches, in height; the climate is healthy and always spring-like, as it is protected on the north by a range of mountains; this tribe Homer has also recorded as being beset by cranes. It is reported that in springtime their entire band, mounted on the backs of rams and she-goats and armed with arrows, goes in a body down to the sea and eats the cranes' eggs and chickens, and that this outing occupies three months; and that otherwise they could not protect themselves against the flocks of cranes that would grow up; and that their houses are made of mud and feathers and eggshells.

The Adventures of Alexander

PSEUDO-CALLISTHENES
(THIRD CENTURY)
The Romance of Alexander the Great,
II, 209

Then, departing from there, we came to a verdant place where there were giant-like wild men, as big as the first, barrel-chested, hairy, and reddish colored. And they had faces like lions. And others called Oxoli had hair four cubits long, and they were as wide as a spear. These very powerful men came to us in tunics of rawhide, ready to fight without spears or arrows. They slew many of our group. And since many of our friends and youths were lost, I ordered that a blaze be started in order to fight them with fire. Thus the men went away. And of our soldiers, losses numbered 120,000; I ordered that pyres be lit and their remaining bones be taken to Spetriada. But they disappeared completely. And we quickly entered their caves and found tied to their doors wild beasts as large as the dogs we call dantakes, four cubits long, three-eyed, and of motley coloring. . . . And departing from there, we came to a place where a delicious and abundant spring rose. And I ordered the army to camp and, mindful of the carnivores, to make a ditch and a barricade around us so that the troops might rest and recuperate a bit. Then there appeared to us, about nine or ten o'clock, a man as hairy as a goat. And once again, I was startled and disturbed to see such beasts.

I thought of capturing the man, for he was ferociously and brazenly barking at us. And I ordered a woman to undress and go to him on the chance that he might be vanquished by lust. But he took the woman and went far away where, in fact, he ate her. And he roared and made strange noises with his thick tongue at all our men who had run forth to reach her and to set her free. And when his other comrades heard him, countless myriads of them attacked us from the brushes. There were 40,000 of us. So I ordered that the brushes be set afire; and when they saw the fire, they turned and fled. And we pursued them and tied up three of them, but they died since they refused to eat for eight days. And they did not have human reason, but, rather, barked wildly like dogs.

The Monsters of the East

SAINT ISIDORE OF SEVILLE
Etymologies, XI, 3, 12–27

Just as amongst single peoples, some

Eagle-man, miniature from *The Romance of Alexander* (1338), Oxford, Bodleian Library

individuals are said to be monstrous humans, so within the human species as a whole there exist some peoples composed of monsters, like the Giants, the Cynocephali, the Cyclopes, and other similar races. The Giants were so called due to an etymology in the Greek language. The Greeks consider the Giants to be gegeneis, which means earth born, because according to the myth, the earth itself gave birth to them with its immense mass, making them similar to itself Some people who do not know the Holy Scriptures wrongly believe that before the flood, the prevaricator angels had congress with the daughters of human beings, and that from this union were born the Giants, in other words extraordinarily strong and tall men who filled up the earth. The Cynocephali are so called because they have dogs' heads and because their barking shows them to be more animal than human: they are born in India. India is also the origin of the Cyclopes, so called because they are believed to have a single eye in the center of their foreheads. They are also known as agriophagitai because they feed only on the flesh of wild animals. Some believe that in Libya are born the Blemmyes, with headless trunks and with their mouths and eyes on their chests. Other creatures are said to be born without necks and with their

eyes on their shoulders. It has been written that in the Far East there exist peoples with monstrous faces: some without noses, the face deformed and entirely flat; others with the lower lip so prominent that, when they sleep, they use it to cover the whole of their faces to protect themselves from the burning sun; others still whose mouths seem to have healed over and who feed themselves only through a small hole using oat straws; some, finally, are said to be without tongues and communicate only with signs and movements. They say that amongst the Scythians live the Panotii, who have ears so large that they can use them to cover their whole bodies.... It is said that the Artabatitae live in Ethiopia and walk prone like sheep: none of them is thought to live beyond forty years of age. The Satyrs are small men with hooked noses, horns on their heads and feet like those of a goat. St Anthony saw one in the solitude of the desert. When questioned by the servant of God, he is said to have replied: "I am a mortal, one of those who live in the desert region and whom the gentiles, deceived by many errors, worship as Fauns and Satyrs." People also speak of forest-dwelling men, whom some call fig fauns. It is said that in Ethiopia lives the race of Sciapods, who have single legs and are capable of extraordinary speed: the Greeks call them Skiòpodes because, when they lie down on their backs due to the great heat of the sun, they shade themselves with their own enormous feet. The Antipodes, inhabitants of Libya, have the soles of their feet facing backward, in other words behind their legs, and eight toes on each foot. The Hippopods live in Scythia: they have a human form and horses' feet. It is said that in India there also lives a race called the Makròbioi, who stand twelve feet tall. Also in India lives a race who stand one cubit tall and are known to the Greeks as Pygmaei, which derives from the word cubit, and of whom we have already spoken: they live in the mountainous regions of India, close to the ocean. They [also] say that in India lives a race of women who conceive at the age of five and do not live beyond eight years of age.

The Basilisk

BRUNETTO LATINI
(1220–1294 OR 1295)
Li livres dou trésor, IV, 3

The basilisk is a kind of serpent, and so filled with venom that it shines forth from every part, and not only its venom but also its stench can poison from near or far, because it corrupts the air and ruins the trees, and its sight kills the birds flying in the air, and with its sight it will poison a man when it sees him: although the men of old say it will not harm he who sees it first. And its size, and its feet, and the white patches on its back and its crest are just like those of a cockerel, and it goes half of the time upright, and the other half along the ground like other serpents. And although it is such a proud beast, a weasel will kill it. And I tell you that when Alexander found basilisks, he had vessels cast in glass for men to go inside, so the men could see the serpents, but the serpents could not see the men, and so they killed them with arrows, and through this ingenuity his army was freed of them; and this is the nature of the basilisk.

Boucicaut Master, *Harvesting Pepper*, from the *Livre des merveilles du monde* (fifteenth century), Paris, Bibliothèque nationale de France

ANONYMOUS

De rebus in oriente mirabilibus
(SIXTH CENTURY)

They come from Babylonia to the Red Sea because of the multitude of snakes called *corsiae* which are in those places. The snakes have horns as big as a ram's. If they strike or touch anyone, he immediately dies. In those lands there is an abundance of pepper. The snakes fervently guard the pepper: in order to harvest the pepper the people do the following: they set fire to the place and then the snakes are forced to flee into the earth; and this is why the pepper is black. . . .

In the same area there are born Cinocefali, who we call Conopenae: their manes are like horses' and they flaunt them, they have boars' tusks and dogs' heads and they can even breathe fire through their mouths. . . .

The Nile is the king of all rivers, and it flows through Egypt; the people who live near the river call it Archoboleta, which means "great water." In these regions are born great multitudes of elephants. There are people born there who are fifteen feet tall, with white bodies and two faces on a single head. They have red knees and long noses. When the time comes for them to give birth, they travel in ships to India and there they bring their young into the world. They give birth to people of three colors, with heads like lions' heads and mouths and twenty feet: if they see or perceive anyone in those lands, or if anyone tries to chase them, then they take flight. . . .

Beyond the River Brixontes, east from there, there are people born big and tall, who have feet and shanks twelve feet long, flanks with chests seven feet long. They are of a black color, and all we can do is be wary of them: if

they were to catch a person they would devour him.

Then there is another island in this river, south of here, on which there are born men without heads who have their eyes and mouth in their chests....

Also in those places there are women with boar's tusks, hair down to their heels and an ox-tail at the bottom of their back; they are thirteen feet tall, with splendid bodies with skin the whiteness of marble, while their feet are those of a camel. Alexander the Great of Macedon could not capture them alive so he killed many of them, because they have offensive and disgusting bodies.

Near those places there live women who have beards down to their breasts, and who wear clothes out of horse's hide; they are great huntresses, and instead of dogs they breed tigers, leopards and other species of wild beasts which are born on the mountain: and with these they hunt....

ANONYMOUS
The Letter of Prester John, sent to Emperor Manuel I Komnenos of Constantinople in 1165 (abridged)

John, priest by the almighty power of God and the might of our Lord Jesus Christ, King of Kings and Lord of Lords, to his friend Emanuel, prince of Constantinople, greeting, wishing him health, prosperity, and the continuance of divine favor.

Our Majesty has been informed that you hold our Excellency in love and that the report of our greatness has reached you. Moreover, we have heard through our treasurer that you have been pleased to send to us some ob-

jects of art and interest that our Exaltedness might be gratified thereby.

Being human, I have received it in good part, and we have ordered our treasurer to send you some of our articles in return....

Should you desire to learn the greatness and excellency of our Exaltedness and of the land subject to our scepter, then hear and believe: I, Presbyter Johannes, the Lord of Lords, surpass all under heaven in virtue, in riches, and in power; seventy-two kings pay us tribute.... In the three Indies our Magnificence rules, and our land extends beyond India, where rests the body of the holy apostle Thomas [Judas the Twin]; it reaches toward the sunrise over the wastes, and it trends toward deserted Babylon near the Tower of Babel. Seventy-two provinces, of which only a few are Christian, serve us. Each has its own king, but all are tributary to us.

Our land is the home of elephants, dromedaries, camels, crocodiles, meta-collinarum, cametennus, tensevetes, wild asses, white and red lions, white bears, white merules, crickets, griffins, tigers, lamias, hyenas, wild horses, wild oxen, and wild men—men with horns, one-eyed men, men with eyes before and behind, centaurs, fauns, satyrs, pygmies, forty-ell-high giants, cyclopses, and similar women. It is the home, too, of the phoenix and of nearly all living animals.

We have some people subject to us who feed on the flesh of men and of prematurely born animals, and who never fear death. When any of these people die, their friends and relations eat him ravenously, for they regard it as a main duty to munch human flesh. Their names are Gog and Magog, Anie,

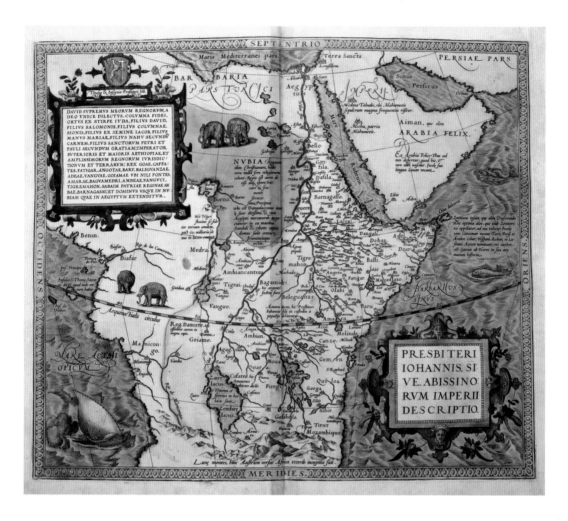

The Empire of Prester John, from Abraham Ortelius, *Theatrum orbis terrarum* (1564), Basel, University Library

Agit, Azenach, Fommeperi, Befari, Conei-Samante, Agrimandri, Vintefolei, Casbei, and Alanei. These and similar nations were shut in behind lofty mountains by Alexander the Great, toward the north. We lead them at our pleasure against our foes, and neither man nor beast is left undevoured, if our Majesty gives the requisite permission. And when all our foes are eaten, then we return with our hosts home again. These accursed fifteen nations will burst forth from the four quarters of the earth at the end of the world, in the times of the Antichrist, and overrun all the abodes of the saints as well as the great city Rome, which, by the way, we are prepared to give to our son who will be born, along with all Italy, Germany, the two Gauls, Britain, and Scotland. We shall also give him Spain and all of the land as far as the icy sea. The nations to which I have alluded, according to the words of the prophet, shall not stand in the judgment on account of their offensive practices, but will be consumed to ashes by a fire that will fall on them from heaven.

Our land streams with honey and is

overflowing with milk. In one region grows no poisonous herb, nor does a querulous frog ever quack in it; no scorpion exists, nor does the serpent glide amongst the grass, nor can any poisonous animals exist in it or injure anyone.

Among the heathen flows, through a certain province, the River Indus; encircling Paradise, it spreads its arms in manifold windings through the entire province. Here are found the emeralds, sapphires, carbuncles, topazes, chrysolites, onyxes, beryls, sardius, and other costly stones. Here grows the plant Assidos which, when worn by anyone, protects him from the evil spirit, forcing it to state its business and name; consequently the foul spirits keep out of the way there. In a certain land subject to us all kinds of pepper is gathered and is exchanged for corn and bread, leather and cloth. . . .

At the foot of Mount Olympus bubbles up a spring which changes its flavor hour by hour, night and day, and the spring is scarcely three days' journey from Paradise, out of which Adam was driven. If anyone has tasted thrice of the fountain, from that day he will feel no fatigue, but will, as long as he lives, be as a man of thirty years. Here are found the small stones called Nudiosi, which, if borne about the body, prevent the sight from waxing feeble and restore it where it is lost. The more the stone is looked at, the keener becomes the sight.

In our territory is a certain waterless sea consisting of tumbling billows of sand never at rest. None have crossed this sea—it lacks water altogether, yet fish of various kinds are cast up upon the beach, very tasty, and the like are nowhere else to be seen.

Three days' journey from this sea are mountains from which rolls down a stony, waterless river which opens into the sandy sea. As soon as the stream reaches the sea, its stones vanish in it and are never seen again. As long as the river is in motion, it cannot be crossed; only four days a week is it possible to traverse it.

Between the sandy sea and the said mountains, in a certain plain, is a fountain of singular virtue, which purges Christians and would-be Christians from all transgressions. The water stands four inches high in a hollow stone shaped like a mussel-shell. Two saintly old men watch by it and ask the comers whether they are Christians or are about to become Christians, then whether they desire healing with all their hearts. If they have answered well, they are bidden to lay aside their clothes and to step into the mussel. If what they said be true, then the water begins to rise and gush over their heads. Thrice does the water thus lift itself, and everyone who has entered the mussel leaves it cured of every complaint.

Near the wilderness trickles between barren mountains a subterranean rill which can only by chance be reached, for only occasionally the earth gapes, and he who would descend must do it with precipitation, ere the earth closes again. All that is gathered under the ground there is gem and precious stone. The brook pours into another river and the inhabitants of the neighborhood obtain thence abundance of precious stones. Yet they never venture to sell them without having first offered them to us for our private use: should we decline them, they are at liberty to dispose of them to strangers. Boys there are trained to remain

three of four days under the water, diving after the stones.

Beyond the stone river are the ten tribes of the Jews, which, though subject to their own kings, are, for all that, tributary to our Majesty.

In one of our lands, [in the torrid zone], are worms called salamanders. These worms can only live in fire, and they build cocoons like silk-worms which are unwound by the ladies of our palace and spun into cloth and dresses, which are worn by our Exaltedness. These dresses, in order to be cleaned and washed, are cast into flames.... When we go to war, we have fourteen golden and bejeweled crosses borne before us instead of banners. Each of these crosses is followed by 10,000 horsemen and 100,000 foot soldiers, fully armed, without reckoning those in charge of the luggage and provision. When we ride abroad plainly we have a wooden, unadorned cross without gold or gem about it, borne before us, in order that we meditate on the sufferings of our Lord Jesus Christ; also a golden bowl filled with earth to remind us of that whence we sprung and that to which we must return; but besides these there is borne a sliver bowl full of gold, as a token to all that we are the Lord of Lords.

All riches, such as are upon the world, our Magnificence possesses in superabundance. With us, no one lies, for he who speaks a lie is thenceforth regarded as dead; he is no more thought of or honored by us. No vice is tolerated by us. Every year we undertake a pilgrimage, with retinue of war, to the body of the holy prophet Daniel, which is near the desolated site of Babylon. In our realm fishes are caught, the blood of which dyes purple. The Amazons and the Brahmins are subject to us.

The palace in which our Supereminency resides is built after the pattern of the castle built by the apostle Thomas for the Indian king Gundoforus.

The Version by John Mandeville

JOHN MANDEVILLE
The Travels of Sir John Mandeville,
XXX

This Prester John hath under him many kings and many isles and many diverse folk of diverse conditions. And this land is full good and rich, but not so rich as is the land of the great Chan [khan]. For the merchants come not thither so commonly for to buy merchandises, as they do in the land of the great Chan, for it is too far to travel to. And on that other part, in the Isle of

Cathay, men find all manner thing that is need to man—cloths of gold, of silk, of spicery and all manner avoirdupois. And therefore, albeit that men have greater cheap in the Isle of Prester John, natheles, men dread the long way and the great perils in the sea in those parts.

For in many places of the sea be great rocks of stones of the adamant, that of his proper nature draweth iron to him. And therefore there pass no ships that have either bonds or nails of iron within them. And if there do, anon the rocks of the adamants draw them to them, that never they may go thence. I myself have seen afar in that sea, as though it had been a great isle full of tree, and buscaylle, full of thorns and briars, great plenty. And the shipmen told us, that all that was of ships that were drawn thither by the adamants, for the iron that was in them. And of the rotten-ness, and other thing that was within the ships, grew such buscaylle, and thorns and briars and green grass, and such manner of thing; and of the masts and the sail-yards; it seemed a great wood or a grove. And such rocks be in many places thereabout. And therefore dare not the merchants pass there, but if they know well the passages, or else that they have good lodesmen....

In the land of Prester John be many diverse things and many precious stones, so great and so large, that men make of them vessels, as platters, dishes and cups. And many other marvels be there, that it were too cumbrous and too long to put it in scripture of books....

In that desert be many wild men, that be hideous to look on; for they be horned, and they speak nought, but they grunt, as pigs. And there is also great plenty of wild hounds. And there

be many popinjays, that they clepe psittakes their language. And they speak of their proper nature, and salute men that go through the deserts, and speak to them as apertly as though it were a man. And they that speak well have a large tongue, and have five toes upon a foot. And there be also of another manner, that have but three toes upon a foot, and they speak not, or but little, for they cannot but cry.

The Account by Álvares

FRANCISCO ÁLVARES
Verdadeira informação das terras do Preste João das Indias
(*A True Relation of the Lands of Prester John of the Indies*, 1540)

And there we saw that Prester John was seated upon a platform reached by six steps, all of it richly decorated. On his head he wore a crown of gold and silver, that is to say one piece in gold and the other in silver, and held a silver cross in his hand, and his face was covered by a piece of blue taffeta, which rose and fell so that at times all of his face could be seen, but was then covered over again. To his right was a page dressed in silk

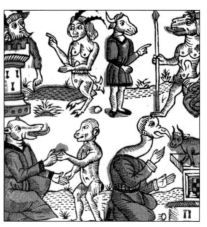

Monstrous creatures from *The Travels of Sir John Mandeville* (fourteenth century)

with a silver cross in his hand, adorned with figures in relief.... He was dressed in a sumptuous garment of gold brocade, and a broad-sleeved silk shirt tied round with a fine cloth of silk and gold, like a bishop's apron, and was sitting in majesty, just as God the Father is depicted in frescoes. In addition to the page holding the cross, on either side there was another page in similar dress, with an unsheathed sword in his hand. With regard to age, coloring and stature, the Prester appears to be young, not very dark, in other words with skin of chestnut brown ... of unexceptional stature and looks to be twenty-three years old. He has a round face, large eyes, an aquiline nose, and his beard was beginning to grow....

In the following days, no one knew which way he might take, but everyone lodged where they saw the white tent erected.... He rode with his crown on his head, surrounded by red curtains. Those who bore these curtains carried them atop thin spears. The Prester is preceded by twenty pages and in front of them six horses, richly adorned, and in front of these horses walk six mules with saddles, also very finely adorned, and each of them is led by four men. And in front of these mules travel twenty gentlemen on other mules, and neither can other people on foot or on horseback come near.

The Testimonial
of Marco Polo

MARCO POLO
The Travels of Marco Polo (1298), I, 46–47

Caracoron is a city of some three miles in compass. (It is surrounded by a strong earthen rampart, for stone is scarce there. And beside it there is a great citadel wherein is a fine palace in which the Governor resides." 'Tis the first city that the Tartars possessed after they issued from their own country. And now I will tell you all about how they first acquired dominion and spread over the world.

Originally the Tartars dwelt in the north on the borders of Chorcha. Their country was one of great plains; and there were no towns or villages in it, but excellent pasture-lands, with great rivers and many sheets of water; in fact it was a very fine and extensive region. But there was no sovereign in the land. They did, however, pay tax and tribute to a great prince who was called in their tongue UNC CAN, the same that we call Prester John, him in fact about whose great dominion all the world talks. The tribute he had of them was one beast out of every ten, and also a tithe of all their other gear. Now it came to pass that the Tartars multiplied exceedingly. And when Prester John saw how great a people they had become, he began to fear that he should have trouble from them. So he made a scheme to distribute them over sundry countries, and sent one of his Barons to carry this out. When the Tartars became aware of this they took it much amiss, and with one consent they left their country and went off across a desert to a distant region toward the north, where Prester John could not get at them to annoy them. Thus they revolted from his authority and paid him tribute no longer. And so things continued for a time.

Now it came to pass in the year of Christ's Incarnation 1187 that the Tartars made them a King whose name was Chinghis Kaan. He was a

From Francisco Álvares,
A True Relation of the
Lands of Prester John
of the Indies (1540),
woodcut

man of great worth, and of great ability (eloquence), and valor. And as soon as the news that he had been chosen King was spread abroad through those countries, all the Tartars in the world came to him and owned him for their Lord. And right well did he maintain the Sovereignty they had given him. What shall I say? The Tartars gathered to him in astonishing multitude, and when he saw such numbers he made a great furniture of spears and arrows and such other arms as they used, and set about the conquest of all those regions till he had conquered eight provinces. When he conquered a province he did no harm to the people or their property, but merely established some of his own men in the country along with a proportion of theirs, whilst he led the remainder to the conquest of other provinces. And when those whom he had conquered became aware how well and safely he

protected them against all others, and how they suffered no ill at his hands, and saw what a noble prince he was, then they joined him heart and soul and became his devoted followers. And when he had thus gathered such a multitude that they seemed to cover the earth, he began to think of conquering a great part of the world. Now in the year of Christ 1200 he sent an embassy to Prester John, and desired to have his daughter to wife. But when Prester John heard that Chinghis Kaan demanded his daughter in marriage he waxed very wroth, and said to the Envoys, "What impudence is this, to ask my daughter to wife! Wist he not well that he was my liegeman and serf? Get ye back to him and tell him that I had liever set my daughter in the fire than give her in marriage to him, and that he deserves death at my hand, rebel and traitor that he is!" So he bade the Envoys begone at once, and never come into his presence again. The Envoys, on receiving this reply, departed straightway, and made haste to their master, and related all that Prester John had ordered them to say, keeping nothing back.

The Byzantine Automaton

LIUTPRAND OF CREMONA
(TENTH CENTURY)
Antapodosis, VI, 5

There stands beside the palace in Constantinople a building of marvelous size and beauty, which is known to the Greeks as *Magnaura*, a name almost equivalent to "magna aura" (strong breeze).... This is how Constantine had the place prepared both for the messengers of the

Spaniards, who had just arrived at that time, and for me and Liutifredo. In front of the emperor's throne stood a tree of bronze, but gilded, with branches filled with a variety of birds also made of gilded bronze, which produced the calls of the different birds according to their species. The emperor's throne was set up in such a way that at one moment it appeared on the ground, then higher up the next moment and immediately afterward at a great height, and it was guarded, so to speak, by huge lions, which might have been of bronze or wood, but were covered in gold. Beating the ground with their tails and with their mouths open, they emitted a roar with their movable tongues. So in this place, I was taken into the presence of the emperor on the shoulders of two eunuchs. And although upon my arrival the lions brought forth a roar and the birds clamored in the different calls of their species, they aroused neither fear nor wonder in me, because I had been informed of all these things by others who were already familiar with them. Having prostrated myself three times in honor of the emperor, I raised my head and having earlier seen him sitting not far from the ground, I then saw him dressed in new clothes and sitting close to the ceiling; how that happened I could not imagine, unless he had been raised up there by a winch.

The Taprobane of Mandeville

JOHN MANDEVILLE
The Travels of Sir John Mandeville,
XXXIII

Toward the east part of Prester John's land is an isle good and great, that

men clepe Taprobane, that is full noble and full fructuous. And the king thereof is full rich, and is under the obeissance of Prester John. And always there they make their king by election. In that isle be two summers and two winters, and men harvest the corn twice a year. And in all the seasons of the year be the gardens flourished. There dwell good folk and reasonable, and many Christian men

amongst them, that be so rich that they wit not what to do with their goods. . . .
Beside that isle, toward the east, be two other isles. And men clepe that one Orille, and that other Argyte, of the which all the land is mine of gold and silver. And those isles be right where that the Red Sea departeth from the sea ocean. And in those isles men see there no stars so clearly as in

Water-pumping system, from al-Jazari, *The Book of Knowledge of Ingenious Mechanical Devices* (1206), Istanbul, Topkapi Palace Museum

other places. For there appear no stars, but only one clear star that men clepe Canapos. And there is not the moon seen in all the lunation, save only the second quarter.

In the isle also of this Taprobane be great hills of gold, that pismires keep full diligently. And they fine the pured gold, and cast away the un-pured. And these pismires be great as hounds, so that no man dare come to those hills for the pismires would as-sail them and devour them anon. So that no man may get of that gold, but by great sleight. And therefore when it is great heat, the pismires rest them in the earth, from prime of the day into noon. And then the folk of the country take camels, dromedaries, and horses and other beasts, and go thither, and charge them in all haste that they may; and after that, they flee away in all haste that the beasts may go, or the pismires come out of the earth. And in other times, when it is not so hot, and that the pismires ne rest them not in the earth, then they get gold by this subtlety. They take mares that have young colts or foals, and lay upon the mares void vessels made there-for; and they be all open above, and hanging low to the earth. And then they send forth those mares for to pasture about those hills, and with-hold the foals with them at home. And when the pismires see those vessels, they leap in anon: and they have this kind that they let noth-ing be empty among them, but anon they fill it, be it what manner of thing that it be; and so they fill those vessels with gold. And when that the folk sup-pose that the vessels be full, they put forth anon the young foals, and make them to neigh after their dams. And then anon the mares return toward

their foals with their charges of gold. And then men discharges them, and get gold enough by this subtlety. For the pismires will suffer beasts to go and pasture amongst them, but no man in no wise.

The Sepulchre of Adam in Ceylon

ARTURO GRAF

"The Myth of the Earthly Paradise" III, in *Miti, leggende e superstizioni del Medio Evo* (*Myths, Legends and Superstitions of the Middle Ages*, 1892–1893)

According to another opinion that was extremely widely held in both East and West and still persists in the East, Adam and Eve passed the years of their exile on the island of Serendib, or Ceylon. This belief is without doubt of Mohammedan ori-gin, or rather it is a Buddhist belief transformed by the Mohammedans; so the Buddhists believed, and still believe, that the Buddha stayed for some time on a mountain on the is-land of Ceylon, which is known as Langka to the Brahmins of the main-land; that there he lived a contempla-tive life; and that on subsequently as-cending to heaven, he left in the rock the imprint of his foot, for all to see. The Mohammedans, by a process that is very common in the history of legends, transferred accounts of the Buddha to Adam, and the two tradi-tions continued to exist side by side. A curious testament to this is offered by Marco Polo in the account of his travels. He says that on the island of Ceylon, on the peak of a high moun-tain that can be reached only with

the aid of chains, stands a tomb, which is Adam's tomb, according to the Saracens, and according to the idolatrists (by which he means the Buddhists) is the tomb of Sergamon Borcam. The subsequent account shows that this Sergamon is none other than the Buddha, who was subject, as we know, to another similar transformation, becoming Saint Josaphat of the Christian legend. The Arabs called the mountain Rahud, and the first of their writers to have made mention of the legend appears to have been Suleyman. Edrisi, who wrote his geographical treatise at the court of Roger II of Sicily in 1154, and who claims, among many other things, to have visited the cave of the Seven Sleepers at Ephesus, and to have seen their bodies amid the aloe, myrrh, and camphor, whether dead or sleeping again it is unclear, recounts the legend of the mountain, which he calls el-Rahuk. According to his account, the Brahmins say the footprint of Adam is to be found at the summit of the mountain, and that it is seventy cubits long and luminous. From that point, with one stride, Adam reached the sea, which lies two or three days' journey away. The Mohammedans also say that Adam, having been banished from Paradise, fell onto the island of Serendip, and there he died, after undertaking a pilgrimage to the place where Mecca would later stand. A description of the mountain can also be found in the travels of Ibn-Battuta. The legend transferred from the East to the West and from the Mohammedans to the Christians; and the mountain in Ceylon, which was later called Pico de Adam by the Portuguese, became famous.

Eutychius, Patriarch of Alexandria (d. 940) says only that Adam was banished to a mountain in India, but the mountain in question is still the mountain in Ceylon. Odoric of Pordenone describes it succinctly, writing that at its summit was a lake formed, according to the island's inhabitants, from the tears cried by Adam and Eve over the death of Abel. Giovanni de' Marignolli gives a more detailed and explicit account. The Angel of the Lord took Adam and placed him on the mountain in Ceylon, and Adam's footprint remained miraculously imprinted in the marble, measuring two and a half spans in length. Atop another mountain, four short days' travel away from the first, the Angel placed Eve, and the two sinners were left apart, caught up in their mourning, for forty days, after which the angel led Eve to Adam, who by then was in despair. On the first mountain, alongside the footprint, were to be found a statue of a seated figure, with its right hand extended to the West; Adam's house; a spring of the purest water, which was thought to come from Paradise, and which contained gems, formed, according to the opinion of the island's inhabitants, by Adam's tears; and a garden full of trees that bore excellent fruit. Many pilgrims visited this holy place. In the late seventeenth century, Vincenzo Coronelli was still stating that Adam was buried on the summit of the mountain, and that a lake formed from the tears shed by Eve over Abel's death could be seen there. This last claim contradicted another belief, which does not seem, however, to have been very widespread. Burchard of Mount Sion, whom we

Anonymous,
Adam's Peak (1750),
engraving

have already mentioned, says that on the side of a mountain in the Valley of Hebron was the cave where Adam and Eve cried for a hundred years over the death of Abel, and that the beds on which they slept could still be seen, as well as the spring from which they drank the waters. So while Adam's tomb was believed to lie at the summit of the mountain in Ceylon, it was also placed in many other locations.

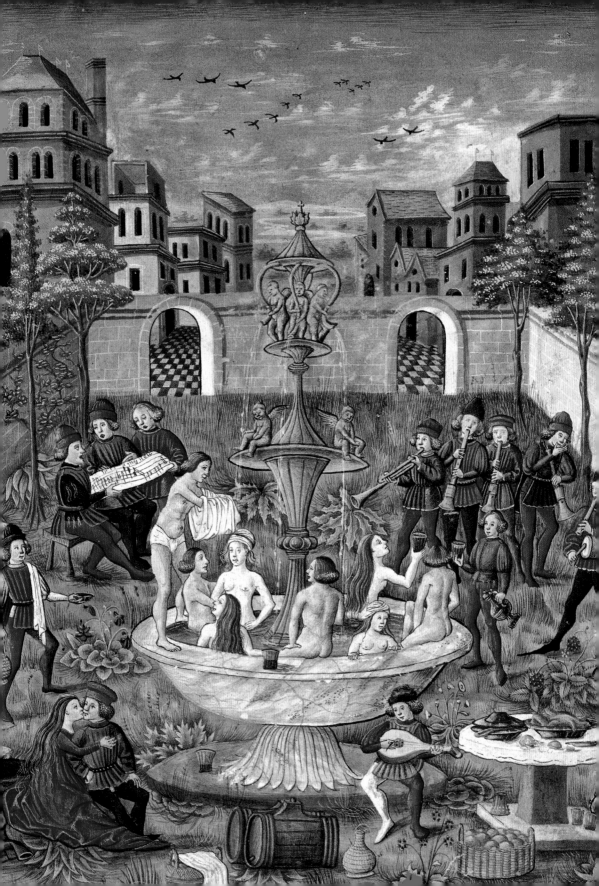

5.

THE EARTHLY PARADISE, THE ISLES OF THE BLESSED, AND EL DORADO

Left:
Lombard School,
De sphaera: Il giardino dell'amore, o hortus con la fontana della giovinezza (fifteenth century),
Ms. Lat. 209 DX2 14 c.10r,
Modena, Biblioteca estense universitaria

Right:
Jacob de Backer,
The Garden of Eden (c. 1580),
Bruges, Groeningemuseum

The Earthly Paradise was one of the wonders of the Orient. In Judeo-Christian culture, the <u>Bible</u> tells us of the Earthly Paradise when, in <u>Genesis</u> (3:24), we read the story of the place of delights in which Adam and Eve had lived and of the way in which they were exiled after committing original sin: God "drove out the man; and he placed at the east of the garden of Eden Cherubims, and a flaming sword which turned every way, to keep the way of the tree of life." After this the Earthly Paradise became a place of nostalgia, which all would like to rediscover but which remains the object of an endless search.

This dream of a place where at the beginning of the world one lived in a state of bliss and innocence, then lost, is common to many religions and is often represented as a kind of anteroom of the Celestial Paradise.

Anonymous, *Jain
Cosmological Map*
(c. 1890), gouache
on canvas, Washington
D.C., Library of Congress

In Jainism, Hinduism, and Buddhism, there is talk of a
Mount Meru, from which four rivers spring (as in the biblical Paradise
four rivers spring: the Pison, Gihon, Tigris, and Euphrates) and on
which stands the abode of the gods and man's ancient homeland. In
the *Mahabharata*, the god Indra builds the moving city of Indra Loka,
which has much in common with the Garden of Eden.

In Taoist legend (Lieh-tzu's *Treatise on Perfect Emptiness*,
c. 300 BC), there is a mention of a dream of a wonderful place where
there are neither chiefs nor subjects and everything happens with
natural spontaneity. The inhabitants go into the water without
drowning, whipping them leaves no wound, and they rise into the air
as if walking on the ground. A happy age is also mentioned in Egyptian
myths, in which perhaps for the first time there appears the dream of
the Garden of the Hesperides. The paradise of the Sumerians was
called Dilmun, and in that place there was neither illness nor death.

Lucas Cranach the Elder,
The Golden Age (c. 1530),
Munich, Alte Pinakothek

Paolo Fiammingo,
*Love in the Golden
Age* (1585), Vienna,
Kunsthistorisches Museum

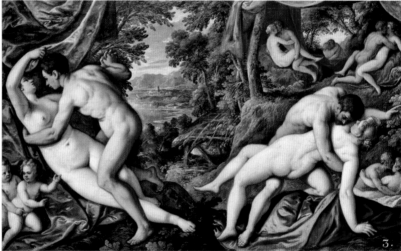

The Kunlun Mountains were the place of the Earthly Paradise for Taoists. Both Chinese and Japanese mythology mention Mount Penglai (which various legends locate in different places), where there was no pain or winter and great bowls of rice and wine were never empty, while magical fruits could heal all illnesses and, naturally, people enjoyed eternal youth. The Greeks and the Latins told fabulous tales of a Golden Age and the heavenly realms of Cronus and Saturn (where, according to <u>Hesiod</u>, men lived without worries and, while

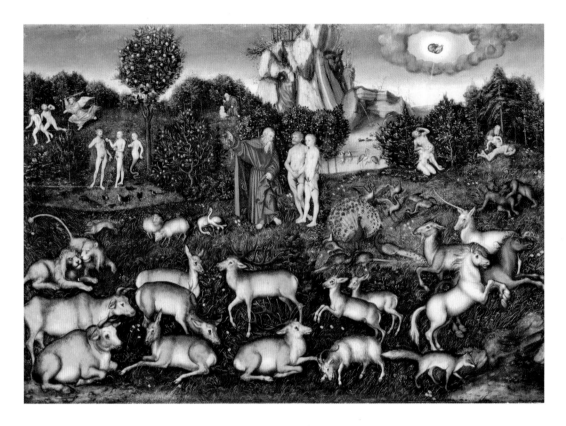

Lucas Cranach the Elder, *The Garden of Eden* (detail, 1530), Dresden, Gemäldegalerie Alte Meister

remaining eternally young, were nourished by the earth itself without having to do any work and they died as if overtaken by sleep).

In Pindar's time, the notion of the Isles of the Blessed had already emerged (destined to be developed in the Middle Ages and beyond) as a place where just men had already gone through three earthly incarnations, while in both Homer and Virgil, we find descriptions of the Elysian Fields where the blessed live. And Horace mentions this precisely with reference to the anxieties of Roman society after the civil wars, as an escape from an unpleasant reality.

In the Koran, the characteristics of the Celestial Paradise seem similar to those of the various earthly paradises of the Western tradition: the blessed live in gardens of delights, among beautiful young girls and abundant fruits and drinks. And this image of the paradisiacal garden inspired the wonderful Islamic architecture of gardens, cool places with the gurgling sound of gushing waters.

In short, it seems that every culture—because the world of

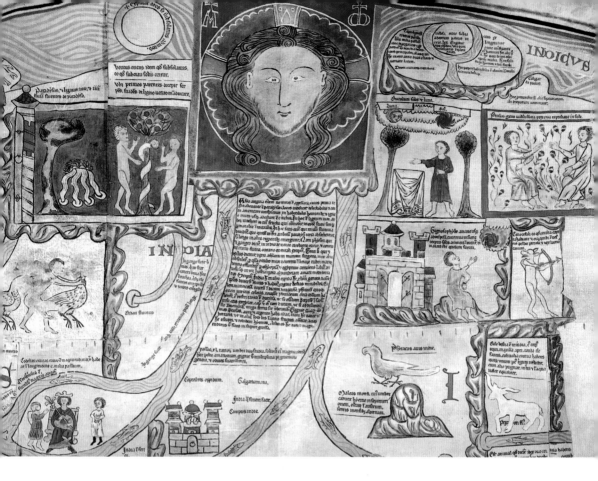

Gervase of Ebsdorf,
The Earthly Paradise
(c.1234), detail from
the *Mappa Mundi*

everyday reality was often cruel and hard to live in—dreams of a happy land to which men once belonged, and may one day return. As Arturo Graf (1892-93) points out in his classic study of the Earthly Paradise, some scholars even suggested that the Eden myth echoed "the hazy memory of an ancient social condition, before the establishment of land ownership."

But let us come back to the biblical Eden. Right from the start, tradition had it that it lay in the East, in fact in the farthest East, where the sun rises. Nonetheless, its location was not devoid of ambiguity, for this East did not have the air of being so far distant, given that the garden was the source of four rivers, two of which were the Tigris and the Euphrates, which flow through Mesopotamia, and hence are almost at the center and not the extreme periphery of the world. But since the Tigris and the Euphrates could have sprung from very distant lands, medieval maps placed the Garden of Eden in a vague and remote India (see the texts from <u>Augustine</u> and <u>Isidore of Seville</u>).

Jacopo Bassano,
The Earthly Paradise
(1573), Rome,
Galleria Doria
Pamphilj

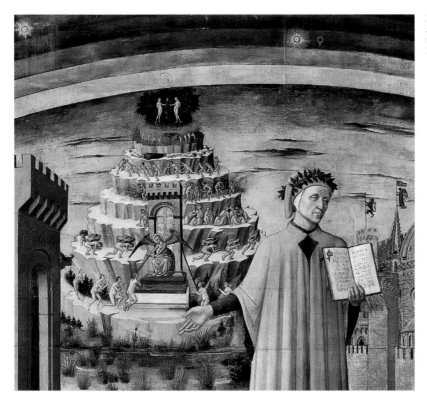

Domenico di Michelino,
Dante and His Poem (detail,
fifteenth century), Florence,
Duomo

In one of his maps, Cosmas Indicopleustes, whose dubious geography we have already discussed, shows the lands beyond the ocean, and therefore beyond the known world, where men supposedly lived before the Flood and where the Earthly Paradise supposedly still stood. Most medieval maps (see for example the *Silos Apocalypse*) place Paradise within the circle of the ocean, but in the fourteenth century, the Hereford *Mappa mundi* shows it as a circular island on the boundaries of the inhabited world. Dante, instead, placed it on the summit of the Mount of Purgatory and hence in a hemisphere unknown to the men of his day.

Others, again, were to place it in lands identified with Atlantis (but we shall be talking about that vanished continent later) and in the Isles of the Blessed. As for Mandeville, who usually has a penchant for astonishing descriptions, this time our storyteller, faced with the mystery of Eden, confesses—at least for once—that he has never seen it.

Athanasius Kircher,
*Topographia Paradisis
Terrestris* (1675),
from *Arca Noe*

Giovanni dei Marignolli, who in the fourteenth century had been on a mission to the lands of the great khan of the Tartars, says in his *Chronicon* that Paradise lies forty miles from the island of Ceylon, from where you could supposedly hear the sound of its falling waters—and in fact according to many, the waters of the rivers of Paradise fell from such a height that the roar deafened all the inhabitants of neighboring regions.

The Garden of Eden was visited in many *visions*, texts that tell of personages who in dream or in reality went to the next world and therefore saw the Garden. There are diverse such visions, and many of them came before Dante Alighieri's extramundane journey. These are the *Vita di san Macario romano*, the *Viaggio di tre santi monaci al paradiso terrestre*, the *Vision of Thurkill*, the *Vision of Tundale*, and the *The Treatise on St. Patrick's Purgatory*. The latter is the legend of the well of Saint Patrick, whereby Sir Owain (in Ireland) first visits the place where the damned are tormented and then arrives in the Garden of Eden in

153

which the good live—in the process of overcoming the pains of purification—and blissfully await access to the Celestial Paradise.

From Tertullian to the Schoolmen, there had been lengthy debate as to whether Paradise lay in the torrid zones, and hence far from the known world, or in temperate zones that could grant it the mild climate it enjoyed. In general, the theory of a temperate zone won the day, and Aquinas supported this opinion (in question 102 of the first part of the *Summa Theologica*): "Those who say that paradise was on the equinoctial line are of opinion that such a situation is most temperate, on account of the unvarying equality of day and night; that it is never too cold there, because the sun is never too far off; and never too hot, because, although the sun passes over the heads of the inhabitants, it does not remain long in that position. However, Aristotle distinctly says that such a region is uninhabitable on account of the heat. . . . This seems to be more probable; because, even those regions where the sun does not pass vertically overhead, are extremely hot on account of the mere proximity of the sun. But whatever be the truth of the matter, we must hold that paradise was situated in a most temperate situation, whether on the equator or elsewhere."

In any case, it was believed that Eden stood in a very high position, because only that way could it have survived the Flood—and we shall be seeing the curious conclusions that Christopher Columbus later drew from this opinion. And in order to find the highest place of all, Ludovico Ariosto, in his *Orlando furioso*, free of theological concerns, was to take Astolfo astride a hippogryph to an Earthly Paradise that lies on the route to the moon.

SAINT BRENDAN'S ISLE A second tradition located the Earthly Paradise in the West and much farther north. This tradition springs from or is reinforced by an eleventh-century text, the *Navigatio Sancti Brendani* (Voyage of Saint Brendan). This Irish monk, who lived around the sixth century, set sail westward aboard a flimsy curragh (a boat with a wooden frame covered by thin layers of hide), and legend has it that on such vessels Irish monks traveled as far as America or that they rediscovered Atlantis.

Saint Brendan's Isle, in map by Pierre Desceliers (1546), University of Manchester Library

Saint Brendan and his mystical mariners came across many islands—the island of birds: the island of Hell, the one reduced to a rock on which Judas was chained; and a fake island that had already fooled Sinbad, on which Brendan's boat landed. Only after one day, on lighting fires, did his crew see that the island was irritated and realize that it wasn't an island but a terrifying sea monster called Jasconius.

But what fired the imagination of posterity was the Isle of the Blessed, a place of every delight and sweetness, where our sailors arrived after seven years of vicissitudes.[1]

The Isle of the Blessed could not fail to create an irrepressible desire, and so throughout the Middle Ages and into the Renaissance, people firmly believed in its existence. It appears on the Ebstorf Map, as well as on one made by Paolo Toscanelli del Pozzo for the king of Portugal. Sometimes it is on the latitude of Ireland; in more modern maps, it descends southward, on a level with the Canary Islands, or the Fortunate Isles, and often these latter islands were confused with the island known as Saint Brendan's Isle. Sometimes it is

1. *Saint Brendan does not speak of the Earthly Paradise explicitly, but of a "promised land of the saints," while the island was understood in various popularized medieval texts to be the Earthly Paradise. See Scafi (2006, pages 41–42 of the Italian edition).*

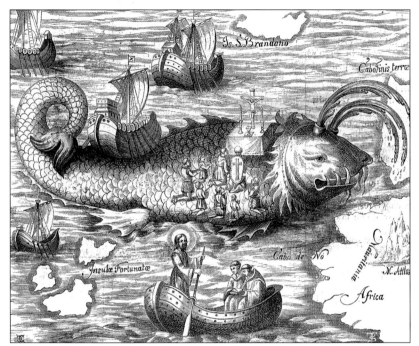

Anonymous, *Jasconius Mistaken for an Island* (1621), print

identified with the Madeira group and sometimes with a nonexistent island such as the legendary Antilia, and this is the case with the *Arte de navegar* by Pedro de Medina in the sixteenth century. On Martin Behaim's globe (1492), the island was situated far more to the west and near the equator. And it had already been dubbed Perdita, the Lost Island. In his *De imagine mundi,* Honorius of Autun had described it as the most pleasant of islands: "There is a certain island of the Ocean called Perdita, and it excels all the lands of the earth in beauty and fertility of all things. Found once by chance, it was later sought again and not found, whence it is called Perdita." In the fourteenth century, Pierre Bersuire talks in the same terms of the Fortunate Isles, so called because "only by chance and fortune are they sometimes found, but then if you want to find them again they cannot be found again."

The Lost Island, never rediscovered, was sought by many, especially after the discovery of Cape of Good Hope and America had triggered the fever of exploration; some claimed at least to have located its position, and so, in 1519, when Emmanuel I of Portugal gave up in favor of Spain (with the Treaty of Evora) all his rights to the Canary

Islands, the Lost or Concealed Island was expressly included in the renunciation. In 1569 Gerardus Mercator still included it in his map.

The one who expressed in a contemporary fashion the sense of nostalgia for the Lost Island was Guido Gozzano.[2]

PARADISE IN THE NEW WORLD The end of the Middle Ages is made to coincide, by what is an established convention by now, with the discovery of America in 1492, and so Columbus is seen as the first man of the modern world. In fact, a popular belief that refuses to die holds that he was the first to maintain, against general hostility, that the world was round. This is nonsense because—as we have seen in chapter 1—the Greeks already knew this and it was accepted (at least by learned men) by medieval culture. Columbus believed that the world was round and, like everyone in his day, he believed it lay motionless at the center of the universe, given that Copernicus's heliocentric theory was to be published in *De revolutionibus orbium coelestium* more than fifty years after the discovery of America. But Columbus's calculations of the dimensions of the Earth were wrong, and his opponents were right when they maintained that the distance from Spain and the first extensions of the East, which Columbus wanted to reach via the West, was too great to be covered (naturally, neither they nor Columbus supposed that the American continents lay in that expanse of ocean).

In reality, the first protagonist of modernity was one of the last personalities of the Middle Ages and obviously a person inclined to a literal interpretation of Scripture. One of Columbus's fixations in his attempt to reach what he believed was the Far East was that of rediscovering the Earthly Paradise.

A book that had influenced him profoundly was the *Imago mundi* by Cardinal Pierre d'Ailly (and we still possess Columbus's personal copy with his handwritten notes in the margin), in which the commonplaces of the Garden of Eden are repeated. On several occasions in his ship's log, Columbus thought he could identify territories, covered in forests with a wealth of fruit and inhabited by multicolored birds, with the promised land. Not only this, but convinced that this

2. *See the passage in the anthology in chapter 12 on the Terra Australis.*

land lay at an altitude sufficiently high to be able to touch the sky, he informed the Spanish royals of the amazing theory that the world was not entirely round but, in the part he had discovered, it lengthened into the form of a pear.

After Columbus, the theory of an earthly paradise in American territory was picked up again by Antonio de León Pinelo (1556) in his *Paraíso en el Nuevo Mundo* (Paradise in the New World). The discovery of the New World had led to the birth of a huge debate over the origins of the American people, and many had backed the theory of an emigration on the part of Noah's descendants. But Pinelo did not believe that the Amerindians came from the Mediterranean; quite the contrary: they lived on the continent before the Flood; over there Noah had built the ark that, being conceived as a galley weighing 28,125 tons, could have crossed the ocean and reached Mount Ararat in Armenia. The voyage supposedly lasted from November 1625 to November 1626 (dates calculated since the beginning of the world), starting from the Andean Cordillera, entering the Asian continent near China, reaching the Ganges, down to Armenia, for 3,605 leagues. From all this, the intended conclusion was that the Earthly Paradise lay in the New World, and Pinelo showed that the four rivers that flow from the Earthly Paradise were not those mentioned in the Bible but the Rio de la Plata, the Amazon, the Orinoco, and the Magdalena.

In fact, nevertheless, it seems that from that moment onward, no one looked for the Earthly Paradise in the new continents anymore. Vespucci, more prudent than Columbus, had merely observed that a certain very fertile land "seemed" like the Earthly Paradise, without committing himself any further.

PARADISE IN PALESTINE In preceding epochs, Paradise had been sought in Africa and Asia. In his *Traité de la situation du paradis terrestre* (Treatise on the Location of the Earthly Paradise) of 1691, Pierre-Daniel Huet had taken into consideration, with some skepticism, all hypotheses, including the fairly odd one that located Eden in the city of Hédin in Artois, on account of the similarity of the names Hédin and Eden. But all in all, he tended to favor Mesopotamia, in particular the

west bank of the Tigris, and he enclosed a minutely detailed map of the various places along with his book.

Dom Augustin Calmet (1706), in his commentary on the books of the Old and New Testaments, said it was in Armenia.

But the most fascinating theory has to be that of placing Eden in the one true promised land, in other words in Palestine. For example, Isaac de la Peyrère (1665) in his *Preadamitae*, having calculated that the Eastern chronologies dated the origin of the world much further back than the Bible had done, had concluded from this that the creation of Adam and then the coming of Christ concerned only the Middle Eastern area, whereas in other lands, things had gone differently and many millennia before. Hence it was pointless to locate the Earthly Paradise in distant lands where people had other things to do, and that research should be limited to the area between Egypt and the Euphrates.

Believing Eden lay in places never before visited made it possible to think that it was very extensive, but if it was in the Middle East, how could it be so small, hedged in by the desert and the sea? If Adam had not sinned, Eden would have had to accommodate all of future humanity, and seeing that the Lord had commanded the first men to multiply, where would Adam's descendants have lived when their number

Frontispiece to Pierre-Daniel Huet's *Treatise on the Position of the Earthly Paradise* (1691), Paris

had grown beyond measure? Would they have been driven out of Eden? Such big problems had taken up pages and pages of discussions on Holy Writ.

Later, and by way of proof of the power of myth, Eden was to reappear in Africa, and Alessandro Scafi (2006) in his monumental history *Mapping Paradise* tells us that (in the middle of the nineteenth century) even Doctor Livingstone, more of a missionary than an explorer,

was convinced that when he went to seek the source of the Nile, if he found it, he would have also found the Earthly Paradise.

E L D O R A D O But the Middle East did not seem to be so profuse in natural riches, and the desire for a better land than the one people were condemned to live in drew utopians, explorers, and adventurers to the New World. And so another legend began to gain ground, that of a secular Eden, El Dorado.

We should point out that in many earthly paradises, the inhabitants lived forever, and many accounts cited a fountain of eternal youth. In the past, Herodotus had mentioned an underground spring in Ethiopia (it was believed that the Ethiopians and the inhabitants of central Africa in general were very long-lived), but successive legends speak of a spring in the Garden of Eden that not only healed all ills but rejuvenated those who bathed in it. In the *Romance of Alexander,* there is mention of the Water of Life, a mythical fountain that could be found only after crossing the "Dark Lands" of Abkhazia, and Arab sources also dealt with Alexander's adventures.

The miraculous fountain is mentioned in numerous Chinese legends, and in a Korean popular fable, two poor peasants discover it by chance: on drinking a mouthful, they instantly become young again. This myth survived throughout the Middle Ages, only to move on to America. There, Juan Ponce de León became the apostle of the fountain of eternal youth. He was on the ships that, with Christopher Columbus, had reached the island of Hispaniola (now Haiti). Here, the Indians had told him that on an island there existed a fountain capable of restoring youth. But the location of the island was approximate and ranged from the northern coast of South America and across the Caribbean as far as Florida. Between 1512 and 1513, Ponce de León had sailed to those places in vain and did so again until 1521, when he was apparently hit by an Indian arrow off the Florida coast, then perished from infection in Cuba.

But the myth of the fountain did not die with Ponce de León, and the Englishman Walter Raleigh (1596) undertook various explorations to identify this El Dorado.

Murshid al-Shirazi,
folio from Nezami, *Khamseh*
(1548), showing Khizr and
Ilyas (Elias) at the fountain
of life, Washington D.C.,
Smithsonian Libraries

Pages 162-3:
Nicolas Poussin, *Spring; or,
The Earthly Paradise* (1660–
1664), Paris, Louvre

By the time the search for El Dorado no longer seduced any-
one, the topic was picked up again in an ironic key, in the spirit of a
criticism of our world, by Voltaire in *Candide*.

The location of the fountain gave rise to many fantasies
about the *hortus conclusus*, closed as Eden was after Adam's expulsion
but still full of delights. And the echo of the Eden myth, by now trans-
formed into a sensual and diabolical pagan fable, is found for example
in the description of the garden in which the sorceress Armida holds
Rinaldo prisoner in the coils of her amorous wiles in Torquato Tasso's
Jerusalem Delivered.

But here we are invading the territory of fictional imaginary
places, which we shall be dealing with in the final chapter.

The Beginning

Genesis, II, 7–15, III, 23–24
(King James Version)

And the Lord God formed man of the dust of the ground, and breathed into his nostrils the breath of life; and man became a living soul.

And the Lord God planted a garden eastward in Eden; and there he put the man whom he had formed. And out of the ground made the Lord God to grow every tree that is pleasant to the sight, and good for food; the tree of life also in the midst of the garden, and the tree of knowledge of good and evil. And a river went out of Eden to water the garden; and from thence it was parted, and be-

came into four heads. The name of the first is Pison: that is it which compasseth the whole land of Havilah, where there is gold; and the gold of that land is good: there is bdellium and the onyx stone. And the name of the second river is Gihon: the same is it that compasseth the whole land of Ethiopia. And the name of the third river is Hiddekel: that is it which goeth toward the east of Assyria. And the fourth river is Euphrates. And the Lord God took the man, and put him into the garden of Eden to dress it and to keep it.

Therefore the Lord God sent him forth from the garden of Eden, to till the ground from whence he was taken. So he drove out the man; and he placed at the east of the garden of Eden

Jean-Auguste-Dominique Ingres, *The Golden Age* (1862), Cambridge, Fogg Museum

Anonymous, *Scene of the Elysian Fields, in Homage to the Deceased Girl Octavia Paolina* (third century), detail with Hermes the psychopomp, the deceased girl, and children picking roses, fresco on plaster, from the Hypogeum of the Octavians, Rome, Museo Nazionale Romano (Palazzo Massimo alle Terme)

Cherubims, and a flaming sword which turned every way, to keep the way of the tree of life.

The Golden Age

HESIOD
(LATE EIGHTH CENTURY BC)
Works and Days, II, 109–126

First of all the deathless gods who dwell on Olympus made a golden race of mortal men who lived in the time of Cronos when he was reigning in heaven. And they lived like gods without sorrow of heart, remote and free from toil and grief: miserable age rested not on them; but with legs and arms never failing they made merry with feasting beyond the reach of all evils. When they died, it was as though they were overcome with sleep, and they had all good things; for the fruitful earth unforced bare them fruit abundantly and without stint. They dwelt in ease and peace upon their lands with many good things, rich in flocks and loved by the blessed gods.

The Elysian Fields

VIRGIL (70–19 BC)
The *Aeneid*, VI, 632–648

. . . and thro' the gloomy shades they pass'd,
And chose the middle path. Arriv'd at last,
The prince with living water sprinkled o'er
His limbs and body; then approach'd the door,
Possess'd the porch, and on the front above
He fix'd the fatal bough requir'd by Pluto's love.
These holy rites perform'd, they took their way
Where long extended plains of pleasure lay:
The verdant fields with those of heav'n may vie,
With ether vested, and a purple sky;
The blissful seats of happy souls below.
Stars of their own, and their own suns, they know;
Their airy limbs in sports they exercise,

*Mohammed Visiting the
Earthly Paradise*, from
the Turkish manuscript
Miraj Nameh (fifteenth
century) by Mir Haydar,
Paris, Bibliothèque
nationale de France

And on the green contend the wres-
tler's prize.
Some in heroic verse divinely sing;
Others in artful measures lead the ring.
The Thracian bard, surrounded by the
rest,
There stands conspicuous in his flow-
ing vest;
His flying fingers, and harmonious
quill,
Strikes sev'n distinguish'd notes, and
sev'n at once they fill.

The Paradise of the Koran

Koran, XLVII, 15

The similitude of Paradise which is
promised to the pious—in it are rivers of
water without corruption, and rivers of
milk, the taste whereof changes not,
and rivers of wine delicious to those
who drink; and rivers of honey clari-
fied; and there shall they have all kinds
of fruit and forgiveness from their Lord!

The Paradise of Saint Augustine

SAINT AUGUSTINE
The Literal Meaning of Genesis, VIII

I am well aware that many authors
have written a great deal on the subject
of paradise: however, there are three
opinions, let us call them, that are the
most widely held on this subject. The
first is held by those who wish to un-
derstand "paradise" only in the literal
sense; the second is held by those who
understand it only in an allegorical
sense; the third is held by those who
take "paradise" in both senses: in other
words sometimes in a literal sense and

sometimes in an allegorical sense. To
put in briefly, therefore, I confess that
my preference lies with the third opin-
ion.... In consequence the paradise
where God placed man must also be
considered to be none other than a
place, in other words a region, in which
an earthly man could live....
On the subject of these rivers, why
should I try any harder to confirm that
they are real rivers rather than figura-
tive expressions, as if they were not real-
ities but only names signifying some
other reality, given that they are very
well known in the lands through which
they flow, and are known to almost all
peoples? It can therefore be established
that these rivers truly exist: antiquity
has changed the names of two of them,
as [was the case] with the river now
known as the Tiber, whereas it was once
called the Albula; the Gihon is in fact the
same river that is now called the Nile;
the river that is now called the Ganges,
meanwhile, was called the Pishon; the
other two, the Tigris and the Euphrates,
on the other hand, have kept their names
to this day....

The Paradise of Isidore

ISIDORE OF SEVILLE
Etymologies, XIV, 3, 2–4

Paradise is located in the east. Its
name, translated from Greek into
Latin, means "garden." In Hebrew in
turn it is called Eden, which in our
language means "delights." The com-
bination of both names gives us the
expression "garden of delights," for ev-
ery kind of fruit-tree and non-fruit
bearing tree is found in this place, in-
cluding the tree of life. It does not

grow cold or hot there, but the air is always temperate.

A spring which bursts forth in the center irrigates the whole grove and it is divided into the headwaters of four rivers. Access to this location was blocked off after the fall of humankind, for it is fenced in on all sides by a flaming sword, that is, encircled by a wall of fire, so that the flames almost reach the sky.

Also the Cherubim, that is, a garrison of angels, have been drawn up above the flaming sword to prevent evil spirit from approaching, so that the flames drive off human beings, and angels drive off the wicked angels, in order that access to Paradise may not lie open either to flesh or to spirits that have transgressed.

The Paradise of Mandeville

JOHN MANDEVILLE
The Travels of Sir John Mandeville,
XXXIII

Paradise terrestrial, as wise men say, is the highest place of earth, that is in all the world. And it is so high that it toucheth nigh to the circle of the moon, there as the moon maketh her turn; for she is so high that the flood of Noah ne might not come to her, that would have covered all the earth of the world all about and above and beneath, save Paradise only alone. And this Paradise is enclosed all about with a wall, and men wit not whereof it is; for the walls be covered all over with moss, as it seemeth. And it seemeth not that the wall is stone of nature, ne of none other thing that the wall is. And that wall stretcheth from the south to the north, and it hath not but one entry that is

closed with fire, burning; so that no man that is mortal ne dare not enter. . . . For by land no man may go for wild beasts that be in the deserts, and for the high mountains and great huge rocks that no man may pass by, for the dark places that be there, and that many. And by the rivers may no man go. For the water runneth so rudely and so sharply, because that it cometh down so outrageously from the high places above, that it runneth in so great waves, that no ship may not row ne sail against it. And the water roareth so, and maketh so huge noise and so great tempest, that no man may hear other in the ship, though he cried with all the craft that he could in the highest voice that he might.

The Vision of Thurcill

MATTHEW PARIS
(C. 1200–1259)
Chronica majora, II, 4 (1840)

Thurcill and his guides soon proceeded toward the plain stretching off to the east of the temple, and arrived in a delightful place, sprinkled with the most varied flowers; the plants, trees, and fruits exuded sweet fragrances. This place was watered by a clear spring that gave rise to four streams of different substance and color. Above this spring was a superb tree with immense boughs, standing to a prodigious height. This tree was abundantly laden with fruits of all kinds that delighted the senses of smell and sight. Beneath the tree, by the fountain, stood a man of fine and gigantic stature, dressed from his feet to his breast in a tunic of many colors, woven with infinite skill. With one eye he seemed to laugh, and

Anonymous,
Fall from Paradise,
In Clm 15709, fol.171v,
Munich, Bayerische
Staatsbibliothek

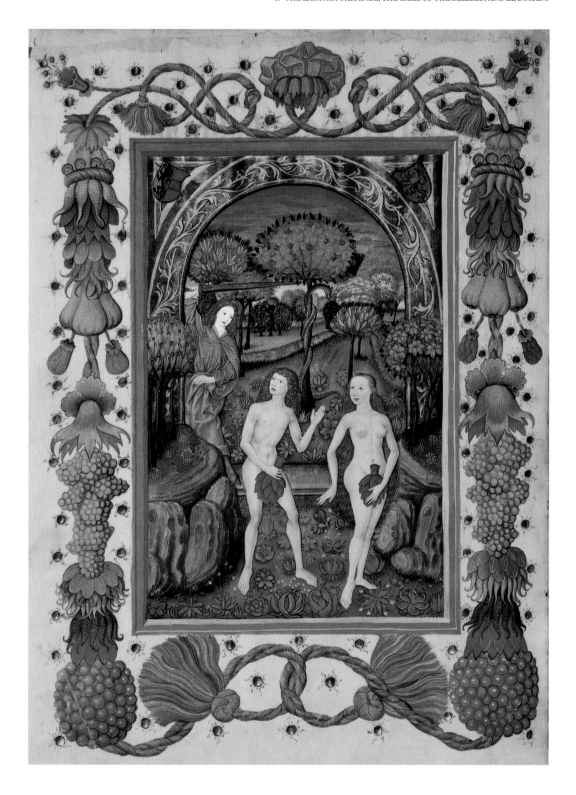

with the other he seemed to cry. "You see," said Saint Michael, "the first father of the human race, Adam: by laughing with one eye he shows the joy he feels for the ineffable glorification of those of his children who are to be saved; and by crying with the other he shows the grief caused to him by those of his children who must be turned away and damned by the judgment of the Lord of Justice. The robe he wears does not yet form a complete tunic: it is the robe of immortality and glory that was stripped from him for his first disobedience. But from the time of Abel, the righteous son among his children, to the present day, this robe has been remade by the successive generations of the righteous. And as these chosen ones have shone with different virtues, so the robe has been made up of different colors. When the number of the chosen ones is complete, the robe of glory and immortality will be completed too; and then the world will end."

Saint Patrick's Well

HENRY OF SALTREY
A Treatise on Saint Patrick's Purgatory, IX, 54–56 (c. 1190)

He saw before him a certain great wall rising high into the air. The wall was furthermore miraculous, and built with incomparable beauty, and within it he saw a closed gate, which shone with an enchanting radiance, adorned with various precious metals and stones. As he was approaching, but was still half a mile away, the gate was opened toward him, and through it came forth a perfume of such sweetness that it seemed to him that if all the world had been transformed into fra-

grances, it would not have been able to exceed the splendor of such delicacy, and from it he received such strength that at that time he believed he could bear without injury all the torments he had already overcome.

Looking through the gate, he saw a land illuminated by a great light, which outshone the brilliance of the sun, and was taken with a great desire to go in. . . . The land was truly illuminated by a light of such brightness that just as the light of a lamp is canceled out by the brilliance of the sun, in the same way it would seem that the midday sun could be overcome by the amazing radiance of the light of that land. Furthermore, the land was so vast that he could see no boundary to it, except in the region where he had passed through the gate. The land was also adorned with pleasant fields filled with different species of flowers and fruit trees, manifold herbs and woody plants whose perfume, as he later said, could have sustained him for eternity.

Astolfo in the Earthly Paradise

LUDOVICO ARIOSTO
Orlando furioso XXXIV, 51–55

In the mid plain arose a palace fair,
Which seemed as if with living flames
 it brent.
Such passing splendor and such glorious light
Shot from those walls, beyond all usage bright.

Thither where those transparent
 walls appear,
Which cover more than thirty miles in
 measure,

Hieronymus Bosch,
*Visions of the Hereafter:
The Terrestrial Paradise
and the Ascent of the
Blessed* (fifteenth
century), Venice, Palazzo
Grimani

Gustave Doré, *Ruggiero on the Hippogriff,* from *Orlando furioso*

At ease and slowly moved the cavalier,
And viewed the lovely region at his lei-
sure;
And deemed—compared with this—
that sad and drear,
And seen by heaven and nature with
displeasure,
Was the foul world, wherein we dwell
below:
So jocund this, so sweet and fair in
show!

Astound with wonder, paused the
adventurous knight,
When to that shining palace he was
nigh,
For, than the carbuncle more crimson
bright,
It seemed one polished stone of san-
guine dye.

An elder, in the shining entrance-hall
Of that glad house, toward Astolpho
prest;
Crimson his waistcoat was, and white
his pall;
Vermillion seemed the mantle, milk
the vest:
White was that ancient's hair, and
white withal
The bushy beard descending to his
breast;
And from his reverend face such glory
beamed,
Of the elect of Paradise he seemed.

He, with glad visage, to the paladin,
Who humbly, from his sell had lighted,
cries:
"O gentle baron, that by will divine
Have soared to this terrestrial
paradise!
Albeit nor you the cause of your
design,
Nor you the scope of your desire
surmise,

Believe, you not without high mystery
steer
Hitherward, from your arctic
hemisphere."

The Island of Saint Brendan

The Voyage of St. Brendan
(TENTH CENTURY)

Having sailed through the cloud for an hour, when they emerged, they saw a great bright light like the light of the sun, which resembled a bright and shining yellow halo; and as they moved toward it, the brightness increased to such an extent that they marveled at it greatly, and in the sky they could see stars that cannot be seen elsewhere much more clearly, and the progress of the seven planets, and so much light had appeared in the sky that there was no need of the sun. Saint Brendan asked what was the source of so much light and whether in those parts there was another sun that was larger, more beautiful and brighter than ours, and the other man replied: "The light that appears so great in these parts comes from another sun that does not resemble the one that appears to us amongst the signs of the heavens. And the sun that gives out this light never moves from its own place, and it is higher and ten thousand times brighter than the one that revolves around us, and just as the moon receives the light of the sun, the sun that illuminates the world is illuminated by this other sun." ...

Having given praise to God they went ashore and saw a land more exquisite than any other on account of its beauty and the wonderful, graceful and delightful things that it contained: clear and exquisite rivers flowing with the sweetest fresh and smooth waters, and

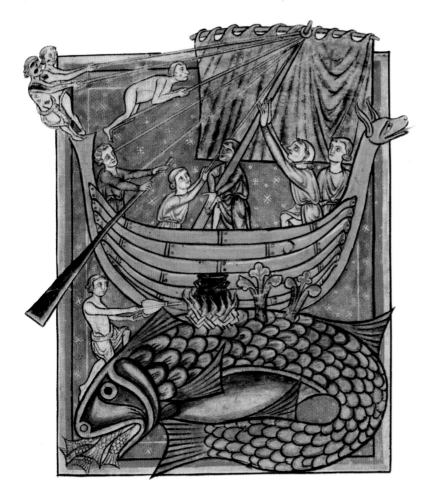

Anonymous,
*The Voyage of Saint
Brendan*
(thirteenth century),
private collection

different kinds of exquisite trees bear-
ing exquisite fruits, and roses and lilies
and flowers and violets and herbs and
everything sweetly scented . . . And
there were little birds harmoniously
singing a gentle song of great sweetness,
so that it appeared to be springtime.
And there were roads and paths all care-
fully constructed in various ways, and
precious stones, and so much goodness
that it cheered the heart of all those who
saw it, and beasts both tame and wild,
which roamed or stayed as they pleased,
all together in domestic harmony with-
out wanting to do one another any harm

. . . And there were vines and pergolas al-
ways well supplied with exquisite grapes
of extraordinary flavor . . .

And when Brendan asked how this
place could contain so many such beau-
tiful things of such virtue, goodness
and beauty, the Steward replied: "Our
Lord God created this place at the be-
ginning of the world on the highest
point of the earth, and because of its
height it was not reached by the waters
of the flood . . . Furthermore the wheel
of the heavens and the stars turns more
directly above this place than any other
. . . So there is never darkness here and

The Pear-Shaped Earth of Columbus, from William Fairfield Warren, *Paradise Found* (1885)

every ray of the sun reaches this place directly . . . Here, there is no one who commits mortal or venial sins, or does as he ought not to do."

The Pear-Shaped Earth

CHRISTOPHER COLUMBUS
The Third Voyage, Letter to the Catholic Kings from Hispaniola, May–August 1498

I have always read that the world, both land and water, was spherical, as the authority and researches of Ptolemy and all the others who have written on this subject demonstrate and prove, as do the eclipses of the moon and other experiments that are made from east to west, and the elevation of the North Star from north to south. But I have seen this discrepancy, as I have said. I am compelled, therefore, to come to this view of the world: I have found that it does not have the kind of sphericity described by the authorities, but that it has the shape of a pear, which is all very round, except at the stem, which is rather prominent, or that it is as if one had a very round ball, on one part of which something like a woman's teat were placed, this part with the stem being the uppermost and nearest to the sky, lying below the equinoctial line in this ocean sea, at the end of the East. . . . And this view is greatly supported by the fact that the sun, when Our Lord first created it, was at the first point of the East, and the first light was here in the Orient. Here where the world is highest. Although Aristotle was of the opinion that the Antarctic pole or the land beneath it is the highest part of the world and nearest the sky, otherwise wise men opposed him, saying that the highest part is beneath the Arctic pole. . . .

I do not find and have never found any Latin or Greek work which definitely locates the Terrestrial Paradise in this world, nor have I seen it securely placed on any world map on the basis of proof. Some put it at the sources of the Nile in Ethiopia, but others have visited all these countries without finding evidence of it in the mildness of the sky, or in its height toward the sky, by which it might be understood that it was there, or that the waters of the flood, which had risen above, had penetrated to it. . . .

I have already stated my thoughts on this hemisphere and the form it takes: I furthermore believe that by venturing below the equinoctial line, and arriving at the highest point of which I spoke, I would find a greater mildness of climate and much diversity in the stars and the waters; and this is not because I believe the highest point is navigable, that there is water there, and that it is possible to ascend to it, but because I believe that place to be the site of the Terrestrial Paradise, which no one may reach save by the will of God. . . .

I cannot accept that the Terrestrial Paradise takes the form of rugged mountains, as it has been described, rather I believe it to be located at the summit of that place that resembles the nipple of the pear and to which, little by little, as one approaches it, one gradually ascends from a great distance. And I believe, as I have said, that

no one can reach its summit, and that this water may arise from that place, however distant it may be, and flow out at the place from where I have come, forming this lake. These are major clues as to the Terrestrial Paradise, because the location is consistent with the opinion of the saints and scholarly theologians I have cited, and the signs are also very much consistent with my ideas, since I have never read nor heard of such a quantity of fresh water being so far inside and so close to the salt water.

Walter Raleigh at El Dorado

SIR WALTER RALEIGH
The Discovery of Guiana (1595)

... I have been assured by such of the Spaniards as have seen Manoa, the imperial city of Guiana, which the Spaniards call El Dorado, that for the greatness, for the riches, and for the excellent seat, it far exceedeth any of the world, at least of so much of the world as is known to the Spanish nation. It is founded upon a lake of salt water of 200 leagues long, like unto Mare Caspium. And if we compare it to that of Peru, and but read the report of Francisco Lopez and others, it will seem more than credible; and because we may judge of the one by the other, I thought good to insert part of the 120th chapter of Lopez in his *General History of the Indies*, wherein he describeth the court and magnificence of Guayna Capac, ancestor to the emperor of Guiana, whose very words are these: ...
"All the vessels of his house, table, and kitchen, were of gold and silver, and the meanest of silver and copper for strength and hardness of metal. He had in his wardrobe hollow statues of gold which seemed giants, and the figures in proportion and bigness of all the beasts, birds, trees, and herbs, that the earth bringeth forth; and of all the fishes that the sea or waters of his kingdom breedeth. He had also ropes, budgets, chests, and troughs of gold and silver, heaps of billets of gold, that seemed wood marked out (split into logs) to burn. Finally, there was nothing in his country whereof he had not the counterfeit in gold. Yea, and they say, the Ingas had a garden of pleasure in an island near Puna, where they went to recreate themselves, when they would take the air of the sea, which had all kinds of garden-herbs, flowers, and trees of gold and silver; an invention and magnificence till then never seen. Besides all this, he had an infinite quantity of silver and gold unwrought in Cuzco, which was lost by the death of Guascar, for the Indians hid it, seeing that the Spaniards took it, and sent it into Spain." ...
I ... was very desirous to understand the truth of those warlike women, because of some it is believed, of others not....
These Amazons have likewise great store of these plates of gold, which they recover by exchange chiefly for a kind of green stones, which the Spaniards call *piedras hijadas*, and we use for spleen-stones (stones reduced to powder and taken internally to cure maladies of the spleen); and for the disease of the stone we also esteem them. Of these I saw divers in Guiana; and commonly every king or cacique hath one, which their wives for the most part wear, and they esteem them as great jewels.

Candide at El Dorado

VOLTAIRE
Candide, XVII–XVIII

He stepped out with Cacambo toward the first village which he saw. Some

Theodor de Bry,
Grand Voyages (1590),
Frankfurt

children dressed in tattered brocades played at quoits on the outskirts. Our travellers from the other world amused themselves by looking on. The quoits were large round pieces, yellow, red, and green, which cast a singular luster! The travellers picked a few of them off the ground; this was of gold, that of emeralds, the other of rubies—the least of them would have been the greatest ornament on the Mogul's throne.

"Without doubt," said Cacambo, "these children must be the king's sons that are playing at quoits!"
The village schoolmaster appeared at

this moment and called them to school.
"There," said Candide, "is the preceptor of the royal family."
The little truants immediately quitted their game, leaving the quoits on the ground with all their other playthings. Candide gathered them up, ran to the master, and presented them to him in a most humble manner, giving him to understand by signs that their royal highnesses had forgotten their gold and jewels. The schoolmaster, smiling, flung them upon the ground; then, looking at Candide with a good deal of surprise, went about his business. . . .

Immediately two waiters and two girls, dressed in cloth of gold, and their hair tied up with ribbons, invited them to sit down to table with the landlord. They served four dishes of soup, each garnished with two young parrots; a boiled condor which weighed two hundred pounds; two roasted monkeys, of excellent flavor; three hundred humming-birds in one dish, and six hundred fly-birds in another; exquisite ragouts; delicious pastries; the whole served up in dishes of a kind of rock-crystal. The waiters and girls poured out several liqueurs drawn from the sugar-cane....

As soon as dinner was over, Cacambo believed as well as Candide that they might well pay their reckoning by laying down two of those large gold pieces which they had picked up. The landlord and landlady shouted with laughter and held their sides. When the fit was over: "Gentlemen," said the landlord, "it is plain you are strangers, and such guests we are not accustomed to see; pardon us therefore for laughing when you offered us the pebbles from our highroads in payment of your reckoning. You doubtless have not the money of the country; but it is not necessary to have any money at all to dine in this house. All hostelries established for the convenience of commerce are paid by the government. You have fared but very indifferently because this is a poor village; but everywhere else, you will be received as you deserve." ...

"The kingdom we now inhabit is the ancient country of the Incas, who quitted it very imprudently to conquer another part of the world, and were at length destroyed by the Spaniards.
"More wise by far were the princes of their family, who remained in their native country; and they ordained, with the consent of the whole nation, that none of the inhabitants should ever be permitted to quit this little kingdom; and this has preserved our innocence and happiness. The Spaniards have had a confused notion of this country, and have called it *El Dorado*; and an Englishman, whose name was Sir Walter Raleigh, came very near it about a hundred years ago; but being surrounded by inaccessible rocks and precipices, we have hitherto been sheltered from the rapaciousness of European nations, who have an inconceivable passion for the pebbles and dirt of our land, for the sake of which they would murder us to the last man."

The Garden of Armida

TORQUATO TASSO
Jerusalem Delivered (1581), XVI, 9–27

When they had passed all those trou-
 bled ways,
The garden sweet spread forth her
 green to show,
The moving crystal from the foun-
 tains plays,
Fair trees, high plants, strange herbs
 and flowerets new,
Sunshiny hills, dales hid from
 Phoebus' rays,
Groves, arbors, mossy caves, at once
 they view,
And that which beauty most, most
 wonder brought,
Nowhere appeared the art which all
 this wrought.

So with the rude the polished mingled
 was
That natural seemed all and every
 part,
Nature would craft in counterfeiting
 pass,

And imitate her imitator, art:
Mild was the air, the skies were clear as
glass,
The trees no whirlwind felt, nor
tempest smart,
But ere the fruit drop off, the blossom
comes,
This springs, that falls; that ripens and
this blooms.

The leaves upon the self-same bough did
hide
Beside the young, the old and ripened
fig;
Here fruit was green, there ripe with
vermeil side,
The apples new and old grew on one
twig,
The fruitful vine her arms spread high
and wide
That bended underneath their clusters
big,
The grapes were tender here, hard,
young and sour,
There purple ripe, and nectar sweet
forth pour.

The joyous birds, hid under greenwood
shade,
Sung merry notes on every branch and
bough;
The wind that in the leaves and waters
played,
With murmur sweet, now sung, and
whistled now;
Ceased the birds, the wind loud
answer made,
And while they sung, it rumbled soft
and low;
Thus were it hap or cunning, chance
or art,
The wind in this strange music bore
its part.

With party-colored plumes and purple
bill,

A wondrous bird among the rest there
flew,
That in plain speech sung love-lays
loud and shrill,
Her leden [language] was like human
language true;
So much she talked, and with such wit
and skill,
That strange it seemed how much
good she knew:
Her feathered fellows all stood hush to
hear;
Dumb was the wind, the waters silent
were.

"The gentle budding rose," quoth she,
"behold,
That first scant peeping forth with
virgin beams,
Half ope, half shut, her beauties doth
upfold
In its fair leaves, and less seen, fairer
seems,
And after spreads them forth more
broad and bold,
Then languisheth, and dies in last ex-
tremes,
Nor seems the same, that decked bed
and bower
Of many a lady late, and paramour:

"So, in the passing of a day, doth pass
The bud and blossom of the life of
man,
Nor e'er doth flourish more, but like
the grass
Cut down, becometh withered, pale
and wan:
Oh, gather then the rose, while time
thou hast;
Short is the day, done when it scant
began;
Gather the rose of love, while yet thou
may'st
Loving be loved, embracing, be em-
braced."

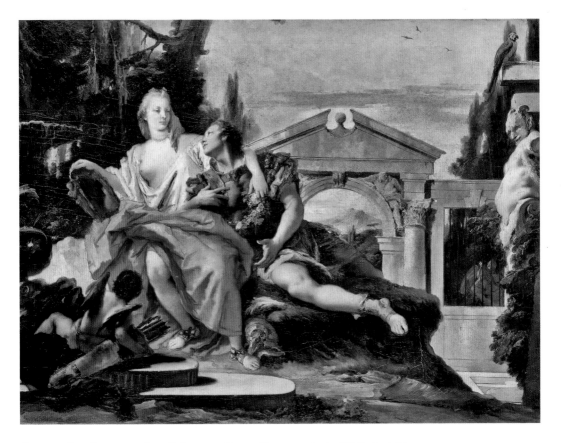

She ceased; and, as approving all she
 spoke,
The choir of birds their heavenly tunes
 renew;
The turtles sighed, and sighs with kisses
 broke;
The fowls to shades unseen by pairs
 withdrew;
It seemed the laurel chaste, and stub-
 born oak,
And all the gentle trees on earth that grew,
It seemed the land, the sea, and heaven
 above,
All breathed out fancy sweet, and sighed
 out love.
Through all this music rare, and strong
 consent
Of strange allurements, sweet 'bove
 mean and measure,

Severe, firm, constant, still the knights
 forthwent,
Hardening their hearts 'gainst false en-
 ticing pleasure,
'Twixt leaf and leaf their sight before
 they sent,
And after crept themselves at ease and
 leisure,
Till they beheld the queen, set with their
 knight
Besides the lake, shaded with boughs
 from sight.
Her breasts were naked, for the day was
 hot;
Her locks unbound waved in the
 wanton wind;
Some deal she sweat, scorched with
 love's flame, I wot!
Her sweat-drops bright, white, round,
 like pearls of Inde;

Giovanni Battista Tiepolo,
*Rinaldo Enchanted by
Armida* (1753), Bayerische
Schlösserverwaltung,
Würzburger Residenz

Her humid eyes a fiery smile forth shot
That like sunbeams in silver fountains
 shined,
O'er him her looks she hung, and her
 soft breast
The pillow was, where he and love took
 rest.

His hungry eyes upon her face he fed,
And feeding them so, pined himself
 away;
And she, declining often down her
 head,
His lips, his cheeks, his eyes kissed, as
 he lay,
Wherewith he sighed, as if his soul had
 fled
From his frail breast to hers, and there
 would stay
With her beloved sprite: the armed pair
These follies all beheld and this hot fare.

And with that word she smiled, and
 ne'ertheless
Her love-toys still she used, and plea-
 sures bold!
Her hair, that done, she twisted up in
 tress,
And looser locks in silken laces rolled,
Then garland-wise her curls she did up-
 dress,
Wherein, like rich enamel laid on gold,
The twisted flowerets smiled, and her
 white breast
The lilies there that spring with roses
 dressed.

The jolly peacock spreads not half so
 fair
The eyed feathers of his pompous
 train;
Nor so bends golden Iris in the air
Her twenty-colored bow, through
 clouds of rain;
Yet all her ornaments, strange, rich and
 rare,

Her girdle did in price and beauty
 stain,
Nor that, with scorn, which Tuscan
 Guilla lost,
Nor Venus' cestus, could match this for
 cost.

Of mild denays, of tender scorns, of
 sweet
Repulses, war, peace, hope, despair, joy,
 fear,
Of smiles, jests, mirth, woe, grief, and
 sad regret,
Sighs, sorrows, tears, embracements,
 kisses dear,
That mixed first by weight and measure
 meet,
Then at an easy fire attempered were,
This wondrous girdle did Armida frame,
And, when she would be loved, wore the
 same.

But when her wooing fit was brought to
 end,
She congee [a farewell bow] took, kissed
 him, and went her way;
For once she used every day to wend
'Bout her affairs, her spells and charms
 to say:
The youth remained, yet had no power
 to bend
One step from thence, but used there to
 stray
'Mongst the sweet birds, through every
 walk and grove
Alone, save for an hermit false called
 Love.

And when the silence deep and friendly
 shade
Recalled the lovers to their wonted
 sport,
In a fair room for pleasure built, they
 laid,
And longest nights with joys made sweet
 and short.

6.

ATLANTIS, MU, AND LEMURIA

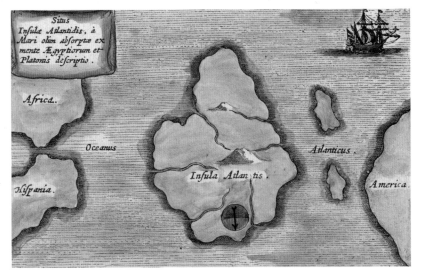

Left:
Athanasius Kircher, *Atlantis*, from *Mundus subterraneus* (1664), Amsterdam

Right:
Illustration for Jules Verne's *Twenty Thousand Leagues under the Sea* (1869–1870), chapter 9, "Atlantis"

Pages 184–5:
Thomas Cole, *The Course of Empire: Destruction* (1836), Collection of the New York Historical Society. The image was intended to represent the ruins of Atlantis.

Of all legendary lands, Atlantis is the one that, over the centuries, has most exercised the imagination of philosophers, scientists, and seekers of mysteries (cf. Albini 2012). And naturally what has reinforced the legend more and more is the persuasion that a vanished continent really existed and that it is difficult to rediscover traces of it because it sank into the sea. The notion that there were once lands above water that subsequently vanished is by no means a crazy one. In 1915 Alfred Wegener formulated the theory of continental drift, and today it is believed that 225 million years ago, the Earth consisted of a single continent, Pangaea, which then (about 200 million years ago) began to split up slowly, giving rise to the continents we know today. And so in the course of this process, many Atlantises may have arisen and then disappeared.

The first texts we have at our disposal are two dialogues by Plato, *Timaeus* and *Critias* (and unfortunately the latter was left un-

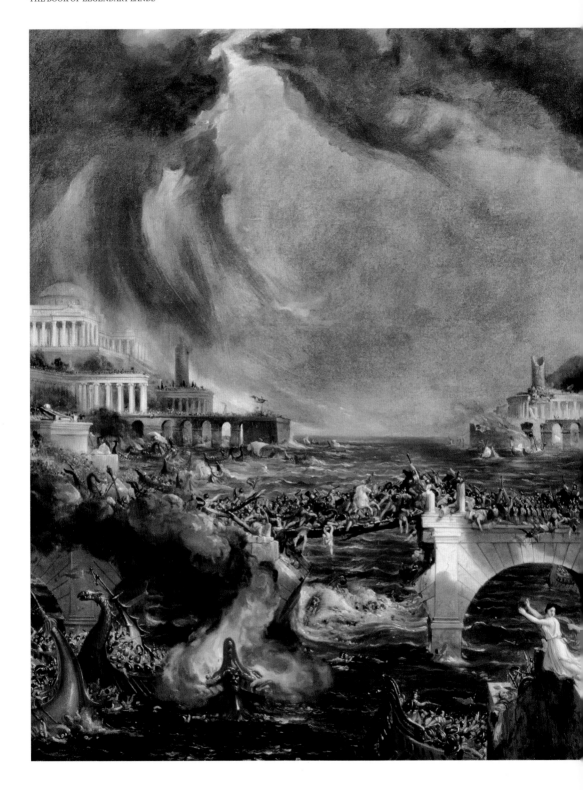

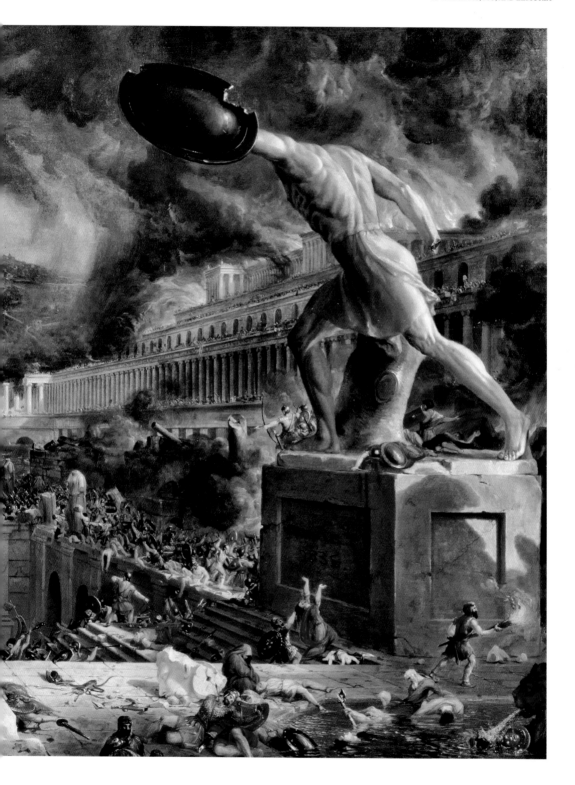

finished just when it seemed about to promise new revelations on that world that vanished into nothingness).

Plato shows that he was referring to older myths and cites an account by Solon on revelations received from the ancient Egyptians, and without naming Atlantis as such, Herodotus (fifth century BC) had mentioned the "Atlantes" as the people of North Africa, vegetarians who never slept. But in effect the two Platonic texts are the only ones from which we can begin.

The text of *Timaeus* is more succinct. Plato says that, beyond the Pillars of Hercules, and hence in the ocean, there lay an island bigger than Libya (Africa) and Asia put together. On this island, Atlantis, there had grown up a great and beautiful culture that also ruled over regions on the Mediterranean side of the pillars, from Libya to Egypt and over Europe as far as Tyrrhenia. "This vast power," it says in *Timaeus* (25b–d), "gathered into one, endeavored to subdue at a blow our country and yours and the whole of the region within the straits; and then, Solon, your country shone forth, in the excellence of her virtue and strength, among all mankind. She was pre-eminent in courage and military skill, and was the leader of the Hellenes. And when the rest fell off from her, being compelled to stand alone, after having undergone the very extremity of danger, she defeated and triumphed over the invaders, and preserved from slavery those who were not yet subjugated, and generously liberated all the rest of us who dwell within the pillars. But afterward there occurred violent earthquakes and floods; and in a single day and night of misfortune all your warlike men in a body sank into the earth, and the island of Atlantis in like manner disappeared in the depths of the sea. For which reason the sea in those parts is impassable and impenetrable, because there is a shoal of mud in the way; and this was caused by the subsidence of the island."

Vidal-Naquet (2005) suggested that the war between Athens and Atlantis alluded to an original Athens, as Plato would have wished it still to be, and to an Athens that had become an imperialist power after the Persian wars. But yet again, as in other chapters of this book, we must not worry about the endless problems that some texts pose,

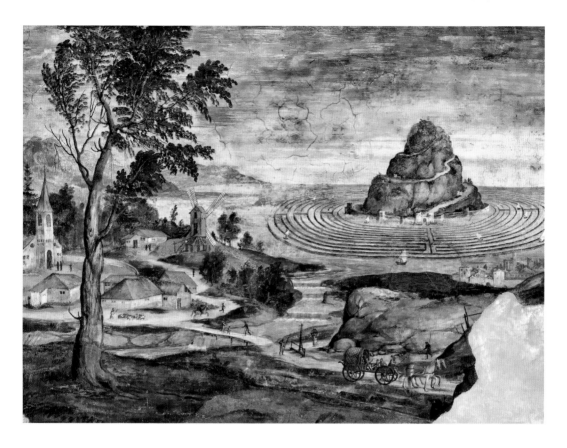

School of Giulio Romano,
*Sala dei Cavalli: Mount
Olympus on a Water
Labyrinth*
(sixteenth century), Mantua,
Palazzo Ducale

but about how the legend gradually located Atlantis in the most un-imaginable and unthinkable places.

Plato's account immediately influenced many classical authors. Aristotle does not mention Atlantis, but in a passage from *De caelo* (2.4), which seems to have inspired Columbus, he maintained that the region of the Pillars of Hercules, on account of the world's roundness, bordered with India; and that the two rivers of the ocean were once united was proven by the fact that elephants were found on both coasts (and Plato had talked about elephants in Atlantis). In *Meteorology* (2.1), he wrote that the parts of the sea beyond the Pillars were sheltered from the wind by the mud, and so we come back to the idea expressed in *Timaeus* that the island, on sinking, had left a muddy sea bottom.

The Platonic idea was picked up again by Diodorus Siculus (first century BC), Pliny the Elder (first century AD), and Philo of

Alexandria, more or less in the same period. Plutarch (first to second century AD), in his *Life of Solon*, regretted that *Critias* stopped just when the reader was beginning to enjoy the story.

The myth was also taken up by Christian authors, such as Tertullian, while Theopompus of Chios, a contemporary of Plato (of whose *Philippic* we now possess only fragments) and, more extensively, six centuries later Aelian (*Varia Historia*, 3.18) parodied *Critias*, talking of Merope, an island lying beyond the Atlantic Ocean, whose inhabitants were twice as tall and lived twice as long as ordinary men.

Later, in the fifth century AD, Proclus, who had written a commentary on *Timaeus*, was inclined to think that Atlantis had existed but noted (76.10) that even though "others say that Atlantis is a fable, a fiction devoid of reality," nonetheless its myth entailed "an indication of eternal truths" and hence conveyed "a hidden meaning."

In the sixth century AD, Cosmas Indicopleustes (following *Timaeus*) talked again about Atlantis but afterward, for the entire Middle Ages, it seems that no one was interested in that legend anymore. During the Renaissance, others were to deal with it again. Apart from Marsilio Ficino, Girolamo Fracastoro, and Giovanni Battista Ramusio (1556), all of whom located Atlantis in America, as did Francisco López de Gómara (1554), who, in his *History of the Indies*, showed how the new lands seemed to fit the Platonic account marvelously and suggested the hypothesis that the Atlanteans were the Aztecs. Francis Bacon (1627), who entitled his utopia *New Atlantis* not by chance, clearly said that the ancient Atlantis was America, citing the realms of Peru and Mexico.

But that Atlantis could not be America, still intact, and not an island but a continent, had already been judiciously observed by Montaigne.

Others, such as Bartolomeo de Las Casas (1551–1552), associated Atlantis with the lost tribes of Israel, blazing the trail for those, much later, who were to guess that Atlantis was Palestine, an idea that recurred frequently until at least the *Essai historique et critique sur l'Atlantique des anciens* (A Critical History of the Atlantis of the Ancients) by Baër (1762), in which he maintains that the Atlantic

Ocean was none other than the Red Sea, and the destruction of the Atlantean civilization was to be identified with the end of Sodom and Gomorrah.

We cannot mention all those who referred to Atlantis in one way or another, including Father Athanasius Kircher (1665), who left the most famous map of the island. He placed it more or less where the Canary Islands are today and thought that the catastrophe could be explained by submerged volcanic activity (and he talks about this in his *Mundus subterraneus* [The Subterranean World], in which he deals with these topics).

Something new came along with the publication of *Atlantis, or Man's Homeland* by Olof Rudbeck (written between 1679–1702). Rudbeck was a serious scholar, naturalist, and anatomist, rector of the University of Uppsala, a correspondent of Descartes, and his *Atlantis* had interested Newton, ever ready to throw himself into occultist explorations, who moreover in his *Chronology of Ancient Kingdoms*, published posthumously in 1728, made numerous references to Atlantis. In Rudbeck's view, the location of the Atlanteans was in Sweden, to where, he maintained, one Atlante, the son of Japheth and hence the grandson of Noah, had moved. The Nordic runes had allegedly preceded the Phoenician alphabet. Rudbeck thus inaugurated that celebration of the Hyperboreans as the chosen people that were then to go on to produce many myths of Aryan power (see the chapter on Thule and Hyperborea).

Rudbeck's ideas were mocked by Giambattista Vico (1744), who also argued against the claims of many authors of his day that the language of their country was the direct descendant, or even the origin, of the tongue of Adam.[1] But, paying no heed to Vico's criticism of nationalistic myths, Angelo Mazzoldi (1840) maintained that Atlantis was the Italian peninsula.

To get back to the Nordic-Scandinavian hypothesis, Rudbeck's suggestion was picked up again in the *Lettres sur l'Atlantide de Platon* (Plato's Letters on Atlantis) by Jean-Sylvain Bailly (1779) who went so far as to locate Atlantis further north than Sweden itself, in Iceland or Greenland, in Spitzbergen, in the Svalbard Islands, or in

1. *See Eco (1993).*

Olof Rudbeck the Elder Explains Atlantica to the Learned of the World, frontispiece to *Atlantica sive Manheim* (seventeenth century), copper engraving

Novaya Zemlya. Bailly had had a dispute with Voltaire (even though his *Letters* could not have reached the grand old man, who died before receiving them; and for his part, since 1756, Bailly's venerable opponent, in his *Essay on the Customs and the Spirit of the Nations* had already written that, if Atlantis had ever existed, it should have been the Island of Madeira.

On the other hand, in the seventeenth and eighteenth centuries, another kind of reflection began to make way on the possible location of Atlantis, this time with scientific pretensions, and on this subject, Ciardi (2002) talks about "the second youth of Atlantis." This takes the form of a series of researches on the possible age of the Earth, evidently in disagreement with biblical chronologies, and based on new studies of fossils and attempts at terrestrial stratigraphy. In this way the Platonic myth was seen as proof of the telluric movements that had, in the course of millennia, transformed the face of the planet, and a debate came into being between "Neptunists" and "Plutonists" (was Atlantis destroyed by water or volcanic eruptions?)

And so Atlantis passed from myth to geology and palaeontology, and interested scientists, such as Buffon, Cuvier, Alexander von Humboldt, and even Darwin. But we must get back to the legend—because, while men of science prudently reread Plato, occultists and mystery seekers continued to give their imaginations free rein.

William Blake believed that England was the heir to Atlantis and also the home of the lost tribes of Israel. And two masters of nineteenth-century esotericism, Fabre d'Olivet (see the anthology in chapter 7 on Thule and Hyperborea) and the theosophist Madame Blavatsky (1877) in her *Isis Revealed*, could not avoid fantasizing about Atlantis.

With solely narrative pretensions, but with a description more replete with meaning than any mysteriosophical text, an almost perfect illustration of Platonic fantasies, we find the submarine discovery of that world swallowed up by the sea in *Twenty Thousand Leagues Under the Sea* by Jules Verne (1870).

Piet Mondrian, *Evolution* (1911), inspired by the writings of Madame Blavatsky, The Hague, Gemeentemuseum

But the author who more than anyone else revitalized the Atlantis myth and who to this day is still quoted by every adept of the myth was Ignatius Donnelly (1882) with his *Atlantis*. A few years later, in his *The Great Cryptogram* (1888), this man of imperturbable credulity distinguished himself not as the first, but certainly the best known, champion of the so-called Bacon-Shakespeare controversy, according to which the intention was (and still is) to prove that the author of Shakespeare's plays was Francis Bacon. Donnelly loses himself in dizzying analyses of cryptograms, or hidden messages, in the Shakespearian texts in which Bacon shows himself as their true author.

We could expect no less from his theory on Atlantis, and it suffices to reproduce the beginning of his book, leaving the floor to him: "There once existed in the Atlantic Ocean, opposite the mouth of the Mediterranean Sea, a large island, which was the remnant of an

Atlantic continent, and known to the ancient world as Atlantis. The description of this island given by Plato is not, as has been long supposed, fable, but veritable history. Atlantis was the region where man first rose from a state of barbarism to civilization. It became, in the course of ages, a populous and mighty nation, from whose overflowings the shores of the Gulf of Mexico, the Mississippi River, the Amazon, the Pacific coast of South America, the Mediterranean, the west coast of Europe and Africa, the Baltic, the Black Sea, and the Caspian were populated by civilized nations. It was the true Antediluvian world; the Garden of Eden; the Gardens of the Hesperides; the Elysian Fields; the Gardens of Alcinous; the Mesomphalos; Olympus; the Asgard of the traditions of the ancient nations; representing a universal memory of a great land, where early mankind dwelt for ages in peace and happiness. The gods and goddesses of the ancient Greeks, the Phoenicians, the Hindus, and the Scandinavians were simply the kings, queens, and heroes of Atlantis; and the acts attributed to them in mythology are a confused recollection of real historical events. The mythology of Egypt and Peru represented the original religion of Atlantis, which was sun worship. The oldest colony formed by the Atlanteans was probably in Egypt, whose civilization was a reproduction of that of the Atlantic island. The implements of the Bronze Age of Europe were derived from Atlantis. The Atlanteans were also the first manufacturers of iron. The Phoenician alphabet, parent of all the European alphabets, was derived from an Atlantean alphabet, which was also conveyed from Atlantis to the Mayas of Central America. Atlantis was the original seat of the Aryan or Indo-European family of nations, as well as of the Semitic peoples, and possibly also of the Turanian races. Atlantis perished in a terrible convulsion of nature, in which the whole island sank into the ocean, with nearly all its inhabitants. A few persons escaped, in ships and on rafts, and carried to the nations east and west the tidings of the appalling catastrophe, which has survived to our own time in the Flood and Deluge legends of the different nations of the Old and New Worlds."

In order to confer scientific value on his theory, Donnelly

had studied all the earthquakes and all the floods (and subsequent submersions) of catastrophic proportions that had occurred in historical times, the seaquakes that had caused the disappearance of islands near Iceland, Java, Sumatra, and Sicily, in the Indian Ocean, and the Lisbon earthquake. At the time when Atlantis was above sea level, there were islands that connected it with Europe on the one side and America on the other.

Perhaps owing to Donnelly's influence or for other reasons, in the twentieth century, searches were made for the ruins of Atlantis or for one of its colonies in Tartessus (a vanished Iberian city mentioned in the Bible and in Herodotus), without probative results, or in the Sahara, buried beneath the sand. It was thought that the Berbers of the Atlas Mountains, with their white skin, blue eyes and blond hair, were the survivors of the ruin of Atlantis, and the ethnologist Leo Frobenius sought Atlantis father south, as far as Niger. Some thought of the island of Thera, which had sunk in the Mediterranean in the fifteenth century BC and of which all that remains is supposedly identifiable with the island of Santorini.

Finally, for a long time, there was talk of the map that the

Anonymous, Minoan, *The Departure of the Flotilla*, detail from the Akrotiri fresco, Thera, 1650–1500 BC, Athens, National Archaeological Museum

Turkish admiral Piri Reis (Piri ibn Haji Mehmed) had drawn in 1513 on the hide of a gazelle (see Cuoghi 2003). It is a document of extreme cartographic interest but one in which many have believed they saw a representation of the Antarctic (which the admiral could not have known), while Atlantologists saw a portrayal of Atlantis, located between Tierra del Fuego and a Terra Incognita—without anything to justify this interpretation.[2]

Some have connected the disappearance of Atlantis with the so-called mystery of the Bermuda Triangle, where contemporary legend has it that airplanes and ships have vanished (even though according to experts the number of incidents in the Triangle is no greater than any other region of high aero-naval traffic). There is talk of a still-active energy source in the submerged ruins of Atlantis, or of electromagnetic disturbances and gravitational anomalies caused by the ancient Atlantean cataclysm, while others have suggested that the Atlantean survivors live in an undersea city that still exists in the depths of the Triangle, and to which the claimed disappearances are due, even though they offer no explanation as to why the Atlanteans amuse themselves with this form of piracy.

2. See chapter 12 on Solomon's Isle and Terra Australis.

Naturally, the obsessive memory that sprang from the pages of Plato has led to the hypothesis of other vanished continents. One of these is Lemuria, which Donnelly had mentioned, another presumed cradle of the human race. Lemuria supposedly existed between Australia, New Guinea, and the Solomon and Fiji islands—and other "lemurologists" say it united Africa and Asia—even though scientists have established that neither the Pacific nor the Indian Ocean possesses any geological formation that might correspond to the hypothetical Lemuria.

The intrepid Madame Blavatsky could not avoid talking about Lemuria, and in the Lemurids she saw some of the "Great Initiates" that esotericists are forever seeking to rediscover.

A relative of Lemuria (so much so that the two names are often used to describe the same land) is the continent of Mu. In the nineteenth century, the abbot Charles Étienne Brasseur had tried to translate a Mayan codex by applying the (totally erroneous) method of decipherment conceived in the sixteenth century by Diego de Landa. And he had understood (mistakenly) that the manuscript talked about a land that had sunk during a cataclysm. On finding symbols he did not understand, he thought to translate them as Mu. This idea was appropriated first by Augustus Le Plongeon (1896) and later and more widely by Colonel James Churchward (whose *The Lost Continent of Mu* is

Admiral Piri Reis, *Map of the World* (1513), Istanbul, Topkapi Palace Library

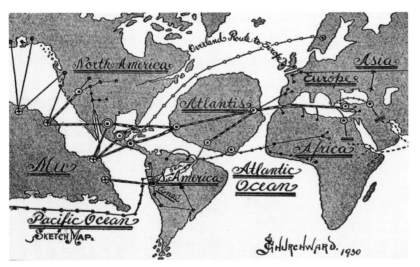

James Churchward, *The Children of Mu* (1933), New York, Ives Washburn

still remembered), to whom an Indian priest is supposed to have shown some ancient tablets that talked about the origin of humanity and had been written by presumed "Holy Brothers" who came from a mother continent in Southeast Asia.

Fragment of the
Codex Tro-cortesianus II
(*Madrid Codex,*
c. 900–1521), Madrid, Museo
de América

According to the tablets, man had appeared for the first time on the continent of Mu, inhabited by various tribes ruled by a king called Ra-Mu. Mu was for the most part populated by a white race that had brought science, religion, and trade throughout the world. As happens with all mother continents, Mu was also struck by volcanoes and seaquakes and had then sunk thirteen thousand years ago, even before Atlantis (a colony of Mu), which supposedly sank only one thousand years later.

Finally, in 1912, Paul Schliemann, a grandson of the archaeologist who had unearthed the ruins of Troy, in an evident attempt to emulate his grandfather, had published on October 20, 1912, in the *New York American* a revelation on the discovery of Atlantis that later turned out to be a hoax—after which the suggestion that Paul was not the great archaeologist's grandson began to gain ground.

The revelations
of Paul Schliemann,
The New York American,
12 October 1912

All these fantasies are often based on the fact that pyramids and ziggurats are found both in Egypt and in the Middle East as well as in other Asiatic and Amerindian civiliza-

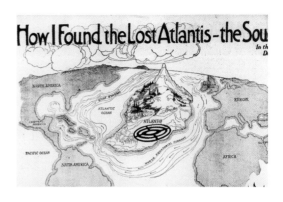

tions. This proves very little, because structures based on mounds can be invented independently by different cultures, given that they represent the way sand piles up owing to wind action, just as stepped structures are often the effect of normal erosion and the form of trees could suggest the form of the column anywhere. But for mystery seekers, the fact that megaliths and constructions made of monolithic blocks slotted together are widespread in South America, Egypt, Lebanon, Israel, Japan, Central America, England, and France was supposedly proof that they are the legacy of an older civilization.

Atlantis also seduced many occultists who gravitated to the Nazi party. For this, see the chapter on Thule and Hyperborea, but it is worth remembering that Hans Hörbinger's theory of eternal ice maintained that the submersion of Atlantis and Lemuria was caused when the Earth captured the moon. In *Atlantis die Urheimat der Arier* (Atlantis, the Original Homeland of the Aryans, 1922), Karl Georg Zchaetzsch had written, followed by one of the maximum theorists of Nazi racism, Alfred Rosenberg, about a dominant "Nordic-Atlantean" or "Aryan-Nordic" race. It is said that in 1938 Heinrich Himmler had organized a search in Tibet with a view to finding the remains of the white Atlanteans. Another theorist of the primordial nature of the Hyperboreans, Julius Evola (1934), traced an imaginary map of the migrations of the "Borean race," one from north to south, the other from east to west, seeing Atlantis as an image of the polar center. Toward the south, there supposedly remained traces of Lemuria "of which certain black and southern peoples may be considered the last crepuscular remnants." In general, Evola says that "in those places

Georg Wilhelm Pabst
(director), *L'Atlantide* (1932)

where there meet inferior races devoted to chthonian demonism and mixed with animal nature there remain memories of mythologized struggles in which the clash between a divine-luminous type (an element of Boreal derivation) and a dark, non-divine type is always emphasized."

In conclusion, as happened with the Grail (see the chapter on this subject), in the course of the centuries, Atlantis was moved to the most unlikely areas: not only, as we have seen, from the Azores to North Africa, from America to Scandinavia, and from the Antarctic to Palestine, but also according to various real or pseudo-scientists, to the Sargasso Sea, Bolivia, Brazil, and Andalusia.

More recently, Sergio Frau (2002) concluded that the Pillars of Hercules formed not the Strait of Gibraltar but the Strait of Sicily, and in that case, Atlantis supposedly lay in Sardinia, where there has been found a Phoenician term (*Trshsh*) which could be read as "Tartessus"—and so also the mythical Atlantean colony seems to have been moved from Spain to Sardinia. And even though we might object that Atlantis has disappeared, while Sardinia is still in its place, Frau points out that Sardinia was apparently struck by seaquakes so powerful that they give birth to the legend of its destruction by the sea. And on the other hand, if in reality the Greeks had never sailed farther than the Strait of Sicily, Plato, too, would have had extremely vague ideas about an island that still flourished when he was writing *Timaeus* and *Critias*.

The myth of Atlantis led to interest in other submerged civilizations. One of these is the city of Ys (or Kêr-Is in Breton), mentioned

Illustration for
Le Petit roi d'Ys
(*The Sunken City*, 1914)
by Georges-Gustave
Toudouze

in many myths of Brittany and which supposedly stood in the Bay of Douarnenez. Ys was engulfed by the sea to punish the daughter of King Gradlon and the inhabitants for their sins. The legend has different sources; there is talk of Ys after the Christianization of Brittany, but it has pagan origins, albeit undocumented.

The versions are many, but in the anthology we print the legend in narrative form, citing a thrilling novel for youngsters by Georges-Gustave Toudouze, *The Sunken City* (1914).

There is an infinity of short stories, novels, and films inspired by Atlantis (or by Mu), and we cannot mention them all. We will cite only Arthur Conan Doyle's *The Maracot Deep* (1929), an account of a scientific expedition to the Atlanteans, who had already been living on the ocean floor for eight thousand years. The African jungle is the setting for Edgar Rice Burroughs's Opar cycle: Opar is a city buried in the jungle, where Tarzan has various adventures, and was an ancient colony of Atlantis, where two races had survived: most beautiful women and men in simian form. Henry Rider Haggard's *She* (1886–1887) deals with a mysterious African civilization older than that of ancient Egypt, ruled by a beauteous and cruel queen.

In *She* there is no mention of Atlantis, but it was the subject of a hugely popular novel, *Atlantis*, by Pierre Benoit (1919), who in his

Dust-jacket illustration of Edgar Rice Burroughs' *Tarzan and the Jewels of Opar* (A. C. McClurg, 1918)

day was accused of plagiarizing Rider Haggard's book. Benoit tells of an island that existed in the sea that once covered the Sahara, transformed into a subterranean city, ruled by a beautiful and ruthless queen, Antinea, who changes her visitors—bewitched by her charms—into golden statues. Numerous films have been based on this novel, including one by Georg Wilhelm Pabst in 1932, not to mention various comics.

Hugo Pratt, map of the
Island of Mu, from *Mu*
(1988–1989), last of the
Corto Maltese graphic
novels

Among famous graphic novels inspired by Atlantis or Mu, we recall an episode in the *Tim Tyler's Luck* comics, "The Mysterious Flame of Queen Loana," by Lyman Young; *The Enigmas of Atlantis* by Edgar P. Jacobs, with the adventures of Professor Mortimer (1957); and, for the Italian Corto Maltese stories, *Mu la città perduta* (Mu, the Lost City) by Hugo Pratt (1988).

Atlantis: Toward an Atlantological Bibliography

A N D R E A A L B I N I
Atlantis: In the Textual Sea (2012), pp. 32–34

Poster for the film
Atlantis, the Lost Continent
(1961)

The quantity of books, articles, and documents written on the subject of Atlantis is impressive. In 2004, the academic Chantal Foucrier wrote that websites on Atlantis added up to around 90,000 pages. Even then, the figure was probably an underestimation: research conducted in May 2010 on the search engine Google showed almost 23 million indexed pages in English. Similarly, the tally of mentions in Spanish stood at around 1,200,000, with 1,800,000 mentions in German, and finally 463,000 and 380,000 in Italian and French respectively.... The number of printed works published on the subject over the years is no less impressive. In 1841, T. Henri Martin listed several dozen serious contributions to the literature on Atlantis in his *Studies on Plato's Timaeus*: a number that would certainly have been supplemented by a series of more eccentric publications. As for the authors, in a classic of critical studies on Atlantis originally published in 1954, Lyon Sprague de Camp listed 216 "Atlantists," as he called them, in alphabetical order, indicating their profession, the year in which they wrote on the subject, and their conclusions about Atlantis. Of this number, only 37 authors reached the conclusion that the story of Atlantis referred to an "imaginary" or "doubtful" place, or to an "allegory" whereas all the others suggested a real location. The imbalance in favor of those with a "geographical theory" is understandable if we consider that those with a professional interest in Plato in the fields of classical, historical, or philosophical studies are unlikely to take the account of Atlantis seriously enough to devote anything more than a mere mention to it.

In a bibliography on "Atlantis and related issues" that appeared in 1926, Claude Roux and Jean Gattefossé listed 1,700 entries, with subject areas covering geography, ethnography, and ancient migrations across all the continents, as well as floods, ancient traditions, and continental drifts. This was a wide variety of topics compared to the theme of Plato's account in the strict sense, but we have to bear in mind that this dispersion is a constant feature of books on Atlantis, even though recurrent themes can be detected. As an illustration, in 1989 the French essayist and underwater treasure hunter Pierre Jarnac wrote that with all the books published on Atlantis, it would be possible to create a library of over 5,000 volumes.

The Account of the *Critias*

P L A T O (428–348 BC)
Critias, 113b–e, 114c–116c, 120d–121c

I have before remarked in speaking of the allotments of the gods, that they distributed the whole earth into portions differing in extent, and made for themselves temples and instituted sacrifices. And Poseidon, receiving for his lot the island of Atlantis, begat children by a mortal woman, and settled them in a part of the island, which I will describe. Looking towards the sea, but in the centre of the whole island, there was a plain which is said to have been the fairest of all plains and very fertile. Near the plain again, and also in the centre of the island at a distance of about fifty stadia, there was a mountain not very high on any side. In this mountain there dwelt one of the earth born primeval men of that country, whose name was Evenor, and he had a wife named Leucippe, and they had an only daughter who was called Cleito. The maiden had already reached womanhood, when her father and mother died; Poseidon fell in love with her and had intercourse with her, and breaking the ground, inclosed the hill in which she dwelt all round, making alternate zones of sea and land larger and smaller, encircling one another; there were two of land and three of water, which he turned as with a lathe, each having its circumference equidistant every way from the centre, so that no man could get to the island, for ships and voyages were not as yet. He himself, being a god, found no difficulty in making special arrangements for the centre island, bringing up two springs of water from beneath the earth, one of warm water and the other of cold, and

making every variety of food to spring up abundantly from the soil. . . .
Now Atlas had a numerous and honourable family, and they retained the kingdom, the eldest son handing it on to his eldest for many generations; and they had such an amount of wealth as was never before possessed by kings and potentates, and is not likely ever to be again, and they were furnished with everything which they needed, both in the city and country. For because of the greatness of their empire many things were brought to them from foreign countries, and the island itself provided most of what was required by them for the uses of life. In the first place, they dug out of the earth whatever was to be found there, solid as well as fusile, and that which is now only a name and was then something more than a name, orichalcum, was dug out of the earth in many parts of the island, being more precious in those days than anything except gold. There was an abundance of wood for carpenter's work, and sufficient maintenance for tame and wild animals. Moreover, there were a great number of elephants in the island; for as there was provision for all other sorts of animals, both for those which live in lakes and marshes and rivers, and also for those which live in mountains and on plains, so there was for the animal which is the largest and most voracious of all. . . . With such blessings the earth freely furnished them; meanwhile they went on constructing their temples and palaces and harbours and docks. And they arranged the whole country in the following manner: First of all they bridged over the zones of sea which surrounded the ancient metropolis, making a road to and from the royal palace. And at the very beginning they built the palace in the

habitation of the god and of their ancestors, which they continued to ornament in successive generations, every king surpassing the one who went before him to the utmost of his power, until they made the building a marvel to behold for size and for beauty. And beginning from the sea they bored a canal of three hundred feet in width and one hundred feet in depth and fifty stadia in length, which they carried through to the outermost zone, making a passage from the sea up to this, which became a harbour, and leaving an opening sufficient to enable the largest vessels to find ingress. Moreover, they divided at the bridges the zones of land which parted the zones of sea, leaving room for a single trireme to pass out of one zone into another, and they covered over the channels so as to leave a way underneath for the ships; for the banks were raised considerably above the water. Now the largest of the zones into which a passage was cut from the sea was three stadia in breadth, and the zone of land which came next of equal breadth; but the next two zones, the one of water, the other of land, were two stadia, and the one which surrounded the central island was a stadium only in width. The island in which the palace was situated had a diameter of five stadia. All this including the zones and the bridge, which was the sixth part of a stadium in width, they surrounded by a stone wall on every side, placing towers and gates on the bridges where the sea passed in. The stone which was used in the work they quarried from under-

Ignazio Danti, fresco map of Liguria (detail showing Neptune, 1560), Rome, Galleria delle carte geografiche, Museo Vaticano

neath the centre island, and from underneath the zones, on the outer as well as the inner side. One kind was white, another black, and a third red, and as they quarried, they at the same time hollowed out double docks, having roofs formed out of the native rock. Some of their buildings were simple, but in others they put together different stones, varying the colour to please the eye, and to be a natural source of delight. The entire circuit of the wall, which went round the outermost zone, they covered with a coating of brass, and the circuit of the next wall they coated with tin, and the third, which encompassed the citadel, flashed with the red light of orichalcum. . . .

Such was the vast power which the god settled in the lost island of Atlantis; and this he afterwards directed against our land for the following reasons, as tradition tells: For many generations, as long as the divine nature lasted in them, they were obedient to the laws, and well-affectioned towards the god, whose seed they were; for they possessed true and in every way great spirits, uniting gentleness with wisdom in the various chances of life, and in their intercourse with one another. They despised everything but virtue, caring little for their present state of life, and thinking lightly of the possession of gold and other property, which seemed only a burden to them; neither were they intoxicated by luxury; nor did wealth deprive them of their self-control; but they were sober, and saw clearly that all these goods are increased by virtue and friendship with one another, whereas by too great regard and respect for them, they are lost and friendship with them. By such reflections and by the continuance in

them of a divine nature, the qualities which we have described grew and increased among them; but when the divine portion began to fade away, and became diluted too often and too much with the mortal admixture, and the human nature got the upper hand, they then, being unable to bear their fortune, behaved unseemly, and to him who had an eye to see grew visibly debased, for they were losing the fairest of their precious gifts; but to those who had no eye to see the true, they appeared glorious and blessed at the very time when they were full of avarice and unrighteous power. Zeus, the god of gods, who rules according to law, and is able to see into such things, perceiving that an honourable race was in a woeful plight, and wanting to inflict punishment on them, that they might be chastened and improve, collected all the gods into their most holy habitation, which, being placed in the centre of the world, beholds all created things. And when he had called them together, he spake as follows . . . [The rest of the dialogue of *Critias* has been lost.]

The Atlanteans

DIODORUS SICULUS
(FIRST CENTURY BC)
Bibliotheca historica, III, 56

But since we have made mention of the Atlantians, we believe that it will not be inappropriate in this place to recount what their myths relate about the genesis of the gods. . . . Now the Atlanteans, dwelling as they do in the regions on the edge of Okeanos and inhabiting a fertile territory, are reputed far to excel their neighbours in rever-

ence towards the gods and the human-
ity they showed in their dealings with
strangers, and the gods, they say, were
born among them. And their account,
they maintain, is in agreement with
that of the most renowned of the
Greek poets, when he represents Hera
as saying:
For I go to see the ends of the bounti-
ful earth,
Oceanus source of the gods and Tethys
divine
their mother.
This is the account given in their
myth: Their first king was Uranus,
and he gathered the human beings,
who dwelt in scattered habitations,
within the shelter of a walled city and
caused his subjects to cease from their
lawless ways and their bestial manner
of living, discovering for them the uses
of cultivated fruits, how to store them
up, and not a few other things which
are of benefit to man; and he also sub-
dued the larger part of the inhabited
earth, in particular the regions to the
west and the north. And since he was a
careful observer of the stars he fore-
told many things which would take
place throughout the world; and for
the common people he introduced the
year on the basis of the movement of
the sun and the months on that of the
moon, and instructed them in the sea-
sons which recur year after year.
Consequently the masses of the peo-
ple, being ignorant of the eternal ar-
rangement of the stars and marvelling
at the events which were taking place
as he had predicted, conceived that
the man who taught such things par-
took of the nature of the gods, and af-
ter he had passed from among men
they accorded to him immortal hon-
ours, both because of his benefactions
and because of his knowledge of the

stars; and then they transferred his
name to the firmament of heaven,
both because they thought that he had
been so intimately acquainted with
the risings and the settings of the
stars and with whatever else took
place in the firmament, and because
they would surpass his benefactions
by the magnitude of the honours
which they would show him, in that
for all subsequent time they pro-
claimed him to be the king of the uni-
verse.

PLINY THE ELDER (23–79)
Natural History, II, 90 and 92

For another way also in which nature
has made islands is when she tore
Sicily away from Italy, Cyprus from
Syria, Euboea from Boeotia, Atalantes
and Macrias from Euboea, Besbicus
from Bithynia, Leucosia from the
Sirens' Cape.
Cases of land entirely stolen away by
the first of all (if we accept Plato's sto-
ry [*Timaeus* 24e]), the vast area cov-
ered by the Atlantic ...

AELIAN (C. 170–235)
Various Histories, III, 18

... that Europe, Asia and Africk were
Islands surrounded by the Ocean:
That there was but one Continent one-
ly, which was beyond this world, and
that as to magnitude it was infinite:
That in it were bred, besides other
very great Creatures, Men twice as big
as those here, and they lived double
our age: That many great Cities are
there, and peculiar manners of life;
and that they have Laws wholly differ-
ent from those amongst us: That there
are two Cities farre greater than the
rest, nothing to like each other; one

named Machimus, Warlike, the other Eusebes, Pious: That the Pious people live in peace, abounding in wealth, & reap the fruits of the Earth without Ploughs or Oxen, having no need of tillage or sowing. They live, as he said, free from sickness, and die laughing, and with great pleasure: They are so exactly Just, that the Gods many times vouchsafe to converse with them. The Inhabitants of the City Machimus are very Warlike, continually armed and fighting: They subdue their Neighbours, and this one City predominates over many. The Inhabitants are not fewer than two hundred Myriads. . . . He said that they once designed a Voiage to these our Islands, and sailed upon the Ocean, being in number a thousand Myriads of men, till they came to the Hyperboreans; but understanding that they were the happiest men amongst us, they contemned us as persons that led a mean inglorious life, and therefore thought it not worth their going farther.

The New Atlantis

FRANCIS BACON
The New Atlantis (1626)

We sailed from Peru, where we had continued by the space of one whole year, for China and Japan, by the South Sea, taking with us victuals for twelve months; and had good winds from the east, though soft and weak, for five months' space and more. But then the wind came about, and settled in the west for many days, so as we could make little or no way, and were sometimes in purpose to turn back. . . . And it came to pass that the next day

about evening we saw within a kenning before us, toward the north, as it were thick clouds, which did put us in some hope of land, knowing how that part of the South Sea was utterly unknown, and might have islands or continents that hitherto were not come to light. Wherefore we bent our course thither, where we saw the appearance of land, all that night; and in the dawning of next day we might plainly discern that it was a land flat to our sight, and full of boscage, which made it show the more dark. And after an hour and a half's sailing, we entered into a good haven, being the port of a fair city. Not great, indeed, but well built, and that gave a pleasant view from the sea. . . .

. . . there came toward us a person (as it seemed) of a place. He had on him a gown with wide sleeves, of a kind of water chamolet, of an excellent azure color, far more glossy than ours; his under–apparel was green, and so was his hat, being in the form of a turban, daintily made, and not so huge as the Turkish turbans; and the locks of his hair came down below the brims of it. A reverend man was he to behold. . . . The next day, about ten of the clock; the governor came to us again, and after salutations said familiarly that he was come to visit us, and called for a chair and sat him down; and we, being some ten of us (the rest were of the meaner sort or else gone abroad), sat down with him; and when we were set he began thus: "We of this island of Bensalem (for so they called it in their language) have this: that by means of our solitary situation, and of the laws of secrecy, which we have for our travellers, and our rare admission of strangers; we know well most part of the habitable world, and are ourselves unknown. . . ."
. . . considering they had the languages

Franciscu Bayeu y Subías,
*Olympus: The Fall of the
Giants* (1764), Madrid,
Museo del Prado

of Europe, and knew much of our State and business; and yet we in Europe (notwithstanding all the remote discoveries and navigations of this last age) never heard any of the least inkling or glimpse of this island. . . .

At this speech the governor gave a gracious smile and said that we did well to ask pardon for this question we now asked, for that it imported, as if we thought this land a land of magicians, that sent forth spirits of the air into all parts, to bring them news and intelligence of other countries. . . .

"You shall understand (that which perhaps you will scarce think credible) that about 3,000 years ago, or somewhat more, the navigation of the world (especially for remote voyages) was greater than at this day. . . .

"At the same time, and an age after or more, the inhabitants of the great Atlantis did flourish. For though the narration and description which is made by a great man with you, that the descendants of Neptune planted there, and of the magnificent temple, palace, city, and hill; and the manifold streams of goodly navigable rivers, which as so many chains environed the same site and temple; and the several degrees of ascent, whereby men did climb up to the same, as if it had been a Scala Coeli; be all poetical and fabulous; yet so much is true, that the said country of Atlantis, as well that of Peru, then called Coya, as that of Mexico, then named Tyrambel, were mighty and proud kingdoms, in arms, shipping, and riches. . . .

"But the divine revenge overtook not long after those proud enterprises. For within less than the space of 100 years the Great Atlantis was utterly lost and destroyed; not by a great earthquake, as your man saith, for that whole tract is

little subject to earthquakes, but by a particular deluge, or inundation; those countries having at this day far greater rivers, and far higher mountains to pour down waters, than any part of the old world. . . ."

Montaigne's Thinking

MICHEL DE MONTAIGNE
(1533–1592)
Essays, I, 30, "Of Cannibals"

Plato maketh *Solon* to report (Plat. *Tim.*) that he had learn't of the Priests of the Citie of Says in *Ægypt*, that whilom, and before the generall Deluge, there was a great land called *Atlantis*, situated at the mouth of the strait of *Gibraltar*, which contained more firme land than *Affrike* and *Asia* together. . . .

But there is no great apparence the said Iland should be the new world world we have lately discovered; for it wellnigh touched *Spaine*, and it were an incredible effect of inundation to have removed the same more than twelve hundred leagues, as we see it is. Besides, our moderne Navigations have now almost discovered that it is not an Iland, but rather firme land, and a continent.

Vico's Skepticism

GIAMBATTISTA VICO
Principles of the New Science (1744), II, 430

Having now to enter upon a discussion of this matter, we shall give a brief sample of the opinions that have been held respecting it—opinions so uncer-

Francis Bacon, frontispiece to his *Instauratio Magna* (1620)

those of the Hebrews, were inverted runes; and that the Greeks finally straightened them here and rounded them there by rule and compass. And because the inventor is called Merkurssman among the Scandinavians, he will have it that the Mercury who invented letters for the Egyptians was a Goth. Such license in rendering opinions concerning the origins of letters should prepare the reader to receive the things we shall say of them here not merely with impartial readiness to see what they bring forward that is new, but with diligence to meditate upon them and to accept them for what they must be: namely, principles of all the human and divine knowledge of the gentile world.

HELENA BLAVATSKY
The Secret Doctrine (1893),
vol. II, pp. 6–9

Therefore, in view of the possible, and even very probable confusion, that may arise, it is considered more convenient to adopt, for each of the four Continents constantly referred to, a name more familiar to the cultured reader. It is proposed, then, to call the first continent, or rather the first terra firma on which the first Race was evolved by the divine progenitors:— I. "The Imperishable Sacred Land." The reasons for this name are explained as follows: This "Sacred Land"—of which more later on—is stated never to have shared the fate of the other continents; because it is the only one whose destiny it is to last from the beginning to the end of the Manvantara throughout each Round. It is the cradle of the first man and the dwelling of the last *divine* mortal, chosen as a *Sishta* for the future seed of

tain, frivolous, inept, pretentious or ridiculous, and so numerous, that we need not relate them. By way of sample, then: because in the returned barbarian times Scandinavia by the conceit of the nations was called *vagina gentium* and was believed to be the mother of all other nations in the world, therefore by the conceit of the scholars Johannes and Olaus Magnus were of opinion that their Goths had preserved from the beginning of the world the letters divinely invented by Adam. This dream was laughed at by all the scholars, but this did not keep Johannes van Gorp from following suit and going one better by claiming that his own Dutch language, which is not much different from Saxon, has come down from the Earthly Paradise and is the mother of all other languages. This claim was ridiculed by Joseph Justus Scaliger, Philipp Camerarius, Christian Becman, and Martin Schoock. And yet this conceit swelled to the bursting point in the *Atlantica* of Olof Rudbeck, who will have it that the Greek letters came from the runes; that the Phoenician letters, to which Cadmus gave the order and values of

humanity. Of this mysterious and sacred land very little can be said, except, perhaps, according to a poetical expression in one of the Commentaries, that the "pole-star has its watchful eye upon it, from the dawn to the close of the twilight of 'a day' of the GREAT BREATH."

II. The "HYPERBOREAN" will be the name chosen for the Second Continent, the land which stretched out its promontories southward and westward from the North Pole to receive the Second Race. . . .

III. The third Continent, we propose to call "Lemuria." The name is an invention, or an idea, of Mr P. L. Sclater, who asserted, between 1850 and 1860, on zoological grounds the actual existence, in prehistoric times, of a Continent which he showed to have extended from Madagascar to Ceylon and Sumatra. It included some portions of what is now Africa; but otherwise this gigantic Continent, which stretched from the Indian ocean to Australia, has now wholly disappeared beneath the waters of the Pacific, leaving here and there only some of its highland tops which are now islands. . . .

IV. "Atlantis" is the Fourth Continent. It would be the first historical land, were the traditions of the ancients to receive more attention than they have hitherto. The famous island of Plato of that name was but a fragment of this great Continent.

V. The Fifth Continent was America; but, as it is situated at the Antipodes, it is Europe and Asia Minor, almost coeval with it, which are generally referred to by the Indo-Aryan Occultists as the fifth. If their teaching followed the appearance of the Continents in their geological and geographical order, then this classification would have to be altered. But as the sequence of the Continents is made to follow the order of evolution of the Races, from the first to the fifth, our Aryan Root-race, Europe must be called the fifth great Continent. The Secret Doctrine takes no account of islands and peninsulas, nor does it follow the modern geographical distribution of land and sea. . . .

The claim that physical man was originally a colossal pre-tertiary giant, and that he existed 18,000,000 years ago, must of course appear preposterous to admirers of, and believers in, modern learning. The whole *posse comitatus* of biologists will turn away from the conception of this third race Titan of the Secondary age, a being fit to fight as successfully with the then gigantic monsters of the air, sea, and land . . . The modern anthropologist is quite welcome to laugh at our Titans, as he laughs at the Biblical Adam, and as the theologian laughs at his pithecoid ancestor. . . . Occult sciences claim less and give more, at all events, than either Darwinian Anthropology or Biblical Theology.

Nor ought the Esoteric Chronology to frighten any one; for, with regard to figures, the greatest authorities of the day are as fickle and as uncertain as the Mediterranean wave.

To Atlantis with Captain Nemo

JULES VERNE
Twenty Thousand Leagues Under the Sea (1870), II, 9

In a few moments we had put on our equipment. Air tanks, abundantly

charged, were placed on our backs, but the electric lamps were not in readiness. I commented on this to the captain.

"They'll be useless to us," he replied. I thought I hadn't heard him right, but I couldn't repeat my comment because the captain's head had already disappeared into its metal covering. I finished harnessing myself, I felt an alpenstock being placed in my hand, and a few minutes later, after the usual procedures, we set foot on the floor of the Atlantic, 300 meters down. Midnight was approaching. The waters were profoundly dark, but Captain Nemo pointed to a reddish spot in the distance, a sort of wide glow shimmering about two miles from the Nautilus. What this fire was, what substances fed it, how and why it kept burning in the liquid mass, I couldn't say. Anyhow it lit our way, although hazily, but I soon grew accustomed to this unique gloom. . . . After half an hour of walking, the seafloor grew rocky. Jellyfish, microscopic crustaceans, and sea-pen coral lit it faintly with their phosphorescent glimmers. I glimpsed piles of stones covered by a couple million zoophytes and tangles of algae. My feet often slipped on this viscous seaweed carpet, and without my alpenstock I would have fallen more than once. When I turned around, I could still see the Nautilus's whitish beacon, which was starting to grow pale in the distance.

Those piles of stones just mentioned were laid out on the ocean floor with a distinct but inexplicable symmetry. I spotted gigantic furrows trailing off into the distant darkness, their length incalculable. There also were other peculiarities I couldn't make sense of.

It seemed to me that my heavy lead soles were crushing a litter of bones that made a dry crackling noise. So what were these vast plains we were now crossing? . . .

It was one o'clock in the morning. We arrived at the mountain's lower gradients. But in grappling with them, we had to venture up difficult trails through a huge thicket.

Yes, a thicket of dead trees! Trees without leaves, without sap, turned to stone by the action of the waters, and crowned here and there by gigantic pines. It was like a still-erect coalfield, its roots clutching broken soil, its boughs clearly outlined against the ceiling of the waters like thin, black, paper cutouts. Picture a forest clinging to the sides of a peak in the Harz Mountains, but a submerged forest. The trails were cluttered with algae and fucus plants, hosts of crustaceans swarming among them. I plunged on, scaling rocks, straddling fallen tree trunks, snapping marine creepers that swayed from one tree to another, startling the fish that flitted from branch to branch. Carried away, I didn't feel exhausted any more. I followed a guide who was immune to exhaustion. . . .

We arrived at a preliminary plateau where still other surprises were waiting for me. There picturesque ruins took shape, betraying the hand of man, not our Creator. They were huge stacks of stones in which you could distinguish the indistinct forms of palaces and temples, now arrayed in hosts of blossoming zoophytes, and over it all, not ivy but a heavy mantle of algae and fucus plants.

But what part of the globe could this be, this land swallowed by cataclysms? Who had set up these rocks and stones

Illustration for Jules Verne's
*Twenty Thousand Leagues
Under the Sea* (1869–1870)

like the dolmens of prehistoric times? Where was I, where had Captain Nemo's fancies taken me?

I wanted to ask him. Unable to, I stopped him. I seized his arm. But he shook his head, pointed to the mountain's topmost peak, and seemed to tell me:

"Come on! Come with me! Come higher!"

I followed him with one last burst of energy, and in a few minutes I had scaled the peak, which crowned the whole rocky mass by some ten meters. I looked back down the side we had just cleared. There the mountain rose only 700 to 800 feet above the plains; but on its far slope it crowned the receding bottom of this part of the Atlantic by a height twice that. My eyes scanned the distance and took in a vast area lit by intense flashes of light. In essence, this mountain was a volcano. Fifty feet below its peak, amid a shower of stones and slag, a wide crater vomited torrents of lava that were dispersed in fiery cascades into the heart of the liquid mass. So situated, this volcano was an immense torch that lit up the lower plains all the way to the horizon.

As I said, this underwater crater spewed lava, but not flames. Flames need oxygen from the air and are unable to spread underwater; but a lava flow, which contains in itself the principle of its incandescence, can rise to a white heat, overpower the liquid element, and turn it into steam on contact. Swift currents swept away all this diffuse gas, and torrents of lava slid to the foot of the mountain, like the disgorgings of a Mt. Vesuvius over the city limits of a second Torre del Greco.

In fact, there beneath my eyes was a town in ruins, demolished, overwhelmed, laid low, its roofs caved in, its temples pulled down, its arches dislocated, its columns stretching over the earth; in these ruins you could still detect the solid proportions of a sort of Tuscan architecture; farther off, the remains of a gigantic aqueduct; here, the caked heights of an acropolis along with the fluid forms of a Parthenon; there, the remnants of a wharf, as if some bygone port had long ago harbored merchant vessels and triple-tiered war galleys on the shores of some lost ocean; still farther off, long rows of collapsing walls, deserted thoroughfares, a whole Pompeii buried under the waters, which Captain Nemo had resurrected before my eyes!

Where was I? Where was I? I had to find out at all cost, I wanted to speak, I wanted to rip off the copper sphere imprisoning my head.

But Captain Nemo came over and stopped me with a gesture. Then, picking up a piece of chalky stone, he advanced to a black basaltic rock and scrawled this one word: ATLANTIS

The Word of Rosenberg

ALFRED ROSENBERG
The Myth of the Twentieth Century
(1936), I

Geographers depict for us continental masses between North America and Europe whose fragments we see in Iceland and Greenland. On Novaya Zemlya, in one area of the far north, old water lines are revealed more than 100 metres above the present ones. These suggest that the north pole has shifted and that a much milder cli-

mate once prevailed in the Arctic. All in all, the old legends of Atlantis may appear in a new light. It seems far from impossible that in areas over which the Atlantic waves roll and giant icebergs float, a flourishing continent once rose above the waters, and upon it a creative race produced a far reaching culture and sent its children out into the world as seafarers and warriors. But even if this Atlantis hypotheses should prove untenable, a prehistoric Nordic cultural centre must still be assumed.

The Secret of Ys

GEORGES-GUSTAVE TOUDOUZE
The Little King of Ys (1914), III

"Oh yes!" interrupted the little captain of the *Corentine*, with the expression of someone who knows, "out where the city of Ys once stood . . . I know. I've often seen—"
Jobic didn't manage to finish his sentence: he was amazed by the effect that these simple words had on his listeners. Mornant and Gerolamo Trottier leaped to their feet.
"You know . . . You've seen?" stammered Mornant. Jobic looked at them in great surprise, as if it were something absolutely natural.
"Of course! . . . Everyone around these parts knows that many, many years ago the sea swallowed up a city by the name of Ys, to punish the sins of the people who lived there. There's even a Breton song, which you'll understand better if I translate it for you: 'Have you heard, have you heard—What the man of God said—to King Gradlon of Ys . . .'"

"Oh! I thought you meant something else entirely. So you only know the song, the one that everyone knows round here . . . And nothing else?"
"But of course, sir, I know more than the song. The song's good enough for farmers, for old rag and bone men! But I'm talking about the city itself. Yes sir, the houses under the water."
Mornant came closer, placing his hands on the boy's shoulders, and in a voice designed to inspire calm, he said slowly:
"Listen to me carefully, Jobic. What I'm asking you is very important, and your answer might be worth more than you can imagine. I came here with the sole purpose of searching for the city of Ys, and I have a firm and unshakeable belief that it exists. I think that the ruins of the city are somewhere around here, beneath the waters of the bay, and I will spend weeks or even months looking for them. So think carefully about what you're saying. Are you telling us that you know about the city?"
Jobic also became very serious and stood up with his hand raised as if swearing an oath; looking straight into the other man's eyes, he replied:
"Yes, I know about the city of Ys."
"Because you've been told about it at school or in conversation? Like a story or a legend?"
"I know about it because I've seen it."
"You've seen a drawing of it, an image of it?:
"I've seen it in the sea, under the water."
"You've imagined you've seen it because you've heard people talking about it?"
"I've seen it twenty times with my own eyes. I've touched pieces of stone from its buildings that have come up

Posters for Jacques
Feyder's film L'Atlantide,
based on the novel by
Pierre Benoît

Posters for Jacques Feyder's film *L'Atlantide*, based on the novel by Pierre Benoît

from the seabed in our nets. It was my uncle who took me there to show me where not to drop lobster pots, or else they'd get caught on the walls on the bottom. And he told me that once, many, many years ago—"

"That's right, in the fifth century AD."

"Maybe! But anyway, before France became France he told me that the bay of Douarnenez didn't exist, and that between the Cap de la Chèvre and the Pointe du Raz stood Ys, a magnificent city behind a sea wall, ruled by an old and very wise king called Gradlon,

who had a very wicked daughter called Ahès—"

"That's the Breton name. In French, she's called Dahut," Trottier interrupted.

"I'm not saying she isn't," continued Jobic, unperturbed. "And one evening, when Gradlon was asleep, Ahès met a dancer at a ball at the royal court, who convinced her to steal the golden key to the gates from her father and to open the gates, which held back the sea. The dancer was the devil. Ahès stole the key, opened the door and the Ocean crashed down onto the

city of Ys. Awoken by his friend Saint Winwaloe, Gradlon climbed onto his horse and carried off his daughter, but the sea raced after him with the speed of a high tide, and a voice shouted out: 'Throw down the demon you're carrying behind you!' Ahès fell, the waves swallowed her up, and the sea stopped on the Plage du Riz, whilst Gradlon continued to Landévennec, and the bay of Douarnenez was created. And there you have it."

Gerolamo Trottier rubbed his hands together:

"A marvellous folk adaptation of a seismic phenomenon that destroyed Ys in the space of a few minutes, burying it alive a hundred meters under the water, whilst creating this marvellous bay through a process of geological subsidence."

The City in the Sea

EDGAR ALLAN POE
"The City in the Sea" (1845)

Lo! Death has reared himself a throne
In a strange city lying alone
Far down within the dim West,
Where the good and the bad and the
 worst and the best
Have gone to their eternal rest.
There shrines and palaces and towers
(Time-eaten towers that tremble not!)
Resemble nothing that is ours.
Around, by lifting winds forgot,
Resignedly beneath the sky
The melancholy waters lie.

No rays from the holy heaven come
 down
On the long night-time of that town;
But light from out the lurid sea
Streams up the turrets silently—

Évariste-Vital Luminais,
The Flight of King Gradlon
(1884), Rennes,
Musée des beaux-arts

Gleams up the pinnacles far and free—
Up domes—up spires—up kingly
 halls—
Up fanes—up Babylon-like walls—
Up shadowy long-forgotten bowers
Of sculptured ivy and stone flowers—
Up many and many a marvelous
 shrine
Whose wreathéd friezes intertwine
The viol, the violet, and the vine.
Resignedly beneath the sky
The melancholy waters lie.
So blend the turrets and shadows there
That all seem pendulous in the air,
While from a proud tower in the town
Death looks gigantically down.

There open fanes and gaping graves
Yawn level with the luminous waves;
But not the riches there that lie
In each idol's diamond eye—
Not the gaily-jeweled dead

Tempt the waters from their bed;
For no ripples curl, alas!
Along that wilderness of glass—
No swellings tell that winds may be
Upon some far-off happier sea—
No heavings hint that winds have been
On seas less hideously serene.

But lo, a stir is in the air!
The wave—there is a movement there!
As if the towers had thrust aside,
In slightly sinking, the dull tide—
As if their tops had feebly given
A void within the filmy Heaven.
The waves have now a redder glow—
The hours are breathing faint and
 low—
And when, amid no earthly moans,
Down, down that town shall settle
 hence,
Hell, rising from a thousand thrones,
Shall do it reverence.

7.

ULTIMA THULE AND HYPERBOREA

Olaus Magnus,
Carta marina (detail, 1539),
private collection

THULE Thule was mentioned for the first time in a travelogue by the Greek explorer Pytheas, who had described it as a land in the North Atlantic, a land of fire and ice in which the sun never set. It had been mentioned by Eratosthenes, Dionysius Periegetes, Strabo, Pomponius Mela, Pliny the Elder, and Virgil (who in the 1.30 mentions it as the last land beyond the boundaries of the known world), and Antonius Diogenes in the romance *The Incredible Wonders beyond Thule*, in the second century AD. The myth was picked up again by Martianus Capella and survived throughout the Middle Ages, from Boethius to Bede to Petrarch, until modern writers, who, even when they no longer look for it, use it as a poetic myth. From time to time the island has been identified with Iceland, the Shetlands, the Fair Isles, or the island of Saaremaa. But what counts is that this inaccurate geographical information gave rise to the myth of *Ultima Thule.*

In the *Carta Marina* (Map of the Sea) by Olaus Magnus (1539) we find the most famous image of this legendary island.

But other islands in the Far North were mentioned by fourteenth-century navigators, such as Nicolò and Antonio Zeno, who maintained they had landed on islands such as Frisland and Eslanda. In 1558, one of their descendants, Nicolò Zeno, published a book, *The Discovery of the Islands of Frisland, Iceland, Greenland, Estotiland, and Icaria Made by Two Brothers Zeni*—and even on Mercator's maps, we find the islands of Frisland and Drogio. In 1570 Ortelius recorded the islands of Frisland, Drogio, Icaria, and Estotiland on the map "Septentrionalium regionum descriptio" (Description of the Region of Ursa Minor, i.e., the Far North) in his *Theatrum Orbis terrarum*

(Theater of the World). Influenced by Nicolò Zen's book, the erudite English occultist John Dee, much respected at the British court, had planned to find a passage toward the Pacific located to the north and gave Martin Frobisher the task of making due explorations.

Norman ships, from *The Tapestry of Queen Mathilda* (1027–1087), Bayeux, Musée de la Tapisserie

THE HYPERBOREANS The Thule myth then merged with that of the Hyperboreans. The Hyperboreans ("those who live beyond Boreas," which was the personification of the north wind) were thought by the ancients to be a people who lived in a very distant land lying north of Greece. This region was a perfect country, illuminated by a sun that shone for six months a year.

Hecataeus of Miletus (sixth century BC) located the Hyperboreans in the Far North, between the ocean (which surrounded the known lands like a ring) and the Riphean Mountains (a legendary mountain chain of uncertain location, sometimes in the Far North and sometimes at the mouth of the Danube).

Hecataeus of Abdera (fourth to third century BC) in his *On the Hyperboreans* (of which we know only a few fragments), places these mountains on an island in the ocean "no smaller than Sicily in size," an island from which it was possible to see the moon from close up.

Hesiod located the Hyperboreans "near the high waterfalls of the Eridanus." Given that the Eridanus was the Po, then his Hyperboreans did not live too far north, but when it came to the Far North, Hesiod's view was decidedly provincial, while his idea of the Po was too fantastic. On the other side of the Greek world, there was debate about the geographical location of this river, and some sources had it that the Eridanus debouched into the northern ocean. Pindar located the Hyperboreans in the region of the "shadowy sources" of the Ister (which was the Danube), and in a passage from *Prometheus Unbound*, Aeschylus says that the source of the Ister lay in the land of the Hyperboreans and the Riphean Mountains. According to Damastes of Sigeum, the Riphean Mountains stood northward of gold-guarding griffins.

Herodotus gives a summary of a poem by Aristeas of Proconnesus, now lost, in which the author spoke of a journey to distant regions inspired by Apollo, to the land of the Issedones, "beyond which" there supposedly lived the one-eyed Arimaspi, the griffins, and finally the Hyperboreans, who lived in a land of eternal springtime where feathers fluttered in the air.

In general, in ancient accounts, Hyperborea, wherever it was, was not indicated as the home of a chosen people, but at the height of nationalistic hypotheses on the origins of languages, the Far North was seen more and more as the homeland and language of the primordial race. In the *Circles of Gomer*, Rowland Jones (1771) maintained that the primordial language was Celtic and that "no tongue except English shows itself to be so close to the first universal language. . . . Celtic dialects and wisdom derive from the circle of Trismegistus, Hermes, Mercury or Gomer." Bailly had said that the Scythians were one of the oldest nations and the Chinese themselves descended from them, but he had also said that the Atlanteans, too, were their descendants. In short, the cradle of civilization was supposedly the north, and from there the mother races had spread out toward the south—and according to some, in this process they had degenerated. Hence the belief in a Hyperborean origin of the Aryan race, the only one left uncontaminated.

There are many interpretations of the polar legend: accord=
ing to some authors, it was precisely the cold of the Nordic countries
that had encouraged civilization, while the Mediterranean and
African heat had produced inferior races; according to others, howev-
er, Nordic civilization had reached full development as it descended to
the more temperate regions of Asia; according to others again, the po-
lar zones had enjoyed a balmy climate. For example, in his *Paradise
Found* (1885), William F. Warren, despite his status as rector of Boston
University, held that the cradle of humanity, the location of the
Earthly Paradise, was the North Pole. As an orthodox anti-Darwinian,
he explained that mankind as we know it was not the result of the evo-
lution of inferior beings but the opposite, because the first inhabitants
of the pole were beautiful and long-lived, and only after the Flood and
an Ice Age had they immigrated to Asia, where they had changed into

Thomas Ender, *Glacier*
(nineteenth century),
Bremen, Kunsthalle

Pages 228–229:
Abraham Ortelius,
Map of Iceland
(sixteenth century)

the inferior beings of our time; in prehistory the polar regions were supposedly sunny and temperate, and the involution of the species had occurred in the cold of the Central Asian steppes.

In order to support the theory of a temperate pole, it would have been necessary to admit (as occultists and "polar theorists" of all kinds have continued to do to this day) that climatic changes had been due to a notable shift of the terrestrial axis. This notion has produced such a quantity of more or less scientific works, arguments, and disquisitions that we cannot sum them all up here, given that a history of legendary lands is only interested in knowing in what way these countries were imagined, and for now it is sufficient to include the temperate poles in their number.[1]

Warren, who still had a smidgen of scientific seriousness, had not accepted the theory of the shift in the terrestrial axis and suggested that the first descendants of the polar peoples, once they arrived in Asia, saw the firmament from a different perspective, and in their ignorance as degenerate descendants, they had invented false astronomical beliefs based on it. In any case, here we are faced with the establishment of the superiority of the "polar peoples" and the inferiority of Asians and the Mediterranean peoples, which was later to nourish the myth of Aryanism.

The location of the original Aryans also produced an infinity of hypotheses. In 1883 Karl Penka said they sprang from northern Germany and Scandinavia; in the same year Otto Schrader maintained they came from the Ukraine. The first to think of another continent for the fathers of the human race were eighteenth-century Enlightenment figures, including Voltaire, Kant, and Herder, against biblical tradition. At the time, they thought of India, but obviously the German Romantics tended to think of a people whose roots lay in the Teutonic tribes that Caesar had failed to defeat and which gave rise to Romano-barbarian civilization and the great flourishing of the medieval Gothic cathedrals. There was nothing else to do but connect Indian civilization with that of the Nordic peoples, and even linguists saw to this with their research into Sanskrit as the mother tongue of humanity.[2]

1. *For a documented presentation of all the "polar" theories, see Goodwin (1996).*

2. *See Eco (1993).*

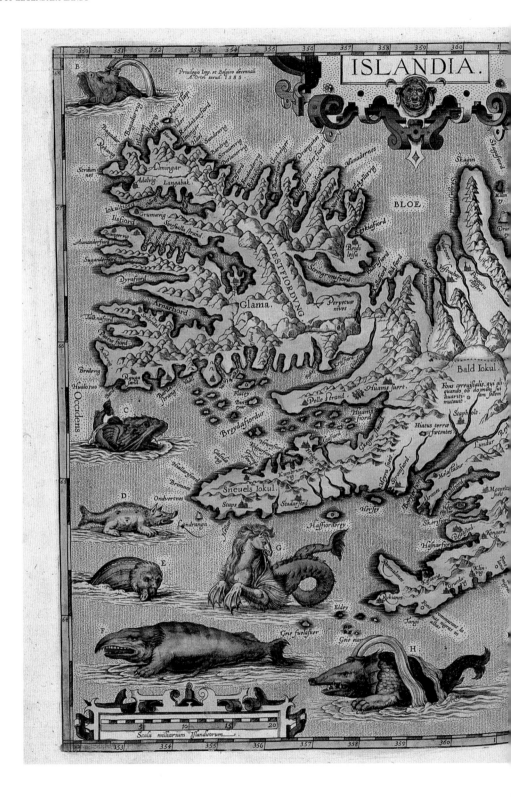

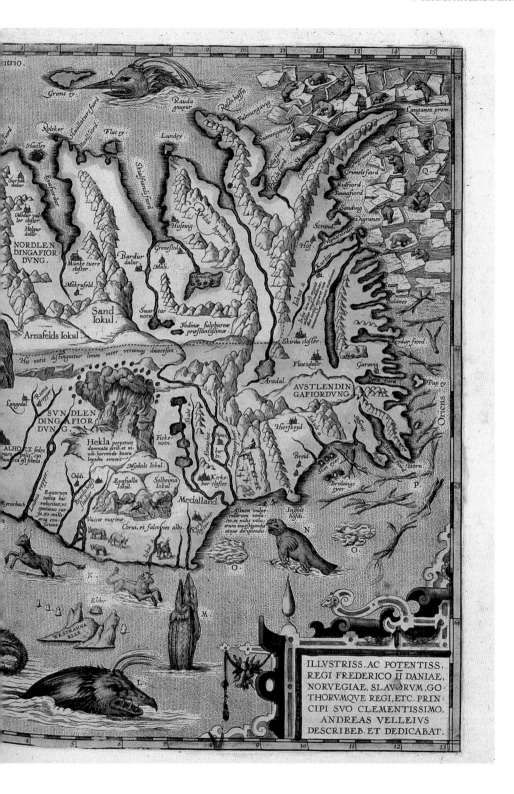

ILLVSTRISS. AC POTENTISS.
REGI FREDERICO II DANIAE,
NORVEGIAE, SLAVORVM, GO
THORVMQVE REGI, ETC. PRIN
CIPI SVO CLEMENTISSIMO,
ANDREAS VELLEIVS
DESCRIBEB. ET DEDICABAT.

Even though many of the scholars who encouraged it were unaware of what their research would lead to, this marked the birth of the myth of Aryanism.[3]

The Occultist tradition was the factor that profoundly influenced this myth. In *The Secret Doctrine* (1888), Madame Blavatsky, whom we have already met on the subject of Atlantis, supported the theory of the migration of a perfect race from north of the Himalayas, but after the Flood, this race purportedly migrated as far as Egypt (which allows us to think that Blavatsky's theories were not, at least not intentionally, racist). Blavatsky described a fantastic history of humanity, in which Hyperborea was represented as a polar continent that extended from today's Greenland to Kamchatka and was supposedly the home of the second race of humanity, gigantic androgynes with monstrous features.

Friedrich Nietzsche in *The Antichrist* (1888) says, "We are Hyperboreans," and takes the opportunity to celebrate the ancient Nordic virtues as compared to the degeneration of Christianity.

The map we find in Joscelyn Godwin's *Arktos* (1996) clearly shows us in how many places the land of the Hyperboreans has been located over time. Even if the entire theory had some element of truth, only one of these locations would be correct, and so we find ourselves faced with about fifteen legends. The Hyperboreans, like the Grail, have slithered like eels across the centuries.

In the nineteenth century, the Hyperborean origin of Aryanism exercised many occultist authors, such as Fabre d'Olivet (1822), but the myth was obviously reinvigorated with Pan-Germanism and Nazism.

THE POLAR MYTH AND NAZISM In Nazi circles before Hitler's rise to power, there were groups of adepts of occult sciences. It is still a subject for debate as to which Nazi officials truly belonged to the various occult sects and to what degree Hitler really subscribed to this cultural climate.[4] But in any case, there is no doubt that 1912 saw the birth of a *Germanorden* that supported Ariosophy, in other words, the philosophy of Aryan superiority. In 1918 Baron von

3. *It was Friedrich Schlegel who coined the term "Aryans" in 1819. For the myth of Aryanism see the excellent Olender (1989).*

4. *See, for example, the studies by Galli (1983) and Goodricke-Clarke (1985).*

Map showing the various hypotheses on the origin of Aryans in Joscelyn Godwin's *Arktos* (1996)

N. OF FINLAND (Rhys) Bailly's Atlantis POLAR HOMELAND (Warren, Tilak, Spencer)

SCANDINAVIAN HOMELAND (Penka)

CENTRAL EUROPE (Taylor)

BALTIC HOMELAND (Rendall)

BOREAL RACE (Fabre d'Olivet)

SIBERIA

UKRAINIAN HOMELAND (Schrader, Morris)

Bailly's Migrations

"SCYTHIA"

BLACK SEA

MEDITERRANEAN SEA

CASPIAN SEA

CENTRAL ASIAN HOMELAND (Rhode, Max Müller)

MONGOLIA

EGYPT SYRIA

MESOPOTAMIAN HOMELAND (Mommsen, Hale)

IRAN

GOBI CIVILIZATION (Blavatsky)

HIMALAYAS (Herder) TIBET (Kant)

CHINA

RED SEA

ARABIAN PENINSULA

INDIAN HOMELAND (Voltaire)

INDIA

AFRICA

INDIAN OCEAN

Sebottendorff founded the Thule Gesellschaft, a secret society with a pronounced racist streak. And it was in the Thule Gesellschaft that the adoption of the swastika begins.

In 1907 a certain Jörg Lanz had founded an Order of the New Temple, which seems to have inspired Himmler with the idea of the SS and all their principles of Aryan supremacy. For the inferior races, Lang had recommended castration, sterilization, deportation to Madagascar, and incineration as a sacrifice to the divinity—all principles that, mutatis mutandis, were later to be applied by Nazi racism.

In 1935 Himmler was to found the *Ahnenerbe Forschungs- und Lehrgemeinschaft* (Society for Research and Teaching of the

Ancestral Inheritance), an institute devoted to research into the anthropological and cultural history of the Germanic race, which aimed at rediscovering the greatness of the populations of ancient Germany, the origin of the Nazi superior race. It is said that this association, influenced by the fantasies of Otto Rahn (of whom we shall be speaking in the chapter on the Grail), was interested in finding the sacred relic, obviously seen not as a Christian symbol but as a source of power for the true descendants of Nordic paganism. It seems that Himmler was also strongly influenced by that current of Ariosophy, which, following the thinking of Guido von List (who died before the advent of Nazism but left a plethora of devoted disciples), attached capital importance to the ancient Nordic runes, seen not so much as a system of writing of the ancient Germanic peoples, but as magic symbols through which one could obtain occult powers, practice divination and sortileges, prepare amulets, and permit the circulation of a subtle energy that pervaded the entire universe and which served therefore to determine the course of events—nor should we forget that the Nazi swastika was inspired by runic characters.

In a television interview granted after the war, General Karl Wolff, who commanded the SS in Rome, said that Hitler, who had ordered him to kidnap Pope Pius XII to intern him in Germany, had also told him to go to the Vatican Library and take from it certain runes that evidently had an esoteric value for him. Wolff said he had put off the kidnapping with various pretexts, including the difficulty of finding the precise location of the famous runes beforehand. Whether or not this was the truth (certainly the plan to kidnap the pope is document-

Emblem of the Thule Gesellschaft (1919)

ARYAN IDEAL REALITY

Gerade du! (You too!), Aryan
ideal from the magazine
Signal

Portrait of Adolf Hitler
(1923)

Arno Breker, *Readiness*
(1939)

Joseph Goebbels at a rally
(1931)

Josef Thorak, *Comradeship*
(1937), ideal of Aryan beauty

Portrait of Heinrich
Himmler (1945)

ed), in any event occultism, hostility towards any form of modern scientific theory (thought to be of Jewish origin), and the frantic research for a pure and original German wisdom—all these were elements that circulated in the Nazi community.

The other theorist who left a strong mark on the events of Nazism was Alfred Rosenberg, whose *Myth of the Twentieth Century* (1930) was the biggest success in Germany, after Hitler's *Mein Kampf,* and sold more than one million copies; and here, too, we find references to the myth of the Nordic race and, naturally, Atlantis and Ultima Thule.[5]

Finally, see the texts on Hyperborean civilization by Julius Evola (1934 and 1937).

THE THEORY OF ETERNAL ICE Apart from the myth of Hyperborea, there were even wilder geoastronomies, which have apparently inspired very serious thoughts and decisions, albeit decidedly not commendable ones. Since 1925, Nazi circles had publicized a theory known as WEL, for *Welteislehre* (world ice theory), by an Austrian pseudoscientist, Hanns Hörbiger,. The theory had been made known by the book *Glacial Cosmogony* by Philipp Fauth (1913), much of which was written by Hörbiger himself. It had enjoyed the favor of men such as Rosenberg and Himmler. But with Hitler's rise to power, Hörbiger was taken seriously in some scientific circles too, for example by scholars such as Philipp Lenard, who had discovered X-rays with Wilhelm Röntgen.

In Hörbiger's view, the cosmos was the theatre of an eternal struggle between fire and ice, which does not produce evolution but an alternation of cycles, or epochs. Once there was a huge, very hot body, millions of times bigger than the sun, which collided with an immense accumulation of cosmic ice. The mass of ice had penetrated this incandescent body, and after having worked in its interior as steam for hundreds of millions of years, it eventually caused the whole thing to blow up. Various fragments were projected into both frozen space and an intermediate zone, where they constituted the solar system. The moon, Mars, Jupiter, and Saturn

5. *For a text by Rosenberg, see the anthology in chapter 6 on Atlantis.*

Philipp Fauth, from
Glacial Cosmonogie (1913)

are frozen, and one ring of ice is the Milky Way, in which traditional astronomy sees stars; but these were photographic tricks. Sunspots are produced by blocks of ice detached from Jupiter.

Now the force of the original explosion was waning, and each planet does not make an elliptical revolution, as official science erroneously believes, but a roughly spiral one (imperceptible) around the bigger planet that attracts it. At the end of the cycle in which we are living, the moon will draw closer and closer to the Earth, gradually making the level of the oceans rise, submerging the tropics and leaving only the highest mountains above sea level; cosmic rays will become more powerful and will cause genetic mutations. In the end, our satellite will explode, transforming itself into a ring of ice, water, and gas, which will eventually fall on the Earth. Owing to complex factors due to the influence of Mars, the Earth, too, will change into an icy globe, and in the end it will be reabsorbed by the sun. Then there will be a new explosion and a new beginning, just as in the past the Earth had already possessed and then reabsorbed another three satellites.

Clearly this cosmogony entailed a kind of eternal return, which referred to very ancient myths and epics. Yet again, what even modern Nazis call the knowledge of tradition was thus opposed to the false knowledge of liberal and Jewish science. What's more, a glacial cosmogony seemed very Nordic and Aryan. Pauwels and Berger (1960) attribute to this profound belief in the glacial origins of the cosmos Hitler's confidence that his troops could cope easily with the Russian winter. But Pauwels and Berger also maintain that the need to find out how the cosmic ice would react had also delayed experiments on the V-1, the prototype of the missiles that Nazi Germany counted on to turn the tide of war in their favor.

A pseudo Elmar Brugg (1938), had published a book honoring Hörbiger as the Copernicus of the twentieth century, maintaining that the theory of eternal ice explained the deep bonds that unite earthly events with cosmic forces and concluding that the silence of democratic-Judaic science regarding Hörbiger was a typical case of a conspiracy among the mediocre.

A CONTRADICTION: THE HYPERBOREANS OF THE MEDITERRANEAN At first, the theory of pure Aryanism obviously excluded Mediterranean peoples, such as the French, the Italians, and even the British, but gradually the various racist speculations had to recognize all European peoples as Aryans. See the pathetic attempts of Fascist racism and its magazine *La difesa della razza* (The Defence of the Race), which had tried at all costs to make even small, dark Mediterranean peoples fit the "Hyperborean" model; having to transform the hook-nosed Dante Alighieri into an Aryan, it had come up with the theory of the "aquiline race." This having been done, it was only a matter (as the ultimate conclusions were to have it) of eliminating the non-Aryans, the Semitic peoples in particular.

It was also a matter or Aryanizing, or "polarizing," even that most Mediterranean of countries, Greece, which could not be ignored, because all of German Romanticism recognized it as the cradle of civilization. Even in the twentieth century, Heidegger, a

Front cover of the racist magazine *La difesa della razza* (first edition, 5 August, 1938)

philosopher suspected of Nazi sympathies, said that you can philosophize only in German or Greek.

Thus steps were taken to Aryanize Greece in the twentieth century, maintaining that Greek civilization purportedly sprang from an invasion of the Mediterranean by Indo-European peoples. A debated theory, not devoid of probative arguments, but one that does not interest us here, where it suffices to note how much the "polar" model had prevailed in the last two centuries, also inspiring other "polar" legends that we shall have to deal with in the chapter on the hollow Earth.

Thule

STRABO (64 BC–AD 19)
Geographica, IV, 5, 5

Concerning Thule our historical information is still more uncertain, on account of its outside position; for Thule, of all the countries that are named, is set farthest north. . . . the people live on millet and other herbs, and on fruits and roots; and where there are grain and honey, the people get their beverage, also, from them.

Herodotus and the Hyperboreans

HERODOTUS (C. 484–430/420 BC)
Histories IV, 13

Aristeas also, son of Caystrobius, a native of Proconnesus, says in the course of his poem that wrapt in Bacchic fury he went as far as the Issedones. Above them dwelt the Arimaspi, men with one eye; still further, the gold-guarding griffins; and beyond these, the Hyperboreans, who extended to the sea. Except the Hyperboreans, all these nations, beginning with the Arimaspi, were continually encroaching upon their neighbours. Hence it came to pass that the Arimaspi drove the Issedonians from their country, while the Issedonians dispossessed the Scyths; and the Scyths, pressing upon the Cimmerians, who dwelt on the shores of the Southern Sea, forced them to leave their land. Thus even Aristeas does not agree in his account of this region with the Scythians.

Detail of an Apulian red figure volute crater, Arimasmus riding a griffin (340 BC), Berlin, Antikensammlung, Staatliche Museen zu Berlin

DIODORUS SICULUS
(FIRST CENTURY BC)
Library of History, II, 47, 1–6

Now for our part, since we have seen fit to make mention of the regions of Asia which lie to the north, we feel that it will not be foreign to our purpose to discuss the legendary accounts of the Hyperboreans. Of those who have written about the ancient myths, Hecataeus and certain others say that in the regions beyond the land of the Celts there lies in the ocean an island no smaller than Sicily. This island, the account continues, is situated in the north and is inhabited by the Hyperboreans, who are called by that name because their home is beyond the point whence the north wind (Boreas) blows; and the island is both fertile and productive of every crop, and since it has an unusually temperate climate it produces two harvests each year. Moreover, the following legend is told concerning it: Leto was born on this island, and for that reason Apollo is honoured among them above all other gods; and the inhabitants are looked upon as priests of Apollo, after a manner, since daily they praise this god continuously in song and honour him exceedingly. And there is also on the island both a magnificent sacred precinct of Apollo and a notable temple which is adorned with many votive offerings and is spherical in shape. Furthermore, a city is there which is sacred to this god, and the majority of its inhabitants are players on the cithara; and these continually play on this instrument in the temple and sing hymns of praise to the god, glorifying his deeds.

The Hyperboreans also have a language, we are informed, which is peculiar to them, and are most friendly disposed towards the Greeks, and especially towards the Athenians and the Delians, who have inherited this goodwill from most ancient times. The myth also relates that certain Greeks visited the Hyperboreans and left behind them there costly votive offerings bearing inscriptions in Greek letters. And in the same way Abaris, a Hyperborean, came to Greece in ancient times and renewed the good-will and kinship of his people to the Delians. They say also that the moon, as viewed from this island, appears to be but a little distance from the earth and to have upon it prominences, like those of the earth, which are visible to the eye. The account is also given that the god visits the island every nineteen years, the period in which the return of the stars to the same place in the heavens is accomplished; and for this reason the nineteen-year period is called by the Greeks the "year of Meton." At the time of this appearance of the god he both plays on the cithara and dances continuously the night through from the vernal equinox until the rising of the Pleiades, expressing in this manner his delight in his successes. And the kings of this city and the supervisors of the sacred precinct are called Boreadae, since they are descendants of Boreas, and the succession to these positions is always kept in their family.

The Hyperborean People

FRIEDRICH NIETZSCHE
The Antichrist (1888), 1, 2, 5, 19

Let us look each other in the face. We are Hyperboreans—we know well enough how remote our place is.

Odin on His Throne
(nineteenth century),
colored print

"Neither by land nor by water will you find the road to the Hyperboreans": Pindar, even in his day, knew *that* much about us. Beyond the North, beyond the ice, beyond *death—our* life, *our* happiness. . . . We have discovered that happiness; we know the way: we got our knowledge of it from thousands of years in the labyrinth. Who *else* has found it?—The man of today?—"I don't know either the way out or the way in; I am whatever doesn't know either the way out or the way in"—so sighs the man of today. . . . *This* is the sort of modernity that made us ill—we sickened on lazy peace, cowardly compromise, the whole virtuous dirtiness of the modern Yea and Nay. This tolerance and *largeur* of the heart that "forgives" everything because it "understands" everything is a sirocco to us. . . . We were brave enough, we spared neither ourselves nor others: but we were a long time finding out *where* to direct our courage. We grew dismal; they called us fatalists. *Our* fate—was the fulness, the tension, the *storing up* of powers. We thirsted for the lightnings and great deeds: we kept as far as possible from the happiness of the weakling, from "resignation." . . . There was thunder in our air; nature, as we embodied it, became overcast—*for we had not yet found the way*. The formula of our happiness: a Yea, a Nay, a straight line, a *goal*. . . .

What is good?—Whatever augments the feeling of power, the will to power, power itself, in man.
What is evil?—Whatever springs from weakness.
What is happiness?—The feeling that power *increases*—that resistance is overcome.

Not contentment, but more power; *not* peace at any price, but war; *not* virtue, but efficiency (virtue in the Renaissance sense, *virtu*, virtue free of moral acid).
The weak and the botched shall perish: first principle of *our* charity. And one should help them to it.
What is more harmful than any vice?—Practical sympathy for the botched and the weak— Christianity. . . .

One should not deck out and embellish Christianity: it has waged a war to the death against this *higher* type of man, it has put all the deepest instincts of this type under its ban, it has developed its concept of evil, of the Evil One himself, out of these instincts—the strong man as the typical reprobate, the "outcast among men." Christianity has taken the part of all the weak, the low, the botched; it has made an ideal out *antagonism* to all the self-preservative instincts of sound life; it has corrupted even the faculties of those natures that are intellectually most vigorous, by representing the highest intellectual values as sinful, as misleading, as full of temptation. The most lamentable example: the corruption of Pascal, who believed that his intellect had been destroyed by original sin, whereas it was actually destroyed by Christianity! . . .

The fact that the strong races of northern Europe did not repudiate this Christian god does little credit to their gift for religion—and not much more to their taste. They ought to have been able to make an end of such a moribund and worn-out product of the *décadence*. A curse lies upon them because they were not equal to it; they

made illness, decrepitude and contradiction a part of their instincts.…

A N T O I N E F A B R E D ' O L I V E T

On the Social State of Man; or,
Philosophical Observations on the
History of the Human Race (1822), I, 1

I shall transport myself for this purpose to an epoch sufficiently remote from this in which we are living, and, fortifying my mental vision, which as long prejudice may have weakened, I shall fix across the obscurity of centuries the moment when the White Race, of which we are a part, came to appear upon the scene of the world. At this epoch of which I shall seek later to determine the date, the White Race was still weak, savage, without laws, without arts, without civilization of any sort, destitute of memories, and too devoid of understanding even to conceive a hope. It inhabited the environs of the Boreal pole where it had it origin. The Black Race, more ancient than the White, was dominant upon the earth and held the sceptre of science and of power; it possessed all of Africa and the greater part of Asia, where it had enslaved and restrained the Yellow race. Some remnants of the Red Race had languished obscurely upon the summits of the highest mountains of America and had survived the horrible catastrophe which had just struck them; these weak remnants were unknown; the Red Race to whom they had belonged had not long since possessed the Occidental hemisphere of the globe; the Yellow Race, the Oriental; the Black Race then sovereign, spread to the south on the equatorial line, and, as I have just said, the White Race which was only then springing up, wandered about the environs of the Boreal pole.

These four principal races and the numberless varieties which result from their mixture compose the *Kingdom of Man*.… These four races clashed and fought together, turn by turn, distinguished and confused. Many times they disputed among themselves the scepter of the world.… My intention is not to enter into the vicissitudes anterior to the the actual order of things, the infinite details of which would overpower me with a useless burden and would not lead me to the end that I purpose to attain. I shall devote myself only to the White Race to which we belong and to outlining the history, from the epoch of its last appearance at the environs of the Boreal pole: it is from there that they descended in swarms at diverse times to make incursions as much upon other races when they were still dominant as upon themselves when they had seized the dominion. The vague memory of this origin, surviving the torrent of the centuries has caused the Boreal pole to be named the nursery of Mankind. It has given birth to the name Hyperboreans and to all the allegorical fables which have been recited concerning them; it has furnished, in short, numerous traditions which have led Olaüs Rudbeck to place in Scandinavia the Atlantis of Plato and which authorized Bailly to discern upon the rocks, deserted and whitened by the hoarfrost of Spitzbergen, the cradle of all sciences, all arts, and all mythologies of the world.

It is assuredly very difficult to say at what epoch the White Race, or the Hyperboreans, began to be united by any form of civilization, and it is still less easy to say at what more remote epoch they began to exist. Moses, who

Konrad Dielitz, Wagner's *Siegfried*, act II, scene 6, illustration (nineteenth century)

speaks of them in the sixth chapter of *Beræshish* [Genesis], under the name of Ghiboreans, whose names have been so celebrated in the depths of time, traces their origin to the first ages of the world. One finds a hundred times the name of Hyperboreans in the writings of the ancients, and never any positive light upon them. According to Diodorus of Sicily their country was nearest to the moon; which can be understood from the elevation of the pole which they inhabited. Æschylus in his *Premetheus* [*sic*], placed them upon the Rhipæn [*sic*] mountains. A certain Aristeas of Proconesus, who, is it said, had made a poem upon these people, and who claimed to have visited them, affirmed that they occupied the country northeast of upper Asia which we call today Siberia. Hecate [*read* Hecataeus] of Abdera, in a work published in the time of Alexander, placed them still further back, and lodged them among the white bears of Nova Zembla on an island called *Elixoïa*. The pure truth is, as avowed by Pindar more than five centuries before our era, that no one knew in which region was situated the country of this people. Herodotus himself, so curious to collect all antique traditions, has in vain interrogated the Scythians about them and had been unable to discover anything certain.

The Symbolism of the Pole

JULIUS EVOLA
Revolt Against the Modern World (1934)

In addition to the symbol of the pole, there are some recurrent and very specific traditional data that indicate the North as the site of an island, terra firma, or mountain, the meaning of which is often confused with the location of the first era; in other words, we are confronted by a motif that simultaneously has a spiritual and a real meaning, pointing back to a time when the symbol was reality and the reality a symbol and history and metahistory were not two separated parts but rather two parts reflecting each other. This is precisely the point in which it is possible to enter into the events conditioned by time. Allegedly, according to tradition, in an epoch of remote prehistory that corresponds to the Golden Age or Age of Being, the symbolical island or "polar" land was a real location situated in the Arctic, in the area that today corresponds to the North Pole. This region was inhabited by beings who by virtue of their possession of that nonhuman spirituality (characterized by gold, "glory," light, and life) that in later times will be evoked by the abovementioned symbolism, founded the race that exemplified the Uranian tradition in a pure state; this race, in turn, was the central and most direct source of the various forms and manifestations this tradition produced in other races and civilizations....

Hyperborea, the White Island of the Aryans

JULIUS EVOLA
The Mystery of the Grail (1937)

Another fundamental traditional teaching, which I have discussed elsewhere with corresponding documentation, is the location of the centre or primordial seat of the Olympian civilization of the Golden Age in a

Henry Fuseli (Johann Heinrich Füssli), *Thor Battering the Mitgard Serpent* (1790), London, Royal Academy of Arts

Due volti due età

ma lo stesso sorriso, la stessa razza

Lino Businco, "The woman as depository of the characteristics of a racial type," in *La difesa della razza* (20 September, 1938)

Right:
Johann Heinrich Wüest, *The Rhone Glacier* (1769), Zurich, Kunsthaus

Boreal or Nordic-Boreal region that became uninhabitable. A tradition of Hyperborean origins, in its original Olympian form or in its new emergences of a heroic type, is at the basis of founding or civilizing deeds performed by races that spread into the Eurasian continent during the period from the end of the glacial age through the Neolithic Era. Some of these races must have come directly from the North; others seem to have had as their country of origin a Western-Atlantic land in which some kind of replica of the Northern centre had been established. This is the reason why various concordant symbols and memories refer to a land that sometimes is Northern-Arctic and other times Western.

Among the many designations of the Hyperborean centre that came to be applied also to the Atlantic centre was Thule, or "White Island," or "Island of Splendour" (the Hindu Śveta-dvīpa; the Hellenic Leuké island; the "original seed of the Arian race" or Ariyana Vaego in ancient Iran); and "Land of the Sun" or "Land of Apollo," that is, Avalon. Concordant memories in all Indo-European traditions talk about the disappearance of such a seat (which later on was mythologized) following an ice age or a flood. This is the real, historical counterpart of the various allusions to something that, beginning with a given period, has allegedly been lost or become hidden and untraceable. This too is the reason why the "Island" or "Land of the Living" (the term "living" here referring to members of the original divine race), which is the land to which the well-known symbols of the Supreme Centre of the world allude, was often confused with the "region of the dead" (the term "dead" here referring to the extinct race). Thus, for instance, according to a Celtic doctrine, mankind's primordial ancestor was the god of the dead (Dispater) who dwells in a faraway region beyond the ocean, in those "faraway islands" whence, according to the Druids' teachings, some of the prehistoric inhabitants of Gaul came directly. Moreover, according to a classical tradition, after having been the lord of this earth, the king of the Golden Age, Kronos-Saturn, was dethroned and castrated (that is, deprived of the power to beget, to give life to a new stock; he still lives, though asleep, in a region located in the Far North, close to the Arctic Sea, which was also called the Cronid Sea. The generated various confusions, but essentially it is always the same transposition in superhistory, under the species of a latent or invisible reality or centre, of ideas referring to the Hyperborean theme.

THE MIGRATIONS OF THE GRAIL

The subject of this book is legendary lands and places. If we tackle the topic of the Grail and the Arthurian cycle, and if we had to take into account the immense material of the so-called Breton cycle, with all its contradictions and various versions, we would need hundreds and hundreds of pages. But as we have to deal only with places, our task becomes easier, because we must simply ask ourselves about two magical places, King Arthur's castle, with its Round Table, and the legendary Avalon where the Grail was kept.

The Ardagh Chalice (early eighth century), Dublin, National Museum of Ireland

Right:
Dante Gabriel Rossetti, *The Damsel of the Sanct Grael* (1874), private collection

THE ARTHURIAN LEGEND We must, albeit rapidly, sum up the main themes of the Arthurian legend. The material of the Breton cycle is contradictory, starting with the main protagonists, whose deeds often change from one text to the next. For example, the figure of Arthur is shrouded in the fog of myth. He appears as a captain in sixth-century Welsh texts, then as Arturus Rex in the *Historia Britonum*, attributed to the Welsh monk Nennius, who may have written it around 830.

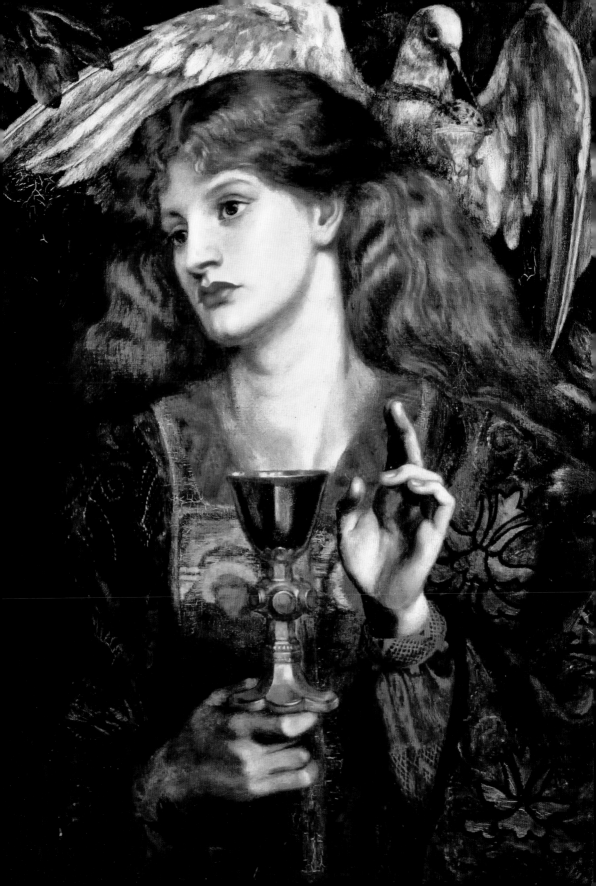

Arthur also appears in various lives of the saints of the sixth century, but he was to be mentioned as a royal personage only in the *Historia regum Britanniae* by Geoffrey of Monmouth. Finally he makes a triumphant entrance in the Breton cycle as the youth, protected by the wizard Merlin, who becomes king of Logres as only he was able to extract a sword stuck in a stone.

By way of an example of the intersections of texts and legendary traditions, see the question of the sword Excalibur, which in certain revisitations of the legend is identified as the one that the young Arthur succeeded in pulling out of the stone. In reality (or rather in the written sources of the legend) this sword, named for the first time by Robert de Boron and Chrétien de Troyes (and which Arthur was later to break in a clash with King Pellinor), was not Excalibur. Excalibur was to be more distinctly described by Thomas Malory in *Le morte d'Arthur*, and was given to Arthur by Viviane, the Lady of the Lake—and the sword was handed to him by an arm that emerged from the surface of a lake.

It guaranteed the king's invulnerability because it was always kept in a silver scabbard. But the scabbard was lost owing to Morgana (Arthur's half-sister), and it was on that circumstance that Arthur received his deathblow. Then he ordered the sword to be thrown back into the lake, and no one has ever thought that one day it might be rediscovered. Nonetheless, the incorrigible adepts of the Grail have sometimes thought to find it again in the abbey of San Galgano, near Siena, where there is a sword that Saint Galgano purportedly stuck in a stone in commemoration of the cross. Apart from the fact that it is problematic to connect Saint Galgano with the Arthurian legend, you need a lot of good will to identify the two swords, given that Galgano's was planted there as a protest against war, whereas with his two swords, Arthur, if we are to believe the cycle of his deeds, had decapitated or split from head to waist a great number of enemies.[1]

Another equally ambiguous figure is the wizard Merlin, son of a devil, who often appears as Arthur's benevolent counselor but in other traditions is portrayed as an evil being.

1. *On the authenticity of the sword, see research by Cali and Garlaschelli (2001).*

Above:
Aubrey Beardsley,
illustration for Sir Thomas
Malory's *Le Morte d'Arthur*
(1893–1894), lithograph,
private collection

Above right:
Walter Crane, *Arthur Draws
the Sword from the Stone*,
frontispiece illustration
for Henry Gilbert's *King
Arthur's Knights* (1911),
colored lithograph

WHAT WAS THE GRAIL? No less uncertainty surrounds the
central object in the Breton cycle, the Grail. What was the Grail? It
seems it was a vase, a chalice, a plate (in various texts we learn that
the bowl or plate was a "gradale," a container of refined foods; see the
text by <u>Helinand of Froidmont</u>). This dish or bowl could have con-
tained the blood shed by Christ on the cross, or may have been the
goblet used by him during the Last Supper, but sometimes it has been
suggested that it was the spear of Longinus that had wounded Christ
in the side. But in <u>Wolfram von Eschenbach's</u> *Parzifal*, it was said to
be a stone, known as *lapsit exillis* (a name that later votaries of the
Grail read as *lapis exillis*, thus giving rise to the most diverse etymol-
ogies and interpretations). In Chrétien de Troyes' *Le conte du Graal*
(and we are around 1180), there is no mention of *the* Grail but of "*a*
Grail," and this object moves from the generic to the singular and
unique only in other works of the cycle.

In Chrétien de Troyes, there are no references to the blood of
Christ, but they appear a few years afterward in *Joseph d'Arimathie* by

Robert de Boron: the Grail is, yes, the goblet used at the Last Supper, but then Joseph of Arimathea uses it to collect the blood shed on the cross. Joseph immigrated to the West, and after various vicissitudes, the Grail was kept in Avalon, delivered to a Fisher King struck by a mysterious wound that could be healed only when the purest of knights (and this was Parsifal in Boron) came to Avalon to ask the king a ritual question about the mystery of the Grail.

Arthur and Parsifal, floor mosaic (1163), nave of Otranto Cathedral

The Holy Grail appears to the Knights of the Round Table, from the *Livre de Messire Lancelot du Lac* (fifteenth century), pseudo–Walter Map (Gautier Map), Ms. français 120, fol. 524v, Paris, Bibliothèque Nationale de France

On the other hand, see the anthology for a selection of various authors who describe the apparition of the Grail, and you will understand why the comparison of the different texts contributes to make this mystery grow. So much so that from Boron's version onward, the Grail acquired more and more symbolic significance, and possession of it tended to become associated with the participation of a group of the elect who knew the secrets that Christ purportedly revealed to Joseph but which had remained unknown to the "official" disciples, who were to build the Church. And this helps us to understand why the Grail legend, down to our own times, has fascinated Gnostics and occultists of all kinds, who are always striving to conquer a secret that, as it may not be spoken and is concealed by the mystic symbol of the Grail, will be forever unattainable.

According to Julius Evola (1937) the Grail is something that lies "beyond the boundaries of ordinary awareness," and in any case, it refers to a Nordic tradition opposed to the Christian one. For Jessie Weston (1920), it is a fertility symbol whose origins lie in Celtic mythology.[2] René Guénon (1950) thought it was the symbol of a lost traditional truth—in other words, that truth that has always captivated esotericists of all ages, which was purportedly known in

2. *This was the interpretation that inspired Eliot's* The Waste Land.

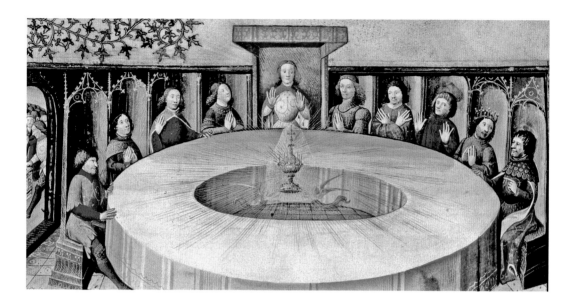

the past, only to disappear in modern times. In this sense, over the centuries, the Grail was to remain the prototype of every "empty" secret, all the more fascinating the more it always eluded every attempt to reveal it, and it was to prove the origin of the endless search for lost knowledge.

WHERE IS THE GRAIL? In any case, after Boron, the Grail was to be in Avalon, and it was on many occasions the object of quests by the Knights of the Round Table, the great characters of the Breton cycle, such as Parsifal, Lancelot, Galahad, and others. Incidentally, later legend has it that these knights were heroes devoted solely to the protection of damsels in distress, whereas in the cycle, not only do there appear somewhat aggressive damsels, but a knight's favorite occupation was to go to Cornwall to encounter other knights and challenge them to duels that were sometimes to the death, out of a pure taste for knightly combat.

Where was Avalon? On this subject, the tradition has run riot, but the destination that to this day moves thousands of tourists and devotees of the Grail is the city of Glastonbury, in Somerset.

One of the reasons that have led people to fantasize about Glastonbury is that in 1191, near the old church, monks had found a stone

George Arnald, *The Ruins of Glastonbury Abbey* (nineteenth century), private collection

bearing an inscription (in Latin): "Here lies buried the famous King Arthur, with his second wife, Guinevere, on the island of Avalon."

As is recounted on a plaque that is still there, in 1278 the remains of Arthur and Guinevere, in the presence of King Edward I, were interred inside the abbatial church, and they disappeared with the ruin of the abbey in 1539. In fact, Robert de Boron wrote that Arthur, deeply disheartened by his wife Guinevere's betrayal and the death of the beloved Gawain, receives his death blow during his last battle, and says that he will not die but will instead be taken to Avalon to have his wounds healed by his half-sister Morgana. He had promised to return, but since then nothing more was heard of him. In any case, if he had retired to Glastonbury, no one will be able to pray by his grave anymore.

This leaves us with the question of the whereabouts of Camelot. Not mentioned in the first texts of the Arthurian cycle, the

King Arthur's Round Table
(c. 1290), Great Hall of
Winchester Castle

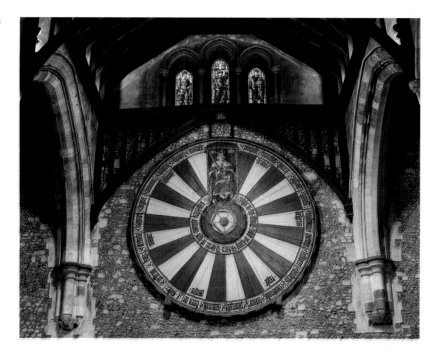

name appears in the French romances of the twelfth century (it is cited for the first time by Chrétien of Troyes in his *Le chevalier de la charrette*). Robert de Boron said the Arthurian realm was in Logres, but in Welsh, <u>Lloegr</u> is a name of uncertain origin that means England in general. Then the name Camelot gradually gained ground and, for example, Thomas Malory mentions it repeatedly in *Le morte d'Arthur*. A passage from that text makes one think of Winchester, and in fact in the Great Hall of Winchester, you can still see a Round Table, but recent carbon-14 dating has proved that it is made from trees cut down in the thirteenth century (and that in its current form it was repainted in the fifteenth or sixteenth century).[3] But Caxton, who printed *Le morte d'Arthur*, was inclined to locate Camelot in Wales.

In short, the location of Camelot, even for Grail devotees, is more imprecise than that of Avalon, but in the popular imagination, there is now an image of a fabled Camelot (nor should we forget Mark Twain's tale of 1889, *A Connecticut Yankee at King Arthur's Court*) spread by the cinema industry, which has come up with endless stories about Arthur's castle—from the *Parsifal* of 1904 to the renowned musical *Camelot* of 1960 and many others down to modern times.

3. *See Polidoro (2003).*

Gustave Doré, *Camelot*
(c. 1860), from *Idylls
of the King*, Alfred, Lord
Tennyson (1856-1885),
private collection

But the story of the Grail does not end with French and English texts, because German authors stepped in, clearly not very interested in celebrating the splendors of Anglo-Norman culture, so that in the *Parzifal* by Wolfram von Eschenbach (thirteenth century), not only does the chalice, as we have seen, become a stone, but the wounded king becomes Amfortas, and the *lapis* is kept in a place that is hard to locate, Muntsalväsche. In another romance, the *Jüngerer Titurel* by Albrecht von Scharfenberg, Muntsalväsche appears in Galicia, and the Grail is kept in a huge circular temple, the Gralsburg. At this point, apart from the notable geographical shift, the temple is reminiscent of that in Jerusalem, and not by chance, because in *Parzifal* the knights who guard the Grail are Knights Templar—and with this, in the future, the two myths were to merge, even though in Wolfram's day, the Templars still lived in their forts, in peace and well fed, and still had not become martyrs or the founders of sects as mysterious as they are nonexistent. In *Tinturel* the Grail is even taken to the realm of Prester John, and here is where two myths really do merge, the one of the holy stone and that of John's fabled kingdom.

We should also mention the welter of alchemical interpretations that were to read *lapis exillis* as *lapis elisir*, or the philosopher's stone, while others were to interpret it as *lapis ex coelis* and talk about a shooting star that had then been used to adorn Lucifer's crown.

THE ROMANTIC REBIRTH OF THE MYTH On considering the story of the Grail, we realize that by the end of the Middle Ages, the production of the Breton-cycle romances ceased, and the sacred chalice seemed to hold no more interest for the men of the Renaissance, the Baroque, and the Enlightenment. But the myth was revived during the Romantic period.

The story of Merlin was revisited in the early nineteenth century by Friedrich Schlegel and his wife, Dorothea Mendelssohn, and in England Alfred Tennyson was to dedicate his verses to aspects of the Arthurian legend; see, for example, *The Lady of Shalott*, inspired by events narrated in Malory's *Le morte d'Arthur*. The Lady of Shalott lived near Camelot, oppressed by a curse laid on her by the evil

Morgana: she would have died if she looked toward Camelot. So she spent her life closed up in her tower, observing the outside world only by looking into a mirror. But one day she sees Lancelot in the mirror and falls madly in love with him—even though she knows that the knight loves Queen Guinevere. Knowing she has to die, she flees aboard a boat to get as far as possible from the man she loves. The boat is dragged toward Camelot by the current of the River Avon, as the lady expires singing.

Anthony Frederick Augustus Sandys, *Morgan le Fay* (1864), Birmingham Museum and Art Gallery

The most luxuriant portrayals of the events of the Round Table were produced by the Pre-Raphaelite painters within the framework of a return to medieval spirituality, and the image of the Grail reappears in many Masonic rituals and in Rosicrucian circles. An extravagant author, Joséphin Péladan, founded toward the end of the nineteenth century the Mystic Order of the Rose, the Temple, and the Grail.

Finally, the Breton cycle was to give rise to the frescoes in the castle of Neuschwanstein in Bavaria, a maniacal re-evocation ordered by a mad monarch, Ludwig II of Bavaria, fascinated by the Wagnerian revival.

In fact Wagner had appropriated von Eschenbach's account, in *Lohengrin*, *Tristan und Isolde*, and *Parsifal* (where the quest for the Grail involves a process of initiation), while the place in which it was guarded, perhaps inspired by Wolfram's Muntsalväsche, became Montsalvat.

THE MOVE TO MONTSÉGUR But where is Montsalvat? For some, the name calls up Montségur, the Cathar fortress in the Pyrenees and their last bastion before their complete destruction. Occultists of all periods have considered the Cathars not only heretics but the guardians of a gnosis, a secret knowledge. It did not take much to merge the secret of the Grail with the secret of the Cathars. This identification had already appeared in the nineteenth century and was the work first of Claude Fauriel (1846) and then of Eugène Aroux (1858), a bizarre occultist and Rosicrucian who had devoted part of his work to discussing a sect known as the Faithful to Love—of which

Dante Gabriel Rossetti, *How Sir Galahad, Sir Bors and Sir Percival Were Fed with the Sanct Grael; but Sir Percival's Sister Died by the Way* (1864), London, Tate Gallery

Left:
Sir Edward Burne-Jones, *The Last Sleep of Arthur in Avalon* (1891–1898), Museo de Arte de Ponce, Puerto Rico

Dante was supposedly a member—close to the Cathar heresy, and then to establishing a relationship among the Grail, Catharism, and Provençal towns (*The Mysteries of Chivalry and Platonic Love in the Middle Ages*), without neglecting what struck him as clear relations with Masonry.

Some of these rumors found many followers in early twentieth-century Provence, perhaps also for reasons connected with regionalism and tourism, but the most interesting supporter of this theory was an odd, erudite German mountaineer and speleologist, and later an SS officer, Otto Rahn.

Von Eschenbach's version of the myth, allied to popular Wagnerian mysticism, its interest in the ideal of Catharist "purity," which in Rahn's view called up the purity of the Knights Templar, plus the idea that these last were the heirs to the "Hyperborean" knowledge of the ancient druids on the one hand and, on the other, the nascent ideal of an Aryan purity that was cultivated in proto-Nazi circles, all had prompted Rahn (from 1928 to 1932) to make a series of research efforts in Spain, Italy, Switzerland, but especially in Languedoc, among the ruins of Montségur.

There Rahn had got wind of some tradition according to which, on the night before the final assault on the heretics' fortress,

three Cathars had supposedly saved the relics of the king of the Merovingians, Dagobert II. Rahn was convinced that the Grail was one of those relics, given that by that time he had posited an incontrovertible relationship among druids, Cathars, Templars, and the Knights of the Round Table.

With a typical "hermetic" preposterous connection, Rahn decided that the Cathars of Montségur were the descendants of druids who had converted to Manichaeism. Proof of this, at least for him, was the fact that their priests were akin to the Catharist "perfect ones." The secret wisdom of the Cathars was supposedly preserved by the last troubadours, whose songs—apparently dedicated to their ladies— referred to Sophia, the Wisdom of the Gnostics.

On exploring Montségur and its environs, Rahn had discovered secret underground passages and caverns in which he had imagined miraculous rituals of the Grail, asserting that he had found rooms whose walls were covered with Templar symbols together with Cathar emblems. The drawing of a spear immediately made him think of Longinus's spear, underlining yet again the links with the symbolism of the Grail.

Hence (even though various scholars of the mysticism of the Grail and Catharism have pointed out that, in those Cathar texts still extant, the Grail is never mentioned) there arose the legend that Rahn had finally found the Grail and that it had been kept until the end of the Second World War at Wewelsburg, the SS castle near Paderborn.

After 1933, Rahn lived in Berlin, working on further studies of the Grail; his search for a primordial traditional religion, the Religion of Light, had attracted the attention of the chief of the SS, Heinrich Himmler, and Rahn was persuaded to join the Schutzstaffel officially.

We know that Otto Rahn fell into disfavor with the Nazi leadership in 1937 (suspected of homosexuality and, it was said, of having Jewish origins), and for disciplinary reasons was assigned to various tasks in Dachau concentration camp. This was not the best of curricula, even though in the winter of 1938–39, he had resigned from the SS. But a few months later, he was found dead amid the snows of the Tyrolean

The ruins of Montségur,
photograph by Otto Rahn

4. *Di Carpegna (2011) points*
out that the mysticism of the
Grail is found
in many nationalist
and traditionalist far-right
movements, such as
Le Pen's Front National
or in the rites of the
Ku Klux Klan, and even
in the neo-Templarist
claims of the madman
Anders Behring Breivik,
who slaughtered ninety-two
people in Norway in 2011.

Mountains, and the mystery of his death (accident? suicide? a decision by Nazi leaders to silence the possessor of embarrassing secrets? punishment for a dissident?) was never solved.[4]

On the other hand, the myth of a "Pyrenean" Grail, as Zambon (2012) called it, did not seduce the Nazis alone. Already in the

The Green Man
in Rosslyn Chapel, Scotland

1930s, again in the south of France, others had established a Societé
des amis de Montségur et du saint Graal (and so the Grail was a mysti-
cal concept, more than a visible reality, as it was for Rahn), whose
members intended to fight Nazism in the name of Occitan spirituality.

In any case, it is thanks to these opposing forms of mysticism
that, apart from the pilgrims who go to Glastonbury or travel through
Galicia without managing to find Gralsburg, we also have pilgrimages
to Montségur in competition with those to nearby Lourdes.

THE JOURNEY OF THE GRAIL On the other hand, a consis-
tent tradition has it that many events in the life of Merlin and
Morgana did not occur in England but in France, in the forest of
Brocéliande, which is today identified with the forest of Paimpont,
near Rennes. But while Brocéliande is not traditionally associated
with the Grail, we could cite another dozen places where the most dis-
parate sources say the holy chalice is hidden, from the Castle of
Gisors to Castel del Monte in Puglia or the Castle of Roseto Capo
Spulico in Calabria (by association with the legend attributed to
Emperor Frederick), to Rosslyn Chapel in Scotland (at least thanks
to the imagination of Dan Brown in *The Da Vinci Code*), to Canada,

Detail from the Church of
Gran Madre di Dio, Turin

Narta Monga in the Caucasus Mountains, to the church of Gran
Madre di Dio in Turin, to San Juan de la Peña, and so on.

 The shadow of Montségur was to loom over the last incarna-
tion of the Grail, that of Rennes-le-Château. But since this is intended
to be a "history" of legendary lands, respect for chronology obliges us
to deal with this story in a final chapter, in which we can talk about a
real place that becomes legendary by virtue of a colossal misrepresen-
tation—a sign that traditions are not necessarily extremely ancient,
but can be produced de novo to be sold to credulous buyers.

Porta della Pescheria,
archivolt with scenes
from the Arthurian cycle
(1100), Modena Cathedral,
north side

The Gradalis

The Book of the Graal, quoted by
Helinandus of Froidmont (c. 1160–
1237), in *Chronicle*

At this time a certain marvellous
vision was revealed by an angel to a
certain hermit in Britain concerning
S. Joseph, the decurion who deposed
from the cross the Body of Our Lord,
as well as concerning the paten or
dish in the which Our Lord supped
with His disciples, whereof the
history was written out by the said
hermit and is called "Of the Graal"
(de Gradali). Now, a platter, broad and
somewhat deep, is called in French
"gradalis" or "gradale," wherein
costly meats with their sauce are
wont to be set before rich folk by de-
grees ("gradatim") one morsel after
another in divers orders, and in the
vulgar speech it is called "graalz," for
that it is grateful and acceptable to
him that eateth therein, as well for
that which containeth the victual, for
that haply it is of silver or other pre-
cious material, as for the contents
thereof, to wit, the manifold courses
of costly meats.

Words of Merlin to Arthur

ROBERT DE BORON
(TWELFTH–THIRTEENTH CENTURY)
Merlin

Merlin said to him: "Arthur, you are
king by the grace of God. Your father
Uther was a man of great merit: in his
day the Round Table was created, to
symbolize the table at which our Lord
sat on Holy Thursday, when he predict-
ed Judas's betrayal. It was modelled on
the Table of Joseph, which in turn was
created for the Grail, when it separated
the good from the wicked. . . .
It came to pass that the Grail was en-
trusted to Joseph while he was impris-
oned: it was brought to him by our Lord
in person. Once freed from prison,
Joseph went forth into a desert along
with many of the people of Judea.
. . . Joseph went to pray before his vessel
to ask our Lord to tell him what he
should do. Thereupon the voice of the
Holy Spirit spoke out and told him to
build a table. This he did, and when it
was ready, he placed his vessel upon it
and ordered the people to sit down:
those who were free of sin sat down at
the table, whereas those who were
guilty of sin left, as they were unable to

Anonymous,
The Knights of the Round Table (thirteenth century), painting on paper, Paris, Bibliothèque nationale de France

remain near it. At this table there was an empty place, since Joseph believed that no one should sit at the place that had belonged to our Lord. . . .

Know then that our Lord established the first table; Joseph created the second; and in the days of your father, Uther Pendragon, I had the third made, which is destined for great glory: all across the world, people will speak of the chivalry that you will gather around it in your time. Know also that Joseph, to whom the Grail was entrusted, left it on his death to his brother-in-law, who was named Bron. He had twelve sons, one of whom was named Alan the Fat, to whom Bron, the Fisher King, entrusted the guardianship of his brothers. At our Lord's command, Alan left Judea for these islands to the west and arrived with his people in our country. The Fisher King lives on the island of Ireland, in one of the most beautiful places that exist on this earth. But be aware that he finds himself in the worst situation that a man has ever known, as he is gravely ill. Yet I can promise you that however old and infirm he might be, he cannot die until a knight of the Round Table has completed sufficient deeds of war and chivalry—in tournaments and in his search for adventures—to become the most famous in the world.

When he has achieved such fame as to be able to visit the court of the rich Fisher King and has asked what purpose the Grail has served and what purpose it now serves, the king will immediately be cured and, after revealing our Lord's secret words to him, will pass from life into death. This knight will have guardianship of the blood of Jesus Christ. And so the enchantments in the land of Britain will be broken and the prophecy will be fulfilled in its entirety.

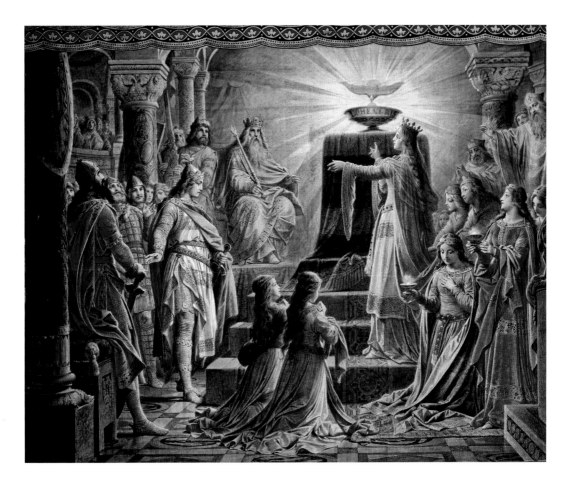

The Apparitions of the Grail

CHRÉTIEN DE TROYES
(TWELFTH CENTURY)
Perceval: The Story of the Grail

And no house lit by candles could ever provide a brighter light than there was in that hall. While they were talking of one thing and another, a boy came from a chamber clutching a white lance by the middle of the shaft, and he passed between the fire and the two who were sitting on the bed. Everyone in the hall saw the white lance with its white head; and a drop of blood issued from the tip of the lance's head, and right down to

the boy's hand this red drop ran. The lord's guest gazed at this marvel that had appeared there that night, but restrained himself from asking how it came to be, because he remembered the advice of the nobleman who had made him a knight, who had instructed him to beware of talking too much; he feared it would be considered offensive if he asked, so he did not. Just then two other boys appeared, and in their hands they held candlesticks of the finest gold, inlaid with black enamel. The boys who carried the candlesticks were handsome indeed, and in each candlestick burned ten candles at the very least. A girl who came in with the boys, fair and

Wilhelm Hauschild,
The Miracle of the Grail
(nineteenth century),
Neuschwanstein Castle

comely and beautifully adorned, was holding a grail between her hands. When she entered holding the grail, so brilliant a light appeared that the candles lost their brightness like the stars or the moon when the sun rises. After her came another girl, holding a silver trencher. The grail, which went ahead, was made of fine, pure gold; and in it were set precious stones of many kinds, the richest and most precious in the earth or the sea: those in the grail surpassed all other jewels, without a doubt. They passed before the bed as the lance had done, and disappeared into another chamber. The boy saw them pass, but did not dare to ask who was served from the grail, for he had taken the words of the wise nobleman to heart.

ROBERT DE BORON
The Didot Perceval: or, The Romance of Perceval in Prose, VII

Just as they seated themselves and the first course was brought to them, they saw come from a chamber a damsel very richly dressed who had a towel about her neck and bore in her hands two little silver platters. After her came a youth who bore a lance, and it bled three drops of blood from its head; and they entered into a chamber before Perceval. And after this there came a youth and he bore between his hands the vessel that Our Lord gave to Joseph in the prison, and he bore it very high between his hands. And when the king saw it he bowed before it saying his "mea culpa" and all the others of the household did the same. When Perceval saw this he marveled much and he might willingly have asked concerning it if he had not feared to annoy his host. And he pondered much on it throughout the evening, but he remembered his mother who had told him that he ought not to speak too much and should not inquire too much about things. And therefore he restrained himself and did not ask of it, and the king in many different phrases hinted that he might ask about this, but he said nothing for he was so oppressed from the two nights before when he had been awake that he almost fell asleep over the table. Thereupon the youth who bore the Grail returned and re-entered the chamber where he had been and whence he had come, and the youth who bore the lance also; and the damsel followed them. Yet never did Perceval ask anything. When Bron the Fisher King saw that he would ask nothing concerning it he was very sad. And thus it was borne before all the knights who had hostel there because Our Lord Jesus Christ had told him that he would never be cured until a knight would ask what one served with this, and it was necessary that this knight be the best in the world. And Perceval himself ought to have succeeded in this, and if he had asked it the king would have been cured.

ANONYMOUS
Perlesvaus: The High History of the Holy Graal (thirteenth century), VI

Thereon, lo you, two damsels that issue forth of a chapel, whereof the one holdeth in her hands the most Holy Graal, and the other the Lance whereof the point bleedeth thereinto. And the one goeth beside the other in the midst of the hall where the knights and Messire Gawain sat at meat, and so sweet a smell and so holy came to them therefrom that they forgat to eat. Messire Gawain looketh at the Graal, and it seemed him that a chalice was therein, albeit none there was as at this time, and

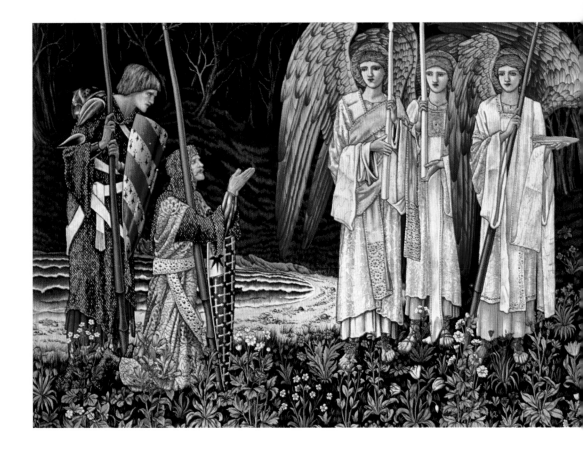

he seeth the point of the lance whence the red blood ran thereinto, and it seemeth him he seeth two angels that bear two candlesticks of gold filled with candles. And the damsels pass before Messire Gawain, and go into another chapel. And Messire Gawain is thoughtful, and so great a joy cometh to him that nought remembereth he in his thinking save of God only. The knights are all daunted and sorrowful in their hearts, and look at Messire Gawain. Thereupon behold you the damsels that issue forth of the chamber and come again before Messire Gawain, and him seemeth that he seeth three there where before he had seen but two, and seemeth him that in the midst of the Graal he seeth the figure of a child. . . .

. . . he looketh up and it seemeth him to be the Graal all in flesh, and he seeth above, as him thinketh, a King crowned, nailed upon a rood, and the spear was still fast in his side. Messire Gawain seeth it and hath great pity thereof, and of nought doth he remember him save of the pain that this King suffereth.

ANONYMOUS
La queste del Saint Graal (thirteenth century), from the *Prose Lancelot*

They were all sitting in silence when a clap of thunder rang out so loudly and violently that it seemed the building was sure to collapse. Immediately afterward, a ray of sunshine shone in, illuminating the room with an extraordinary

Edward Burne-Jones, *The Attainment: The Vision of the Holy Grail to Sir Galahad, Sir Bors and Sir Percival* (1894), Birmingham Museum and Art Gallery

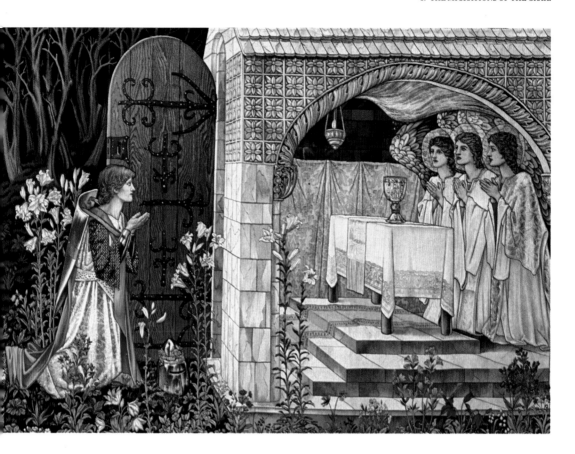

brightness. They all felt as if they had been illuminated by the grace of the Holy Spirit and began to look at one another, wondering where it could have come from; but no one in the room was able to speak a word: they were all left dumbstruck. They remained a long while unable to speak, staring at one another like mute beasts, whereupon the Holy Grail entered the room covered by a cloth of white silk, yet no one could see who was carrying it. The Grail entered through the main door and as soon as it was inside, the palace seemed to be filled with perfumes as if it had been strewn with all the spices of the world. It moved into the center of the room and passed around each table; and with its passing, each place was laden with the

food desired by its occupant. As soon as everyone had been served, the Holy Grail vanished in such a way that no one knew what had become of it, nor where it had gone....

WOLFRAM VON ESCHENBACH
(1170–1220) *Parzival,* IX

And the heathen, Flegetanis, could
 read in the heavens high
How the stars roll on their courses,
 how they circle the silent sky,
And the time when their wandering
 endeth—and the life and the lot
 of men
He read in the stars, and strange
 secrets he saw, and he spake again

Low, with bated breath and fearful, of
 the thing that is called the Grail,
In a cluster of stars was it written, the
 name, nor their lore shall fail.
And he quoth thus, " A host of angels
 this marvel to earth once bore,
But too pure for earth"s sin and sorrow
 the heaven they sought once more,
And the sons of baptized men hold It,
 and guard It with humble heart,
And the best of mankind shall those
 knights be who have in such ser-
 vice part."

". . . then know, by a *stone* they live,
And that stone is both pure and pre-
 cious—Its name hast thou never
 heard?
Men call it *Lapis Exilis*. . . .
. . . And this stone all men call the Grail."

THOMAS MALORY
Le Morte d'Arthur (1485), XIII, 7

And then the king and all estates went
home unto Camelot, and so went to
evensong to the great minster. And so
after upon that to supper, and every

knight sat in his own place as they were
toforehand. Then anon they heard
cracking and crying of thunder, that
them thought the place should all to-
drive. In the midst of this blast entered
a sunbeam more clearer by seven times
than ever they saw day, and all they
were alighted of the grace of the Holy
Ghost. Then began every knight to be-
hold other, and either saw other, by
their seeming, fairer than ever they
saw afore. Not for then there was no
knight might speak one word a great
while, and so they looked every man on
other as they had been dumb. Then
there entered into the hall the holy
Graile covered with white samite, but
there was none might see it, nor who
bare it. And there was all the hall ful-
filled with good odours, and every
knight had such meats and drinks as he
best loved in this world—and when the
holy Graile had been borne through the
hall, then the holy vessel departed sud-
denly, that they wist not where it be-
came. Then had they all breath to
speak. And then the king yielded
thankings to God of His good grace
that he had sent them. "Certes," said
the king, "we ought to thank our Lord
Jesu greatly for that he hath shewed us
this day at the reverence of this high
feast of Pentecost."
"Now," said Sir Gawaine, "we have been
served this day of what meats and
drinks we thought on, but one thing be-
guiled us, we might not see the Holy
Grail, it was so preciously covered.
Wherefore I will make here avow, that
to-morn, without longer abiding, I shall
labour in the quest of the Sancgreal,
that I shall hold me out a twelvemonth
and a day, or more if need be, and never
shall I return again unto the court till I
have seen it more openly than it hath
been seen here: and if I may not speed I

Walter Crane, *Sir Galahad Is Brought to the Court of King Arthur* (c. 1911), private collection

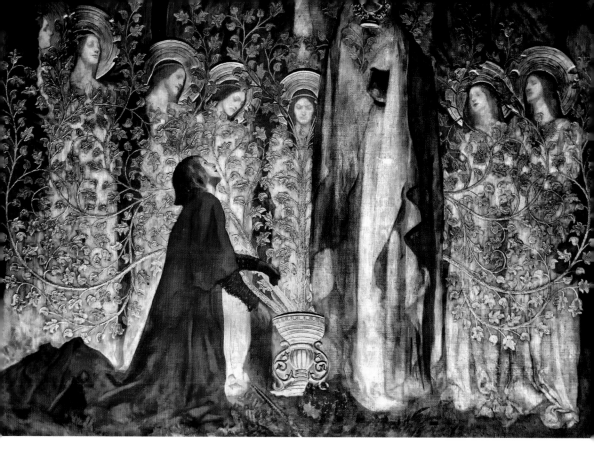

Edwin Austin Abbey,
Galahad and the Holy Grail
(1895), private collection

shall return again as he that may not be against the will of our Lord Jesu Christ." When they of the Table Round heard Sir Gawaine say so, they arose up the most party, and made such avows as Sir Gawaine had made.

The Grail Is Nowhere

JULIUS EVOLA
The Mystery of the Grail (1937)

Pindar said that the land of the Hyperboreans cannot be reached on foot or by ship, and that only such heroes as Heracles could find it. In the Chinese tradition, the island located at the further ends of the Northern lands can be reached only by a flight of the spirit; in the Tibetan tradition, Sambhala, the mystical Northern seat related to Kalki-avatara, was said to

"dwell in my spirit." This theme occurs also in the Grail cycle. The castle of the Grail in the *Queste* is called *palais spirituel* and in the *Perceval Ii Gallais* it is called "castle of souls" (in the sense of spiritual beings). . . .And while Plutarch relates that the vision of Kronos in the Hyperborean seat occurs in a state of sleep, it is in a state of apparent death that Lancelot, in *Le Morte d'Arthur* has the vision of the Grail. Moreover, in the *Queste*, it is in a state of either sleep or death that Lancelot has the vision of the wounded knight crawling up to the Grail to sooth his suffering. These are experiences beyond ordinary consciousness. Sometimes the castle is described as invisible and unreachable. Only the elect can find it, either out of sheer chance or through a magical spell, since it usually vanishes from the sight of its seekers. . . .

The seat of the Grail always appears as a castle or fortified regal palace, but never as a church or temple. Only in later texts is mention made of an altar or chapel of the Grail, in relation to the more Christianized version of the legend, in which it is eventually identified with the chalice used at the Last Supper. In the most ancient redactions of the legend there is nothing of this sort; the close relation of the Grail with the sword and the lance, as well as with the figure of a king or a person with regal traits, suffices to reveal the later Christian representation as extrinsic. The seat of the Grail, which must be defended "unto death," can be related neither merely to the Church and Christianity, which, as I have argued, constantly ignored this cycle of myths, nor even, more generally speaking, to a religious or mystical center. It is rather an initiatory center that retains the legacy of the primordial tradition, according to the undivided unity of the two dignities, namely, the regal and the priestly.

The Lady of Shalott

ALFRED, LORD TENNYSON
The Lady of Shalott (1842)

Part II
There she weaves by night and day
A magic web with colors gay.
She has heard a whisper say,
A curse is on her if she stay
　　To look down to Camelot.
She knows not what the curse may be,
And so she weaveth steadily,
And little other care hath she,
　　The Lady of Shalott.
And moving thro' a mirror clear
That hangs before her all the year,
Shadows of the world appear.

There she sees the highway near
　　Winding down to Camelot;
There the river eddy whirls,
And there the surly village-churls,
And the red cloaks of market girls,
　　Pass onward from Shalott.

Sometimes a troop of damsels glad,
An abbot on an ambling pad,
Sometimes a curly shepherd-lad,
Or long-hair'd page in crimson clad,
　　Goes by to tower'd Camelot;
And sometimes thro' the mirror blue
The knights come riding two and two:
She hath no loyal knight and true,
　　The Lady of Shalott.

But in her web she still delights
To weave the mirror's magic sights,
For often thro' the silent nights
A funeral, with plumes and lights
　　And music, went to Camelot;
Or when the moon was overhead,
Came two young lovers lately wed:
"I am half sick of shadows," said
　　The Lady of Shalott.

Part III
A bow-shot from her bower-eaves,
He rode between the barley-sheaves,
The sun came dazzling thro' the leaves,
And flamed upon the brazen greaves
　　Of bold Sir Lancelot.
A redcross knight for ever kneel'd
To a lady in his shield,
That sparkled on the yellow field,
　　Beside remote Shalott.

The gemmy bridle glitter'd free,
Like to some branch of stars we see
Hung in the golden Galaxy.
The bridle bells rang merrily
　　As he rode down to Camelot;
And from his blazon'd baldric slung
A mighty silver bugle hung,
And as he rode his armor rung,

August von Spiess, *Parsifal at the Court of Amfortas* (1883/1884), decoration of the Singers' Hall at Neuschwanstein Castle

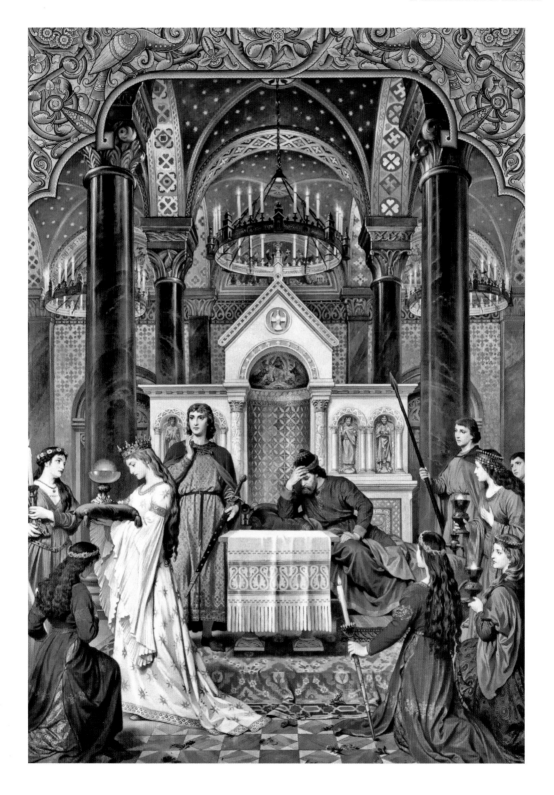

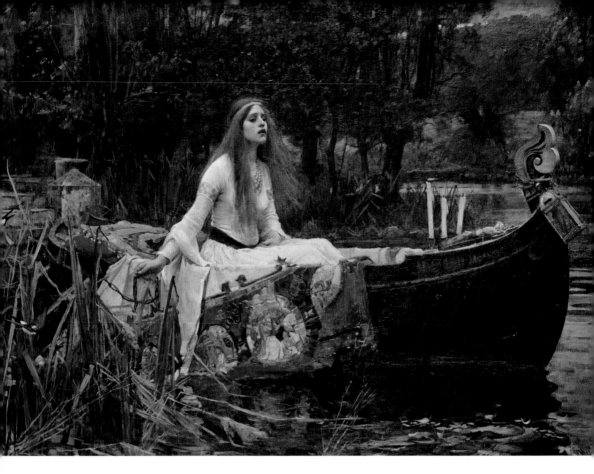

Beside remote Shalott.
All in the blue unclouded weather
Thick-jewell'd shone the saddle-leather,
The helmet and the helmet-feather
Burn'd like one burning flame together,
 As he rode down to Camelot;
As often thro' the purple night,
Below the starry clusters bright,
Some bearded meteor, trailing light,
 Moves over still Shalott.

His broad clear brow in sunlight glow'd;
On burnish'd hooves his war-horse trode;
From underneath his helmet flow'd
His coal-black curls as on he rode,
 As he rode down to Camelot.
From the bank and from the river
He flash'd into the crystal mirror,
"Tirra lirra," by the river
 Sang Sir Lancelot.

She left the web, she left the loom,
She made three paces thro' the room,
She saw the water-lily bloom,
She saw the helmet and the plume,
 She look'd down to Camelot.
Out flew the web and floated wide;
The mirror crack'd from side to side;
"The curse is come upon me," cried
 The Lady of Shalott.

Part IV
In the stormy east-wind straining,
The pale yellow woods were waning,
The broad stream in his banks
 complaining,
Heavily the low sky raining
 Over tower'd Camelot;
Down she came and found a boat
Beneath a willow left afloat,
And round about the prow she wrote
 The Lady of Shalott.

John William Waterhouse,
The Lady of Shalott (1888),
London, Tate Gallery

And down the river's dim expanse
Like some bold seër in a trance,
Seeing all his own mischance—
With a glassy countenance
 Did she look to Camelot.
And at the closing of the day
She loosed the chain, and down she lay;
The broad stream bore her far away,
 The Lady of Shalott.

Lying, robed in snowy white
That loosely flew to left and right—
The leaves upon her falling light—
Thro' the noises of the night
 She floated down to Camelot;
And as the boat-head wound along
The willowy hills and fields among,
They heard her singing her last song,
 The Lady of Shalott.

Heard a carol, mournful, holy,
Chanted loudly, chanted lowly,
Till her blood was frozen slowly,
And her eyes were darken'd wholly,
 Turn'd to tower'd Camelot;
For ere she reach'd upon the tide
The first house by the water-side,
Singing in her song she died,
 The Lady of Shalott.

Under tower and balcony,
By garden-wall and gallery,
A gleaming shape she floated by,
Dead-pale between the houses high,
 Silent into Camelot.
Out upon the wharfs they came,
Knight and burgher, lord and dame,
And round the prow they read her name,
 The Lady of Shalott.

Who is this? and what is here?
And in the lighted palace near
Died the sound of royal cheer;
And they cross'd themselves for fear,
 All the knights at Camelot:
But Lancelot mused a little space;

He said, "She has a lovely face;
God in his mercy lend her grace,
 The Lady of Shalott."

OTTO RAHN
The Court of Lucifer (1937)

The editor of my *Parzival* edition believed that the castle of which Wolfram speaks was to be found in the Pyrenees. The place names, like Aragon and Katelangen (Catalonia), must have suggested this hypothesis. The Pyrenees peasants are not mistaken then, when they choose to see in Montségur Castle, the castle of the Holy Grail. And the snow that Parzival, the Grail seeker, must cross on horseback, on the way to his fortress-sanctuary, could well have been Pyrenean snow. The name Montsalvage, which only Wolfram gives to the castle of the Grail, in French would give you, as many would testify, *Mont sauvage*. The French word *sauvage* comes from the Latin *silvaticus* (from *silva*: forest). Forests are certainly not lacking in the region of Montségur—but only in this region. It must also be noted that, in the local dialect, *Mont sauvage* is pronounced *Moun salvatgé*. Differing from Wolfram, who served as his guarantor all the same, Richard Wagner, the author and composer of *Lohengrin* and *Parzival*, called the castle Montsalvat. This means "Mount of Salvation" but Montsalvat and Montsalvage could easily be interpreted, one as much as the other, as *Moun ségur*, the sure mountain or the mountain of security. Thus, even from this point of view, Montségur Castle, in whose environs I'm staying, could be considered the castle of the Grail, so much sought after.

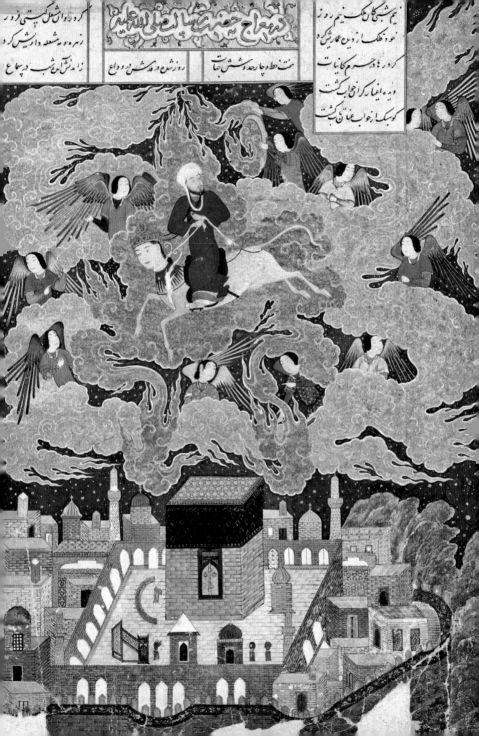

9

ALAMŪT,
THE OLD MAN OF THE MOUNTAIN,
AND THE ASSASSINS

We have already mentioned Rennes-le-Château. In fact there have always been real places (that can be visited to this day) that become transfigured into legendary ones, often for political reasons. And this is the case with the fortress or castle of Alamūt that stood, and some of whose ruins still stand, southwest of the Caspian Sea.

Alamūt, the Eagle's Nest. In its heyday, it must have seemed awesome, especially in the eyes of those who tried to besiege it, in vain, until it was taken and destroyed by the Mongols in 1256. As it was, but above all as legend has handed it down to us, built on a high ridge a quarter of a mile long and sometimes only a few steps wide, thirty at most, to those arriving on the road to Azerbaijan, it appeared in the distance like a natural wall, dazzling white in the sunshine, sky blue in the purplish sunset, pale and then blood red between dawn and daybreak, looming hazily among the clouds on some days or flashing with reflected lightning. Along its upper borders, it was just possible to make out the rough artificial finish of quadrilateral towers; from below, it appeared as a series of rocky blades soaring upward for hundreds of meters, which loomed over you, the most accessible side being a slippery slope of scree. When the castle was intact and inhabited, entry was gained by a few secret spiral stairways carved out of the rock, which a single archer could defend. This is what we have been told of Alamūt, the impregnable fortress of the Assassins, which could be reached only by flying on an eagle's back.

The story of the Assassins was developed in the Middle Ages by chroniclers close the crusaders, such as William of Tyre, Gerard of Strasbourg, or Arnold of Lübeck, and Marco Polo, down to the most

influential modern exponent of the myth, Joseph von Hammer-Purgstall, and his *History of the Assassins* (1818).

What went on in the fortress of Alamūt? It was ruled from the start by a fascinating, mystic, and ferocious personage, Hasan-e Sabbūh, who assembled his acolytes there; in fact, he raised them from childhood. These were the *fidā'iyyūn*, or fedayeen, "faithful unto death," whom he used to carry out his political assassinations.

Various modern scholars have tried to reassess the legend of Hasan, but it has survived to the point that to this day we use the term *assassination* to refer to the killing of a public figure for political. Regarding the obedience shown by the Assassins to their chief, it says in the *Novellino* (a medieval collection of short stories) that, when Frederick II visited Hasan at Alamūt, the terrifying old man, to demonstrate his power, pointed to two of his followers standing on the top of a tower; he touched his beard, and the two men plunged into the void and crashed into the ground.

Now let us turn briefly to historical data that are not legendary.

The inhabitants of Alamūt were Shiites, in other words followers of Islam's biggest schism: some of the faithful considered Ali (Mohammed's cousin and husband of Fatima, the Prophet's daughter) as Mohammed's only true heir, whereas power and the succession had been taken by Abu Bakr, who had assumed the title of caliph, a title that was then passed on to Othman, Mohammed's son-in-law. This was followed by a series of internecine struggles and battles until Ali's assassination. From that point, the disciples of Ali developed Shiite doctrine (opposed to Sunni doctrine, which claims orthodoxy), remaining devoted to the memory of Ali as the true imam, warrior, and saint, a salvific figure deserving of supreme dominion over the Muslim world and whose origins were considered divine.

When the Fatimid caliph of Cairo al-Mustansir billâh had transferred the institution of the imamate from his son Nizâr to his younger son Musta'li, those loyal to Nizâr broke off to form the Persian Ismailites. They were headed by Hasan-e Sabbāh—who had become a devoted Ismailite after a series of spiritual events—and had obtained possession of the fortress of Alamūt in 1090–91.

According to Henry Corbin (1964) the name of Ismailism had been obscured by the "black romance" constructed by the Crusaders, by Marco Polo, and naturally by Hammer-Purgstall, as well as by Sylvestre de Sacy (1838), who had all maintained that the word *assassin* derived from *hashshashin,* or the devotees of hashish. To tell the truth, many legends about the Assassins spring from Muslim sources, but let us stick to a nonfictional reconstruction of events.

Corbin believed that Hasan's preaching and proselytism were exclusively spiritual, inspired by esoteric principles. Nonetheless, Corbin seems to overlook other historical data that tell us that Hasan was not only a spiritual master but also a politician, who in order to back up his religious beliefs had gradually constituted a series of fortresses from where he could control all the surrounding territory, and Alamūt was considered the most important stronghold, from which it was possible to control the roads to Azerbaijan and Iraq. Hasan-e Sabbāh lived there, and there he was to stay until he died, surrounded by his faithful followers.

Hasan was a charismatic leader of strict virtue and had even sentenced his two sons to death, one because he drank wine, and the other because he was guilty of murder. What is certain is that Hasan made widespread use of political assassination, as would his successors. They included the terrible Sinan, dubbed the Old Man of the Mountain, even though with the growth of the legend, Hasan had also been referred to by this sobriquet. Although the various medieval texts we know of were written after Hasan's death (1124) and date from the epoch in which the Crusader realms of the Holy Land and Saladin had relations with the sect ruled by Sinan, it is said that the sultan's prime minister, Nizam al-Mulk, had been stabbed to death by an assassin whom Hasan had ordered to dress as a dervish in order to get close to him, when the Crusaders were still struggling to conquer Jerusalem. Sinan was also accused of the murder of the marquis Corrado di Monferrato. It was said that he had instructed two of his men to infiltrate the ranks of the infidels, mimicking their customs and language, and then, disguised as monks, when the bishop of Tyre offered a banquet to the unwitting marquis, they had killed him. But

The Capture of Alamūt
(1113), Persian manuscript,
fol. 177v, Paris, Bibliothèque
nationale de France

the story is obscure because some sources lead us to suspect that Corrado's murder was the work of some of his Christian colleagues, and there were even rumors of a possible involvement on the part of Richard the Lionheart. This much to explain just how difficult it is to separate history from legend. Nonetheless, Sinan inspired fear, in Saladin and the Crusaders, while at the same time (and here, too, occultist legends have grown up), he had some rather shady dealings with the Knights Templar.

But let us move on to the legend. According to some Sunni Arab writers, and then according to Christian chroniclers, the Old Man of the Mountain had discovered an atrocious way of making his men faithful unto death; invincible war machines. He took them up while still boys (and some say from birth) to the top of the fortress, and in the beautiful gardens there he debilitated them with delights: wine, women, flowers; he stupefied them with hashish and, by the time they could no longer do without the perverse bliss of that seeming paradise, he dragged them out still asleep, made them experience a normal, lackluster life for the first time, and offered them with these alterna-

tives: "If you go and kill whom I shall command you to, the Paradise you have left will be yours again once more and forever; if you fail, you will be plunged back into this squalor."

Film still from *Prince of Persia: The Sands of Time* (2010)

Those men, stupefied by the drug, sacrificed themselves to be sacrificed, killers without doubt condemned to be killed in their turn.

And in these terms the legend of Alamūt has spread over the centuries, inspiring poems, novels, and films—to this day.

The Assassins

ARNOLD OF LÜBECK
(1150–1211 OR 1214)
Chronica Slavorum, VII, 8

Note that there is a certain race of Saracens in the mountains in the territory of Damascus, Antioch and Aleppo. In their own language they are called Assassins, and in Romance "lords of the mountains" [*segnors de Montana*]. This race of men lives without law, eats pork flesh contrary to the law of the Saracens and its members have sex promiscuously with any women, even their mothers and sisters. They live in the mountains, and are almost impregnable there, since they take refuge in immensely strong castles, and their land is not particularly fertile, unless one lives off beasts. They have a lord among them who strikes the utmost fear into all the Saracen princes near and far, as well as among the nearby Christian barons, since he is accustomed to slay them in an extraordinary way. I shall explain how this happens. This prince has many very beautiful palaces in the mountains, which are enclosed within very high walls. Entrance is impossible except through a little door that is most carefully guarded. He has many sons of his peasants brought up from the cradle in these palaces, and they are taught various languages, namely Latin, Greek, Romance, Arabic and many others. They are instructed by his teachers from their earliest years until they reach adulthood, that they must obey every word and command of the lord of this land. If they do this, then he will grant the joys of paradise to them, through the power he has over living Gods. They are, however, taught that they cannot be saved if they fail to obey the wishes of the prince of this land, even in the slightest way. They are confined to these palaces from the cradle, and they never see any other man apart from their instructors and teachers, nor are they told anything else until the moment when they are summoned into the presence of the prince and ordered to kill someone.

MARCO POLO (1254–1324)
Travels, XXIII and XXIV

Mulehet is a country in which the Old Man of the Mountain dwelt in former days; and the name means "Place of the Aram." I will tell you his whole history as related by Messer Marco Polo, who heard it from several natives of that region.

The Old Man was called in their language Aloadin. He had caused a certain valley between two mountains to be enclosed, and had turned it into a garden, the largest and most beautiful that ever was seen, filled with every variety of fruit. . . .

Now no man was allowed to enter the Garden save those whom he intended to be his Ashishin. . . . He kept at his Court a number of the youths of the country, from 12 to 20 years of age, such as had a taste for soldiering, and to these he used to tell tales about Paradise, just as Mahommet had been wont to do, and they believed in him just as the Saracens believe in Mahommet. Then he would introduce them into his garden, some four, or six, or ten at a time, having first made them drink a certain potion which cast them into a deep sleep, and then causing them to be lifted and carried in. . . . When therefore they awoke, and found themselves in a place so charming,

they deemed that it was Paradise in very truth. And the ladies and damsels dallied with them to their hearts' content, so that they had what young men would have; and with their own good will they never would have quitted the place.

Now this Prince whom we call the Old One kept his Court in grand and noble style, and made those simple hill-folks about him believe firmly that he was a great Prophet. And when he wanted one of his Ashishin to send on any mission, he would cause that potion whereof I spoke to be given to one of the youths in the garden, and then had him carried into his Palace. So when the young man awoke, he found himself in the Castle, and no longer in that Paradise; whereat he was not over well pleased. He was then conducted to the Old Man's presence, and bowed before him with great veneration as believing himself to be in the presence of a true Prophet. The Prince would then ask whence he came, and he would reply that he came from Paradise! and that it was exactly such as Mahommet had described it in the Law. This of course gave the others who stood by, and who had not been admitted, the greatest desire to enter therein.

So when the Old Man would have any Prince slain, he would say to such a youth: "Go thou and slay So and So; and when thou returnest my Angels shall bear thee into Paradise. And shouldst thou die, natheless even so will I send my Angels to carry thee back into Paradise." So he caused them to believe; and thus there was no order of his that they would not affront any peril to execute, for the great desire they had to get back into that Paradise of his. And in this manner the Old One got his people to murder any one whom

he desired to get rid of. Thus, too, the great dread that he inspired all Princes withal, made them become his tributaries in order that he might abide at peace and amity with them.

JOSEPH VON HAMMER-PURGSTALL
The Story of the Assassins (1818), IV

At the center of both the Persian and Assyrian territory of the Assassins, that is to say, both in Alamūt and in Massiat, beautiful gardens were laid out with a high wall at their perimeter, a veritable eastern Paradise. Flower beds and orchards divided by canals, dappled groves and verdant meadows through which brooks chattered noisily, rose arbors and vineyards, lofty halls and tiled pavilions adorned with Persian carpets and Greek fabrics, where gold, silver, and crystal goblets glittered on gold, silver, and crystal trays, and charming maidens and lusty boys, dark-eyed and seductive like the houris and young men in Mohammed's Paradise, soft and intoxicating as the cushions on which they reclined and the wine they proffered. All this breathed pleasure, an orgy of the senses, and lustfulness. The young man, whose strength and resolve had shown him worthy to be initiated into the order of Assassins, would be invited to the table to talk to the Grandmaster or Grandprior, who would then drug him with a henbane opiate and have him carried into the garden. When he awoke, he would believe himself transported to Paradise and all its delights, and everything around him, namely the houris, confirmed this both literally and palpably. When he had taken his fill of the pleasures of Paradise, promised to the

Théodore Chassériau,
The Tepidarium (1853),
Paris, Musée d'Orsay

blessed by the Prophet, and when his lust and strength were waning; when he had drunk of the all-consuming bliss from the sparkling eyes of the houris, and of the rousing wine in sparkling goblets, he sank into an exhausted and intoxicated slumber, from which he awoke a few hours later, once again by the side of his master. The master confirmed the young man's belief that physically he had never left his side, whereas spiritually he had been transported to Paradise, where he had enjoyed a foretaste of the delights that await the faithful who sacrifice their lives for their beliefs, in obedience of their masters. And thus these beguiled young men blindly dedicate themselves to becoming the instruments of death, and zealously pursue the opportunity to sacrifice life on this earth to be blessed with life eternal. What Mohammed promised to the Muslims in the Koran, but what to some might appear as no more than a beautiful dream and an empty promise, they had already enjoyed in reality, and the joys of heaven inspired them to hellish acts. Of course, this deception could not remain undiscovered, and in all likelihood the fourth Grandmaster, who divulged all the mysteries of godlessness, also revealed to his people the joys of Paradise, though for them it could no longer have held much attraction, as they could already do anything they liked on earth. What in the past had served as a means to pleasure now became an end in itself, and the rapture of the opium rush became a replacement for heavenly delights, for the enjoyment of which they lacked the means and the strength.

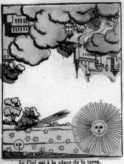

Le Ciel est à la place de la terre.
Der Himmel ist an der Stelle der Erde.

L'enfant donne la bouillie à la maman.
Das Kind gibt der Mutter den Brei.

La bonne est maîtresse.
Die Magd ist Hausfrau.

Le Mouton est berger et les hommes moutons.
Das Schaaf ist Hirde und der Mensch Schaaf.

Le Dindon conduit les enfants au champ.
Der Welschhahn führt die Kinder auf's Feld.

Le Poisson pêche l'homme.
Der Fisch fängt den Menschen.

Le Chien est à table, le maître mange les os.
Der Hund sitzt am Tische, sein Herr nagt d. Knochen.

L'âne conduit le Meunier au moulin.
Der Esel führt den Müller zur Mühle.

Le Cheval monte l'homme
Das Pferd steigt auf den Menschen.

L'Ours fait danser son maître.
Der Bäre läßt seinen Herren tanzen.

Les Hommes sont en cage, les animaux regardent.
Die Menschen sind im Käfig die Thiere Zuschauer.

Les Femmes font la patrouille.
Die Frauen machen die Patrouille.

Le Bœuf tient le soc de la charrue.
Der Ochse führt den Pflug.

Le Conscrit enseigne les Généraux.
Der Rekrute unterrichtet die Generäle.

Robert Macaire et Bertrand conduisent les Gendarmes
Robert Macaire und Bertrand führen die Gendarmen.

Le Chien chasse son maître dans la baraque.
Der Hund jagt seinen Herren in den Stall

10

THE LAND OF COCKAIGNE

In many legends, the Earthly Paradise takes on a totally materialistic form, and that is the Land of Cockaigne. As Arturo Graf (1892–93) points out, "between the two imaginations there is no constant and sure separation, and in fact it shifts by degrees from one to the other: Paradise is sometimes only a little nobler and a little more spiritual than the Land of Cockaigne, and sometimes that land, rather idealized, becomes a Paradise."

The Greeks have told us about happy lands such as Aristophanes' city of the birds, which abounds in riches and delights, and in his *True History* (which begins by saying it is full of lies), Lucian talks about a city of the blessed made entirely of gold, where ears of corn bear loaves instead of grains—not to mention the abundance of the pleasures of Venus. In a treatise, Greek in origin, translated into Latin in the fourth century and entitled *Expositio totius mundi*, there is a description of a country where a happy people who know no disease feed on honey, and bread that falls from the sky.

In the Middle Ages, Cockaigne appears for the first time in a poem, *Unibos*, from the tenth century. The peasant Unibos (One-ox) convinces three persecutors that a happy realm lies at the bottom of the sea, and so he induces them to plunge in and thus rids himself of them. But other sources of inspiration came from the Orient, and Persian romances often mention the blissful land of Shadu-kam. Graf says that an *abbas Cucaniensis* is mentioned in a goliardic poem of the twelfth century and that a certain Warnerius de Cuccagna appears on a map dated 1188. The oldest component that has come down to us is a thirteenth-century fabliau entitled *Li fabliaus de Coquaigne*, in which the author says he had gone to the Land of Cockaigne because the pope

John William Waterhouse,
illustration from
The Decameron (1916),
Liverpool, National
Museums

had sent him there to do penitence. And there he found all the marvels
that were later repeated in different versions of the legend.

In the *Cane di Diogene* (Diogenes' Dog) by Francesco Fulvio
Frugoni (1689), the Island of Cockaigne is located in the Mare della
Broda (the Sea of Broth), "shrouded in white fog that looks like soft
ricotta cheese. The rivers run with milk, from the fountains come
forth muscatel, malmsey, sweet wine, and the wine of Garganico. The
mountains are made of cheese, and the valleys of mascarpone. The
trees bear ewe's milk cheeses and mortadella sausages. When it is
stormy, the hailstones are made of sugared almonds, and if it rains it
rains gravy."

Tradition is not clear about the whereabouts of Cockaigne.
In the *Decameron*, the character Maso tells Calandrino about the won-
ders of the Land of Bengodi (an Italian version of Cockaigne), a place
where vines are tied up with sausages, and says that it lies in the
Basque country, and is zillions of miles from Florence.

In a German religious play, *Schlaraffenland* (the German
name for this happy land) lies between Vienna and Prague. Graf (1892
–93, Appendix) reports that in the *Historia nuova della città di
Cuccagna, data in luce da Alessandro da Siena e Bartolamio suo com-
pagno* (The New History of the City of Cockaigne by Alessandro da
Siena and his Companion Bartolamio), it says that in order to go to

Cockaigne you must travel for twenty-eight months by land and sea; and Teofilo Folengo places it "in some remote corner of the world."[1] In an English poem, written between the thirteenth and fourteenth centuries, the Land of Cockaigne is in the middle of the sea, west of Spain—and it also says that Cockaigne is better than Heaven, where there is nothing to eat but fruit and only water to drink.

This is an observation that should not be underestimated: while a desire for happiness and innocence aroused the idea of the Earthly Paradise in pious souls, for the poor and hungry of all epochs, the image of the delights of Cockaigne has always aroused the more mundane desire to endure no more hardship and to satisfy appetites of a more animal and urgent nature. In the various accounts, the authors often speak to the underprivileged, announcing that for them, too, the time has finally come to live it up. The legend of Cockaigne did not spring from any milieu permeated with mysticism but flourished among the masses of common people who had suffered from hunger for centuries.

The freedom enjoyed in Cockaigne was such that, as during Carnival, things can easily be reversed and a peasant can mock a bishop. In fact, one association with Cockaigne is the theme of a world of contraries, with men drawing a plough directed by an ox, the miller of a topsy-turvy mill who carries the packsaddle instead of his donkey, a fish that catches the fisherman, or animals gazing at two humans inside a cage. The idea of a land of contraries appears in the illuminated margins of medieval codices whose subject was often very serious, where for example we see hares chasing the hunter—and one theme that gave rise to many prints is that of the cats' castle besieged by mice.

In Rabbinic literature, it says, "I have seen an inverted world. The powerful were below, the humble on high" (the Babylonian Talmud, *Baba Bathra*), while a fusion of fantasies about Cockaigne and visions of a world of contraries is found in a fable by the Brothers Grimm (1812).

On the other hand, evangelical assurances whereby the underprivileged shall have a higher place in heaven also aim at the de-

1. *See Graf, 1892–93, appendix.*

scription of a world of contraries. Except that Lazarus, while the rich man Epulonus is suffering in hell, does not banquet at his table but limits himself to sitting in bliss at Abraham's side. The fantasies about Cockaigne translate on a visceral level dreams of justice that others have cultivated on a spiritual level.

That dreams of Cockaigne may distance us from reality and that pursuing unbridled pleasures may lead us to become like beasts is moralistically pointed out by Carlo Collodi, with the image of the degraded Eden that is the Land of Bengodi (the Land of Toys), where in a short space of time Pinocchio runs through both crime and punishment.

Pinocchio's Bengodi is the negation of the Earthly Paradise, and with the last misadventures of the renowned puppet we can end our research into the quest for a lost Eden that was never found again.

The Cats' Castle Besieged and Stormed by the Rats (nineteenth century), popular print, London, British Museum

Pages 294–295:
The Folly of Man; or, The World Turned Upside-Down (eighteenth century), colored print, Marseille, Musée des Civilisations de l'Europe et de la Méditerranée

The Island of Dreams

LUCIAN
A True Story, II

Near us, to port, was Cork, where the men were going, a city built on a great round cork. At a distance and more to starboard were five islands, very large and high, from which much fire was blazing up. Dead ahead was one that was flat and low-lying, not less than five hundred furlongs off. When at length we were near it, a wonderful breeze blew about us, sweet and fragrant, like the one that, on the word of the historian Herodotus, breathes perfume from Araby the blest. The sweetness that met us was as if it came from roses and narcissi and hyacinths and lilies and violets, from myrrh and laurel and vines in bloom. Delighted with the fragrance and cherishing high hopes after our long toils, we gradually drew near to the island at last. Then we saw many harbours all about it, large and unfretted by beating waves; transparent rivers emptying softly into the sea; meads, too, and woods and songbirds, some of them singing on the shore and many in the branches. A rare, pure atmosphere enfolded the place, and sweet breezes with their blowing stirred the woods gently, so that from the moving branches came a whisper of delightful, unbroken music, like the fluting of Pandean pipes in desert places. . . .

The city itself is all of gold and the wall around it of emerald. It has seven gates, all of single planks of cinnamon. The foundations of the city and the ground within its walls are ivory. There are temples of all the gods, built of beryl, and in them great monolithic altars of amethyst, on which they make their great burnt-offerings. Around the city runs a river of the finest myrrh, a hundred royal cubits wide and five deep, so that one can swim in it comfortably. For baths they have large houses of glass, warmed by burning cinnamon; instead of water there is hot dew in the tubs. For clothing they use delicate purple spiderwebs. As for themselves, they have no bodies, but are intangible and fleshless, with only shape and figure. Incorporeal as they are, they nevertheless live and move and think and talk. In a word, it would appear that their naked souls go about in the semblance of their bodies. Really, if one did not touch them, he could not tell that what he saw was not a body, for they are like upright shadows, only not black. Nobody grows old, but stays the same age as on coming there. Again, it is neither night among them nor yet very bright day, but the light which is on the country is like the gray morning toward dawn, when the sun has not yet risen. Moreover, they are acquainted with only one season of the year, for it is always spring there and the only wind that blows there is Zephyr. The country abounds in flowers and plants of all kinds, cultivated and otherwise. The grape-vines yield twelve vintages a year, bearing every month; the pomegranates, apples and other fruit-trees were said to bear thirteen times a year, for in one month, their Minoan, they bear twice. Instead of wheat-ears, loaves of bread all baked grow on the tops of the halms, so that they look like mushrooms. In the neighbourhood of the city there are three hunted and sixty-five springs of water, as many of honey, five hundred of myrrh—much

LA FOLIE DES HOMMES

Ce grotesque desseins en un Globe tracé
Fait voir en racourci le Monde renversée.

La Femme a de Mousquet la quenouille l'Epoux
Et berce pour surcroix l'Enfant sur ses genoux.

Qui peut sans s'etonner voir forger les Chevaux.
Et de l'Homme ferré devenir Maréchaux.

Quel plaisir de Chasser aux Lievres sur la Mer
Et de voir les poissons voler dedans les Airs.

Voyez pour se vanger de celui qui l'Ecorche.
Jean Lapin à son tour tourne l'Homme à la broche.

Voici le plus affreux des Combats singuliers.
Ses Hommes portant Chevaux devenus Chevaliers.

Pendant que l'Oiseau prend au filet deux Anains.
Le Mary voltigeant se vient prendre dedans.

Les Cochons affamez par des Traits inhumains.
Egorgend font griller dépiecent les Humains.

a Paris chez Mondhard rue

OU LE MONDE A REBOURS.

Fille donne ici la Bouillie à sa Mere.
Fils a coups de fouet apprend a vivre à son Pere.

Deux hommes attelez entrainent la Charrue
Le Bœuf est Laboureur et sur leurs dos se ruë.

L'Asne de l'Homme étoit autrefois la monture.
L'Homme porte au moulin a present la monture.

Ici l'Homme civilé s'attache au Ratelier
Le Cheval a son tour devient Palfrenier.

D'un pas grave un Baudet se quarrand dans la Ville.
fait a son Jardinier porter Choux et Lentille.

L'Homme autrefois prenoit a la ligne un poisson
Le poisson aujourd'huy prend l'Homme a l'hameçon.

Quel Objet plein d'horreur un Bœuf tout en furie
fait d'un Homme écorché Sanglante boucherie.
a l'Hôtel de Saumur.

Les Villes tout a coup s'élevant dans les Nuës
Sont au plus haut des Cieux en toute suspenduës
Et pour combler l'horreur d'un tel renversement
Les Astres détachez tombent du Firmament.

smaller, however—seven rivers
of milk and eight of wine.
Their table is spread outside the city
in the Elysian Fields, a very beautiful
mead with thick woods of all sorts
round about it, overshadowing the
feasters. The couches they lie on are
made of flowers, and they are attended
and served by the winds, who, howev-
er, do not pour out their wine, for they
do not need anyone to do this. There
are great trees of the clearest glass
around the table, and instead of fruit
they bear cups of all shapes and sizes.
When anyone comes to table he picks
one or two of the cups and puts them at
his place. These fill with wine at once,
and that is the way they get their drink.
Instead of garlands, the nightingales
and the other song-birds gather flow-
ers in their bills from the fields hard by
and drop them down like snow, flying
overhead and singing. Furthermore,
the way they are scented is that thick
clouds draw up myrrh from the springs
and the river, stand over the table and
under the gentle manipulation of the
winds rain down a delicate dew. At the
board they pass their time with poetry
and song. For the most part they sing
the epics of Homer, who is there him-
self and shares the revelry, lying at ta-
ble in the place above Odysseus. Their
choruses are of boys and girls. . . .
When they stop singing another cho-
rus appears, composed of swans and
swallows and nightingales, and as they
sing the whole wood renders the ac-
companiment, with the winds leading.
But the greatest thing that they have
for ensuring a good time is that two
springs are by the table, one of laugh-
ter and 'the other of enjoyment. They
all drink from each of these when the
revels begin, and thenceforth enjoy
themselves and laugh all the while.

About love-making their attitude is
such that they bill-and-coo openly, in
plain sight of everyone, without any
discrimination, and think no shame
of it at all. Socrates, the only excep-
tion, used to protest that he was above
suspicion in his relations with young
persons, but everyone held him guilty
of perjury. In fact, Hyacinthus and
Narcissus often said that they knew
better, but he persisted in his denial.
They all have their wives in common
and nobody is jealous of his neigh-
bour; in this point they out-Plato
Plato. Complaisance is the universal
rule.

The Land of Cockaigne

Li Fabliaus de Coquaigne
(THIRTEENTH CENTURY)

Once I visited the Pope in Rome,
To ask from him a penance,
And he sent me to a country
Where many marvels I did see:
Now listen as I tell you of the lives
Of the people of that land,
Which God and all his saints,
Have blessed and hallowed
More than any other, I believe.
It is known as the land of Cockaigne,
Where the more you sleep, the more
 you earn. . . .
The walls of all the houses
Are made of sea bass, salmon and
 shad,
The rafters are made of sturgeon,
The shingles made of ham
And the laths are made of sausages.
The land has many delights,
Because all the fields of grain
Are hedged with roasts and hams;
Fat geese walk cooking through the
 streets,

Pieter Bruegel the Elder,
The Land of Cockaigne
(1567), Munich,
Alte Pinakothek

They turn themselves, and close be-
 hind
Are followed by white garlic sauce.
And I tell you that everywhere you go
Along the paths or by the roads
Are tables set up for a feast,
Upon white tablecloths,
Where anyone, without fear
Of contradiction or proscription,
May eat and drink his fill,
Take what his heart desires,
Some take fish and others meat,
And if they wish to fill a cart,
May do so as they please;
Flesh of deer or flying fowl,
Some like it roast and others boiled,
Without putting any money down,
And after eating comes no bill
As is the custom of this realm:
And it is a finely proven truth
That in this blessed land
There runs a river made of wine. . . .

Its people are not base of heart,
But valiant and courteous.
There are six weeks to every month,
And four Easters in a year,
Four feasts of St John,
And four harvests too,
Each day a holiday or a Sunday,
Four All Saints' Days, four
 Christmases,
And four Candlemases each year,
And four Carnivals as well,
But Lent falls every twenty years,
And fasting is such a pleasure,
That all do willingly comply;
From morning to the ninth hour
They eat the bounty sent by God,
Meat or fish or more besides,
And no one dares to tell them no.
Do not think I speak in jest,
But no one be they high or low,
Must toil to earn a living there:
Three times a week

Hot pies rain down
Upon the hairy,
And the bald, I'm sure,
So each one takes all he desires;
And so rich is this land
That purses full of money
At every corner can be found;
Bezants and marabotins
Any man may take for nothing,
But no one buys and no one sells.
So beautiful are the women there,
Ladies and maidens,
Whom any man who so desires
May take without the least offence,
And take with them his pleasure
As long as he pleases and as he likes;
But never are the women blamed,
Only honoured all the more,
And if by chance a lady sees
A man who wakens her desire,
She may take him there and then
And do with him as she wishes. . . .
There is another marvel too,
The like of which you've never heard,
There is a fountain rising there,
Where people can restore their youth,
And then there is no more to tell.

Calandrino
and the Helitropia

GIOVANNI BOCCACCIO
The Decameron (1349–1353),
day eight, third novel

In our owne Citie, which evermore
hath contained all sorts of people,
not long since there dwelt, a Painter,
named Calandrino, a simple man; yet
as much adicted to matters of novelty,
as any man whatsoever could be.
The most part of his time, he spent in
the company of two other Painters,
the one called Bruno, and the other
Buffalmaco, men of very recreative

spirits, and of indifferent good capaci-
ty, often resorting to the said
Calandrino, because they tooke de-
light in his honest simplicity, and
pleasant order of behaviour. At the
same time likewise, there dwelt in
Florence, a yong Gentleman of singu-
lar disposition, to every generous and
witty conceite, as the world did not
yeeld a more pleasant companion, he
being named Maso del Saggio, who
having heard somwhat of Calandrinos
sillinesse: determined to jest with him
in merry manner, and to suggest his
longing humors after Novelties, with
some conceit of extraordinary nature.
He happening (on a day) to meete him
in the Church of Saint John, and see-
ing him seriously busied, in beholding
the rare pictures, and the curious
carved Tabernacle, which (not long
before) was placed on the high Altar in
the said Church: considered with him-
selfe, that he had now fit place and op-
portunity, to effect what hee had long
time desired. And having imparted his
minde to a very intimate friend, how
he intended to deale with simple
Calandrino: they went both very neere
him, where he sate all alone, and mak-
ing shew as if they saw him not; began
to consult between themselves, con-
cerning the rare properties of precious
stones; whereof Maso discoursed as
exactly, as he had beene a most skilfull
Lapidarie; to which conference of
theirs, Calandrino lent an attentive
eare, in regard it was matter of singu-
lar rarity.
Soone after, Calandrino started up,
and perceiving by their loude speak-
ing, that they talked of nothing which
required secret Counsell: he went into
their company (the onely thing which
Maso desired) and holding on still the
former Argument; Calandrino would

Hieronymus Bosch,
The Seven Deadly Sins
(late fifteenth century),
Madrid, Museo del Prado

needs request to know, in what place these precious stones were to be found, which had such excellent vertues in them? Maso made answere, that the most of them were to be had in Berlinzona, neere to the City of Bascha, which was in the Territory of a Countrey, called Bengodi, where the Vines were bound about with Sawcidges, a Goose was sold for a penny, and the Goslings freely given in to boote. There was also an high mountaine wholly made of Parmezane, grated Cheese, whereon dwelt people, who did nothing else but make Mocharones and Ravivolies, boyling them with broth of Capons, and afterward hurled them all about, to whoso-

ever can or will catch them. Neere to this mountaine runneth a faire River, the whole streame being pure white Bastard, none such was ever sold for any money, and without one drop of water in it.

Now trust me Sir, (said Calandrino) that is an excellent Countrey to dwell in: but I pray you tell me Sir, what do they with the Capons after they have boyld them? The Baschanes (quoth Maso) eate them all. Have you Sir, said Calandrino, at any time beene in that Countrey? How? answered Maso, doe you demaund if have beene there? Yes man, above a thousand times, at the least. How farre Sir, I pray you (quoth Calandrino) is that worthy Countrey,

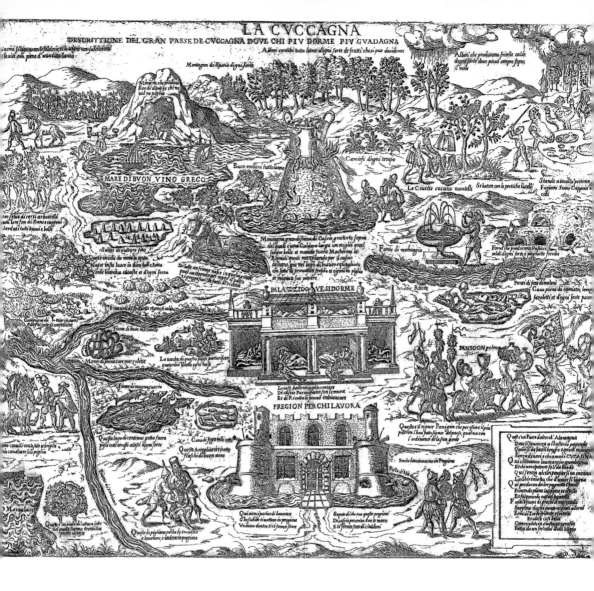

from this our City? In troth, replyed Maso, the miles are hardly to be numbred, for the most part of them, we travell when we are nightly in our beddes, and if a man dreame right; he may be there upon a sudden.

Surely Sir, said Calandrino, it is further hence, then to Abruzzi? Yes questionlesse, replyed Maso; but, to a willing minde, no travell seemeth tedious. Calandrino well noting, that Maso delivered all these speeches, with a stedfast countenance, no signe of smyling, or any gesture to urge the least mis-

like: he gave such credit to them, as to any matter of apparent and manifest truth, and upon this assured confidence, he said.

Beleeve me Sir, the journey is over-farre for mee to undertake, but if it were neerer; I could affoord to goe in your Company; onely to see how they make these Macherones, and to fill my belly with them.

But now wee are in talke Sir, I pray you pardon mee to aske, whether any such precious stones, as you spake off, are to be found in that Countrey, or no?

Cockaigne, the Land Where He Who Sleeps the Most Earns the Most (1575/1590), popular print, London, British Museum

Yes indeed, replyed Maso, there are two kinds of them to be found in those Territories, both being of very great vertue. One kind, are gritty stones, of Settignano, and of Montisca, by vertue of which places, when any Mill-stones or Grind-stones are to bee made, they knede the sand as they use to doe meale, and so make them of what bignesse they please. In which respect, they have a common saying there: that Nature maketh common stones, but Montisca Mill-stones. Such plenty are there of these Mill-stones, so slenderly here esteemed among us, as Emeralds are with them, whereof they have whole mountaines, farre greater then our Montemorello, which shine most gloriously at midnight. And how meanly soever we account of their Mill-stones; yet there they drill them, and enchase them in Rings, which afterward they send to the great Soldane, and have whatsoever they will demaund for them.

The other kinde is a most precious Stone indeede, which our best Lapidaries call the Helitropium, the vertue whereof is so admirable; as whosoever beareth it about him, so long as he keepeth it, it is impossible for any eye to discerne him, because he walketh meerely invisible. O Lord Sir (quoth Calandrino) those stones are of rare vertue indeede: but where else may a man finde that Helitropium? Whereto Maso thus answered: That Countrey onely doth not containe the Helitropium; for they be many times found upon our plaine of Mugnone. Of what bignesse Sir (quoth Calandrino) is the Stone, and what coulour? The Helitropium, answered Maso, is not alwayes of one quality, because some are bigge, and others lesse; but all are of one coulour, namely blacke.

Calandrino committing all these things to respective memory, and pretending to be called thence by some other especiall affaires; departed from Maso, concluding resolvedly with himselfe, to finde this precious stone, if possibly hee could.

A Cockaigne Inside Out

JACOB AND WILHELM GRIMM
Grimms' Fairy Tales (1812–1822)

In the time of Schlauraffen I went forth and saw Rome and the Lateran hanging by a small silken thread, and a man without feet who outran a swift horse, and a keen sharp sword that cut through a bridge. I saw a young ass with a silver nose which pursued two fleet hares, and a lime-tree that was very large, on which hot cakes were growing. I saw a lean old goat which carried about a hundred cart-loads of fat on his body, and sixty loads of salt. Have I not told enough lies? I saw a plough ploughing without horse or cow, and a child of one year threw four millstones from Ratisbon to Treves, and from Treves to Strasburg, and a hawk swam over the Rhine, which he had a perfect right to do. I heard some fishes begin to make such a disturbance with each other, that it resounded as far as heaven, and sweet honey flowed like water from a deep valley to the top of a high mountain, and these were strange things. There were two crows which were mowing a meadow, and I saw two gnats building a bridge, and two doves tore a wolf to pieces; two children brought forth two kids, and two frogs threshed corn together. I saw two mice consecrating

a bishop, and two cats scratching out a bear's tongue. Then a snail came running up and killed two furious lions. There stood a barber and shaved a woman's beard off; and two sucking-children bade their mother hold her tongue. There I saw two greyhounds which brought a mill out of the water; and a broken-down old horse was beside it, and said it was right. And four horses were standing in the yard threshing corn with all their might, and two goats were heating the stove, and a red cow shot the bread into the oven. Then a hen crowed, Cock-a-doodle-doo! The story is all told—cock-a-doodle-doo!

A Land of Plenty

CARLO COLLODI (LORENZINI)

The Adventures of Pinocchio (1881–1882), XXX–XXXI

Lamp-Wick was the laziest boy in the school and the biggest mischief-maker, but Pinocchio loved him dearly. That day, he went straight to his friend's house to invite him to the party, but Lamp-Wick was not at home. He went a second time, and again a third, but still without success. Where could he be? Pinocchio searched here and there and everywhere, and finally discovered him hiding near a farmer's wagon. "What are you doing there?" asked Pinocchio, running up to him. "I am waiting for midnight to strike to go . . . to a real country—the best in the world—a wonderful place!" "What is it called?"

"It is called the Land of Toys. Why don't you come, too?" "I? Oh, no!" "You are making a big mistake, Pinocchio. Believe me, if you don't come, you'll be sorry. Where can you find a place that will agree better with you and me? No schools, no teachers, no books! In that blessed place there is no such thing as study. Here, it is only on Saturdays that we have no school. In the Land of Toys, every day, except Sunday, is a Saturday. Vacation begins on the first of January and ends on the last day of December. That is the place for me! All countries should be like it! . . . " "But how does one spend the day in the Land of Toys?" "Days are spent in play and enjoyment from morn till night. At night one goes to bed, and next morning, the good times begin all over again. What do you think of it?" "H'm—!" said Pinocchio, nodding his wooden head, as if to say, "It's the kind of life which would agree with me perfectly." . . .

The wagon started again. . . . As soon as they had set foot in that land, Pinocchio, Lamp-Wick, and all the other boys who had traveled with them started out on a tour of investigation. They wandered everywhere, they looked into every nook and corner, house and theater. They became everybody's friend. Who could be happier than they? What with entertainments and parties, the hours, the days, the weeks passed like lightning. "Oh, what a beautiful life this is!" said Pinocchio each time that, by chance, he met his friend Lamp-Wick.

Attilio Mussino, *The Land of Toys*, illustration for the novel *Pinocchio* (1911)

Cuitae Amgoroni

Gous atudu

Otni amem

11

THE ISLANDS OF UTOPIA

Left:
Woodcut map of the island
of Utopia on frontispiece
of the 1st edition
of Thomas More's *Utopia*
(1516), London,
British Library

Below:
Woodcut map by Ambrosius
Holbein for the third edition
of Thomas More's *Utopia*,
(1518), London, British
Library

Etymologically, *utopia* means *non-place*—even though some prefer to understand the initial *u* as a Greek *eu*, and so they read *good or excellent place*; others still maintain that by coining this neologism, Thomas More, in his *Libellus vere aureus, nec minus salutaris quam festivus, de optimo rei publicae statu, deque nova insula Utopia* (A Truly Golden Little Book, No Less Beneficial Than Entertaining, of the Best State of a Republic, and of the New Island Utopia) of 1516, in which he describes an ideal state, deliberately played on

Arthur Rackham,
Gulliver (1904), illustration
from *Gulliver's Travels*
by Jonathan Swift

Gulliver in the Land of the Lilliputians (1876), illustration from *Gulliver's Travels* by Jonathan Swift, Stockholm, Landskrona Museum

this ambiguity, given that he took a nonexistent country as a positive model.

As a matter of fact, other ideal societies had already been foreshadowed, for example by Plato in *The Republic* and in *Laws*, but it is with More that a description appears of this non-place, of the island, its cities, and their buildings. Other utopian places were to be described, for example, in *The City of the Sun* by Tommaso Campanella (1602), or in *The New Atlantis* by Francis Bacon (1627).

Political literature, such as what was to become known as science fiction, has a wealth of descriptions of ideal civilizations, and we should cite *The Comical History of the States and Empires of and Moon and Sun* by Cyrano de Bergerac (1649, 1662), *The Commonwealth of Oceana* by James Harrington (1656), *The History of the Sevarites or Sevarambi* by Denis Vairasse (1675), *The Southern Land* by Gabriel de Foigny (1676), *La republique des philosophes or Histoire des Ajaoiens* by Bernard de Fontenelle (1768), *Discoveries in the Southern Hemisphere by a Flying Man* by Nicolas Restif de la Bretonne (1781),[1] the calm and rational society of the Houyhnhnms in *Gulliver's Travels* by Jonathan Swift (1726), the works of Henri de Saint-Simon and Charles Fourier, who, in opposition to the capitalist society of their time, advocated utopian socialism—and at least in Fourier's case, we cannot talk sim-

1. *We shall be dealing with Vairasse, Foigny, and La Bretonne again in chapter 12 on the Austral Land.*

Richard Redgrave,
*Gulliver Exhibited
to the Brobdingnag Farmer*
(nineteenth century),
from *Gulliver's Travels*
by Jonathan Swift, London,
Victoria and Albert Museum

ply of a utopia, because throughout the nineteenth century, the idea of his phalansteries led to some attempts to create them. Also worthy of mention are *A Journey to Icaria* by Étienne Cabet (1840), which prefigures a communist-type society, *Erewhon* by Samuel Butler (1872)—whose name is the word nowhere written backward—and *News from Nowhere* by William Morris (1891).

Sometimes utopia has taken the form of dystopia, accounts of negative societies, as had been already the case with *Mundus alter* by Joseph Hall (1607), and in the twentieth century with Orwell's *1984*, Karel Ðapek's *R.U.R*, Aldous Huxley's *Brave New World*, Robert Sheckley's "Seventh Victim," Ray Bradbury's *Fahrenheit 451, Do Androids Dream of Electric Sheep?* by Philip K. Dick (on which Ridley Scott's more famous film *Blade Runner* was based), not to mention

Charles Verschuuren, poster for the Federal Theatre Project production of *R.U.R.* at the Marionette Theatre (1936–1939), New York

other renowned films such as Fritz Lang's *Metropolis* or *The Planet of the Apes*.

If we wish to stick to the aim of this book, which is to discuss *legendary* places, lands around which have grown legends that for centuries have suggested they really existed, we ought not to talk about the cities, islands, and lands of utopia, because by definition they were presented as non-places (even though their authors wished to foretell situations that could or should have come about one day). And some of these imaginary places, as for example those of Swift, are clearly the result of fictional invention and have not induced legions of gullible explorers to go to look for them. But some of these places (such as the Island of Utopia, the City of the Sun, the Land of Bensalem in *The New Atlantis*) have become *almost* real, and if not believed in, at least desired or desirable—and in Latin their description would have been preceded by *utinam*, an adverb we might translate as "heaven grant that . . . ," "how I would like it if . . . ," or "if only it were. . . ." And often the object of a desire, when desire is transformed into hope, becomes more real than reality itself. Out of a hope in a possible future, many people are prepared to make enormous sacrifices, and maybe even die,

led on by prophets, visionaries, charismatic preachers, and spellbinders who fire the minds of their followers with the vision of a future heaven on Earth (or elsewhere).

As for negative utopias, they have seemed true every time we have recognized situations in our everyday reality suggesting that the gloomy pessimism of those accounts is well founded.

That said, we would not always want to live in those societies recommended to us by utopias, because they often resemble dictatorships that *impose* happiness on their citizens at the cost of their freedom. For example, More's *Utopia* preaches freedom of speech and thought as well as religious tolerance, but limits them to believers and excludes atheists, who are barred from public office, while it warns that "if someone takes the license to wander far from his own district, and is caught without the pass issued by the supreme magistrate . . . he is severely punished; if he dares to do so a second time, he is condemned to slavery." Moreover, utopias have the quality, as literary works, of being somewhat repetitive, because in wishing for a perfect society, we always end up by making a copy of the same model. But here we are not interested in the way of life that these works recommend or in the occasionally explicit criticism of the societies in which the authors lived, but in the places they describe.

These places are not many, because in the infinity of utopias that have been written, not all mention a specific location, and regarding the locations described, few have remained imprinted in the collective imagination in such a way as to create their own legend.

Utopias, as we have said, are repetitive, and the descriptions of utopian cities are also repetitive, because to a certain extent their model is more or less subconsciously derived from the celestial city of the Apocalypse, geometrically splendid and tetragonal, and in some cases from the dream of the Temple of Solomon, which we discussed in the second chapter of this book. Also, in *Christianopolis* by Johann Valentin Andreae (1619), the ideal city is presented very clearly as a new earthly Jerusalem modeled on the celestial city of the Apocalypse.

Precisely in order to show how the various utopias have created images that someone then took seriously enough to wish to realize

Map of Palmanova, from Franz Hogenberg and Georg Braun, *Civitates orbis terrarum* (1572–1616), Nuremberg

them, think of the diverse ideal cities conceived by Renaissance architects. For example, Palmanova takes the form of a star with nine points, surrounded by walls and moats, and six roads converge on the center, in the shape of a hexagonal plaza. In order to resist Turkish attacks, Nicosia, in Cyprus, when it was still under Venetian rule, was designed at least from the outside as an ideal city, where a circular structure protected the old medieval city by means of eleven ramparts.

But perhaps utopians such as More and Campanella were also inspired by previous ideals, given that since the fifteenth century, in his *Treatise on Architecture* (1464), Filarete had designed Sforzinda, which was based on an eight-pointed plan obtained by superimposing two squares rotated at 45 degrees to each other, perfectly inscribed within a circle, and from every gate and tower a straight road led toward the center of the city.

Perhaps the utopia closest to modern interests is that of

Francis Bacon, wherein a system of peaceful and pleasant life is inspired by the acquisition of all scientific knowledge, and in its superabundance, Bacon's House of Solomon, described as a container of all knowledge and all technology, reminds us of the desire for knowledge that motivated, in that same seventeenth century, the collectors of so-called cabinets of curiosities and the *Wunderkammern*, or "wonder rooms," dizzying accumulations of amazing objects and instruments.

Finally, when the legend of a place that cannot be found is created, literature can raise this "not-being-there" by a power of ten, and this is what Jorge Luis Borges does in his short story "Tlön, Uqbar, Orbis Tertius," in which the author says that the origin of that disturbing and occult place is due to ". . . a secret society of astronomers, biologists, engineers, metaphysicians, poets, chemists, algebraists, moralists, painters, and geometers . . . directed by an obscure man of genius." That origin, as well as making us think of Bacon's Bensalem, also explicitly evokes "a German theologian who, in the seventeenth century, described the imaginary community of Rosae Crucis—a community that others founded later, in imitation of what he had prefigured." And the theologian in question, even though Borges does not tell us this, was that same Andreae who had conceived the nonexistent place of Christianopolis.

Plate from Luigi Serafini, *Codex Seraphinianus* (1981), Milan, Franco Maria Ricci

The Island of Utopia

THOMAS MORE
Libellus vere aureus, nec minus salutaris quam festivus de optimo rei publicae statu, deque nova insula Utopia (1516), II

"The island of Utopia is in the middle two hundred miles broad, and holds almost at the same breadth over a great part of it, but it grows narrower towards both ends. Its figure is not unlike a crescent. Between its horns the sea comes in eleven miles broad, and spreads itself into a great bay, which is environed with land to the compass of about five hundred miles, and is well secured from winds. In this bay there is no great current; the whole coast is, as it were, one continued harbour, which gives all that live in the island great convenience for mutual commerce. But the entry into the bay, occasioned by rocks on the one hand and shallows on the other, is very dangerous. In the middle of it there is one single rock which appears above water, and may, therefore, easily be avoided; and on the top of it there is a tower, in which a garrison is kept; the other rocks lie under water, and are very dangerous. The channel is known only to the natives; so that if any stranger should enter into the bay without one of their pilots he would run great danger of shipwreck. For even they themselves could not pass it safe if some marks that are on the coast did not direct their way; and if these should be but a little shifted, any fleet that might come against them, how great soever it were, would be certainly lost. On the other side of the island there are likewise many harbours; and the coast is so fortified, both by nature and art, that a small number of men can hinder the descent of a great army. But they report (and there remains good marks of it to make it credible) that this was no island at first, but a part of the continent. Utopus, that conquered it (whose name it still carries, for Abraxa was its first name), brought the rude and uncivilised inhabitants into such a good government, and to that measure of politeness, that they now far excel all the rest of mankind. Having soon subdued them, he designed to separate them from the continent, and to bring the sea quite round them. To accomplish this he ordered a deep channel to be dug, fifteen miles long; and that the natives might not think he treated them like slaves, he not only forced the inhabitants, but also his own soldiers, to labour in carrying it on. As he set a vast number of men to work, he, beyond all men's expectations, brought it to a speedy conclusion. And his neighbours, who at first laughed at the folly of the undertaking, no sooner saw it brought to perfection than they were struck with admiration and terror.
"There are fifty-four cities in the island, all large and well built, the manners, customs, and laws of which are the same, and they are all contrived as near in the same manner as the ground on which they stand will allow."

The City of the Sun

TOMMASO CAMPANELLA
The City of the Sun (1602)

I have already told you how I wandered over the whole earth. In the course of my journeying I came to Taprobane, and was compelled to go

ashore at a place, where through fear of the inhabitants I remained in a wood. When I stepped out of this I found myself on a large plain immediately under the equator. . . .

I came upon a large crowd of men and armed women, many of whom did not understand our language, and they conducted me forthwith to the City of the Sun. . . .

It is divided into seven rings or huge circles named from the seven planets, and the way from one to the other of these is by four streets and through four gates, that look toward the four points of the compass. Furthermore, it is so built that if the first circle were stormed, it would of necessity entail a double amount of energy to storm the second; still more to storm the third; and in each succeeding case the strength and energy would have to be doubled; so that he who wishes to capture that city must, as it were, storm it seven times. For my own part, however, I think that not even the first wall could be occupied, so thick are the earthworks and so well fortified is it with breastworks, towers, guns, and ditches.

When I had been taken through the northern gate . . ., I saw a level space seventy paces wide between the first and second walls. From hence can be seen large palaces, all joined to the wall of the second circuit in such a manner as to appear all one palace. Arches run on a level with the middle height of the palaces, and are continued round the whole ring. There are galleries for promenading upon these arches, which are supported from beneath by thick and well-shaped columns, enclosing arcades like peristyles, or cloisters of an abbey.

But the palaces have no entrances from below, except on the inner or concave partition, from which one enters directly to the lower parts of the building. The higher parts, however, are reached by flights of marble steps, which lead to galleries for promenading on the inside similar to those on the outside. . . .

On the top of the hill is a rather spacious plain, and in the midst of this there rises a temple built with wondrous art. . . .

The temple is built in the form of a circle; it is not girt with walls, but stands upon thick columns, beautifully grouped. A very large dome, built with great care in the centre or pole, contains another small vault as it were rising out of it, and in this is a spiracle, which is right over the altar. There is but one altar in the middle of the temple, and this is hedged round by columns. The temple itself is on a space of more than 350 paces. Without it, arches measuring about eight paces extend from the heads of the columns outward, whence other columns rise about three paces from the thick, strong, and erect wall. . . . Nothing is seen over the altar but a large globe, upon which the heavenly bodies are painted, and another globe upon which there is a representation of the earth. Furthermore, in the vault of the dome there can be discerned representations of all the stars of heaven from the first to the sixth magnitude, with their proper names and power to influence terrestrial things marked in three little verses for each. There are the poles and greater and lesser circles according to the right latitude of the place, but these are not perfect because there is no wall below. They seem, too, to be made in their relation to the globes on the altar. The pave-

Bartolomeo del Bene,
Civitas veri (1609)

ment of the temple is bright with precious stones. Its seven golden lamps hang always burning, and these bear the names of the seven planets.

At the top of the building several small and beautiful cells surround the small dome, and behind the level space above the bands or arches of the exterior and interior columns there are many cells, both small and large, where the priests and religious officers dwell to the number of forty-nine. A revolving flag projects from the smaller dome, and this shows in what quarter the wind is. The flag is marked with figures up to thirty-six, and the priests know what sort of year the different kinds of winds bring and what will be the changes of weather on land and sea. Furthermore, under the flag a book is always kept written with letters of gold. . . .

The great ruler among them is a priest whom they call by the name Hoh, though we should call him Metaphysic. He is head over all, in temporal and spiritual matters, and all business and lawsuits are settled by him, as the supreme authority. Three princes of equal power—viz., Pon, Sin, and Mor—assist him, and these in our tongue we should call Power, Wisdom, and Love. To Power belongs the care of all matters relating to war and peace. He attends to the military arts, and, next to Hoh, he is ruler in every affair of a warlike nature. He governs the military magistrates and the soldiers, and has the management of the munitions, the fortifications, the storming of places, the implements of war, the armories, the smiths and workmen connected with matters of this sort.

But Wisdom is the ruler of the liberal arts, of mechanics, of all sciences with

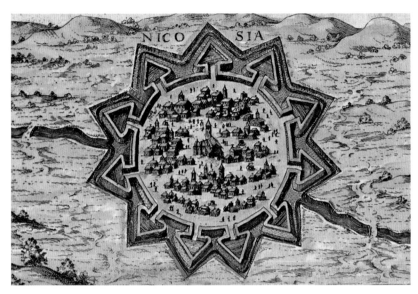

Giacomo Franco,
Map of Nicosia (1597)

their magistrates and doctors, and of the discipline of the schools. As many doctors as there are, are under his control. There is one doctor who is called Astrologus; a second, Cosmographus; a third, Arithmeticus; a fourth, Geometra; a fifth, Historiographus; a sixth, Poeta; a seventh, Logicus; an eighth, Rhetor; a ninth, Grammaticus; a tenth, Medicus; an eleventh, Physiologus; a twelfth, Politicus; a thirteenth, Moralis. They have but one book, which they call Wisdom, and in it all the sciences are written with conciseness and marvellous fluency of expression. This they read to the people after the custom of the Pythagoreans. It is Wisdom who causes the exterior and interior, the higher and lower walls of the city to be adorned with the finest pictures, and to have all the sciences painted upon them in an admirable manner. On the walls of the temple and on the dome, which is let down when the priest gives an address, lest the sounds of his voice, being scattered, should fly away from his audience,

there are pictures of stars in their different magnitudes, with the powers and motions of each, expressed separately in three little verses.

On the interior wall of the first circuit all the mathematical figures are conspicuously painted—figures more in number than Archimedes or Euclid discovered, marked symmetrically, and with the explanation of them neatly written and contained each in a little verse. There are definitions and propositions, etc. On the exterior convex wall is first an immense drawing of the whole earth, given at one view. Following upon this, there are tablets setting forth for every separate country the customs both public and private, the laws, the origins and the power of the inhabitants; and the alphabets the different people use can be seen above that of the City of the Sun.

On the inside of the second circuit, that is to say of the second ring of buildings, paintings of all kinds of precious and common stones, of minerals and met-

als, are seen; and a little piece of the metal itself is also there with an apposite explanation in two small verses for each metal or stone. On the outside are marked all the seas, rivers, lakes, and streams which are on the face of the earth; as are also the wines and the oils and the different liquids, with the sources from which the last are extracted, their qualities and strength. There are also vessels built into the wall above the arches, and these are full of liquids from one to 300 years old, which cure all diseases....

On the interior of the third circuit all the different families of trees and herbs are depicted, and there is a live specimen of each plant in earthenware vessels placed upon the outer partition of the arches. With the specimens there are explanations as to where they were first found, what are their powers and natures, and resemblances to celestial things and to metals, to parts of the human body and to things in the sea, and also as to their uses in medicine, etc. On the exterior wall are all the races of fish found in rivers, lakes, and seas, and their habits and values, and ways of breeding, training, and living, the purposes for which they exist in the world, and their uses to man. Further, their resemblances to celestial and terrestrial things, produced both by nature and art, are so given that I was astonished when I saw a fish which was like a bishop, one like a chain, another like a garment, a fourth like a nail, a fifth like a star, and others like images of those things existing among us, the relation in each case being completely manifest. There are sea-urchins to be seen, and the purple shell-fish and mussels; and whatever the watery world possesses worthy of being known is there fully shown in marvellous characters of painting and drawing.

On the fourth interior wall all the different kinds of birds are painted, with their natures, sizes, customs, colors, manner of living, etc.; and the only real phoenix is possessed by the inhabitants of this city. On the exterior are shown all the races of creeping animals, serpents, dragons, and worms; the insects, the flies, gnats, beetles, etc., in their different states, strength, venoms, and uses, and a great deal more than you or I can think of.

On the fifth interior they have all the larger animals of the earth, as many in number as would astonish you. We indeed know not the thousandth part of them, for on the exterior wall also a great many of immense size are also portrayed. To be sure, of horses alone, how great a number of breeds there is and how beautiful are the forms there cleverly displayed!

On the sixth interior are painted all the mechanical arts, with the several instruments for each and their manner of use among different nations. Alongside, the dignity of such is placed, and their several inventors are named. But on the exterior all the inventors in science, in warfare, and in law are represented.

The House of Solomon

FRANCIS BACON
The New Atlantis (1624)

"The end of our foundation is the knowledge of causes, and secret motions of things; and the enlarging of the bounds of human empire, to the effecting of all things possible.

"The preparations and instruments are these: We have large and deep caves of several depths; the deepest are sunk 600 fathoms; and some of them are digged and made under great hills and mountains; so that if you reckon together the depth of the hill and the depth of the cave, they are, some of them, above three miles deep. For we find that the depth of a hill and the depth of a cave from the flat are the same thing; both remote alike from the sun and heaven's beams, and from the open air. These caves we call the lower region. And we use them for all coagulations, indurations, refrigerations, and conservations of bodies. We use them likewise for the imitation of natural mines and the producing also of new artificial metals, by compositions and materials which we use and lay there for many years. We use them also sometimes (which may seem strange) for curing of some diseases, and for prolongation of life, in some hermits that choose to live there, well accommodated of all things necessary, and indeed live very long; by whom also we learn many things. . . .

"We have high towers, the highest about half a mile in height, and some of them likewise set upon high mountains, so that the vantage of the hill with the tower is in the highest of them three miles at least. And these places we call the upper region, account the air between the high places and the low as a middle region. We use these towers, according to their several heights and situations, for insulation, refrigeration, conservation, and for the view of divers meteors—as winds, rain, snow, hail, and some of the fiery meteors also. And upon them in some places are dwellings of hermits, whom we visit sometimes and instruct what to observe.

"We have great lakes, both salt and fresh, whereof we have use for the fish and fowl. We use them also for burials of some natural bodies, for we find a difference in things buried in earth, or in air below the earth, and things buried in water. We have also pools, of which some do strain fresh water out of salt, and others by art do turn fresh water into salt. We have also some rocks in the midst of the sea, and some bays upon the shore for some works, wherein are required the air and vapor of the sea. We have likewise violent streams and cataracts, which serve us for many motions; and likewise engines for multiplying and enforcing of winds to set also on divers motions.

"We have also a number of artificial wells and fountains, made in imitation of the natural sources and baths, as tincted upon vitriol, sulphur, steel, brass, lead, nitre, and other minerals; and again, we have little wells for infusions of many things, where the waters take the virtue quicker and better than in vessels or basins. And among them we have a water, which we call water of paradise, being by that we do it made very sovereign for health and prolongation of life. . . .

"We have also fair and large baths, of several mixtures, for the cure of diseases, and the restoring of man's body from arefaction; and others for the confirming of it in strength of sinews, vital parts, and the very juice and substance of the body.

"We have also large and various orchards and gardens, wherein we do not so much respect beauty as variety of ground and soil, proper for divers trees and herbs, and some very spacious, where trees and berries are set, whereof we make divers kinds of

drinks, beside the vineyards. In these we practise likewise all conclusions of grafting, and inoculating, as well of wild-trees as fruit-trees, which produceth many effects. And we make by art, in the same orchards and gardens, trees and flowers, to come earlier or later than their seasons, and to come up and bear more speedily than by their natural course they do. We make them also by art greater much than their nature; and their fruit greater and sweeter, and of differing taste, smell, color, and figure, from their nature. And many of them we so order as that they become of medicinal use. "We have also means to make divers plants rise by mixtures of earths without seeds, and likewise to make divers new plants, differing from the vulgar, and to make one tree or plant turn into another.

"We have also parks, and enclosures of all sorts, of beasts and birds; which we use not only for view or rareness, but likewise for dissections and trials, that thereby may take light what may be wrought upon the body of man. Wherein we find many strange effects: as continuing life in them, though divers parts, which you account vital, be perished and taken forth; resuscitating of some that seem dead in appearance, and the like. We try also all poisons, and other medicines upon them, as well of chirurgery as physic. By art likewise we make them greater or smaller than their kind is, and contrariwise dwarf them and stay their growth; we make them more fruitful and bearing than their kind is, and contrariwise barren and not generative. Also we make them differ in color, shape, activity, many ways. We find means to make commixtures and copulations of divers kinds, which have

produced many new kinds, and them not barren, as the general opinion is. We make a number of kinds of serpents, worms, flies, fishes of putrefaction, whereof some are advanced (in effect) to be perfect creatures, like beasts or birds, and have sexes, and do propagate. Neither do we this by chance, but we know beforehand of what matter and commixture, what kind of those creatures will arise. . . .

"I will not hold you long with recounting of our brew-houses, bake-houses, and kitchens, where are made divers drinks, breads, and meats, rare and of special effects. Wines we have of grapes, and drinks of other juice, of fruits, of grains, and of roots, and of mixtures with honey, sugar, manna, and fruits dried and decocted; also of the tears or wounding of trees and of the pulp of canes. And these drinks are of several ages, some to the age or last of forty years. We have drinks also brewed with several herbs and roots and spices; yea, with several fleshes and white meats; whereof some of the drinks are such as they are in effect meat and drink both, so that divers, especially in age, do desire to live with them with little or no meat or bread. And above all we strive to have drinks of extreme thin parts, to insinuate into the body, and yet without all biting, sharpness, or fretting. . . . We have also waters, which we ripen in that fashion, as they become nourishing, so that they are indeed excellent drinks, and many will use no other. . . .

"We have dispensatories or shops of medicines; wherein you may easily think, if we have such variety of plants, and living creatures, more than you have in Europe (for we know what you have), the simples, drugs, and ingredients of medicines, must likewise be in so much the greater variety. We have

them likewise of divers ages, and long fermentations. And for their preparations, we have not only all manner of exquisite distillations, and separations, and especially by gentle heats, and percolations through divers strainers, yea, and substances; but also exact forms of composition, whereby they incorporate almost as they were natural simples. "We have also divers mechanical arts, which you have not; and stuffs made by them, as papers, linen, silks, tissues, dainty works of feathers of wonderful lustre, excellent dyes, and many others, and shops likewise as well for such as are not brought into vulgar use among us, as for those that are. For you must know, that of the things before recited, many of them are grown into use throughout the kingdom, but yet, if they did flow from our invention, we have of them also for patterns and principals.

"We have also furnaces of great diversities, and that keep great diversity of heats; fierce and quick, strong and constant, soft and mild, blown, quiet, dry, moist, and the like. But above all we have heats, in imitation of the sun's and heavenly bodies' heats, that pass divers inequalities, and as it were orbs, progresses, and returns whereby we produce admirable effects. Besides, we have heats of dungs, and of bellies and maws of living creatures and of their bloods and bodies, and of hays and herbs laid up moist, of lime unquenched, and such like. Instruments also which generate heat only by motion. And farther, places for strong insulations; and, again, places under the earth, which by nature or art yield heat. These divers heats we use as the nature of the operation which we intend requireth.

"We have also perspective houses, where we make demonstrations of all lights and radiations and of all colors; and out of things uncolored and transparent we can represent unto you all several colors, not in rainbows, as it is in gems and prisms, but of themselves single. We represent also all multiplications of light, which we carry to great distance, and make so sharp as to discern small points and lines. Also all colorations of light: all delusions and deceits of the sight, in figures, magnitudes, motions, colors; all demonstrations of shadows. We find also divers means, yet unknown to you, of producing of light, originally from divers bodies. We procure means of seeing objects afar off, as in the heaven and remote places; and represent things near as afar off, and things afar off as near; making feigned distances. We have also helps for the sight far above spectacles and glasses in use; we have also glasses and means to see small and minute bodies, perfectly and distinctly; as the shapes and colors of small flies and worms, grains, and flaws in gems which cannot otherwise be seen, observations in urine and blood not otherwise to be seen. We make artificial rainbows, halos, and circles about light. We represent also all manner of reflections, refractions, and multiplications of visual beams of objects.

"We have also precious stones, of all kinds, many of them of great beauty and to you unknown, crystals likewise, and glasses of divers kind; and among them some of metals vitrificated, and other materials, besides those of which you make glass. Also a number of fossils and imperfect minerals, which you have not. Likewise loadstones of prodigious virtue, and other rare stones, both natural and artificial.

"We have also sound-houses, where we

Domenico Remps,
Cabinet of Curiosities
(c. 1690), Florence,
Museo dell'Opificio
delle Pietre Dure

practise and demonstrate all sounds and their generation. We have harmony which you have not, of quarter-sounds and lesser slides of sounds. Divers instruments of music likewise to you unknown, some sweeter than any you have; with bells and rings that are dainty and sweet. We represent small sounds as great and deep, likewise great sounds extenuate and sharp; we make divers tremblings and warblings of sounds, which in their original are entire. We represent and imitate all articulate sounds and letters, and the voices and notes of beasts and birds. We have certain helps which, set to the ear, do further the hearing greatly; we have also divers strange and artificial echoes, reflecting the voice many times, and, as it were, tossing it; and some that give back the voice louder than it came, some shriller and some deeper; yea, some rendering the voice, differing in the letters or articulate sound from that they receive. We have all means to convey sounds in trunks and pipes, in strange lines and distances.

"We have also perfume-houses, wherewith we join also practices of taste. We multiply smells which may seem strange: we imitate smells, making all smells to breathe out of other mixtures than those that give them. We make divers imitations of taste likewise, so that they will deceive any man's taste. And in this house we contain also a confiture-house, where we make all sweatmeats, dry and moist, and divers pleasant wines, milks, broths, and salads, far in greater variety than you have.

"We have also engine-houses, where are prepared engines and instruments for all sorts of motions. There we imitate and practise to make swifter motions than any you have, either out of your muskets or any engine that you have; and to make them and multiply them more easily and with small force, by wheels and other means, and to

make them stronger and more violent than yours are, exceeding your greatest cannons and basilisks. We represent also ordnance and instruments of war and engines of all kinds; and likewise new mixtures and compositions of gunpowder, wild-fires burning in water and unquenchable, also fireworks of all variety, both for pleasure and use. We imitate also flights of birds; we have some degrees of flying in the air. We have ships and boats for going under water and brooking of seas, also swimming-girdles and supporters. We have divers curious clocks and other like motions of return, and some perpetual motions. We imitate also motions of living creatures by images of men, beasts, birds, fishes, and serpents; we have also a great number of other various motions, strange for equality, fineness, and subtilty.

"We have also a mathematical-house, where are represented all instruments, as well of geometry as astronomy, exquisitely made.

"We have also houses of deceits of the senses, where we represent all manner of feats of juggling, false apparitions, impostures and illusions, and their fallacies. And surely you will easily believe that we, that have so many things truly natural which induce admiration, could in a world of particulars deceive the senses if we would disguise those things, and labor to make them more miraculous. But we do hate all impostures and lies, insomuch as we have severely forbidden it to all our fellows, under pain of ignominy and fines, that they do not show any natural work or thing adorned or swelling, but only pure as it is, and without all affectation of strangeness.

"These are, my son, the riches of Salomon's House."

Christianopolis

JOHANN VALENTIN ANDREAE
Christianopolis, VII (1619)

If I describe to you the appearance of the city first of all, I will not be making a mistake. Its shape is a square, whose side is seven hundred feet, well fortified with four towers and a wall. It looks, therefore, toward the four quarters of the earth. Eight other very strong towers, distributed throughout the city, intensify the strength; and there are sixteen other smaller ones that are not to be despised; and the citadel in the midst of the city is well-nigh impregnable. . . . Things look much the same all around, not extravagant nor yet unclean; fresh air and ventilation are provided throughout. About four hundred citizens live here in religious faith and peace of the highest order.

The Heavenly Jerusalem

SAINT JOHN
The Revelation, XXI: 12–27,
King James Version

. . . and had a wall great and high, and had twelve gates, and at the gates twelve angels, and names written thereon, which are the names of the twelve tribes of the children of Israel: On the east three gates; on the north three gates; on the south three gates; and on the west three gates. And the wall of the city had twelve foundations, and in them the names of the twelve apostles of the Lamb. And he that talked with me had a golden reed to measure the city, and the gates thereof, and the wall thereof. And the city lieth foursquare, and the length

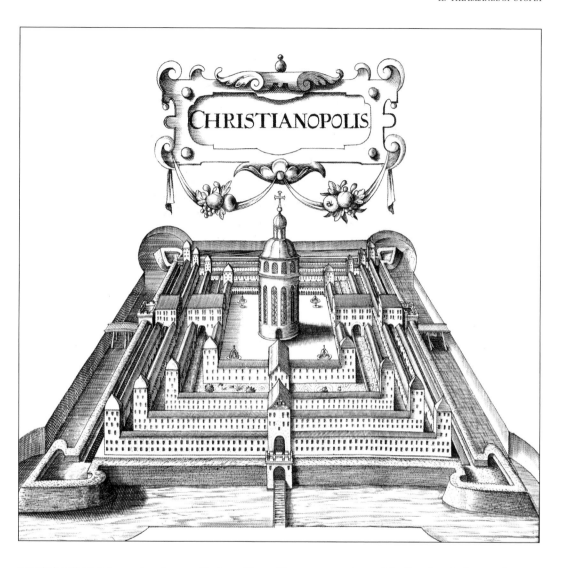

CHRISTIANOPOLIS

Frontispiece illustration from Johann Valentin Andreae's *Description of the Republic of Christianopolis* (1619)

is as large as the breadth: and he measured the city with the reed, twelve thousand furlongs. The length and the breadth and the height of it are equal. And he measured the wall thereof, an hundred and forty and four cubits, according to the measure of a man, that is, of the angel. And the building of the wall of it was of jasper: and the city was pure gold, like unto clear glass. And the foundations of the wall of the city were garnished with all manner of precious

stones. The first foundation was jasper; the second, sapphire; the third, a chalcedony; the fourth, an emerald; the fifth, sardonyx; the sixth, sardius; the seventh, chrysolyte; the eighth, beryl; the ninth, a topaz; the tenth, a chrysoprasus; the eleventh, a jacinth; the twelfth, an amethyst. And the twelve gates were twelve pearls: every several gate was of one pearl: and the street of the city was pure gold, as it were transparent glass. And I saw no temple therein: for the

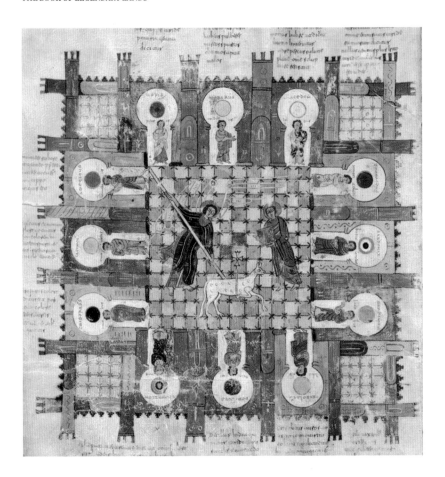

Vision of the Heavenly Jerusalem, from *Commentary on the Apocalypse* by Beatus of Liébana, 950 ca., León Ms. 644, f. 222*v*, New York, The Pierpont Morgan Library

Lord God Almighty and the Lamb are the temple of it. And the city had no need of the sun, neither of the moon, to shine in it: for the glory of God did lighten it, and the Lamb is the light thereof. And the nations of them which are saved shall walk in the light of it: and the kings of the earth do bring their glory and honour into it. And the gates of it shall not be shut at all by day: for there shall be no night there. And they shall bring the glory and honour of the nations into it. And there shall in no wise enter into it any thing that defileth, neither whatsoever worketh abomination, or maketh a lie: but they which are written in the Lamb's book of life.

Unobtainable Places

JORGE LUIS BORGES
"Tlön, Uqbar, Orbis Tertius" (1940)

I owe the discovery of Uqbar to the conjunction of a mirror and an encyclopedia.... The event took place some five years ago. Bioy Casares had had dinner with me that evening and we became lengthily engaged in a vast polemic concerning the composition of a novel in the first person, whose narrator would omit or disfigure the facts and indulge in various contradictions which would permit a few

readers—very few readers—to perceive an atrocious or banal reality. From the remote depths of the corridor, the mirror spied upon us. We discovered (such a discovery is inevitable in the late hours of the night) that mirrors have something monstrous about them. Then Bioy Casares recalled that one of the heresiarchs of Uqbar had declared that mirrors and copulation are abominable, because they increase the number or men.

I asked him the origin of this memorable observation and he answered that it was reproduced in *The Anglo-American Cyclopaedia*, in its article on Uqbar. The house (which we had rented furnished) had a set of this work. On the last pages of Volume XLVI we found an article on Upsala; on the first pages of Volume XLVII, one on Ural-Altaic Languages, but not a word about Uqbar. Bioy, a bit taken aback, consulted the volumes of the index. In vain he exhausted all of the imaginable spellings: Ukbar, Ucbar, Ooqbar, Ookbar, Oukbahr.... Before leaving, he told me that it was a region of Iraq of or Asia Minor. I must confess that I agreed with some discomfort....

The following day, Bioy called me from Buenos Aries. He told me he had before him the article on Uqbar, in volume XLVI of the encyclopedia. The heresiarch's name was not forthcoming, but there was a note on his doctrine, formulated in words almost identical to those he had repeated, though perhaps literally inferior. He had recalled: *Copulation and mirrors are abominable.* The text of the encyclopedia said: *For one of those gnostics, the visible universe was an illusion or (more precisely) a sophism. Mirrors and fatherhood are abominable because they multiply and disseminate that universe. . . .*

We read the article with some care. . . . Reading it over again, we discovered beneath its rigorous prose a fundamental vagueness. Of the fourteen names which figured in the geographical part, we only recognized three—Khorasan, Armenia, Erzerum—interpolated in the text in an ambiguous way. Of the historical names, only one: the impostor magician Smerdis, invoked more as a metaphor. The note seemed to fix the boundaries of Uqbar, but its nebulous reference points were rivers and craters and mountain ranges of that same region. . . .

Two years before I had discovered, in a volume of a certain pirated encyclopedia, a superficial description of a nonexistent country; now chance afforded me something more precious and arduous. Now I held in my hands a vast methodical fragment of an unknown planet's entire history, with its architecture and its playing cards, with the dread of its mythologies and the murmur of its languages, with its emperors and its seas, with its minerals and its birds and its fish, with its algebra and its fire, with its theological and metaphysical controversy. . . . It is conjectured that this brave new world is the work of a secret society of astronomers, biologists, engineers, metaphysicians, poets, chemists, algebraists, moralists, painters, geometers. . . . At first it was believed that Tlön was a mere chaos, an irresponsible license of the imagination; now it is known that it is a cosmos and that the intimate laws which govern it have been formulated, at least provisionally.

THE ISLAND OF SOLOMON
AND THE AUSTRAL LAND

For a long time, certain lands were dreamed of, described, sought for, and recorded on maps. Later they were to vanish from maps, and by now everyone knows that they never existed. Yet these lands had the same utopian function for the development of civilization as the realm of Prester John, which sent exploring Europeans across Asia and Africa, where they then discovered other things.

Henry Roberts, *The Resolution* (1776), watercolor, Sydney, Mitchell Library, State Library of New South Wales

One of these lands is the Austral Land. The idea of this land goes back to the Greeks, from Aristotle (*Meteorology* 2.5) to Ptolemy, and is often confused with the theory of the Antipodes (which we dealt with in chapter 1 on the flat Earth). From the Pythagorean tradition came the idea of the antichthon, or "counter-Earth," a continent symmetrical to the known world (ecumene), indispensable for keeping the planet in equilibrium and preventing it from turning upside down. Pomponius Mela thought that even the island of Taprobane was an extreme promontory of the Austral continent.

In the modern period, Magellan (who thought he had found it) was to call it *Terra Australis recenter inventa sed nondum plene cognita* (i.e., "A land recently found but not yet entirely known").

In order to have a better understanding of what it was, all you need do is examine two ancient maps: whereas Macrobius's classic map could not foresee the existence of America, that of Ortelius shows almost all of Asia, Africa, and America, but neither of them know anything of that region we now call Oceania. Australia had not yet been discovered, and people thought that in this part of the globe there lay an enormous unknown continent that covered the southern part of the Earth, totally uninhabitable or at best infested with ferocious animals.

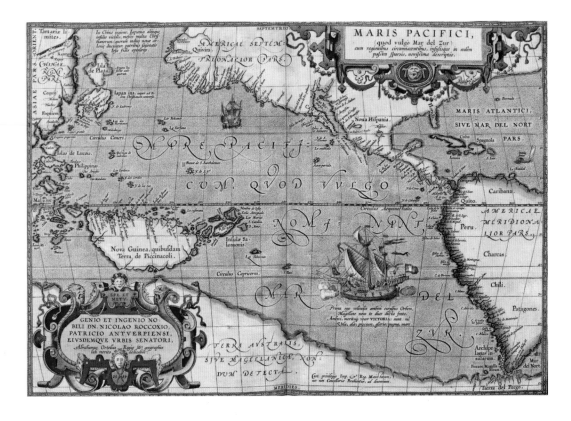

Magellan, on passing through the strait that now bears his name, at the extreme tip of South America, had seen to his left a series of islands with a wealth of forests and snow-covered mountains. This was Tierra del Fuego, but he thought it was an outcrop of the terra incognita. After him, many others were to look for the terra incognita in the South Atlantic, in the southern Indian Ocean, and in the South Pacific.

In particular, the Spanish were the first to sail the Pacific, thanks to the trade winds, which blow westward from the American coast. Thus Álvaro de Saavedra Cerón was to reach New Guinea (thinking that it was already a part of the Terra Incognita), and in 1542 Ruy López de Villalobos was to arrive at the Carolines and then the Philippines. The Spanish also came upon the archipelago of the Marianas, and in 1563 Juan Fernández, sailing from Peru, was to arrive at the archipelago that today bears his name, including Más Afuera (Farther Away) and Más a Tierra (Closer to Land), now known as Alexander Selkirk Island and Robinson Crusoe Island). But the Austral Land was still *incognita*.

Abraham Ortelius,
Map of the Pacific Ocean,
from *Theatrum orbis terrarum* (1606), London,
Royal Geographical Society

Right:
Cornelis de Jode,
Map of New Guinea and the Solomon Islands,
from *Speculum orbis terrae* (Antwerp, Gerard de Jode, 1593), Canberra,
National Gallery of Australia

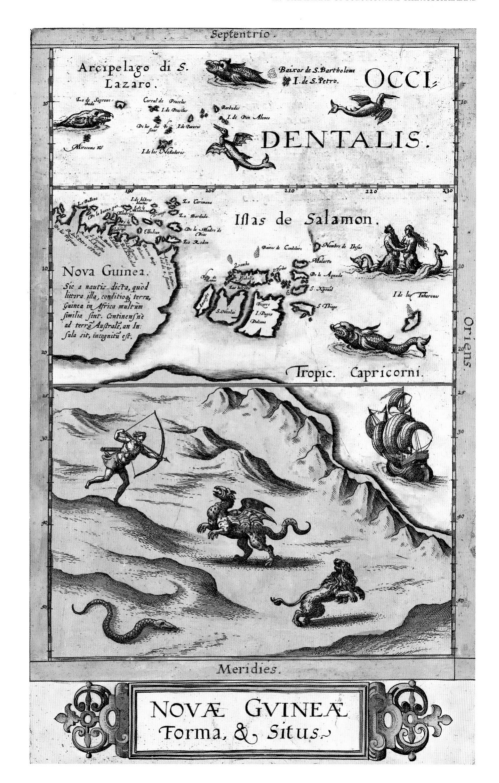

William Hodges,
*James Cook Disembarking on
the Island of Tanna
in New Hebrides* (1774),
Greenwich, National
Maritime Museum

As a matter of fact, it was difficult to sail those boundless seas, for reasons that we shall see later, and in this case we have an exemplary story, that of the Solomon Islands, another legendary land connected with that of the Austral Land, the difference being that the latter did not exist but the Solomons did, except for the fact that, once found, they were immediately lost again.

In 1567 the Spanish sailor Álvaro Mendaña de Neira landed in

certain islands that he instantly named after Solomon, holding that they were full of fabulous riches because they were supposed to be the biblical lands linked to the myth of Ophir and the belief that the golden columns of the Temple had been sent to Jerusalem from there.[1]

Even though Mendaña found no trace of these riches, he went back home bringing news of fabulous lands, and in 1595 he finally persuaded the Spanish government to let him depart on a second journey,

1. *For Solomon and Ophir, see chapter 2 of this book.*

also because in the meantime the "invincible" Spanish Armada had been destroyed by the English, and the English, Dutch, and French were beginning to find their way into the Pacific. It was necessary to be the first to lay hands on the wealth, if it existed, of that island of biblical memory.

On his second voyage, Mendaña discovered the Marquesas Islands, but he could no longer find the Solomons (which were rediscovered more than 150 years later by Louis-Antoine de Bougainville).

Mendaña could no longer find them because to do so he would have had to have precise coordinates (in other words, latitude and longitude), but in his day and for almost another two centuries, while it was easy—with the appropriate nautical instruments—to fix the position of the sun and the stars and hence know the latitude (as well as the hour of the day), there were no means with which to know the line of longitude on which one found oneself. New York and Naples are on the same latitude, but without knowing their longitudes, it would not be possible to know how far apart they are.

For the solution to this problem, which Cervantes had already called the *punto fijo* (and this did not mean, as is commonly believed, the search for *one* precise point but the capacity to "fix *the* point" wherever it lay), since the sixteenth century, Philip II of Spain had offered a fortune, and later Philip III promised six thousand ducats in perpetual income and two thousand by way of an annuity, while the Estates General of Holland offered thirty thousand florins.

The only way to establish the meridian would have been to find out local time and to know what time it was in that moment on the meridian of departure: since every hour of difference corresponds to fifteen degrees of longitude, then you could know the meridian on which you found yourself. But to know the time at home, it was necessary to have on board a chronometer that, despite the pitching of the ship, worked precisely, and that was not possible until the eighteenth century.

In the absence of this wonderful timepiece, and with a view to fixing the point exactly, navigators had come up with the most fanciful ideas, based on the tides, on lunar eclipses, on variations in the magnetic needle, and on the observation of the satellites of Jupiter (which Galileo proposed to the Dutch), but none of these ideas had ever really worked.

Stages of application for sympathetic powder from Kenelm Digby, *Theatrum sympatheticum* (1660), Nuremberg

Given that we are dealing with legends, the most atrocious method was based on sympathetic powder. In the seventeenth century, people were convinced that sympathetic powder, or *unguentum armarium*, was a substance that had to be sprinkled on the weapon that had caused a wound and was still covered in blood, or on a piece of cloth soaked in the blood of the wounded person. Then the air would attract the atoms of blood and with them the atoms of the powder. In their turn, the atoms that came out of the wound would be attracted by the surrounding air. In this way, the atoms of blood, whether they came from the cloth or the weapon or from the wound itself, would meet and be attracted by the wound; the powder penetrated the flesh and speeded up healing, which was possible even if the wounded person was at a distance (see for example Digby 1658 and 1660).

But by the same principle, if you put a highly irritating substance on the weapon rather than the powder, the wounded individual would suffer extreme pain.

In order to solve the problem of longitude (someone had evidently thought), all you needed to do was take a dog, injure it severely, and take it on board an oceangoing ship, making sure to keep the wound open. If every day at a fixed hour, at the point of departure, someone were to put an irritating substance on the weapon that had injured the dog, the dog would instantly feel the effect and would howl in pain. In this way, on the ship it would be possible to know that it was such and such a time on the meridian of departure and, knowing local time, you could deduce the longitude. It has not been ascertained whether the method was actually used, the example appears in an anonymous pamphlet, *Curious Enquiries* (1688), but in all probability this text was intended to mock the various theories about sympathetic powder.

Given that all these methods proved useless, it was impossible to fix longitude until John Harrison invented the marine chronometer, which enabled seafarers to keep the hour of the meridian of departure. Harrison produced his first model in 1735, after which the

Sydney Parkinson,
Portrait of a New Zealand
Man (c. 1770), London,
British Library

A copy of *Curious Enquiries*
(1688), Library Company
of Philadelphia

George Carter, *The Death of Captain Cook at Kealakekua Bay* (1779), private collection

apparatus was perfected, and in 1772 Captain Cook used it on his second voyage. On his first voyage Cook, had eventually reached the coast of Australia, but the British Admiralty still insisted on the search for the Austral Land. On his second voyage, naturally, Cook did not find the dreamed-of land, but he discovered New Caledonia and the Sandwich Islands, came close to Antarctica and reached Tonga and Easter Island. Thanks to the marine chronometer, he definitively fixed the coordinates of those lands, and with his explorations the myth of the Austral Land came to an end.

Lost or never found as far as explorers were concerned, the Austral Land had fired the imagination of many authors of utopias, who had located their ideal civilizations there, and it suffices to cite the *History of the Sevarambi* by <u>Denis Vairasse</u>, *The Southern Land, Known* by <u>Gabriel de Foigny</u>, *Discoveries in the Southern Hemisphere by a Flying Man* by Restif de la Bretonne, or the *The Travels of Henry Wanton to the Undiscovered Austral Regions* by <u>Zaccaria Seriman</u>.[2] Their Austral Lands were wholly invented fantasies that bear witness to the fascina-

2. *Denis Vairasse,* The History of the Sevarites or Sevarambi, *London, Brome, 1675. The affirmations of veracity that open this story persuaded many to read it as a true travelogue and it was interpreted in this sense in a review published in the* Journal des Sçavants.

SUITE DES VUES DE L'ARCHIPEL DES ARSACIDES, PRISES DE DESSUS LE

tion of that myth. Although, as often happens, the utopia could take the form of a dystopia, as was the case with Joseph Hall's *Mundus alter*.

The yearning for a land fantasized about but never found was interpreted by <u>Guido Gozzano</u> in a delightful, melancholy poem. Judging by the way in which Gozzano describes the disappearance of the island (never reached) into a kind of misty distance, it almost seems as though he had in mind those maps found in eighteenth-century books on navigation. This idea of an island that vanishes like some vain illusion obliges us to make an observation: before the problem of longitude was solved, in order to recognize islands, you had to fall back on drawings of their profiles made when they were spotted for the first time. When first seen from a distance, the island (whose form did not

...AU LE S.ͭ JEAN BAPTISTE, COMMANDÉ PAR M. DE SURVILLE, en 1769

Islands in profile, from navigational chart of New Guinea in Charles-Pierre Claret de Fleurieu's *Découvertes des François* (1768–1769)

exist on any map) was recognized, as we would say about a modern American city, by its skyline. But what if there were two islands with a very similar profile, as if they were two cities that both had an Empire State Building and (once) the Twin Towers? Well, you landed on the wrong island, and goodness knows how many times that happened.

Moreover, the outline of an island can change with the color of the sky, mist, the hour of the day, and maybe even according to the season, which might change the consistency of thickly wooded areas. Sometimes the island takes on a light-blue tinge from a distance; it may vanish in the night or in the fog; low clouds can conceal the profile of the mountains. There is nothing more elusive than an island whose profile is the only thing known about it. Arriving on an island

whose map and coordinates you do not have is comparable to being one of Edwin Abbott's characters in *Flatland*, where only one dimension is known and things can be seen only from the front, like lines with no thickness, that is to say without height or depth; only a being outside Flatland could see them from above.

And in fact it was said that the inhabitants of Madeira, Palma, Gomera, and Ferro, deceived by clouds or by ghostly mirages, sometimes thought they had spotted the *lost island* to the west, elusive between sky and sea. Just as you could glimpse amid the reflections of the sea an island that was not there, so could you mix up two islands that were there and never find the one you wanted to get to. As Pliny (2.96) put it, certain islands are always floating.

On the other hand, every so often phantom islands have appeared even in our own century, even in the most authoritative atlases—and naturally always in the vicinity of the Austral Land. In 2012, researchers at the University of Sydney revealed that Sandy Island, in the South Pacific, shown on various maps between New Caledonia and Australia, does not in fact exist, and any exploration of the area reveals that not only is it not there, but it could never have been there, given that all around its purported coordinates the sea is 4,600 feet deep. Similar cases have also been observed for the presumptive islands of Maria-Theresa and Ernest-Legouvé (recorded as lying between the Tuamotu Islands and French Polynesia between the mid nineteenth and early twentieth centuries), in addition to Jupiter Reef, Wachusett Reef, and Rangitiki, whose existence no one has been able to prove though they are still found on some maps (for example, Wachusett Reef still appeared in the 2005 edition of the *National Geographic Atlas of the World*).

And so, as Pliny could not have foreseen, even maps are always floating.

What remains for a chronicle of legendary lands? Now that the myth of the Austral Land had disappeared, and presented with Antarctica, a continent discovered but not completely explored, mystery seekers turned to the legend of the hole in the South Pole and looked to the interior of the globe for what they had lost on the surface.

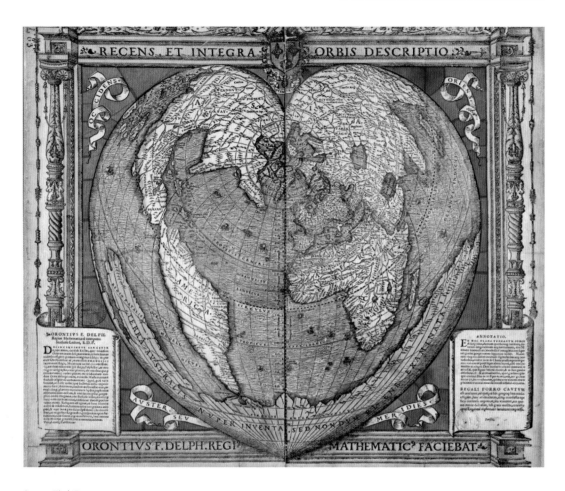

RECENS ET INTEGRA ORBIS DESCRIPTIO

ORONTIVS F. DELPH. REGII MATHEMATIC⁹ FACIEBAT.

Oronce Finé, *Recens e integra orbis descriptio* (1534), world map, Paris, Bibliothèque nationale de France

The Austral Land

DENIS VAIRASSE
The History of the Sevarites or Sevarambi (1677–1678)

Many have sailed along the coasts of the Third Continent, which is commonly described as the Unknown Austral Lands, but no one has ever taken the trouble to visit this land in order to describe it. It is true that its shores can be seen painted on maps, but they are rendered in such an imperfect manner as to give only a very confused impression of them.

No one doubts the existence of this continent, since many have seen it and even disembarked upon it; but as they did not dare to venture into the interior, given that for the most part they arrived there against their will, they have only been able to give the most superficial descriptions.

The history that we offer to the public will remedy this failing considerably. It is written in such a simple manner that no one, I hope, will doubt the truth of its content, as the reader will easily recognize that it has all the characteristics of a genuine history. Be that as it may, I deemed it necessary to supply some further reasons to invest it with greater authority.

339

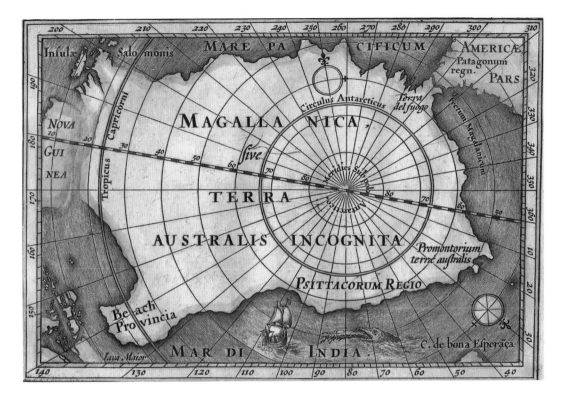

The Austral Language

GABRIEL DE FOIGNY
The Southern Land, Known (1676)

The Australians use the same three ways of explaining their thoughts as are used in Europe; namely signs, voice and writing. They are very much at ease with signs and I have seen that they spend many hours together without communicating in any other way. They only speak when it is necessary to build up a discourse and string together a long series of propositions. All their words are monosyllabic and their conjugations are all alike: for example, af means to love and is conjugated in the present: la, pa, ma, I love, you love, he loves; lla, ppa, mma, we love, you love, they love. They have but one past tense, which we know as the

perfect: lga, pga, mga, I loved, you loved, etc; llga, ppga, mmga, we loved, you loved, etc. The future is lda, pda, mda, I will love, you will love, etc.; llda, ppda, mmda, we will love, you will love, etc. The verb to work in the Austral language is uf, and is conjugated as follows: lu, pu, mu, I work, you work, he works; lgu, pgu, mgu, we work, you work, they work, and in the same way for the other tenses.

They have no declinations, nor any article and very few nouns. They express simple elements with a single vowel and composite objects through the vowels signifying the main elements of which they are composed. They recognise only five simple elements, of which the first and the most noble is fire, which they express with the single letter A. The second is air, which they call E. The third is salt, which they

Petrus Bertius,
*Descriptio terræ
subaustralis,*
from *Tabularum
geographicarum
contractarum libri septem
(Seven Books of Collected
Geographical Tables,*
Amsterdam, 1616),
Historic Maps Collection,
Princeton University

name O; the fourth is water, named I, and the fifth is earth, which is called U. All their adjectives and epithets are distinguished by a single consonant, of which they have a much larger number than Europeans. Each consonant signifies a quality befitting the elements indicated by the vowels; so B means light; C hot; D disagreeable; F dry; and following these rules, they form their nouns so perfectly that on hearing them, one immediately understands the nature of the object they name. For example, they call the stars Aeb, a word that denotes the two elements of which they are composed, and also their brightness. They call the sun Aab; the birds Oef, indicating at once that they inhabit the air and are made of a dry, flavourful matter. Man is named Uel, indicating a partly airborne, partly earthborn substance with the addition of moisture, and so on for other things. The advantage of this way of speaking is that one becomes a philosopher upon learning the first words that one utters, and that in this land, one cannot name any single thing without at the same time explaining its nature, which would seem miraculous to those who are ignorant of the secret of their alphabet and of the composition of their words.

The Island of the Cynocephali (Dog-Headed People)

ZACCARIA SERIMAN
The Travels of Henry Wanton to the Undiscovered Austral Regions and the Kingdoms of the Apes and the Dog-Faced People, V, VII (1764)

Although we knew not which land we had reached, we judged from the qual-ity of the wind stirred up by the storm that we were in the Austral Lands, as we then confirmed through observation of the stars.

Robert knew very well that those lands had never previously been visited by a single European, but gave me no suspicion of this. Moreover, from the height of the Antarctic pole, he had become certain of his conclusion, but he kept it from me so that I might live with the illusion that a ship weighting anchor on those beaches might one day take us away from that desert. . . .

Thus we headed in that direction, and drawing near to the door of the dwelling, we saw appear before our eyes two grey, deformed apes, one male and the other female, sitting on a bench by the entrance to the house. Oh Lord, how amazed we were! Tied around her loins, the female wore a petticoat of rough cloth, whilst her body was similarly covered by a gown of the same material, and upon her head she wore a sort of hat made from palm leaves.

The male was covered by a garment that stretched from his neck down to his feet, and his head was bare. Upon seeing us they were somewhat surprised. They rose to their feet and examined us closely; yet whilst I imagined that something remarkable must arise out of such serious attention, the beasts burst out in such unbridled laughter that my delicate vanity was wounded in no small measure. The female, in particular, could not hold back from mocking us, and for myself I would certainly have taken offence, had not Robert warned me in a low voice that this was neither the place nor the time to defend our honour, which we would have further lost to

our greater shame, and even put our lives in peril, had a misplaced delicacy driven us to any resentment.

I therefore calmed myself as I waited for a time when I would no longer be obliged to serve as a fool to these two sordid beasts.

The female then let out a certain articulate call, at the sound of which a horde of these apes, comprising individuals of all ages, came running to the doorway of the courtyard that served as a farmyard to our beasts. At this point the comedy became all-encompassing. Some of them looked at us and laughed, some examined our blond wigs, mistaking them for our natural hair, some took hold of the hems of our garments and then chattered amongst themselves, but all of them accompanied their amazement with the type of mockery of which only the weak-minded are capable when presented with something new. One of the youngsters held a stick in his hand, and with the usual instinct of his age, took to hitting sometimes our legs, sometimes our arms, as our own children are wont to do with apes.

Illustration from Zaccaria Seriman, *Viaggi di Enrico Wanton* (*The Travels of Henry Wanton*, 1749), Milan

The Island Never Found

G U I D O G O Z Z A N O (1883–1916)
"La più bella" (The Most Beautiful)

But fairest of all is the Island Not-
 Found,
Gained by the king of Spain from his
 cousin
The king of Portugal, with signature
 sealed
And papal bull in gothic Latin script.
The Infante set sail for the fabulous
 kingdom,
Saw the Fortunate Isles: Iunonia,
 Gorgo, Hera,
The Sargasso Sea and the Sea of
 Darkness,
In search of that isle.... But the island
 was not there.
In vain the potbellied galleys with
 their rounded sails,
The caravels in vain armed their
 prows:
With all respect to papal claims,
 the island hid
And Portugal and Spain seek it still.

The island exists. It appears some-
 times from afar
Between Tenerife and Palma, bathed
 in mystery:
"...the Island Not-Found!" The good
 Canarian shows
The foreigner from the high peak
 of Teyde.
It is marked on the maps of the
 corsairs of old.
...Island to be found?...Wandering
 island...
It is the enchanted isle that glides
 across the seas;
Sometimes sailors see it near...
With their prows they graze that
 blessed shore:
Amidst flowers never seen before
 stand lofty palms,
The divine forest, dense, alive,
 breathes scent
The cardamom weeps, the rubber sap
 seeps....
Like a courtesan, its presence is
 revealed
By perfume.... But if the pilot
 advances,
Swiftly it evaporates like a vain
 apparition,
Fading into the blue shades of
 distance....

13

THE INTERIOR OF THE EARTH,
THE POLAR MYTH, AND AGARTHA

Left:
Nicolò dell'Abate,
*Aeneas Descending
into Lake Avernus* (sixteenth
century), Modena, Galleria
Estense

Below right:
Tintoretto, *Christ's Descent
into Limbo* (1568), Venice,
Chiesa di San Cassiano

What goes on in the center of the Earth? The entire ancient tradition imagined that, on penetrating the bowels of the Earth, you entered the realm of the dead. This was the nature of Hades in Homer and Virgil; this was the nature of Dante's inferno and that of the many visions of the hereafter that had preceded his masterpiece, such as the *Book of the Ladder* and other Arabic texts that tell the story of Mohammed's visit to the underworld.

Joachim Patinir,
*Charon Crossing
the River Styx*
(c. 1520–1524), Madrid,
Museo del Prado

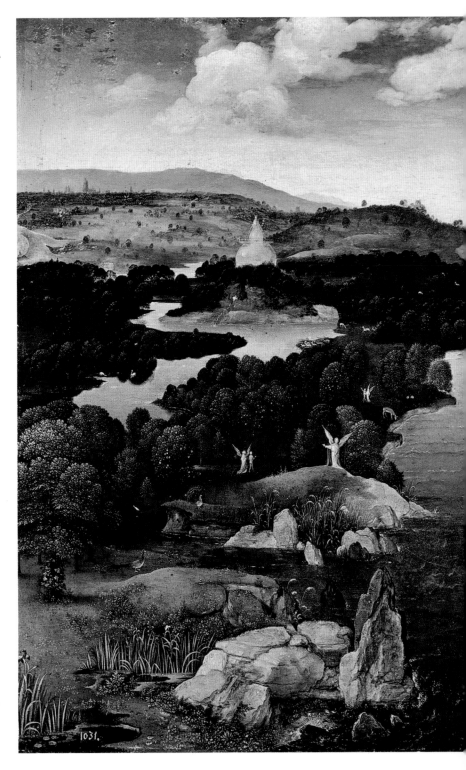

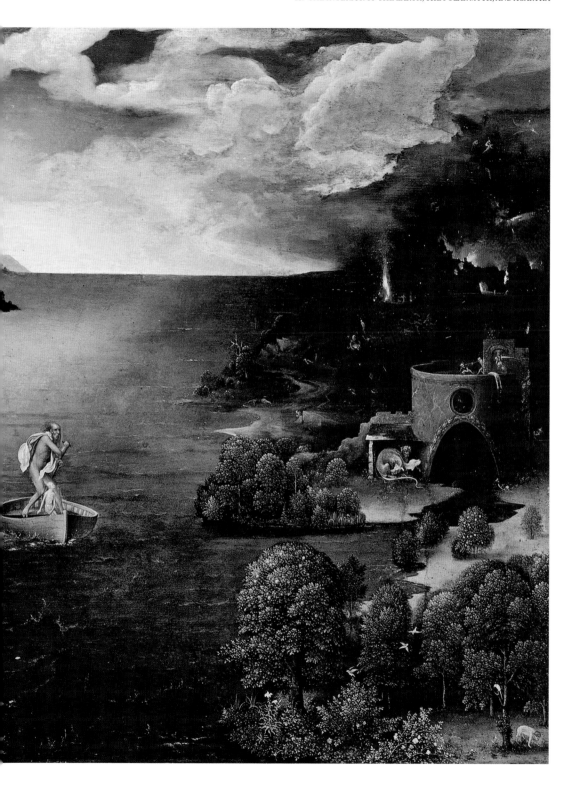

Mohammed Descends into Hell with the Angel Gabriel, miniature from the *Book of Ascension* (fifteenth century, Turkey), Arabic manuscript, Paris, Bibliothèque nationale de France

Below:
Guardian, detail
of the tomb of Khaemweset
(1184–1153 BC), son
of Ramesses III, Thebes

This, too, was the nature of the Elysian Fields, in which dwelled the souls of the just, but also that part of Hades where Zeus had closed up the Titans. Tartarus was described as a pit so deep that if you dropped an anvil into it, it would have taken nine days and nine nights to hit the bottom. In fact there is only one author who suggested that hell was not underground but in the sky, and that was Tobias Swinden (1714) who, in his enquiry on the nature

and location of hell, demonstrated that it could not be at the center of the Earth but in the hottest part of the universe, i.e. at the center of the sun.

But the bowels of the Earth have also attracted the living. The sky was difficult to explore, whereas you could burrow into the Earth, and mines go back a very long way indeed.

The idea of penetrating the heart of the planet, beneath the crust, has always

Tobias Swinden,
*An Enquiry into the Nature
and Place of Hell* (1714),
London, Taylor

Georgius Agricola,
De re metallica, (1556)

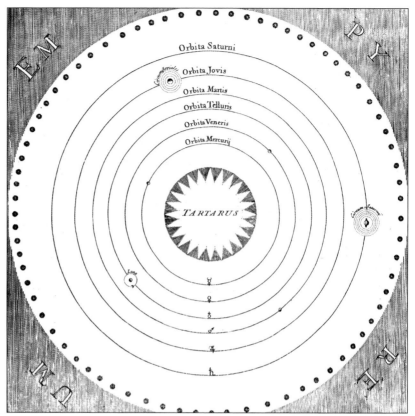

Left:
Giovanni Battista Piranesi,
The Gothic Arch (c. 1761), Los
Angeles County Museum
of Art

Below left:
The Sewers of Paris,
sketch by Jean-Paul Chanois
from *Les Misérables*
(1957), Paris, Collections
Cinémathèque Française

Below right:
Agostino Tofanelli,
*The Catacombs
of St. Callixtus* (1833),
print with watercolor,
private collection

appealed to human beings, and some have seen in this passion for
caves, recesses and underground passages a reaching out toward a
maternal womb into which to return. No doubt we all remember
how, when we were young, before falling asleep, we loved to huddle
under the blankets to fantasize about some subterranean journey,
isolated from the rest of the world; a cave could be a place where
lurked monsters of the abyss, but also a refuge against human ene-
mies or other monsters of the surface. With regard to caverns, peo-
ple have dreamed of hidden treasures and imagined underground
creatures such as gnomes; the Jesus of many traditions was not born
in a stable but in a cave. And artists and novelists gave their imagi-

Thomas Burnet,
*Telluris theoria
sacra* (1681)

nation free rein in creating dark places such as Piranesi's prisons,
the cell in the Château d'If, in which the future count of Monte
Cristo languished for fourteen years, not to mention the celebrated
sewers in Hugo's *Les Misérables* and the adventures of Fantômas.

In his *Sacred Theory of the Earth* (1681) Thomas Burnet
calculated that, in order to submerge the entire planet, the Flood
would have required as much water as could be held by six or eight
oceans. And so he maintained that the Earth before the Flood, cov-
ered by a thin crust, was full of water inside, with a central nucleus
of incandescent material. This primeval Earth was oval in shape,
smooth and perfect without the wrinkles and excrescences (abysses

Athanasius Kircher, *Mundus subterraneus* (1665)

or mountains) we know today, and on it eternal springtime reigned. Then the crust split and the internal waters emerged to cause the Flood. When they withdrew, the Earth assumed the aspect we know today.

In general, however, people thought of an Earth that may have been run through by underground caverns and passages, but whose interior was generally solid. Even Dante imagined the immense funnel of hell, but apart from that the Earth remained solid and rocky, like a ball into which a cone had been carved.

THE HOLLOW EARTH The first theory of a completely hollow Earth comes from the scientist Edmund Halley, after whom the comet is named. A similar hypothesis was allegedly proposed by the great

Michael Dahl,
Edmund Halley (1736),
London, Royal Society

mathematician Leonhard Euler, but this is contested by other scholars, who cite texts by Euler that would leave no doubt in this matter. For his part, Halley published an article in the journal *Philosophical Transactions* of the Royal Society of London (1692) in which he stated that our planet is made up of three concentric hollow spheres, which did not communicate among themselves, and by a hot nucleus, also spherical, situated at their center. The outer sphere rotated more slowly than the inner spheres, and this difference explained the variations of the magnetic poles. The internal atmosphere was luminescent and the internal continents were inhabited, while the gas that escaped from the passages to the poles was the cause of the aurora borealis.

The scientists of the period did not take Halley's theory too

seriously, but the renowned Puritan scientist and theologian, Cotton Mather, better known for his influence on witch hunts in New England, adopted it in *The Christian Philosopher* of 1721. In any case, Halley did not believe it was possible to penetrate this inner part of the globe.

In this book we do not intend to deal with fictional lands, but we must make an exception for the hollow Earth theory; while some novels to be discussed later were influenced by Halley's theory or by those of Symmes, many theories that were purportedly scientific were in turn influenced by fictional inventions. Some of these inventions limit themselves to describing only one subterranean world made of tunnels and passageways inhabited by monsters or primitive peoples, but others describe civilizations that live beneath a celestial hood formed by the convex surface of the planet.

The first of these novels was probably the anonymous *Relation of a Journey from the North Pole to the South Pole via the Center of the World* (1721), followed by *Lamekis* by Charles de Fieux (1734), in eight volumes, wherein the interior of the Earth became the refuge of wise men of Egyptian origin, among underground temples and monsters. The same tradition also includes the later and better known *A Journey to the Center of the Earth* by Jules Verne (1864) down to—from 1945 to 1949—the Shaver Mystery series in the science fiction magazine *Amazing Stories*, in which Richard Sharpe Shaver tells of a superior prehistoric race that survived in the

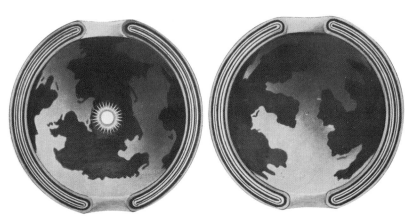

Marshall B. Gardner,
A Journey to the Earth's Interior (1920)

Édouard Riou,
Prehistoric Reptiles,
illustration for Jules Verne's
*Journey to the Centre of the
Earth* (1864)

hollows of the Earth, using fantastic machines left by ancient races to torment those who live on the surface. And it seems that thousands of people subsequently subscribed to the magazine because they said they had heard "fiendish voices" coming from under the ground.

But the first significant fictional account to spring from Halley's theory was a novel by Ludvig Holberg, *Niels Klim's Journey Under the Ground* (1741). Holberg not only describes a utopian society with imagination and a humor often more amusing than that of Swift (parodistic fantasies about morals, science, the equality of the sexes, religion, government and philosophy), but he also explains the structure of an entire solar system in the interior of the planet.

Inspired by Holberg's novel is the disappointing *Icosameron* (1788) by Giacomo Casanova. The Venetian adventurer, by then old and reduced to serving as librarian to the Count of Waldstein in Bohemia, had set his hopes, in terms of literary glory and economic success, on this most slapdash of novels, which was to give him absolutely no renown and used up what little money he still had in printing costs.

Niels Klim's Descent,
from Ludvig Holberg,
*Niels Klim's Journey Under
the Ground* (1767 ed.)

Casanova recounts a decidedly extravagant series of adventures, whose most sensational characteristic lies in the fact that two siblings Edward and Elisabeth, having arrived in that world, give life to a dynasty of terrestrials through the practice of incest, also extended to their descendants, as Casanova had presumed that Adam and Eve had done. As for the rest, in the telling of how the two youngsters descend to the center of the Earth and how they emerge from it, Casanova does not go to the effort of justifying in geoastronomical terms the circumstances that are nonetheless the innovative nucleus of the tale.

Creatures of the Subterranean World, from Ludvig Holberg, *Niels Klim's Journey Under the Ground* (1767 ed.)

As for the succeeding century, we might cite *A Journey to the Center of the Earth* (1821), probably the work of the demonologist Collin de Plancy, and (as we shall see later) *Vril, the Power of the Coming Race* (1871) by Edward Bulwer-Lytton.

To move on to the twentieth century, in 1908 there appeared *The Smoky God* by Willis George Emerson, in which a Norwegian fisherman by the name of Olaf Jansen and his father reach an internal continent where for two years they visit the cities of a subterranean world before emerging at the South Pole.

Carl Gustav Carus,
Fingal's Cave
(nineteenth century),
pen and watercolor,
private collection

Right:
Alan Lee, illustration
for J.R.R. Tolkien,
The Hobbit (2003 ed.)

One of the most popular epics on the subject was the Pellucidar series created by Edgar Rice Burroughs, who peopled these Tarzanesque stories with Verne's subterranean dinosaurs, prehistoric animals and intelligent races who inhabit the Earth's interior, which is illuminated by a small sun and its little planets. The series began with *At the Earth's Core* (1914) and continued with various volumes, including *Pellucidar* (1915).

Perhaps the Russian geologist Vladimir Afanasevich Obruchev was inspired by Burroughs or Verne in his tale of a hollow Earth full of prehistoric beasts in *Plutonia* (1924), and following in Burroughs' tracks, in 1920 Victor Rousseau published *The Eye of Balamok*, wherein we find a center of the Earth illuminated by a central sun at which the inhabitants may not look without dying.

It is not possible to list every narrative work inspired by our myth: Cynthia Ward (2008) lists about eighty titles in the English language alone, but Guy Costes and Joseph Altairac (2006) list and

comment on over 2,200 titles in various languages. Nonetheless, many of these works were not the fruit of fictional imagination but were inspired by serious theories. In 1818 a certain Captain J. Cleves Symmes had written to various erudite societies and to all members of the United States Congress, asserting that he was ready to demonstrate that the Earth is hollow and its interior habitable. He maintained that everything in nature is hollow, such as hair, bone, and the stems of plants, and hence the same must hold for our planet, which he said is composed of five spheres, all habitable both outside and inside. At both poles there are circular apertures surrounded by a circle of ice, and once you get past the ice you discover that the climate is mild.

Symmes left nothing in writing, but he travelled the United States to hold a series of conferences, and in the Academy of Natural Sciences in Philadelphia there is still a wooden model of his universe.

Symmes' theory was absolutely untenable, but it was not easily dismissed. He was famed as a hero of the 1812 war against the British and found numerous followers, and he gave rise to a remarkable number of essays and articles, some written by his son, Americus Vespucius Symmes.[1]

Inspired by Symmes' ideas, in 1892 there appeared a novel by William Bradshaw, *The Goddess of Atvatabar*, and in 1895 the curious *Etidorhpa* ("Aphrodite" written backward) by John Uri Lloyd, in which among other things we find in the bowels of the Earth a forest of extremely tall mushrooms similar to those that had already appeared in Verne's *Journey*. And as for the permanence of these beliefs, see a recent republication of *Etidorhpa* advertised on the Internet as follows: "Fiction? Not at all, as the ignorant would have

1. *And some hold that Symmes' fantasies inspired a short story by Edgar Allen Poe, "Hans Phall," which originally appeared in 1835, in which, during a trip in a hot-air balloon towards the Moon, the North Pole could be seen from above.*

The colossal fungi from
John Uri Lloyd's novel
Etidorhpa (1897)

us believe! The author was a serious scholar of occultism and in his
sensational book he tries to reveal to his readers the terrible reality
he had discovered, which concerns our planet, and the life on it, in-
side it and beyond it."

 Ideas similar to those of Symmes had been theorized by
William Reed, who in his *Phantom of the Poles* (1906) maintained
that in reality the poles had never been discovered because they do
not exist; in their place were supposedly enormous holes leading to
the Inner Continent. In his *A Journey to the Earth's Interior* (1913),
Marshall Gardner talks about a sun inside the Earth. When the re-
mains of mammoths were found perfectly preserved in glacial stra-

ta, he concluded that it was impossible for such a discovery to stay intact for so long, and that what had been found were in fact the remains of creatures who had died only recently, having escaped from the inner continent. Both Reed and Gardner argued that, since icebergs are of fresh water and not salt, they must have been formed from river water from the inner continent (in fact it is known that they come from glaciers, which is why they are fresh water).

Reed's and Gardner's ideas were revisited in 1969 in *The Hollow Earth* by a certain Dr Raymond W. Bernard, who maintained that UFOs come from the inner continent and that ring nebulae prove the existence of hollow worlds. Bernard's book, although it repeats what had been written in preceding decades, enjoyed widespread popularity and is kept in print to this day. It seems that Bernard died of pneumonia in South America, when looking for a tunnel that might lead him to the Earth's interior.

Symmes' ideas also inspired a novel by a Captain Seaborn (which some say was Symmes himself), *Symzonia* (1820), featuring precise diagrams of the interior of the planet. Although Symmes had hypothesized a hollow Earth, he had not dared to imagine that we (he included) lived within it rather than on its convex outer crust. This idea was propounded by Cyrus Reed Teed (1899), who asserted that what we believe to be the sky (according to "the ignorant Copernicus' gigantic and grotesque fallacy" and Anglo-Jewish pseudoscience) is a gaseous mass that fills the interior of the planet with zones of brilliant light. The sun, moon and stars are not heavenly bodies but visual effects caused by a variety of phenomena.

Teed founded a sect, Koreshan Unity, and the Koreshans claimed that they had verified through experiments the concavity of the Earth's surface by using an instrument known as the "rectilineator" on the coast of Florida.

As observed by Willy Ley and L. Sprague de Camp (1952), neither the concept of an Earth full of holes like a maggot-ridden apple, nor that of a hollow Earth, is tenable. In fact, a few kilometers beneath the Earth's surface, there is a zone in which heat and pressure make rock malleable, and so any cavity would close up like holes

in a block of putty as soon as it is put under pressure. Moreover, Isaac Newton had already demonstrated that inside a hollow sphere the force of gravity is equal in all directions, and so any free object, be it water, land, rock or men, would sway weightless in chaotic confusion, while centrifugal force or the tides would cause the sphere to collapse.

Caspar David Friedrich, *The Chalk Cliffs on Rügen* (1818), Winterthur, Switzerland, Oskar Reinhart Collection

But when individuals or entire groups cling fideistically to some untenable idea, not even the evident failure of their theories will persuade them to change their minds—just as in the hearts of believers who beg for a miracle, the fact that the miracle fails to occur does not make them lose their faith.

For example, having won over numerous followers, Teed died in 1908, asserting that his corpse would not putrefy. The body was left on show for a while until it became clear that it would have to be disposed of; this notwithstanding, the Koreshan State Park (now the Koreshan State Historic Site) was instituted in 1967.

After the First World War, the hollow-Earth theory (*Hohlweltlehre*) gained acceptance in Germany through the agency of Peter Bender and Karl Neupert, and was taken very seriously by high-ranking members of the German navy and air force, who were evidently sensitive to some extent to the occultist atmosphere that had been established among some representatives of the regime. Information about Bender is imprecise, and some believed that he and Neupert were one and the same person.[2]

According to Nicholas Goodrick-Clarke (1985), Willy Ley (1956) and Martin Gardner (1957), Bender—influenced by Teed's and, later, Marshall Gardner's theories—had in 1933 also tried to build a rocket to be launched high into the air: if his theory had been correct, the rocket should have landed on the opposite surface of the planet. In reality, the rocket went up a long way, but then came down only a few hundred yards from its launching point. In addition, Bender had suggested that the German navy make an expedition to the island of Rügen (in the Baltic) to try to identify British ships with powerful telescopes aimed upward, along the presumed terrestrial concavity, using infrared rays.[3] This destina-

2. *The only ones to talk about the former were Jacques Bergier and Louis Pauwels, who ignored Neupert; Galli (1989) mentions this hypothesis by Roberto Fondi (undated).*

3. *This is confirmed in a serious study by Kuiper (1946), but Bender is not mentioned.*

tion seems to concur with German Romantic sensibilities, because in the summer of 1801, Caspar David Friedrich drew his inspiration from Rügen, famed for its natural beauty and especially for its white cliffs.

Friedrich's endeavors left us with some very beautiful landscapes, while those of the German navy left no trace. It appears that the Nazis interned Bender in a concentration camp, angered by the time they had wasted on him, and there he died.

Neupert's influence is more certain. Author of a great many publications, he lived until 1949, after which one of his collaborators, Johannes Lang, continued to publish the magazine *Geocosmos* until 1960.

Neupert was another who claimed that the Earth is a spherical bubble; we live on its concave internal surface, and above us move the sun, moon and a "phantom universe," a blue sphere dotted with little lights that we mistake for stars. Copernicus' error was that of believing that light travels in a straight line, whereas it undergoes a curvature.

Following the theories of Bergier and Pauwels, some V-1 rocket launches went wrong precisely because the trajectory had been calculated on the basis of a concave and not convex surface. If these fanciful authors had told us a true story, we would see the historical and providential usefulness of crackpot astronomies. Again in Nazi circles, the novel by Bulwer-Lytton, *Vril, the Power of the Coming Race* (1871), was taken very seriously; in it, a large community of survivors from the destruction of Atlantis lives in the bowels of the Earth, gifted with extraordinary powers because they possess Vril, a kind of cosmic Energy. Bulwer-Lytton (whose novel *Paul Clifford* begins with the line made famous by Snoopy, "It was a dark and stormy night") had probably set out to write science fiction, but since he had been a member of the British occultist society, the Golden Dawn, he had influenced German occultist circles and had inspired, a decade before the advent of Nazism, a Vril Gesellschaft, namely the Vril Society or the Lodge of Light, in which figured Rudolf von Sebottendorff whom we have already met as the founder

of the Thule Gesellschaft. Believers waited for the Coming Race, made up of superior beings of extraordinary power and beauty, to reemerge from the depths of the Earth (as described by Bulwer-Lytton).

The idea of a hollow Earth has appeared again more recently in the work of a mathematician, Mostafa Abdelkader (1983), who by using extremely complex calculations sought to reconcile the geometry of a concave world with the phenomena of the rising and setting sun. One would have to abandon the idea that light rays travel in a straight line and concede that they proceed in a curve and also project the Copernican external cosmos onto the inner geocosmos using a particular mathematical trick, which makes it possible to map all the points outside a sphere on a point within it.

We shall not go into the debates and objections raised by the proposal among experts, some of whom believe that the hypothesis would return us to a form of geocentrism. If we lived in a hollow Earth with the sun at its center, there would not exist an infinite universe beyond our planet, and whether the Earth rotates around an internal sun or vice versa would be of no importance, given that there would be no parameter to refer to. Or, as Abdelkader has written, "All external space becomes enclosed within the hollow Earth" and "objects such as galaxies and quasars that are many billions of light years away would be contracted to microscopic dimensions."

Moreover, according to Abdelkader, if we lived on a convex Earth, all our measurements would work just as they do in a hollow Earth: "Every observation and assessment of the form, direction and distance of every celestial object would yield the same results to an observer, be he situated on the outside or the inside of the Earth," so that the theory of a concave Earth could never be rejected on the basis of empirical observation.

Luckily, Abdelkader writes that, while his assumptions are admissible in a mathematical system, they would not be in a physical system. Abdelkader's work, therefore, was a theoretical exercise that served to demonstrate what others had maintained, that the standards of measurement we use for a convex Earth would also work on

a concave Earth. This would have no bearing on the way in which we live on the Earth's crust, and astronomers point out that, even if we accepted his idea, nothing would change in terms of the way we explore the cosmos.

THE POLAR MYTH Among the various occultist fantasies that circulated in Nazi Germany, a greater credibility was enjoyed by the polar myth mentioned in the chapter on Thule and Hyperborea. The polar model did not merely emphasize the notion that the Western world came from the pole, but also stated that to the pole it must return. Given that the polar regions are now extremely cold, the unshakable adepts of the polar model moved on to another hypothesis: if you reach the pole, through an enormous central hole, you could discover new lands with a mild climate and luxuriant vegetation.

This idea was not a new one. On a geographical map by Mercator (sixteenth century) we find the North Pole represented by an immense cavity into which flow the waters of the surrounding seas before descending into the Earth. Indeed this concept goes back to descriptions in some medieval encyclopedias, according to which at the center of the North Pole there stood a mountain 33 leagues (about 180 kilometres) in circumference (which Mercator still showed on his map) and a dizzying maelstrom into which the waters of the ocean plunged.

In the seventeenth century, Athanasius Kircher, in his *Subterranean World*, had maintained (with the aid of evocative engravings) that the waters of the sea flowing through the Bering Strait entered the vortex of the North Pole, and "amid unknown recesses and tortuous channels" they crossed the center of the Earth to emerge at the South Pole. This circulation of water through the Earth's core struck Kircher as being analogous to the circulation of blood in the human body, which had been discovered by William Harvey about forty years previously.

In the twentieth century, opposition to the theory of the polar hole gained ground with the hypothesis of an unknown land at the North Pole. In 1904 a certain Doctor Harris of the US Coast and

Map of the Arctic Circle
from Gerardus Mercator's
*Septentrionalium terrarum
descriptio* (1595)

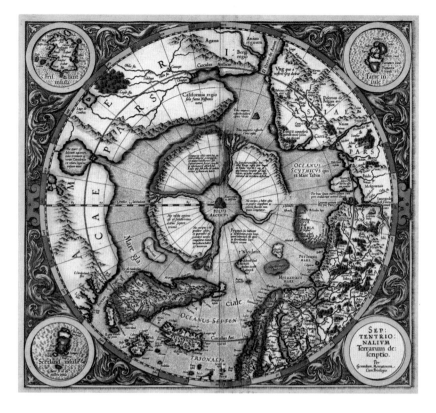

Geodetic Survey published an article in which he claimed that there
ought to be a large stretch of yet undiscovered land in the polar basin
northeast of Greenland, which some Eskimo traditions described as a
large mass that purportedly existed in the North, and that any distur-
bance of the tides north of Alaska could be explained only by the exis-
tence of this mass.

Even though successive modern explorations of the poles
did not encourage either a belief in the hole or in that unknown land
mass, the legend of the American admiral Byrd became widespread.

Richard Byrd was a great American polar explorer; in 1926
he had flown as far as the North Pole (even though his story was con-
tested); in 1929 he flew over the South Pole; and between 1946 and
1956 he made significant Antarctic explorations, receiving honors
and recognition from the American government. But various leg-
ends sprang up around him, and he apparently left a diary in which

Igloos (mid-nineteenth century), Toronto, Royal Ontario Museum

Pages 372-373:
William Bradford,
Icebergs in the Arctic (1882), private collection

he gives a dramatic account of how he found green lands and fertile plains beyond the pole, almost as proof of ancient legends about temperate poles. Reports said his pseudo-diary also afforded a glimpse of a massive polar cavity, and they grew more complex with the assertion that other peoples lived inside that chasm, or that flying saucers came out of it. If no one has heard about these things, the legend continues, then it is because the American government has strictly censored all news on the subject for various complex reasons relating to military security.

True, in a radio broadcast about his Antarctic exploration in 1947, Byrd said that "the area beyond the Pole is the center of a great unknown," and on returning from another of his journeys he alleged that "this expedition has discovered a vast new land." But all this

could also be understood in the most rational sense: the term used was "beyond the Pole" which could be interpreted—with a generous touch of goodwill—as *around* the pole. Lovers of the unknown have always interpreted the expression in whichever way struck them as most promising, and some began to fantasize about the monstrous animals that Byrd's companions supposedly saw beyond the pole.

What engendered the Byrd legend was probably a book by Francis Amadeo Giannini, *Worlds Beyond the Poles* (1959). Giannini was an imaginative character who for years championed a theory of his own, one which was even bolder than that of the hollow Earth: he maintained that the Earth was not a globe, but that those parts of it known to us were only a limited fragment of an infinite mass that extended beyond the poles into a celestial space. In any event, he was pleased with the idea that in 1947 Byrd had supposedly discovered something *beyond* the Pole.

Among those who merrily interpreted the few things Byrd said was Raymond Bernard, whom we have already mentioned. But what is more interesting is to read Byrd's supposed diary.

Is this diary authentic? The question has unleashed an extraordinary number of books and articles, and if you look on the Internet, the sites that discuss it are almost exclusively run by hollow-Earth devotees, while more official sources (see *Encyclopedia Britannica* or Wikipedia) do not mention it. Naturally, advocates of the polar theory object to the apparent necessity to censor the discovery. But we also find texts that go to the length of denying that Byrd had been to the Antarctic in 1947, while his "polar interpreters" assume that on that date he had also been to the North Pole—in secret, of course.

The most prudent conclusion is that the diary is a fake, like the counterfeit diaries of Hitler and Mussolini, but it is possible to think that Byrd may have given free rein to his personal fantasies in some of his private writings. Nor can we forget that he was a member of a Masonic lodge and hence (perhaps) inclined to some occultist beliefs. Finally, some have pointed out that Byrd was accused of having falsified the data regarding his first polar expedition in 1926, and

Admiral Richard E. Byrd,
images for cigarette cards,
Arendts Collection,
New York Public Library

therefore find nothing strange in the suggestion that he might have also falsified the data on his subsequent explorations.

By now the rumors have only served to obscure information about documents that really do exist. But Byrd was considered a hero by the American government and he was certainly a courageous explorer: it is possible that around the irreproachable figure of this pilot there have gravitated mythologies constructed by crackpot devotees. The fact remains that his legend now presents a polar land that is no more real than Saint Brendan's Isle or Peter Pan's Neverland, because these fantasies are ruled out by our more modern geographic knowledge of the poles.

AGARTHA AND SHAMBHALA In order to dream about a subterranean world, it is not necessary to imagine a hollow Earth inhabited on its inner surface. One need only think of a huge underground city that still exists beneath our feet. The advantage of this hypothesis is that underground cities have always existed. In the *Anabasis*, Xenophon wrote that in Anatolia people had dug out underground cities in which to live with their families, domestic animals and the provisions necessary for survival. And tourists who go to Cappadocia can still visit, at least in part, Derinkuyu, which is none other than an ancient settlement hollowed out below the ground. In Cappadocia there are numerous other underground cities on two or three levels,

but Derinkuyu has eleven levels, although many of these have yet to be excavated. The depth of the original city has been estimated at around 85 meters. The city was connected to other underground cities by a multitude of long tunnels and could accommodate between three thousand and fifty thousand people. Derinkuyu was, for example, a place in which the first Christians could hide in order to escape religious persecution or Muslim raids.

From real experiences such as these, some imaginative nineteenth-century writers created the legend of the city of Agartha.

While its propagators cite Eastern traditions or the revelations of Indian gurus, this myth owes something to previous occult theories, such as those of Hyperborea, Lemuria, or Atlantis. In brief, Agartha (sometimes referred to as Agarttha, Agarthi, Agardhi, or Asgartha) is an immense expanse that spreads out below the Earth's surface, an entire country made up of interconnected cities, and a repository of the extraordinary knowledge possessed by the king of the world, the holder of supreme power, who uses this power to influence all global events. Agartha supposedly extends beneath Asia, some say it is under the Himalayas. Many secret entrances to this realm have been mentioned, including the Cueva de los Tayos (Oilbird Cave) on the equator in Ecuador, the Gobi Desert, the cave of the sibyl of Colchis, that of the sibyl of Cumae near Naples, and in other places such as Kentucky, the Mato Grosso, the North or South poles, near the Pyramid of Cheops, and even near Ayers Rock in Australia.

The name Agartha appears for the first time in a work by Louis Jacolliot, a peculiar character who wrote adventure stories modeled on those by Jules Verne and Emilio Salgari, but in time became more famous for his numerous works on Indian civilization. In his *Occult Science in India* (1875), he sought to prove that Western occultism stemmed from Indian roots—and this could not have required much effort, because most occultists of the time drew abundantly on authentic or invented Oriental myths. Jacolliot referred to a Sanskrit text unknown to experts, the *Agrouchada-Parikchai*, a pastiche that he himself created using passages taken from the

Upanishads and other sacred texts, and adding some elements of the Western Masonic tradition. He stated that in certain Sanskrit tablets (never specified), there is mention of a land called Rutas, engulfed by the Indian Ocean, even though he later talked of the Pacific and identified Rutas with Atlantis, which ought to have been in the Atlantic Ocean—but as we have already seen, Atlantis had been located pretty much everywhere. Finally, in his *God's Sons* (1873), Jacolliot talked about "Asgartha" as an immense subterranean place in the Indian subcontinent, city of the high priest of the Brahmins.

To tell the truth, few gave credence to his revelations—only Madame Blavatsky took him seriously, and she was always ready to believe anything. But the man who was to have a remarkable and immediate influence was the marquis Joseph-Alexandre Saint-Yves d'Alveydre, with his *Mission de l'Inde en Europe* (1886). In 1877 Saint-Yves had married the countess Marie-Victoire de Riznitch-Keller, who frequented various occultist circles. By the time she met him the countess was over fifty, while he was around thirty. To give him a title, she bought some land belonging to various marquises of Alveydre. Now able to live on a private income, Saint-Yves devoted himself to his dream: he wanted to find a political formula that might lead to a more harmonious society, a form of synarchy as opposed to anarchy, a European society governed by three councils representing economic power, the magistracy and spiritual power, i.e., the churches and the scientists, an enlightened oligarchy that would eliminate the class struggle, uniting men of the right and left, the Jesuits and the Masons, capitalists and workers.

The project attracted the attention of extreme right-wing groups such as Action Française, with the result that the Left saw Vichy as a synarchic plot, but the Right saw synarchy as the expression of a Judeo-Leninist conspiracy. For others, synarchy was a Jesuit conspiracy aimed at subverting the Third Republic, and for others still, it was a Nazi plot, and of course, the theory of a Masonic-Jewish conspiracy could not be omitted.

In any event, both Left and Right came to believe in a secret society that was hatching a universal plot.

On the death of his wife in 1895, Saint-Yves embarked on his last work, the *Archeometer* (1911). The archeometer was an instrument made up of mobile concentric circles able to form infinite combinations of the signs with which they were covered: zodiacal and planetary signs, colors, musical notes, letters of sacred alphabets, Hebrew, Syriac, Arabic, Aramaic, Sanskrit and the mysterious Vattan, the primordial tongue of the Indo-Europeans.

But we must return to Agartha. When Saint-Yves had written his *Mission de l'Inde*, he said that he had received a visit from a mysterious Afghan, one Hadji Scharipf, who could not have been Afghani because his name is clearly Albanian (and the only photograph we have shows him in a costume out of Balkan operetta). This man apparently revealed to him the secret of Agartha, the Untraceable.

As in Jacolliot, who had perhaps inspired Saint-Yves, Agartha consists of subterranean cities, and the realm is ruled by five thousand wise men or pundits. The central dome of Agartha is illuminated from above by mirrors that let in the light only through the enharmonic spectrum of colors, of which the solar spectrum in our treatises on physics is merely the diatonic. The sages of Agartha study all the sacred languages in order to arrive at the universal language, Vattan. When they engage with mysteries that are too profound, they levitate upward and would shatter their skulls on the dome if their brothers did not hold them back. These sages prepare lightning bolts, orient the cyclical currents of the interpolar and intertropical fluids and of the interferential derivations in the Earth's diverse zones of latitude and longitude, and they select species and create animals that are small, but gifted with extraordinary psychic virtues: they have a yellow cross on the back, like a turtle's, and one eye and one mouth at every extremity. For the first time there appears the concept of a guiding Mind—and certainly Saint-Yves had been influenced by those Masonic doctrines which discern Unknown Superiors behind all historic events, past and future.

L'ARCHÉOMÈTRE

Rapporteur synthétique des Hautes Études

Planche I

Copyright Breveté déposé Reproduction interdite

Les III lettres de construction : A, s, Th.

Left:
Saint Yves d'Alveydre,
The Archeometre (1903**)**

Below:
Max Fyfield,
representation of Agartha
based on the writings
of Raymond W. Bernard

It is possible that some of Saint-Yves' inspiration sprang from those Oriental texts that describe the realm of Shambhala, even though for many occultists the relationship between Agartha and Shambhala is very confused. In many fanciful maps drawn by hollow-Earth devotees, Shambhala was purportedly a city that stood in the subterranean continent of Agartha.

Apart from the fact that, according to other versions, Shambhala is identified with Mu, which has never been defined as an underground continent, it should be remembered that no Oriental source says that Shambhala was underground; on the contrary, even though it was cut off by a mountain range, it extended over beautiful and fertile plains, hills and mountains. It inspired the myth of Shangri-La, invented by James Hilton (1933) in his novel *Lost Horizon*, on which Frank Capra based his well-known film of that name.

Hilton talks of a place in the western extremity of the Himalayas, an area of peace and tranquility where time almost stands still. But here, too, a fictional invention has seduced the occultist world on the one hand, while on the other, it has encouraged speculators in the tourist industry to create fake Shangri-Las across

The entrance to Shangri-La
from the film *The Mummy:
Tomb of the Dragon Emperor*
(2008)

The Paradise of Shambhala
(nineteenth century),
painting on silk, Paris,
Musée Guimet

Asia and America for gullible visitors; and in 2001 in China, the city
of Zhongdian was renamed Shangri-La—or Xianggelila in Chinese.

The first reports of Shambhala reached the West via
Portuguese missionaries, but when they first heard it mentioned
they thought it meant Cathay, i.e., China. The most reliable source is
a sacred text, the *Kalachakra Tantra* (which originated in Vedic
India), which inspired magnificent mystical portrayals. In Tibetan
and Indian Buddhist tradition, Shambhala (sometimes Shambala,
Shambahla or Shamballa) is a realm whose physical reality is be-
lieved by only some, and over the years they have located it in Punjab,
Siberia, the Altai, and various other places. In general, however, it is
taken to be a symbol of a spiritual nature, a pure land, the promise
of an ultimate victory over the forces of evil.

That Shambhala should not be identified with Agartha (at
least according to the Buddhist tradition) comes from a statement
issued by the Dalai Lama Tenzin Gyatso in October 1980, see
Baistrocchi (1995): "The Dalai Lama had enquired beforehand about
the meaning of the term Agartha-Agharti and said definitively, con-
fessing after a brief exchange with his spiritual adviser that he had
never heard that name and far less of a subterranean spiritual realm.
By way of conclusion, he nonetheless added that there might have

been some confusion and that this was probably a matter of the 'great mystery of Shambhala': but for the Dalai Lama, Shambhala is a 'regal realm, albeit suprasensible, between the world of the Gods and the Demons and extremely hard to get to' as it can be reached 'only by the ascetic . . . through complex exercises.'"

In the nineteenth century, a Hungarian scholar, Sándor Kőrösi Csoma, had provided the geographical coordinates of Shambhala (between 45° and 50° north latitude). Ever ready to collect and knock together inaccurate information, and working from poorly translated secondhand sources, in *The Secret Doctrine* (1888), Madame Blavatsky could not ignore Shambhala (although, curiously, she ignores Agartha in her works). It seems that she had received (telepathically) information from her Tibetan informers and stated that the survivors of Atlantis had migrated to the holy land of Shambhala in the Gobi Desert. It seems she was inspired by Kőrösi Csoma because the coordinates he had given could also apply to the Gobi.

Perhaps because of its alleged geographical position, Shambhala made an impression on many politicians, who tried to get symbolic mileage out of it. One Agvan Dorjiev, in an attempt to oppose British and Chinese designs on Tibet, had convinced the Dalai Lama to seek Russian aid, and to this end he had demonstrated to him that the real Shambhala was Russia and that the czar was a descendant of its ancient kings—and it had all worked out for the czar, who had opened a Buddhist temple in Saint Petersburg. In Mongolia, Baron von Sternberg, who fought for the Whites (the czarists) against the Reds (the revolutionaries), convinced that all Jews were Bolsheviks, endeavored to turn his troops into fanatics by promising them rebirth in the army of Shambhala.

After their invasion of Mongolia in 1937, the Japanese tried to convince the Mongols that the original Shambhala was Japan. It is not clear how many in the Nazi high command believed in Shambhala, but in Thule Gesellschaft circles there was a widespread perception that groups of Hyperboreans, after various mi-

grations to Atlantis and Lemuria, had reached the Gobi Desert and founded Agartha. Thanks to evident assonances, Agartha was linked to Asgard, home of the Norse gods. Here matters get confused, because it would seem that one current of thought believed that, after the destruction of Agartha, a group of "good" Aryans had emigrated southward to found another Agartha beneath the Himalayas, while another group had gone northward, where it had become corrupt, and there they had founded Shambhala as a kingdom of evil. As you can appreciate, at this point occult geography gets very muddled, but according to some sources in the 1920s, certain heads of the Bolshevik secret police had planned a mission to find Shambhala, thinking to merge the idea of an earthly paradise with that of a Soviet paradise. From the same source came the rumor of an expedition allegedly sent to Tibet by Heinrich Himmler and Rudolph Hess in the 1930s, obviously with a view to finding the origins of a pure race. In the 1920s and '30s, Nicholas Roerich, a famous Russian explorer, adherent of many occultist beliefs and a mediocre painter, had visited various Asiatic regions in search of Shambhala and had published *Shambhala* (1928). He maintained that he possessed a magical stone, the Chintamani stone, which had come to him from the star Sirius. In his view, Shambhala was the Holy Place, and he associated it with Agartha, with which it was connected in some way by underground passages.

Unfortunately, the only evidence that Roerich has left us of his explorations is almost exclusively that of his horrible pictures.

But let us return to Agartha. A good time after Saint-Yves, Ferdinand Ossendowski, a Polish adventurer who had travelled across central Asia, published a book which was to become a great success, *Beasts, Men, and Gods* (1923), in which the author says he had learned from the Mongols that Agarthi, as he called it, was located beneath Mongolia but the kingdom extended to all the underground passages in the world, numbered millions of subjects, and was ruled by a king of the world.

If you read Ossendowski, you find many pages that appear

Nicholas Roerich,
Shambhala (1946),
private collection

to have been lifted from Saint-Yves, which would lead critics of sound sense to talk of plagiarism. But devotees of the myth, including René Guénon—one of the best-known contemporary thinkers of the tradition—believe that Ossendowski was sincere when he said he had never read Saint-Yves, and the proof of his sincerity was that the first edition of *Mission de l'Inde* (1886) had been destroyed, with only two copies surviving. Guénon fails to consider that the work was posthumously republished by Dorbon in 1910, and so Ossendowski could very well have known it.

But Guénon was persuaded to consider Ossendowski an author beyond doubt (whereas he held Jacolliot to be a writer of scant credibility—the opposite of Madame Blavatsky's view), because he talked about a king of the world, whom Guénon was to make even more famous with his *King of the World* (1925). Guénon, however, was not so much interested in whether Agartha existed physically or whether it was a symbol (as is the case with the Buddhist Shambhala), because he referred to atemporal myths whereby kingship and priesthood had to be strictly united (and obviously one of the tragedies of our time, that for him was the obscure Kali Yuga, is that of having broken this unity). In Guénon's view, the title *king of the world* "understood in its noblest sense . . .

should properly be attributed to Manu, the primordial and universal Lawgiver whose name is found again, in different forms, among numerous ancient peoples." And the idea of kingship and priesthood embodied in one man had also been typical of the myth of Prester John.

While for the Christian tradition the true Melchizedek was Jesus, what Jesus has to do with Agartha is certainly hard to prove, but Guénon's entire booklet does nothing else but associate freely (and in the face of all logic) elements of myths and religions from all ages, as befits someone who champions a primordial tradition that supposedly precedes even revealed religions.[4]

Some have observed the difficulty of associating the myth of subterranean places and caverns (as Guénon does), traditionally connected to the image of the underworld, with a positive supernatural reality of a celestial nature. But we have seen how the fascination of cavities in the Earth is more powerful than any logic, and so, buried in the bowels of the Earth, Agartha lives on, at least in the minds of the crackpots who still wish to believe in it.

4. *See chapter 4 on Prester John for the question of Melchizedek and the union of kingship and priesthood in the figure of Christ.*

The Subterranean World
of Niels Klim

LUDVIG HOLBERG
Niels Klim's Journey Under the Ground
(1741), I–II

*Creatures from Inside the
Earth from Ludvig Holberg,
Niels Klim's Journey Under
the Ground (1767 ed.)*

I had scarcely descended twenty to thirty feet, when [the rope] gave way, and I tumbled with strange quickness down the abyss, armed like Pluto, with a boat-hook, however, in place of a sceptre.

Enveloped by thick darkness, I had been falling about a quarter of an hour, when I observed a faint light, and soon after a clear and bright-shining heaven. I thought, in my agitation, that some counter current of air had blown me back to earth. The sun, moon and stars, appeared so much smaller here than to people on the surface, that I was at a loss with regard to my where-a-bout.

I concluded that I must have died, and that my spirit was now about to be carried to the blessed dwellings. I immediately conceived the folly of this conclusion, however, when I found myself armed with a boat-hook, and dragging behind me a long strip of rope; well knowing that neither of these were needful to land me in Paradise, and that the celestial citizens would scarcely approve of these accessories, with which I appeared, in the manner of the giants of old, likely to attack heaven and eject the gods therefrom.

Finally, a new light glimmered in my brain. I must have got into the subterranean firmament. This conclusion decided the opinion of those, who insist that the earth is hollow, and that within its shell there is another, lesser world, with corresponding suns, planets, stars, &c., to be well-grounded. The result proved that I guessed right. The rapidity of my descent, continually augmented for a long time, now began to decrease gradually. I was approaching a planet which I had from the first seen directly before me.

By egrees it grew larger and larger, when, penetrating the thick atmosphere which surrounded it, I plainly saw seas, mountains and dales on its surface.

As the bold bird, between the billow's
 top
And mountain's summit, sweeps
 around
The muscle-clothed rock, and with
 light wing
Sports on the foam, my body hovered.

I found now that I did not hang in the atmosphere, buoyed up by the strong current of which I have spoken, but that the perpendicular line of my descent was changed to a circle. I will not deny that my hair rose up on my

head in fear. I knew not but that I might be metamorphosed to a planet or to a satellite; to be turned around in an eternal whirl. Yet my courage returned, as I became somewhat accustomed to the motion. The wind was gentle and refreshing. I was but little hungry or thirsty; but recollecting there was a small cake in my pocket, I took it out and tasted it. The first mouthful, however, was disagreeable, and I threw it from me. The cake not only remained in the air, but to my great astonishment, began to circle about me. I obtained at this time a knowledge of the true law of motion, which is, that all bodies, when well balanced, must move in a circle.

I remained in the orbit in which I was at first thrown three days. As I continually moved about the planet nearest to me, I could easily distinguish between night and day; for I could see the subterranean sun ascend and descend—the night, however, did not bring with it darkness as it does with us. I observed, that on the descent of the sun, the whole heavens became illuminated with a peculiar and very bright light. This, I ascribed to the reflection of the sun from the internal arch of the earth.

But just as I began to fancy myself in the near presence of the immortal gods, about to become myself a new heavenly light and wondered at as a brilliant star—behold! a horrible, winged monster appeared, who seemed to threaten me with instant destruction. When I saw this object in the distance I supposed it to be one of the celestial signs, but when it came near I perceived it to be an enormous eagle, which followed in my wake as if about to pounce upon me. I observed that this creature noticed me particularly, but could not determine whether as a friend or enemy.

Had I reflected, I should not have wondered that a human being, swinging round in the air, with a boat-hook in his hand, and a long rope dragging behind him, like a tail, should attract the attention of even a brute creature. My uncommon figure gave, as I afterwards understood, occasion for strange reports to the inhabitants on my side of the planet.

The astronomers regarded me as a comet, with a very long tail. The superstitious thought my appearance to be significant of some coming misfortune. Some draughtsmen took my figure, as far as they could descry it, so that when I landed I found paintings of myself, and engravings taken from them, and hawked about.

But to return; the eagle flew towards me and attacked me with his wings very furiously. I defended myself as well as I could with my boat-hook, and even vigorously, considering my unstable situation. At last, when he attempted to grapple with me, I thrust the hook in between his wings so firmly that I could not extricate it. The wounded monster fell, with a terrible cry, to the globe beneath; and holding the hook, I, well tired of my pendant attitude, was dragged to the planet.

At first my descent was violent, but the increasing thickness of the atmosphere as I approached the planet, made me sink with an easy and soft fall to the earth. Immediately on touching it the eagle died of its wounds.

It was now night; or rather the sun was down, for it was not dark. I could see clearly to read the papers I had in my pocket.

Creatures from Inside the Earth from Ludvig Holberg, *Niels Klim's Journey Under the Ground* (1767 ed.)

The light, as I have already said, comes from the firmament or internal shell of our earth, half of it being brightened at one time like our moon. The only difference between night and day is that the absence of the sun makes the weather a little colder.

My voyage through the air was now ended. I lay for a long time entirely immovable, awaiting my fate with the approach of day. I now observed that the wants and weaknesses of humanity, which, during my passage had ceased, now returned. I was both sleepy and hungry. Fatigued in mind and body I fell into a deep slumber. I had slept, as far as I could judge, about two hours, when a terrible roar, which had previously disturbed my slumbers, suddenly waked me. I had dreamed some curious dreams; in one, I thought myself to be in Norway, at the church in my native town, listening to the singing of our clerk, whose voice was really unpleasant from its

roughness. My first impression therefore, on recovering myself was, that this man was indulging in an extraordinarily ambitious strain. In fact, on opening my eyes, I saw a huge bull within a few feet of me. At the same moment, a vigorous roar from this animal convinced me that I did not listen to church music.

It was now day-break, and the rising sun began to gild the green oaks and fruitful fields, which, spreading abroad in every direction, astonished my recovered sense.

How much greater was my surprise when I saw the trees, of which there were great numbers in my view, move, although not a breeze stirred.

The vicinity of the bull not being pleasing to me, I arose and began to ascend a tree which stood near. As I raised myself by its limbs, it gave a low, yet shrill scream, and I got at the same time a lively slap on my ear, which propelled me headlong to the ground. Here I lay as if struck by lightning, about to give up my spirit, when I heard around me a murmuring noise, such as is heard on the Exchange when the merchants are assembled.

I opened my eyes and saw many trees moving about the field. Imagine my agitation, when one of the trees swept towards me, bent one of its branches, and, lifting me from the ground, carried me off, in spite of my woeful cries, followed by an innumerable number of its companions of all kinds and sizes. From their trunks issued certain articulated sounds, which were entirely incomprehensible to me, and of which I retained only the words: *Pikel-Emi*, on account of their being often repeated. I will here say, these words mean an extraordinary monkey, which creature they took me to be,

from my shape and dress. All this, of course, I learned after being some months among them.

In my present condition, I was far from being able to conceive of the nature of sensible, speaking trees. In truth, so confounded was I, that I forgot I could speak myself. As little could I understand the meaning of the slow, solemn procession, and the confused murmurs which resounded in the air.

I fancied they were reproaching or expressing their contempt of me. I was not far from the truth: for the tree into which I had climbed to escape from the bull, was no less than the wife of the sheriff of the neighbouring town, to which they were now taking me a prisoner.

The buildings and streets of this town were very handsome and extensive. The houses, from their height, appeared like huge towers. The streets were wide and filled with trees, which swayed about and saluted each other by lowering their branches. The greater this declination, the more expressive was it of respect and esteem.

As we passed through a very wide street I saw a tall oak approach a distinguished house, when the trees which escorted me, stepped gracefully back, and bent their branches to the ground. I concluded this must be a more than common personage. In fact, it was the sheriff himself, the very dignitary, whose lady it was insisted I had come too near. I was carried to the hall of this officer's house, and the door was locked upon me. Several trees armed with axes kept guard over me. The axes were held in the branches, which served the same purpose as human hands. I noticed that high up in the branches each wore a head,

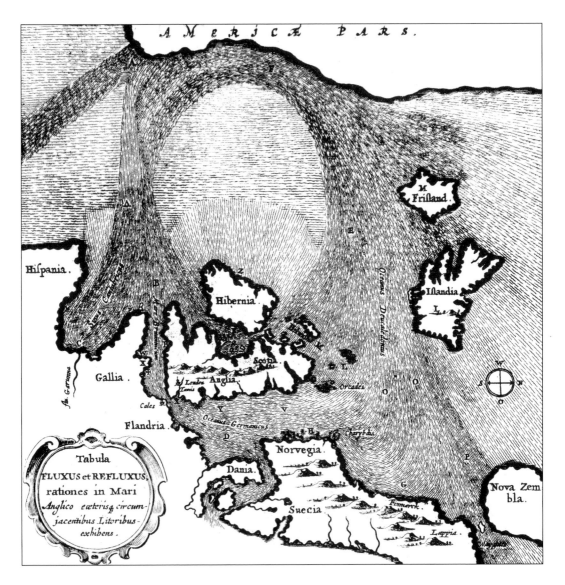

The North Pole,
Athanasius Kircher, *Mundus subterraneus* (1665)

about the size of my own, covered with leaves and tendrils instead of hair. Below were two roots or legs, very short. These trees were much smaller than those on our earth, in fact being about the height of a man; some indeed were much shorter; but these I concluded to be children.

While reflecting on the miserable situation in which I found myself, and weeping over the ill-luck of my adven-ture, my guards stepped up to me and commanded me to follow them. They led me to a splendid building in the middle of the market-place. At the door of this building stood Justice, cut out in the form of a tree, holding among the branches a pair of scales. I presumed the structure to be the court-house, nor was I deceived. I was carried into a large room, the floor of which was overlaid with glit-

tering marble flags of various colours. At the upper end a golden chair was raised a little above the floor, like a judge's seat; in it was seated a sedate palm tree, distinguished from the rest by the gorgeousness of his leaves; a little below him were seated twelve assessors, six on either side. About them stood twenty-four officers holding axes. I was not a little terrified when brought a prisoner before these magnates.

As I entered the hall, all the officers of the court stood up, elevated their branches and then sat down. After this ceremony I was placed at the bar between two trees, the stems of which were covered with sheep-skins. These persons I supposed to be lawyers, and so they were.

Before the trial commenced, the head of the judge was wrapped up in a black blanket. The accuser then made a short speech, which he thrice repeated. The lawyer appointed to defend me, replied in the same manner. A perfect silence then ensued. In half an hour the superior judge rose from the chair, removed the blanket, raised the branches towards Heaven, and spoke with much grace, what I supposed to be my sentence. I was then carried back to my prison.

Entering through the Poles

COLLIN DE PLANCY
Voyage au centre de la terre, I, 21–22 (1821)

Finally, after walking for a quarter of an hour, we actually found ourselves in front of this great black barrier. We had not yet reached the polar mountains, and this was an immense forest, stretching further than we could see. It was made up of bushes and tall trees, which in fact were quite rare; but these trees were as green as pines. . . . The pole was no longer the kingdom of winter and death. . . .

Before making an attempt, Clairancy first wanted to discover the nature of that material (as he later told us); he drew his hunting knife and struck the rock; the point of the knife broke off and a sound rang out like iron; he scratched a few lines in different places, revealing the colour of iron everywhere, mixed slightly with the black and extremely hard earth.

"There can no longer be any doubt," he said to Edward, "These are the iron mountains that the true scholars of physics have spoken about so much." . . .

It took us an hour and a half to climb from the foot of these mountains to the top, and during all that time, we had seen nothing.

However, when we arrived at the platform on top of the mountain range surrounding the pole, as we were rejoicing in having reached that level, broad, vast expanse of ground, lit by a light as pure as daylight, we all felt a sensation that will never leave our memories. Each of us felt his breathing become freer, his body more willing, his movements lighter; we seemed to be hovering, without touching the ground. In this state, we made our way halfway across the platform without noticing, as we searched for our friends. By then we were not far from the other edge, where the waves of light were emerging. From a distance we had taken them for a column of negligible size, in fact they formed an immeasurable mass. Tristan, like me, thought that the pole might be a

source of light and heat, like the sun; Williams and Martinet were afraid of throwing themselves into the fire, and we all resolved to stop . . . but a violent jolt dragged us rapidly onward, making it clear that we no longer could, and that we had been drawn towards the pole by an invincible force from the minute we had set foot on the top of the mountain. . . . Our hair stood up in terror when we saw that we were on the edge of a bottomless precipice where daylight shone in all its brilliance; but none of us had time to think about anything: the whole of our little band was swept into the air by the vortex. . . .

We went down into the chasm, moving fast as if falling from a great height. . . . To our indescribable surprise, we found ourselves in an immense space filled with indistinct light. . . .

"Listen to me," Clairancy finally said. "At the beginning of the eighteenth century, a learned scholar of physics declared that the earth could not be solid, because with a diameter of three thousand leagues, at least two thousand nine hundred of these would serve no purpose. So he posited that inside the globe there was a metallic nucleus that controlled its movements. Whilst this structure was rejected at the time as paradoxical, our adventure has proved it to be true. This is my presumption: the earth, which is inhabited by man on its surface, and which is nine thousand leagues in circumference, is only fifty or one hundred leagues thick at any point. Its interior is empty, with the shape of a globe in its centre; in the middle of this globe is a nucleus or another, smaller planet, and this nucleus is magnetic. . . . The vapours produced in abundance by the magnetic rocks

onto which we have fallen are released directly through the aperture of the pole, where the architect of nature has placed a range of iron mountains forming a crown. We must presume that the southern pole is surrounded in the same way. So, given that the large masses of iron surrounding the two poles attract the magnetic vapours from this central planet equally to either side, it is maintained in perfect equilibrium. What confounds us the most is seeing the sky, when we have the earth above our heads on all sides. But it may be that our globe, which is opaque and dark on its surface, is luminous in its interior, or rather that the air surrounding us conceals the real appearance of this semi-sphere above us. As for the light shining upon us here, I believe it is channelled to us by the same magnetic vapours that, on crossing the two poles, extend out to an infinite height, reflecting the rays of the sun and producing the aurora borealis."

A Vision of the Underground

EDWARD BULWER-LYTTON
The Coming Race, III and IV (1871)

The road itself seemed like a great Alpine pass, skirting rocky mountains of which the one through whose chasm I had descended formed a link. Deep below to the left lay a vast valley, which presented to my astonished eye the unmistakeable evidences of art and culture. There were fields covered with a strange vegetation, similar to none I have seen above the earth; the colour of it not green, but rather of a dull and leaden hue or of a golden red. There were lakes and rivulets which

The Poles, Athanasius Kircher, *Mundus subterraneus* (1665)

seemed to have been curved into artificial banks; some of pure water, others that shone like pools of naphtha. At my right hand, ravines and defiles opened amidst the rocks, with passes between, evidently constructed by art, and bordered by trees resembling, for the most part, gigantic ferns, with exquisite varieties of feathery foliage, and stems like those of the palm-tree. Others were more like the cane-plant, but taller, bearing large clusters of flowers. Others, again, had the form of enormous fungi, with short thick stems supporting a wide dome-like roof, from which either rose or drooped long slender branches. The whole scene behind, before, and beside me far as the eye could reach, was brilliant with innumerable lamps. The world without a sun was bright and warm as an Italian landscape at noon, but the air less oppressive, the heat softer. Nor was the scene before me void of signs of habitation. I could distinguish at a distance, whether on the banks of the lake or rivulet, or halfway upon eminences, embedded amidst the vegetation, buildings that must surely be the homes of men. I could even discover, though far off, forms that appeared to me human moving amidst the landscape.... Right above me there was no sky, but only a cavernous roof. This roof grew higher and higher at the distance of the landscapes beyond, till it became imperceptible, as an atmosphere of haze formed itself beneath.... I now came in full sight of the building. Yes, it had been made by hands, and hollowed partly out of a great rock. I should have supposed it at the first glance to have been of the earliest form of Egyptian architecture. It was fronted by huge columns, tapering up-

170 MUNDI SUBTERRANEI

Poli Arctici Constitutio

Poli Antarctici Constitutio

ward from massive plinths, and with capitals that, as I came nearer, I perceived to be more ornamental and more fantastically graceful than Egyptian architecture allows. As the Corinthian capital mimics the leaf of the acanthus, so the capitals of these columns imitated the foliage of the vegetation neighbouring them, some aloe-like, some fern-like. And now there came out of this building a form—human;—was it human? It stood on the broad way and looked around, beheld me and approached. It came within a few yards of me, and at the sight and presence of it an indescribable awe and tremor seized me, rooting my feet to the ground. It reminded me of symbolical images of Genius or Demon that are seen on Etruscan vases or limned on the walls

of Eastern sepulchres—images that borrow the outlines of man, and are yet of another race. It was tall, not gigantic, but tall as the tallest man below the height of giants.

Its chief covering seemed to me to be composed of large wings folded over its breast and reaching to its knees; the rest of its attire was composed of an under tunic and leggings of some thin fibrous material. It wore on its head a kind of tiara that shone with jewels, and carried in its right hand a slender staff of bright metal like polished steel. But the face! it was that which inspired my awe and my terror. It was the face of man, but yet of a type of man distinct from our known extant races. The nearest approach to it in outline and expression is the face of the sculptured sphinx—so regular in its calm, intellectual, mysterious beauty. Its colour was peculiar, more like that of the red man than any other variety of our species, and yet different from it—a richer and a softer hue, with large black eyes, deep

and brilliant, and brows arched as a semicircle. The face was beardless; but a nameless something in the aspect, tranquil though the expression, and beauteous though the features, roused that instinct of danger which the sight of a tiger or serpent arouses. I felt that this manlike image was endowed with forces inimical to man. As it drew near, a cold shudder came over me. I fell on my knees and covered my face with my hands.

J. CLEVES SYMMES
(1779–1829)
A Letter

St. Louis, Missouri Territory,
North America,
April 10, A. D., 1818

To all the world—I declare the earth is hollow and habitable within; containing a number of solid concentric spheres, one within the other, and that it is open at the poles 12 or 16 degrees.

Still from the film
Journey to the Center of the Earth (2008)

I pledge my life in support of this truth, and am ready to explore the hollow, if the world will support and aid me in this undertaking.
JOHN CLEVES SYMMES,
Of Ohio, late captain of infantry.

N. B.—I have ready for the press a treatise on the principles of matter, wherein I show proofs of the above positions, account for various phenomena and discuss Dr. Darwin's "Golden Secret." My terms are the patronage of this and the new worlds.... I ask 100 brave companions, well equipped, to start from Siberia, in the fall season, with reindeer and sleighs, on the ice of the frozen sea. I engage we find a warm and rich land, stocked with thrifty vegetables and animals, if not men on reaching one degree northward of latitude 82; we will return in the succeeding spring.
J.C.S

Bernard's Hypotheses

R. W. BERNARD
The Hollow Earth (1964)

WHAT THIS BOOK SEEKS TO PROVE

1. That the Earth is hollow and is not a solid sphere as commonly supposed, and that its hollow interior communicates with the surface by two polar openings.
2. That the observations and discoveries of Rear Admiral Richard E. Byrd of the United States Navy, who was the first to enter into the polar openings, which he did for a total distance of 4,000 miles in the Arctic and Antarctic, confirm the correctness of our revolutionary theory of the Earth's structure, as do the observations of other Arctic explorers.
3. That, according to our geographical theory of the Earth being concave, rather than convex, at the Poles, where it opens into its hollow interior, the North and South Poles have never been reached because they do not exist.
4. That the exploration of the unknown New World that exists in the interior of the Earth is much more important than the exploration of outer space; and the aerial expeditions of Admiral Byrd show how such exploration may be conducted.
5. That the nation whose explorers first reach this New World in the hollow interior of the Earth, which has a land area greater than that of the Earth's surface, which may be done by retracing Admiral Byrd's flights beyond the hypothetical North and South Poles, into the Arctic and Antarctic polar openings, will become the greatest nation in the world.
6. That there is no reason why the hollow interior of the earth, which has a warmer climate than on the surface, should not be the home of plant, animal and human life; and if so, it is very possible that the mysterious flying saucers come from an advanced civilization in the hollow interior of the earth.
7. That, in event of a nuclear world war, the hollow interior of the earth will permit the continuance of human life after radioactive fallout exterminates all life on the Earth's surface; and will provide an ideal refuge for the evacuation of survivors of the catastrophe, so that the human race may not be completely destroyed, but may continue.

At the Center of the Egg

CYRUS REED TEED
Koresh: Fundamentals of Koreshan Universology (1899)

The sun, the moon, the planets, and the stars are not great celestial bodies, as they are believed to be, but rather focal points of a force that, being substantial but not material, is susceptible to transmutation from materialization to dematerialization; this capacity for metamorphosis maintains a constant combustion, and in consequence a radiation of the ethereal essences constantly generated by the combustion itself. . . .

The moon and the planets are visual reflections: the moon, of the earth's surface; the planets, of the mercury disks floating between the layers of the metallic planes. . . .

Right at the center of the egg [the universe], lies an eccentric momentum that includes an astral nucleus that is electromagnetically negative and positive and constitutes the central physical star. . . . It moves around an ethereal cone that has its apex turned to the north and its base facing south.

The Origins of the Eskimos

R. W. BERNARD
The Hollow Earth (1964)

Both men are of the opinion that a race of little brown people live in the interior of the Earth. It is possible that the Eskimos descended from these people. . . . Some Eskimo legends tell

Illustration by Adam Seaborn from *Symzonia: Voyage of Discovery*, New York (1820)

of a paradisical land of great beauty to the north. Eskimo legends also tell of a beautiful land of perpetual light, where there is neither darkness at any time nor a too bright sun. . . . Gardner writes: "It is quite possible that the Eskimos are not descended from any tribes driven out of China as that might imply, but that the Chinese as well as the Eskimos originally came from the interior of the earth."

From Byrd's Fictitious Diary

ADMIRAL RICHARD E. BYRD
Diary (1947)

I must write this diary in secrecy and obscurity. It concerns my Arctic flight of the nineteenth day of February in the year of nineteen and forty-seven. There comes a time when the rationality of men must fade into insignificance and one must accept the inevi-

Front cover of
The Hollow Earth, Raymond
W. Bernard (1964)

tability of The Truth! I am not at liberty to disclose the following documentation at this writing ... perhaps it shall never see the light of public scrutiny, but I must do my duty and record here for all to read one day. In a world of greed and exploitation of certain of mankind can no longer suppress that which is truth. . . .

Both magnetic and gyro compasses beginning to gyrate and wobble, we are unable to hold our heading by instrumentation. Take bearing with sun compass, yet all seems well. The controls are seemingly slow to respond and have sluggish quality, but there is no indication of icing! . . .

29 minutes elapsed flight time from the first sighting of the mountains, it is no illusion. They are mountains and consisting of a small range that I have never seen before! . . .

We are crossing over the small mountain range and still proceeding northward as best as can be ascertained. Beyond the mountain range is what appears to be a valley with a small river or stream running through the centre portion. There should be no green valley below! Something is definitely wrong and abnormal here! We should be over ice and snow! To the port-side are great forests growing on the mountain slopes. Our navigation instruments are still spinning, the gyroscope is oscillating back and forth! . . .

I alter altitude to 1400 feet and execute a sharp left turn to better examine the valley below. It is green with either moss or a type of tight knit grass. The light here seems different. I cannot see the Sun anymore. We make another left turn and we spot what seems to be a large animal of some kind below us. It appears to be

an elephant! NO! It looks more like a mammoth! This is incredible! Yet, there it is! . . .

I am encountering more rolling green hills now. The external temperature indicator reads 74 degrees Fahrenheit! I am continuing on our heading now. Navigation instruments seem normal now. I am puzzled over their actions. Attempt to contact base camp. Radio is not functioning! . . .

Countryside below is more level and normal (if I may use that word). Ahead we spot what seems to be a city! This is impossible! Aircraft seems light and oddly buoyant. The controls refuse to respond! My GOD! Off our port and starboard wings are a strange type of aircraft. They are closing rapidly alongside! They are disc-shaped and have a radiant quality to them. They are close enough now to see the markings on them. It is a type of Swastika! This is fantastic. Where are we? What has happened? . . .

Our radio crackles and a voice comes through in English with what perhaps is a slight Nordic or Germanic accent!

The message is: "Welcome, Admiral, to our domain. We shall land you in exactly seven minutes! Relax, Admiral, you are in good hands."
I note the engines of our plane have stopped running! The aircraft is under some strange control and is now turning itself. The controls are useless. . . .
Several men are approaching on foot toward our aircraft. They are tall with blond hair. In the distance is a large shimmering city pulsating with rainbow hues of color. I do not know what is going to happen now, but I see no signs of weapons on those approaching. I hear now a voice ordering me by name to open the cargo door. I comply. . . .
From this point I write all the following events here from memory. It defies the imagination and would seem all but madness if it had not happened.

The radioman and I are taken from the aircraft and we are received in a most cordial manner. We were then boarded on a small platform-like conveyance with no wheels! It moves us toward the glowing city with great swiftness. As we approach, the city seems to be made of a crystal material.

Soon we arrive at a large building that is a type I have never seen before. It appears to be right out of the design board of Frank Lloyd Wright, or perhaps more correctly, out of a Buck Rogers setting! . . .
"Yes," the Master replies with a smile, "you are in the domain of the Arianni, the Inner World of the Earth. We shall not long delay your mission, and you will be safely escorted back to the surface and for a distance beyond.

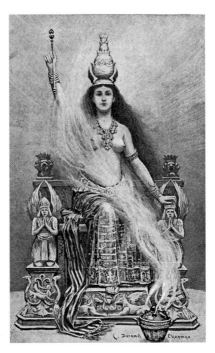

William Bradshaw,
The Goddess of Atvatabar
(1892), New York Public
Library

"But now, Admiral, I shall tell you why you have been summoned here. Our interest rightly begins just after your race exploded the first Atomic bombs over Hiroshima and Nagasaki, Japan. It was at that alarming time we sent our flying machines, the 'Flugelrads,' to your surface world to investigate what your race had done. That is, of course, past history now, my dear Admiral, but I must continue on. You see, we have never interfered before in your race's wars, and barbarity, but now we must, for you have learned to tamper with a certain power that is not for man, namely, that of atomic energy. Our emissaries have already delivered messages to the powers of your world, and yet they do not heed. Now you have been chosen to be witness here that our world does exist. . . ."
The Master continued, "In 1945 and afterward, we tried to contact your

William Bradshaw,
Map of the Interior World
(1892)

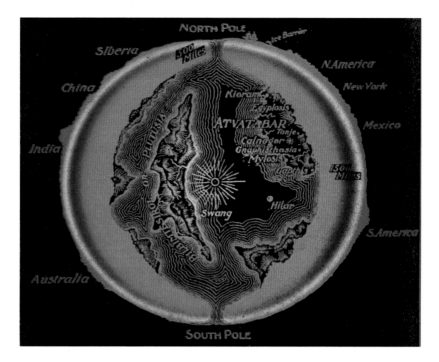

race, but our efforts were met with hostility, our Flugelrads were fired upon. Yes, even pursued with malice and animosity by your fighter planes. So, now, I say to you, my son, there is a great storm gathering in your world, a black fury that will not spend itself for many years. There will be no answer in your arms, there will be no safety in your science. It may rage on until every flower of your culture is trampled, and all human things are leveled in vast chaos. Your recent war was only a prelude of what is yet to come for your race....

"We see at a great distance a new world stirring from the ruins of your race, seeking its lost and legendary treasures, and they will be here, my son, safe in our keeping. When that time arrives, we shall come forward again to help revive your culture and your race. Perhaps, by then, you will have learned the futility of war and its strife ... and after that time, certain of your culture and science will be returned for your race to begin anew...."

March 11, 1947. I have just attended a staff meeting at the Pentagon. I have stated fully my discovery and the message from the Master. All is duly recorded. The President has been advised. I am now detained for several hours (six hours, thirty-nine minutes, to be exact). I am interviewed intently by Top Security Forces and a medical team. It was an ordeal! I am placed under strict control via the national security provisions of this United States of America. I am ordered to remain silent in regard to all that I have learned, on the behalf of humanity! Incredible! I am reminded that I am a military man and I must obey orders....

In closing, I must state that I have

faithfully kept this matter secret as directed all these years. It has been completely against my values of moral right. Now, I seem to sense the long night coming on and this secret will not die with me, but as all truth shall, it will triumph and so it shall. This can be the only hope for mankind. I have seen the truth and it has quickened my spirit and has set me free! . . . For I have seen that land beyond the pole, that center of the great unknown.

Agartha

LOUIS JACOLLIOT
God's Sons, VIII (1873)

The brahmatma lived invisible amongst his wives and favourites in his vast palace. His orders to the priests and provincial governors, to the Brahmins and aryas of all orders, were passed on by messengers wearing silver bracelets engraved with his arms.

When his officials passed through town and country, mounted on their monstrous white elephants, dressed in silk embellished with gold, and preceded by runners who announced their presence with cries of "ahovata! ahovata!" the people fell to their knees at the side of the road and only raised their heads when the procession had disappeared. . . .

When the brahmatma himself went out, he could only do so in a howdah enclosed by curtains woven from cashmere, silk and gold, upon the white elephant dedicated to him, which he alone was permitted to ride, and which almost buckled under the weight of solid gold, Nepalese carpets, jewellery and precious stones. The an-

imal's proboscis was adorned with many bracelets of precious metal, masterpieces of painstaking craftsmanship, and from its great ears hung enormous diamonds of incalculable value. The howdah was of sandalwood inlaid with gold.

The amenities of the palace of this representative of God on earth surpassed all imagining, and the descriptions that the Brahmins have left of the palace of Asgartha far exceed the marvels of Thebes, Memphis, Nineveh and Babylon, which in any case were nothing but a weakened echo of those of their Hindu ancestors. . . .

Finally, the founders of Christianity, after copying from Brahminism the trinity and its miseries, the names and adventures of its incarnations, the virgin mother and, as we will see, their holy oil and altar fire, holy water and other ceremonies, undoubtedly wanted to emphasise their affiliation further by taking the servility of their imitation to the extreme.

After having made Ieseus Christna their Jesus Christ, the Virgin Dvanaguy the Virgin Mary, they took inspiration from Brahminism for their pope.

Where Is Agartha?

ALEXANDRE SAINT-YVES D'ALVEYDRE
The Kingdom of Agarttha: A Journey into the Hollow Earth (1886), I and II

Where is Agarttha? What is the specific region in which it lies? Along what road, through what civilizations, must one walk in order to reach it? . . . Since I know that certain powers, in their competition with each other

across the whole of Asia, will undoubtedly come close to this sacred territory, and since I know that in some future conflict their armies will inevitably seek to approach it and even to enter it, I have no fear of continuing the divulgation I have begun—out of humanity both for these European people and for Agarttha itself.

On the surface and in the bowels of the earth, the true extent of Agarttha defies the embrace and the constraint of profanation and violence.

In Asia alone there are a half a billion people who are more or less aware of its existence and its greatness—not to mention America, whose subterranean regions belonged to Agarttha in very remote antiquity.

But nowhere will there be found among them a traitor who would provide the precise location where its Council of God and its Council of Gods, its pontifical head and its judicial heart, are located

Let it be sufficient for my readers to know that in certain regions of the Himalayas, among the twenty-two temples representing the twenty-two Mysteries of Hermes and the twenty-two letters of certain sacred alphabets, the Agarttha forms the mystical zero, which is to be found nowhere

The sacred territory of Agarttha is independent, organized in accordance with Synarchic principles, and consists of a population that has grown to approach twenty million souls

The libraries of the earlier Cycles are to be found beneath the seas that swallowed up the ancient Southern continent and in the subterranean constructions of ancient antediluvian America.

What I am about to relate both here and throughout the book will seem like a story straight from *One Thousand and one Nights*, yet nothing could be more real.

The actual university archives of Paradesa occupy thousands of miles. For cycles of many centuries, several high initiates possessing the secrets of only certain religions, and knowing the true purpose of certain works, have been obliged, beginning each year, to spend three years carving on

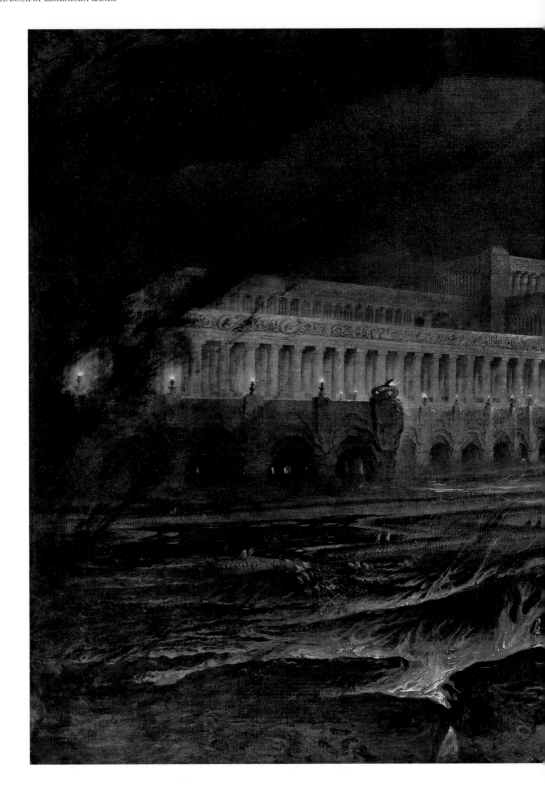

stone tablets all the facts concerning the four hierarchies of sciences forming the total corpus of Knowledge.

Each one of these scholars performs his work in solitude, far from any visible light, beneath the cities, deserts, plains, or mountains.

The reader should picture in his mind a colossal chessboard that extends under the earth's surface to cover almost every region of the Globe.

All the splendors of Humanity's time on earth can be found in each square of this chessboard. In some squares the encyclopedias of the centuries and millennia are located, while in others, lastly, are those of the major and minor Yugas

During the great prayer days, during the celebration of the cosmic Mysteries, although the sacred hierograms are recited in a tone little more than a whisper inside the immense underground dome, a strange acoustic phenomenon takes place on the surface of the earth and the skies.

The travelers and caravans that wander far during the light of day or on clear nights come to a halt, both man and beast, anxiously listening

And these sciences and these arts, and many others as well, continue to be ceaselessly professed, demonstrated, and practiced in the workshops, laboratories, and observatories of Agarttha.

Chemistry and physics have been developed to such a degree that no one would even want to accept my description, were I to depict them here.

We know naught but the forces of the Planet, at the most! . . .

Every year, at a predetermined cosmic time, under the guidance of the Maharishi and the high prince of the Sacred College of Magic, the laure-

ates of the top sections descend once again to visit one of the Plutonian metropolises.

They must first flow through the earth by way of a crack in the surface, which scarcely allows for the passage of a human body.

Breathing comes to a halt, and the Yogi, his hands above his head, slips through it—an experience that feels as if it lasts a century.

Eventually they all fall, one after another, down into an endless sloping gallery. This is where their true journey begins.

As they descend, the air becomes increasingly impossible to breathe and, illuminated by the light from below, they can see the force of the initiates increasing gradually along the length of immense inclined vaults, at the bottom of which they will soon catch sight of hell's fires.

The greater part of their number is forced to stop in the middle of their journey, suffocating and exhausted despite their provisions of breathable air, food, and calorific substances.

Only those continue who have become able, by the practice of secret arts and sciences, to breathe with their lungs as little as possible, and to use their other organs to draw from the air, in any given place, those divine and vital elements it contains wherever it is found.

Finally, after an extremely long journey, those who have persevered will witness something flaming in the distance that looks like an immense subplanetary conflagration

The cyclopean metropolis opens, lit from below by a fluid red ocean that is a distant reflection of the central fire, which has withdrawn into itself during that time of the year.

There is an infinite array of the strangest kinds of architecture, in which all minerals commingled achieve what the fancies and chimeras of the Gothic, Corinthian, Dorian, and Ionian artists would never have dared to dream.

And everywhere, furious at the sight of their home penetrated and invaded by men, a people of human shape and igneous bodies surge forth at the approach of the initiates and leap away on their wings in all directions to perch with their claws clinging to the plutonian walls of their city.

With the Maharishi at their head, the sacred procession follows a narrow path of basalt and hardened lava.

A dull noise can be heard in the distance that seems to extend infinitely, like the shudder caused by the waves of a great equinoctial tide.

During this time, while still moving forward, the Yogis observe and study there strange people, their mores, their customs, their frightening activity, and what use they might be for us.

It is their labors which, at the command of the Cosmic Powers, adapt to our benefit the layers of the earth that supports us, the underground rivers of metalloids and metals that are necessary to us, the volcanoes that guarantee explosions and cataclysms for our globe, and the systems of our mountains and river valleys.

It is also they who prepare the thunder, by damming up the cyclical currents of the interpolar and intertropical fluids beneath the earths' surface, as well as their interweaving derivations in the various zones of Earth's latitudes and longitudes.

It is also they who consume every living seed as it rots, so that it will be able to bear its fruit.

These people are the Autochthonous Inhabitants of the Central Fire; they are the same who were visited by Our Lord Jesus Christ before he ascended back into the Sun, ensuring that the Redemption would purify everything—even the igneous instincts from which the visible hierarchy of beings and things is erected here below

Let us enter this Tabernacle; there we shall see the Brâhatmah, prototype of the Abramites of Chaldea, the Melchizedek priests of Salem, and the Hierophants of Thebes and Memphis, as well as of Saïs and Ammon.

With the exception of the highest initiates, no one has ever come face to face with the Sovereign Pontiff of Agarttha

It was an old man of the Caucasian type, descended from this handsome Ethiopian race, who—after the Red and before the White—formerly held the scepter of the general government of the Earth, and carved in all the mountains those cities and prodigious buildings that can be found everywhere from Ethiopia to Egypt and from India to the Caucasus.

The King of the World

FERDINAND OSSENDOWSKI
Beasts, Men and Gods (1923), V, 46

On my journey into Central Asia I came to know for the first time about "the Mystery of Mysteries," which I can call by no other name. At the outset I did not pay much attention to it and did not attach to it such impor-

Lorenzo Lotto, *The Sacrifice of Melchizedek* (c. 1545), Numana, Museo dell'antico tesoro della Santa Casa di Loreto

tance as I afterwards realized belonged to it, when I had analyzed and connoted many sporadic, hazy and often controversial bits of evidence. The old people on the shore of the River Amyl related to me an ancient legend to the effect that a certain Mongolian tribe in their escape from the demands of Jenghiz Khan hid themselves in a subterranean country. Afterwards a Soyot from near the Lake of Nogan Kul showed me the smoking gate that serves as the entrance to the "Kingdom of Agharti." Through this gate a hunter formerly entered into the Kingdom and, after his return, began to relate what he had seen there. The Lamas cut out his tongue in order to prevent him from telling about the Mystery of Mysteries. When he arrived at old age, he came back to the entrance of this cave and disappeared into the subterranean kingdom, the memory of which had ornamented and lightened his nomad heart. I received more realistic information about this from Hutuktu Jelyb Djamsrap in Narabanchi Kure. He told me the story of the semi-realistic arrival of the powerful King of the World from the subterranean kingdom, of his

appearance, of his miracles and of his prophecies; and only then did I begin to understand that in that legend, hypnosis or mass vision, whichever it may be, is hidden not only mystery but a realistic and powerful force capable of influencing the course of the political life of Asia. From that moment I began making some investigations. The favorite Gelong Lama of Prince Chultun Beyli and the Prince himself gave me an account of the subterranean kingdom. . . .

"This kingdom is Agharti. It extends throughout all the subterranean passages of the whole world. I heard a learned Lama of China relating to Bogdo Khan that all the subterranean caves of America are inhabited by the ancient people who have disappeared underground. Traces of them are still found on the surface of the land. These subterranean peoples and spaces are governed by rulers owing allegiance to the King of the World. In it there is not much of the wonderful. You know that in the two greatest oceans of the east and the west there were formerly two continents. They disappeared under the water but their people went into the subterranean

kingdom. In underground caves there exists a peculiar light which affords growth to the grains and vegetables and long life without disease to the people. There are many different peoples and many different tribes. An old Buddhist Brahman in Nepal was carrying out the will of the Gods in making a visit to the ancient kingdom of Jenghiz—Siam—where he met a fisherman who ordered him to take a place in his boat and sail with him upon the sea. On the third day they reached an island where he met a people having two tongues which could speak separately in different languages. They showed to him peculiar, unfamiliar animals, tortoises with sixteen feet and one eye, huge snakes with a very tasty flesh and birds with teeth which caught fish for their masters in the sea. These people told him that they had come up out of the subterranean kingdom and described to him certain parts of the underground country."

Geographic and Historical Facts Have a Symbolic Value

RENÉ GUÉNON
The King of the World, "Conclusions" (1925)

From the concordant evidence of all the traditions, one conclusion emerges very clearly: the existence of a "Holy Land" *par excellence*, the proto-type of all the other "Holy Lands," the spiritual centre to which all the other centres are subordinated. The "Holy Land" is also the "Land of the Saints," the "Land of the Blessed," the "Land of the Living," the "Land of Immortality"; all these expressions are equivalent, and we must also add the "Pure Land," which Plato relates to the "abode of the Blessed."
We habitually locate this abode in an "invisible world"; but if we want to understand its nature, we must not forget that the same applies to the "spiritual hierarchies" that also occur in all the traditions, and which in reality represent degrees of initiation. In the current period of our terrestrial cycle, in other words in the Kali-Yuga, this "Holy Land," defended by "guardians" who conceal it from profane eyes whilst maintaining certain connections to the outside, is in effect invisible, inaccessible, but only for those who do not possess the qualifications required to enter it. Now should its location in a given region be seen as literally true, or only symbolic, or both things at once? To this question, we shall simply reply that for us, geographical facts themselves, and also historical facts, have, like all others, a symbolic value, which in any case, evidently, does not take anything away from their inherent reality as facts, but which confers upon them, beyond this immediate reality, a higher meaning.

14

THE INVENTION
OF RENNES-LE-CHÂTEAU

In the chapter on the Grail, we saw how a holy relic progressed on its tortuous journey, sometimes finding itself in one place and sometimes in another. One of the most recent legends, which we owe to the books of Otto Rahn, said that it was in Montségur, in the south of France near the Spanish border, an area in which confraternities of greater or less esotericism, devoted to the cult of the magnificent chalice, already flourished. The region was therefore suited to a re-kindling of the legend: all that was needed was a pretext. And the pretext came with the story of the abbot François Bérenger Saunière, about whom, if we are to start off with our feet on the ground, we should first of all provide all the historically proven data.

From 1885 to 1909, Bérenger Saunière was the priest of the municipality of Rennes-le-Château, a small village about forty kilometers from Carcassonne. Around that time there was gossip about a possible relationship with his housekeeper, Marie Dénarnaud, but nothing had ever been proven. What we do know is that Saunière had restored the exterior and interior of the local church and had built both Villa Bethania, where he lived, and up on the hill the Tower of Magdala, which was reminiscent of the Tower of David in Jerusalem.

All of these were extremely costly projects (it has been calculated that the cost was 200,000 francs at the time, roughly equivalent to the value of two hundred years of stipend for a country priest), and naturally the rumors began to circulate, so much so that the bishop of Carcassonne launched an inquiry. Saunière would not cooperate with the inquiry, and the bishop ordered his transfer to another parish. But Saunière refused and withdrew into a more private existence, living on scant means for the rest of his life and dying in 1917.

While the information that we can be sure of ends here, from this point onward there was much conjecture about the strange life of this eccentric priest. It was said that, during the reconstruction of the parish, Saunière had stumbled upon a series of finds, the nature of which is unclear; one of his diaries mentions the discovery of a sepulchre beneath the floor of the church, perhaps the ancient tomb of the lords of the manor. Others had talked of the discovery of a container holding "precious" objects, but probably these were objects of modest value abandoned by the parish priest of Rennes during the French Revolution, before he fled to Spain; or perhaps they were small parchments left there during the consecration ceremony of the church.

Tall tales began to circulate on the basis of these feeble clues, suggesting that Saunière had found a fabulous treasure. In reality, the wily priest had placed advertisements in the press and in religious magazines in which he invited donors to send money in exchange for the promise of a mass for their dear departed, thereby accumulating money for hundreds of masses that he never actually celebrated—and it was for precisely this reason that he had been put on trial by the bishop of Carcassonne. One final, piquant detail: on his death, Saunière left all he had built to his housekeeper, Marie Dénarnaud, who, perhaps to add value to the properties bequeathed to her, had continued to fuel the legend of the treasures of Rennes-le-Château. After he had inherited Marie's property, a certain Noël Corbu opened a restaurant in the village, providing the local press with tidbits about the mystery of the "billionaire curate," thereby prompting the arrival of treasure hunters who carried out digs in the area.[1]

This is the point when, Pierre Plantard comes onto the scene. This singular character had been a political activist in far-right groups inspired by Saint-Yves d'Alveydre's Synarchy,[2] had founded anti-Semitic groups, and at the age of seventeen had inaugurated Alpha Galates, a movement that backed the Vichy collaborationist regime. But this did not inhibit him from presenting his organizations as partisan resistance groups after the liberation.

1. A guidebook of places not to be overlooked by those wishing to find unheard-of riches, Treasures of the World by Robert Charroux (1962), included Rennes-le-Château.

2. See chapter 13 on Agartha. For Plantard's incredible biography, see in particular Buonanno (2009).

In December 1953, having spent six months in prison for breach of trust (later he was to be sentenced to one year for the corruption of minors), Plantard established his Priory of Sion, officially registering the association with the subprefecture of Julien-en-Genevois on May 7, 1956. This would be nothing extraordinary, were it not for Plantard's boast that his priory was almost two thousand years old. This claim was based on documents (later proved false) that Saunière had supposedly found in the course of the renovation of his church. Plantard maintained that he was a descendant of Dagobert II and these documents demonstrated the survival of the line of Merovingian kings.

Moreover, Plantard had deposited in the Bibliothèque Nationale in Paris some manuscripts on the supposed secret documents (false too, obviously) that connected the priory with Rennes-le-Château.

Plantard's fraud had coincided with a book by Gérard de Sède, a journalist who had belonged to surrealist circles, which perhaps explains his taste for paradoxical plots. De Sède had already written a book about the mysteries of Gisors Castle, in Normandy, where—having retired to raise pigs following some literary disappointments—he had met Roger Lhomoy, a man who was half tramp and half possessed. The latter had once worked as a gardener in the castle and had spent two years excavating (furtively and dangerously) its cellars at night. There he found ancient tunnels and had entered a room where, as he claimed in a statement recorded by de Sède, "What I saw then, I shall never forget, because it was a fantastic sight. I am in a Roman vault made of Louveciennes stone, thirty meters long, nine meters broad, and about four and a half meters high at the crown. On my immediate left, close to the hole through which I had passed, there is an altar, in stone, like the tabernacle. On my right, the rest of the building. Halfway up the walls, supported by stone crows, life-sized figures of Jesus Christ and the twelve apostles. Ranging around the walls, stone sarcophagi two meters long and sixty centimeters broad, nineteen of them in all. What I see is unbelievable: thirty chests in precious metal, stacked in columns of ten. And the

Gisors Castle (early nineteenth century), engraving, Paris, Bibliothèque des arts décoratifs

word 'chest' does not come close to describing them: rather, cupboards lying on their sides, each of which measures 2.20 meters in length, 1.80 in height, and 1.60 wide."

The interesting detail is that all subsequent searches, encouraged by de Sède, while they led to some tunnels, did not lead to the fabulous room. But in the meantime de Sède had been approached by Plantard, who asserted that he not only had secret documents that he could not show, but also a map of the mysterious room. In fact he had drawn it himself according to the statements made by Lhomoy, but this encouraged de Sède to write his book and to suggest, as always happens in these cases, that the Templars had a hand in the matter.

In 1967, de Sède published *The Gold of Rennes* (which, it seems, was a manuscript by Plantard subsequently rewritten by de Sède). This book attracted the media to the myth of the Priory of Sion, and to the reproduction of the false parchments that Plantard had in the meantime managed to disseminate in various libraries. But as Plantard himself was later to confess, these had been drawn by Philippe de Chérisey, a humorist with French radio and an actor. In

Gustave Courbet,
Cliffs at Étretat (1869),
Berlin, Alte Nationalgalerie

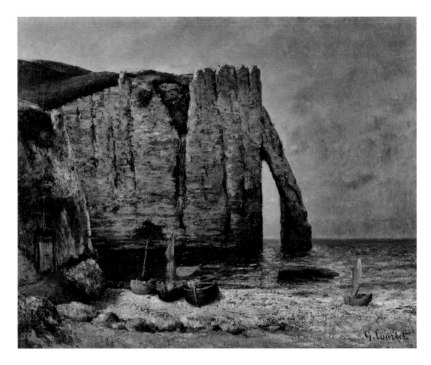

1979 de Chérisey declared that he was the author of the fakes, and that
he had copied the uncial script from documents in the Bibliothèque
Nationale. Moreover, it seems that Chérisey had been inspired by
Maurice Leblanc's novels about <u>Arsène Lupin</u>.

In fact, as explained by Mario Arturo Iannaccone (2005), in
Leblanc's novel *The Hollow Needle*, Lupin discovers the mystery of the
Kings of France: "In his novels, to be read from an anti-Catholic angle,
Leblanc prefigures many elements of the myth of Rennes-le-Château
and crowns Lupin as nothing less than the messianic Grand Monarch.
The Normandy author had a perfect knowledge of the Catholic pro-
phetic tradition, not least because he was born near Gisors, a primary
site for nationalist mysticism. This nationalist and religious ideology
endowed France with a messianic value similar to that attributed to it
during the Revolution, but with a counter-revolutionary slant."

De Sède maintained that the documents, which according to
Plantard had been found by Saunière, were full of signs to be deci-
phered, including a disturbing reference to a very well-known painting
by Nicolas Poussin, in which, as in a painting by Guercino, some shep-

Guercino,
Et in arcadia ego (1618),
Rome, Galleria Nazionale
d'Arte Antica

Nicolas Poussin,
Et in arcadia ego
(seventeenth century),
Paris, Louvre

herds discover a tomb bearing the inscription *Et in Arcadia ego* (Guercino's version also featured a skull on the tomb). This is a classic memento mori (Goethe, too, had used it as an epigraph to his *Travels in Italy*), in which death announces its presence even in happy Arcadia. But Plantard claimed that the phrase had appeared in his family's coat of arms since the thirteenth century (somewhat improbable, because Plantard was the son of a waiter), that the landscape in the painting evokes that of Rennes-le-Château (while Poussin was born in Normandy and Guercino had never even been to France), and that the tombs in both Poussin's and Guercino's works resembled a sepulchre that was visible until the 1980s on a road between Rennes-le-Château and Rennes-les-Bains. Unfortunately, however, it has since been proved that the tomb was built in the twentieth century.

In any case, his evidence stemmed from the fact that the paintings by both artists had been commissioned by the Priory of Sion, and that Plantard was said to have acquired (clearly as proof of something known only to him) a reproduction of Poussin's work. But

the decipherment of Poussin's painting did not stop there: by making an anagram of *Et in Arcadia ego*, he discovered the command *I! Tego arcana Dei*, in other words "Go! I conceal the mysteries of God," and hence "proof" that the tomb was that of Jesus.

Other disturbing hypotheses had been conjectured by de Sède regarding some aspects of the church restored by Saunière.

For example, there appears the inscription *Terribilis est locus iste*, which had mystery aficionados all atremble. In fact (and Saunière must have known this perfectly well), this quotation from Genesis 28:17 exists in many churches and even appears in the introit of masses for church consecrations.[3] It refers to Jacob's vision of ascending to heaven, meeting the angels and talking to God; on reawakening he says, in the Latin version of the Vulgate: "How dreadful is this place! This is none other than the house of God, and this is the gate of heaven." In Latin *terribilis* also means worthy of veneration, capable of inspiring awe—and so there is nothing menacing about the expression.

3. *For example, see the* Missale Romanum *for the* Missa Terribilis, de Communi Dedicationis ecclesiae*: "Terribilis est locus iste: hic domus Dei est et porta caeli: et vocábitur aula Dei." (Terrible is this place: it is the house of God, and the gate of heaven: and shall be called the court of God.)*

In addition, the font is supported by a kneeling demon, interpreted as being Asmodeus, who legend would have it was forced by Solomon to help him build the Temple of Jerusalem, and here too we could cite many Romanesque churches with portrayals of demons.

Above Asmodeus are the depictions of four angels, and below them is engraved the phrase *Par ce signe ti le vincrais* ("By this sign you will conquer him"), which might refer to Constantine's *In hoc signo vinces*, but the addition of that *le* persuaded mystery hunters to count the letters of the phrase: twenty-two, like the teeth of the skull placed at the entrance to the cemetery, twenty-two, like the merlons of the Tower of Magdala, twenty-two, like the steps of the two stairways that lead to the tower. The letters of *le* are the thirteenth and fourteenth of the phrase; put thirteen together with fourteen, and we have 1314, which is the year in which the grand master of the Templars, Jacques de Molay, was burned at the stake.

As we have already seen with the Pyramid of Cheops, you can do whatever you like with numbers. If you were to look at the other statues and note the initials of the saints they represent (Germana, Roch, Anthony the Hermit, Anthony of Padua and Luke), you would get the word Graal, i.e., Grail in old French. We could go on with a list of other mysterious coincidences, or rather those that might appear to be such to a good occultist who wishes to ignore the fact that Romanesque abbeys were full of monstrous creatures (and we still have a celebrated philippic by Saint Bernard against these pointless "portents"), so the abbé Saunière must have wished to restore his church with these traditional iconographies in mind. We have already mentioned the abbot's esoteric associations, even with certain

Detail of *Asmodeus*, holy water font at the entrance to Saunière's church, Rennes-le-Château

Rosicrucian circles of those days, and these hermetic amusements proved nothing regarding the Priory or Jesus' exile in France. Another fanciful interpretation involves an inscription on the base of a statue that says *Christus A.O.M.P.S. defendit*, which has been read as *Christus antiquus ordo mysticus Prioratus Sionis defendit*—in other words, that Christ defends the ancient mystical order of the Priory of Sion. In fact the same inscription is found on the base of Pope Sixtus V's obelisk in Rome; read as *Christus ab omni malo populum suum defendit* it means simply "Christ defends his people from all evil" (see Tomatis 2003).

Perhaps the legend of Rennes-le-Château would have gradually been extinguished if de Sède's book had not made an impression on the journalist Henry Lincoln, who then made three documentaries on Rennes-le-Château for the BBC. During this project he collaborated with Richard Leigh, another aficionado of occult mysteries, and with the journalist Michael Baigent, and together they published the book *The Holy Blood and the Holy Grail* (1982), which soon became a huge bestseller. In a nutshell, the book picked up on the information disseminated by de Sède and Plantard, romanticized it still further and, presenting the entire thing as indubitable historical truth, claimed that the founders of the Priory of Sion were the descendants of Jesus Christ, who purportedly did not die on the cross but married Mary Magdalene and fled to France, where he founded the Merovingian dynasty.

What Saunière had allegedly discovered was not a treasure, but a series of documents that proved the lineage of Jesus: royal blood, and hence *sang real*, later distorted to Santo Graal, or Holy Grail. Saunière's wealth allegedly originated from the gold paid by the Vatican to conceal this terrible secret. Of course, in order to conceive a tale that includes Jesus, Mary Magdalene, the Priory of Sion and the gold of Rennes-le-Château, it was necessary to add the Templars and the Cathars to the mix. Moreover, Plantard had already asserted that the Priory not only had an illustrious origin, but that over the centuries its members had included Sandro Botticelli, Leonardo da Vinci, Robert Boyle, Robert Fludd, Isaac Newton, Victor Hugo, Claude Debussy and Jean Cocteau. Only missing was Asterix, the French comic-book hero.

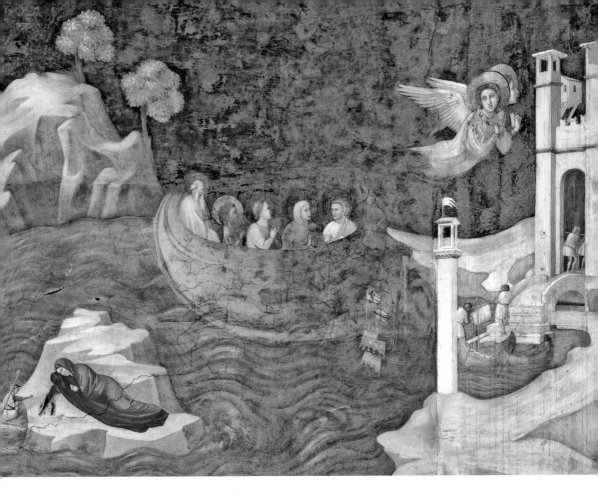

But there are further examples of fanciful reconstruction. Note, for instance, the nonchalance with which Baigent and company talk about the elm tree at Gisors. Attracted by the fact that the Templars could be implicated (although in reality they had stayed in that castle for only two or three years, and this was normal because they had bases all over France), they wanted to draw from this the conclusive proof that the crypt—never rediscovered—contained the Grail. To this end they reported an event that, according to some medieval legends or chronicles, had occurred in the twelfth century at the castle of Gisors. This event about which, the authors admit, "accounts are obscure and confused," involved the cutting down of an elm tree during a dispute between the king of France and the king of England. At a certain point the English had taken refuge at Gisors, and the French cut down the elm tree. That's it. But our authors assert that the story "conceals something more important to be read between the

Giotto, *Mary Magdalene's Voyage to Marseille* (1307–1308), Assisi, Basilica di San Francesco, Cappella della Maddalena

lines." Not even they knew what it was, but they hinted at an entirely hare-brained suspicion that the business had something to do with the Priory of Sion: "Given the strangeness of the accounts handed down to us it would not be surprising if there had been something else, something that people preferred to overlook, or perhaps it was never made public. . . " In this way, Gisors becomes associated with the Priory and, therefore, with the Grail, and has now become another place of pilgrimage for mystery hunters.

We have already followed the frenetic movements of the Grail, from Galicia to Asia. The fact that Gisors is in upper Normandy and hence on the other side of the country from Montségur and Rennes-le-Château, which are in the south of France, does not seem to bother our authors. And instead of two tourist destinations, there are now three.

How such a pile of nonsense could have been taken seriously (and their book not regarded as a work of science fiction) is still a mystery, but the fact remains that it has reinforced the myth of Rennes-le-Château. Ultimately the only ones who did not believe in the hoax were those who had perpetrated it in the first place. After the tale had been fictionally pumped up by Baigent and colleagues, de Sède retracted everything in a book published in 1988, in which he condemned the various frauds and deceptions cooked up around Saunière's village. And in 1989 Pierre Plantard also repudiated all he had stated previously, proposing a second version of the legend according to which the priory had first come to light in Rennes-le-Château in 1781 —and in addition he revised some of his fake documents, adding to the list of the grand masters of the priory the name of Roger-Patrice Pelat, a friend of François Mitterand. Later, Pelat was tried for insider trading and Plantard was called as a witness. He admitted under oath that he had invented the entire story of the priory, and when his apartment was searched, further counterfeit documents were found.[4]

4. *On Plantard's legal misadventures, see Smith (2011) and Introvigne (2005). For a complete bibliography on Rennes-le-Château and Dan Brown, see Smith (2012).*

By that time, no one took him seriously anymore. And so this presumed descendant of Jesus and Mary Magdalene died, unheeded by all, in 2000.

But in 2003 there appeared Dan Brown's now famous novel, *The Da Vinci Code*. Brown was clearly inspired by de Sède, Baigent, Leigh and Lincoln, and numerous other publications on the occult available in specialized bookshops, but he has stated that all the information he provides is historically accurate (see Iannaccone).

It is a common narrative device, from Lucian's *True History* to Jonathan Swift and others, down to Alessandro Manzoni, to begin a novel by stating that it is based on truthful documents. A particularly embarrassing detail is that, *outside the novel*, that is to say in everyday life, Brown has always maintained that his account is historically accurate. In an interview given to CNN on May 25, 2003, he said of his novel: "Ninety-nine percent of it is true. All of the architecture, the art, the secret rituals, the history, all of that is true, the Gnostic gospels. All of that is – all that is fiction, of course, is that there's a Harvard symbologist named Robert Langdon, and all of his action is fictionalized. But the background is all true."

If this really were a historical reconstruction, then there is no explanation for the umpteen blunders that Brown gaily sprinkles throughout his narrative, as when he says that the Priory of Sion had been founded in Jerusalem by "a French king called Geoffrey de Bouillon" when it is known that Geoffrey never accepted the title of king; or that in order to eliminate the Templars, Pope Clement V "had sent secret sealed orders that had to be opened simultaneously by his soldiers all over Europe on Friday October 13, 1307," when it is a historical fact that the messages to the bailiffs and seneschals of the kingdom of France had not been sent by the pope but by King Philip the Fair (nor is it clear how the pope could have had "soldiers all over Europe"); or when he confuses the manuscripts discovered at Qumran in 1947 (which do not mention either "the true story of the Grail" or "the ministry of Christ") with the Nag Hammadi manuscripts, which contain some Gnostic gospels. Or when he talks about a gnomon in the Church of Saint-Sulpice in Paris, saying that it was "a relic from a pagan temple that once stood in this very spot," whereas the gnomon was built in 1743. Finally, in the novel, Saint-Sulpice is indicated on the so-called the Rose Line, which ought to correspond to the Paris meridian,

John Scarlett Davis,
Interior of Saint Sulpice
(1834), Cardiff, National
Museum Wales

a line that allegedly proceeds underground as far as the cellars of the Louvre, below the so-called inverted pyramid, which would be the last resting place of the Holy Grail.

And so to this day numerous mystery hunters make the pilgrimage to Saint-Sulpice to look for the Rose Line, so many of them in fact that the governing body of the church was obliged to put up a notice in English that reads: "The 'meridian' line materialized by a brass inlay in the pavement of this church is part of a scientific instrument built during the 18th century. This was done in full agreement with Church authorities by the astronomers in charge of the newly established Paris Observatory. They used it for defining various parameters of the earth's orbit. Similar arrangements have been made, for the sake of convenience, in other large churches like the Bologna Cathedral where Pope Gregory XIII had preparatory studies made for

the enactment of the present "Gregorian" calendar. Contrary to fanciful allegations in a recent best-selling novel, this is not a vestige of a pagan temple. No such temple ever existed in this place. It was never called a 'Rose-Line.' It does not coincide with the meridian traced through the middle of the Paris Observatory that serves as a reference for maps where longitudes are measured in degrees East or West of Paris. No mystical notion can be derived from this instrument of astronomy except to acknowledge that God the Creator is the Master of time. Please note that the letters 'P' and 'S' in the small round windows at both ends of the transept refer to Peter and Sulpice, the patron saints of the church, not an imaginary 'Priory of Sion.'"

But the most interesting thing is that Lincoln, Baigent and Leigh sued Brown for plagiarism. Now, the preface to *The Holy Blood and the Holy Grail* presents the entire contents of the book as historical truth and does not even attempt to say that this historical truth is the fruit of the authors' exclusive discoveries, because they acknowledge their debt to some previous works that (according to them) supposedly already contained the germs of that truth, but which had not been sufficiently explored—a false affirmation if ever there was one because, we repeat, that kind of literature had been circulating for decades among mystery enthusiasts.

If someone establishes the truth of a historical event (that Caesar was killed on the Ides of March, that Napoléon died on Saint Helena or that Lincoln was assassinated in a theatre by John Wilkes Booth), as soon as the historical truth is made public, it becomes collective property, and someone who writes about the twenty-three stab wounds that Caesar received in the Senate cannot be accused of plagiarism. But Baigent, Leigh and Lincoln, in suing Brown for plagiarism, had publicly admitted that all they had passed off as historical truth was a work of fantasy, and hence their exclusive literary property.

It is true that, in order to lay his hands on Brown's immense fortune, someone might be prepared to swear on the Bible that he is not the son of his legitimate father but of one of the dozens of sailors who habitually frequented his own mother, and Baigent, Leigh and

Lincoln deserve our heartfelt sympathies. But an even more curious thing is that during the trial, Brown maintained that he had never read the book by Lincoln and colleagues, a contradictory defense for an author who asserted that he had taken his information from reliable sources (which said exactly the same things that the authors of *The Holy Blood and Holy Grail* had said).

At this point, we might end the story of Rennes-le-Château, were it not for the fact that it is still a place of pilgrimage. While other legendary places we have dealt with in this book became such in ancient times—and we cannot go back further than Plato to understand how the Atlantis myth came about or locate Ulysses' Ithaca with certainty—and that venerable age makes the legends that surround us respectable if not credible, the case of Rennes-le-Château not only tells us how easy it is to create a legend de novo, but how it can enjoy success even when historians, courts and other institutions have recognized its mendacious nature. All this brings to mind an aphorism by the writer Émile Cammaerts in *The Laughing Prophet*, his study of G. K. Chesterton: "The first effect of not believing in God is to believe in anything."

Arsène Lupin Anticipates Rennes-le-Château

MAURICE LEBLANC
The Hollow Needle (1909), VIII–IX

Front cover of Maurice Leblanc's *The Hollow Needle* (1909), illustration by Marc Berthier

Opposite him, almost level with the cliff, in the open sea rose an enormous rock, over eighty yards high, a colossal obelisk, standing straight on its granite base, which showed at the surface of the water, and tapering toward the summit, like the giant tooth of a monster of the deep....

And all this was mighty and solid and formidable, with the look of an indestructible thing against which the furious assault of the waves and storms could not prevail. And it was definite and permanent and grand, despite the grandeur of the cliffy rampart that commanded it, despite the immensity of the space in which it stood....

And Beautrelet suddenly closed his eyes and convulsively pressed his folded arms to his forehead. Over there—oh, he felt as though he would die for joy, so great was the cruel emotion that wrung his heart!—over there, almost at the top of the Needle of Étretat, a little below the extreme point round which the sea-mews fluttered, a thread of smoke came filtering through a crevice, as though from an invisible chimney, a thread of smoke rose in slow spirals in the calm air of the twilight....

The Étretat Needle was hollow!

Was it a natural phenomenon, an excavation produced by internal cataclysms or by the imperceptible action of the rushing sea and the soaking rain? Or was it a superhuman work executed by human beings, Gauls, Celts, prehistoric men?

These, no doubt, were insoluble questions; and what did it matter? The essence of the thing was contained in this fact: The Needle was hollow. At forty or fifty yards from that imposing arch which is called the Porte d'Aval and which shoots out from the top of the cliff, like the colossal branch of a tree, to take root in the submerged rocks, stands an immense limestone cone; and this cone is no more than the shell of a pointed cap poised upon the empty waters!

A prodigious revelation! After Lupin, here was Beautrelet discovering the key to the great riddle that had loomed over more than twenty centuries! A key of supreme importance to whoever possessed it in the days of old, in those distant times when hordes of barbarians rode through and overran the old world! A magic key that opens the cyclopean cavern to whole tribes fleeing before the enemy! A mysterious key that guards the door of the most inviolable shelter! An enchanted key that gives power and ensures preponderance!

Joseph Michael Gandy, *Rosslyn Chapel* (1810), lithograph, private collection. One of the settings of *The Da Vinci Code*.

Because he knows this key, Caesar is able to subdue Gaul. Because they know it, the Normans force their sway upon the country and, from there, later, backed by that support, conquer the neighboring island, conquer Sicily, conquer the East, conquer the new world!

Masters of the secret, the Kings of England lord it over France, humble her, dismember her, have themselves crowned at Paris. They lose the secret; and the rout begins.

Masters of the secret, the Kings of France push back and overstep the narrow limits of their dominion, grad-

ually founding a great nation and radiating with glory and power. They forget it or know not how to use it; and death, exile, ruin follow.

An invisible kingdom, in mid-water and at ten fathoms from land! An unknown fortress, taller than the towers of Notre Dame and built upon a granite foundation larger than a public square! What strength and what security! From Paris to the sea, by the Seine. There, the Havre, the new town, the necessary town. And, sixteen miles thence, the Hollow Needle, the impregnable sanctuary!

It is a sanctuary and also a stupendous

hiding-place. All the treasures of the kings, increasing from century to century, all the gold of France, all that they extort from the people, all that they snatch from the clergy, all the booty gathered on the battle-fields of Europe lie heaped up in the royal cave. Old Merovingian gold sous, glittering crown-pieces, doubloons, ducats, florins, guineas; and the precious stones and the diamonds; and all the jewels and all the ornaments: everything is there. Who could discover it? Who could ever learn the impenetrable secret of the Needle? Nobody.

The Treasure of Gisors

GERARD DE SÈDE
Les Templiers sont parmi nous, ou L'Enigme de Gisors (The Templars Are among Us, or The Enigma of Gisors, 1962)

"What I saw then, I shall never forget, as it was a fantastic spectacle. I am in a Romanesque chapel in Louveciennes stone, thirty meters long, nine meters wide and about four and a half metres high at the apex of the vault. Immediately to my left, by the opening through which I entered, stands the altar, also in stone, as is its tabernacle. To my right is all the rest of the building. On the walls, at mid-height, supported by stone corbels, are statues of Christ and the twelve apostles, life-sized. Along the walls, resting on the ground, are stone sarcophagi two meters long and sixty centimeters wide: there are 19 of them. And in the nave, my light illuminates an incredible sight: thirty chests made of precious metal, arranged in columns of ten. But the word chest is insufficient: they would be bet-

ter described as wardrobes lying horizontally, each of them measuring 2.20 meters in length, 1.80 meters in height and 1.60 meters in width."

Jesus and Magdalene Newlyweds Today

MICHAEL BAIGENT,
RICHARD LEIGH,
AND HENRY LINCOLN
The Holy Blood and the Holy Grail (Jonathan Cape, London, 1982), pp. 424–426, 430

If our hypothesis is correct, Jesus's wife and offspring (and he could have fathered a number of children between the ages of sixteen or seventeen and his supposed death), after fleeing the Holy Land, found a refuge in the south of France, and in a Jewish community there preserved their lineage. During the fifth century this lineage appears to have intermarried with the royal line of the Franks, thus engendering the Merovingian dynasty. In A.D. 496 the Church made a pact with this dynasty, pledging itself in perpetuity to the Merovingian bloodline— presumably in the full knowledge of that bloodline's true identity. . . . Despite all efforts to eradicate it, Jesus's bloodline or, at any rate, the Merovingian bloodline survived. It survived in part through the Carolingians, who clearly felt more guilty about their usurpation than did Rome, and sought to legitimize themselves by dynastic alliances with Merovingian princesses. But more significantly it survived through Dagobert's son, Sigisbert, whose descendants included Guillem de Gellone, ruler of the Jewish kingdom

Dante Gabriel Rossetti,
Mary Magdalene (1877),
Wilmington, Delaware
Art Museum

of Septimania, and eventually
Godfroi de Bouillon. With Godfroi's
capture of Jerusalem in 1099, Jesus's
lineage would have regained its right-
ful heritage, the heritage conferred
upon it in Old Testament times.
It is doubtful that Godfroi's true pedi-
gree during the time of the Crusades
was as secret as Rome would have
wished it to be. Given the Church's
hegemony, there could not, of course,
have been an overt disclosure. But it

is probable that rumours, traditions
and legends were rife; and these
would seem to have found their most
prominent expression in such tales
as that of Lohengrin, for example,
Godfroi's mythical ancestor—and,
naturally, in the romances of the
Holy Grail.
If our hypothesis is correct, the Holy
Grail would have been at least two
things simultaneously. On the one
hand it would have been Jesus's blood-

line and descendants—the "Sang Raal," the "Real" or "Royal" blood of which the Templars, created by the Prieuré de Sion, were appointed guardians. At the same time the Holy Grail would have been, quite literally, the receptacle, or vessel, which received and contained Jesus's blood. In other words it would have been the womb of the Magdalene—and, by extension, the Magdalene herself. From this the cult of the Magdalene, as it was promulgated during the Middle Ages, would have arisen—and been confused with the cult of the Virgin. It can be proved, for instance, that many of the famous "Black Virgins" or "Black Madonnas" early in the Christian era were shrines not to the Virgin but to the Magdalene—and they depict a mother and child. It has also been argued that the Gothic cathedrals—those majestic stone replicas of the womb dedicated to "Notre Dame"—were also, as *Le Serpent rouge* states, shrines to Jesus's consort, rather than to his mother.

The Holy Grail, then, would have symbolised both Jesus's bloodline and the Magdalene, from whose womb that bloodline issued. But it may have been something else as well. In A.D. 70, during the great revolt in Judaea, Roman legions under Titus sacked the Temple of Jerusalem. The pillaged treasure of the Temple is said to have found its way eventually to the Pyrenees; and M. Plantard, in his conversation with us, stated that this treasure was in the hands of the Prieuré de Sion today. But the Temple of Jerusalem may have contained more than the treasure plundered by Titus's centurions.... If Jesus was indeed "King of the Jews," the Temple is almost certain to have contained co-

pious information relating to him. It may even have contained his body—or at least his tomb, once his body was removed from the temporary tomb of the Gospels....

And on the basis of the evidence we examined, they would seem to have accomplished their mission. They would seem to have found what they were sent to find, and to have brought it back to Europe. What became of it then remains a mystery. But there seems little question that, under the auspices of Bertrand de Blanchefort, fourth Grand Master of the Order of the Temple, something was concealed in the vicinity of Rennes-le-Château— for which a contingent of German miners was imported, under the most stringent security, to excavate and construct a hiding place. One can only speculate about what might have been concealed there. It may have been Jesus's mummified body. It may have been the equivalent, so to speak, of Jesus's marriage licence, and/or the birth certificates of his children. It may have been something of comparably explosive import. Any or all of these items might have been referred to as the Holy Grail. Any or all of these items might, by accident or design, have passed to the Cathar heretics and comprised part of the mysterious treasure of Montségur....

As for the parchments found by Saunière, two of them—or, at any rate, facsimiles of two of them—have been reproduced, published and widely circulated. The other two, in contrast, have been kept scrupulously secret. In his conversation with us M. Plantard stated that they are currently in a safe deposit box in a Lloyds' bank in London. Further than that we have been unable to trace them.

The Protocols
of Rennes-le-Château

MARIO ARTURO
IANNACCONE

"La truffa di Rennes le chateau"
(The Rennes-le-Château Fraud) in
Scienza e Paranormale (2005), 59

Being aware that the myth of Rennes-le-Château, as it is presented, is a fabrication, Dan Brown states in the text that his work is based on "historical facts" and has also defended its contents "in real life." Brown the novelist and Brown the polemicist both make use of the "proof" of the "verifiable" existence of the Priory of Sion. His literary machine, given the delicate arguments at stake, is not set in motion by a literary device (by definition ambiguous) but by falsehood. *The Da Vinci Code* is a novel with an agenda, a pamphlet in disguise. This has been noted by many commentators, but most have smiled and shrugged their shoulders, erroneously justifying the pretence as a "literary expedient." Many novels (we can think of the "papers" in Manzoni's *I promessi sposi* or *The Manuscript Found in Saragossa*) set their narrative machines in motion with recourse to similar expedients. Brown's case is different, however: his statement is not cloaked in any ambiguity; his diegesis is constructed in such a way as to appear lifelike and even true. The secret, apocryphal Dossiers deposited in the Bibliothèque Nationale in Paris, which are said to prove the existence of the Priory of Sion and its treasure chest of glittering secrets, are presented as authentic in Brown's book exactly as they are in hundreds of other less-than-honest works. What Brown does—not illegitimate in itself as it is a literary act—is to use presumed documentary truths for the purposes of ideologico-religious propaganda. For this reason, Brown's actions (and those of the people behind him) are neither innocuous nor innocent, but cynically use falsehoods to reinforce the extradiagetic theory of the "author." It was no coincidence that, mutatis mutandis, Mariano Tomatis made reference to the *Protocols of the Elders of Zion* for this unscrupulous use of truth and falsehood. The caution of our age and past experience would argue in favour of cloaking pamphlets on such delicate subjects in ambiguity.

Recently, the myth of Rennes-le-Château seemed drained by the continual erosion of its veracity. The most recent texts to revisit it exhibited an extreme lack of inventiveness. There was a need to "relaunch" the offering by renewing the product. What was required was a return to the original story (de Sède's 1962 work *Les Templiers sont parmi nous*). A publishing company chose the conspiracy theorist Dan Brown for the job. He had already written *Angels and Demons* (which alludes to a universal conspiracy orchestrated by the Vatican), and is very explicit about his aims (a visit to his personal website can prove very instructive). Soon, a Hollywood blockbuster will even further strengthen the Kulturkampf implicit in these exercises: to rewrite history with the blitheness of a popular magazine, to adapt it to the glibness of a talk-show, without wishing to offend the many naive souls and fans of the novel who came together in a forum to welcome, finally, the arrival of the era of "radical truth" in history.

15

FICTIONAL PLACES
AND THEIR TRUTH

As we said in the introduction, there is an infinity of places that never existed in reality, but where many fictional adventures take place. Many of these places are now a part of the collective imagination, and so we fantasize about Pinocchio's Land of Toys, the island where Sinbad encounters the roc, and the Ringing Island of Rabelais, not to mention the cabin of the seven dwarfs, Sleeping Beauty's castle, Little Red Riding Hood's grandmother's house, or the Magnetic Mountain that appears in many Eastern and Western tales (see the summary in Arturo Graf).

Other places have become material for fiction even though they really existed, such as Robinson Crusoe Island (where a real person, Alexander Selkirk, was marooned, and whose ordeal inspired Defoe), in the Juan Fernández Archipelago off the Chilean coast in the Pacific. The same holds true for a real personage, later fictionalized by Bram Stoker, namely the fifteenth-century *voivode* (warlord) Vlad Țepeș, known by the patronymic Dracula, certainly not a vampire but famed nonetheless for his habit of impaling his enemies. To this day, devotees of Arsène Lupin, the gentleman thief created by Maurice Leblanc, go to visit the Needle of Étretat in Normandy, imagining that it is hollow and contains the treasures of the kings of France, and that it was here that Lupin, intoxicated with power, planned world dominion.

On the other hand, we have seen in the previous chapter how the story of Lupin, taken absolutely seriously, has been introduced into the profusion of fantasies that is the myth of Rennes-le-Château. Finally, the sewers of Paris exist (and you can still visit them today, albeit in part) as do the sewers of Vienna; yet the former be-

Vlad III of Walachia
(c. 1560), Innsbruck,
Ambras Castle

Frontispiece to Jules Verne's
The Mysterious Island
(1874), by Jules-Decarte
Férat

came mythical thanks to Jean Valjean's tortured journey through them in *Les Misérables*, and to the tales of Fantômas, just as the latter became proverbial by virtue of Harry Lime's final attempted getaway in *The Third Man*.

Where these places do not exist, some of them—often for reasons of commercial interest—have been constructed. Hence, for example, the (purported) cell of the count of Monte Cristo in the Château d'If (real) visited by fans of Dumas, Sherlock Holmes' house on Baker Street in London or Nero Wolfe's house in New York. This last is difficult to identify, because Rex Stout always talked of a brownstone at a certain number on West Thirty-Fifth Street, but in the course of his novels he mentioned at least ten different street numbers—and, what is more, there are no brownstones on West Thirty-Fifth Street.

Nonetheless, fans of the larger-than-life detective, in trying to find a reference point for their pilgrimages, decided to elect number 454 as the "authentic" house, so that on June 22, 1996, the City of New York and the Wolfe Pack erected a bronze plaque at that number, which the faithful, if they really want to, can visit. Vandenberg Inc., the Townhouse Experts, still run an advertisement on the Internet: "Would you like to live in a Brownstone just like Nero Wolfe's? Vandenberg Real Estate has many townhouses for sale on the Upper West Side."

We do not know the whereabouts of Armida's garden (in Tasso), Caliban's island, or of Lilliput, Brobdingnag, Laputa, Balnibarbi, Glubbdubdrib, Luggnagg and the land of the Houyhnhnms in *Gulliver's Travels*. The same holds for Verne's mysterious island, Coleridge's Xanadu (even though a fictional Xanadu was reconstruct-

ed by Orson Welles in *Citizen Kane*) and King Solomon's mines. Nor do we know the point where Gordon Pym was shipwrecked, where Doctor Moreau's island lay, or Alice's Wonderland, not to mention the principalities of operetta, from Ruritania to Parador, Freedonia, Sylvania, Vulgaria, Tomainia, Bacteria, Osterlich, Slovetzia, Euphrania, to the Duchy of Strackenz and the realms of Taronia, Carpania, Lugash, Klopstokia, Moronica, Syldavia, Valeska, Zamunda, Marshovia, and the republics of Valverde, Hatay, Zangaro, Hidalgo, Borduria, Estrovia, to Pottsylvania, Genovia and Krakozhia, down to the Kingdom of Ottokar in the Tintin comics.

Likewise, we do not know the location of King Kong's island, Tolkien's Middle Earth, the cave of skulls in the improbable Deep Woods of Bengali in the Phantom comics, planet Mongo and the undersea world where Flash Gordon is captured by Queen Undina, the city in which Mickey Mouse and Donald Duck lived and still live, Narnia, Brigadoon, Harry Potter's Hogwarts, the Bastiani Fortress in Dino Buzzati's *Tartar Steppe,* Jurassic Park and Corto Maltese's Escondida.

Hergé, *The Adventures of Tintin, King Ottakar's Sceptre* (1938)

The Phantom Country in the Phantom comics (1973)

Film still from
Casablanca (1942)

While Batman's Gotham City is presumably a gloomy trans-figuration of New York, we still cannot find Smallville, Metropolis, or Kandor, which in the Superman stories the evil Brainiac has captured and miniaturized in a crystal container.

We do not doubt the nonexistence of the invisible cities invented by <u>Italo Calvino</u>, and, alas, we shall never see again Rick's Café Americain in Casablanca, although for commercial purposes a remarkably disappointing reconstruction of it has been attempted.

On the other hand, no one has ever believed in the real exis-tence of places shown on the Carte du Tendre, a map of an imaginary country invented in the seventeenth century by <u>Madeleine de Scudéry</u>, in her novel *Clélie*.

Equally we can only dream of the largest and most indescribable place of all, which <u>Borges</u> says he had seen through a chink in the steps of a staircase, the Aleph, the point in space from which he had contemplated and attempted to describe the infinite universe.

Among <u>fictional places</u> we might also list those that do not exist *yet*, in other words, all the places in science fiction, starting from the classics, such as the Paris of the year 2000 as imagined by Albert Robida in the nineteenth century. But perhaps these fantasies are classifiable among the utopias, positive or negative as they were or are intended to be.

In any case, those that we are dealing with in this chapter (without claiming to exhaust an infinite list)[1] are not places of legendary illusion, but of *fictional verity*. What is the difference? It is that (even in the case of Robinson Crusoe) we are *convinced* that they do not exist and never have, just like Peter Pan's Neverland or Stevenson's Treasure Island.

And no one sets off to rediscover them, as many tried to with Saint Brendan's Island—whose existence was believed in for centuries.

These places do not excite our credulity because, by virtue of the fictional pact that binds us to the author's words, even though we know they do not exist, we *pretend* that they exist—and we take part as accomplices in the game suggested to us.

Albert Robida, *Leaving the Paris Opera* (c. 1900)

Right:
Map and illustration for Robert Louis Stevenson's *Treasure Island* (1886)

1. For the most comprehensive extant encyclopedia, see Manguel and Guadalupi (1982).

436

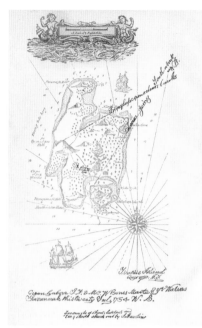

We know perfectly well that the real world exists, a world in which there occurred the Second World War or in which man landed on the moon, and that there are the *possible worlds* of our imagination, in which Snow White, Harry Potter, Inspector Maigret and Madame Bovary all exist. Once we accept the fictional pact, we have already decided to take a narrative possible world seriously, and we have to admit that Snow White was awakened from her sleep by Prince Charming, that Maigret lives in Paris on Boulevard Richard-Lenoir, that Harry Potter studied to be a wizard at Hogwarts, and that Madame Bovary poisoned herself. And those who state that Snow White never wakened from her sleep, that Maigret lived in Boulevard de la Poissonnière, that Harry Potter studied at Cambridge, and that Madame Bovary was saved at the last minute by an antidote administered by her husband, would invite our disagreement (and they might even fail an examination on comparative literature).

Naturally, narrative fiction requires signs of fictionality, from the word *novel* on the cover to beginnings such as "Once upon a time..." But often writing begins with a false sign of veracity. Here is one example: "Mr. Lemuel Gulliver ... about three years ago, Mr.

N. C. Wyeth, illustration for
Robert Louis Stevenson's
Treasure Island (1911)

Gulliver growing weary of the concourse of curious people coming to
him at his house in Redriff, made a small purchase of land, with a con-
venient house, near Newark, in Nottinghamshire.... Before he quitted
Redriff, he left the custody of the following papers in my hands....
I have carefully perused them three times ... There is an air of truth
apparent through the whole; and indeed the author was so distin-
guished for his veracity, that it became a sort of proverb among his
neighbors at Redriff, when any one affirmed a thing, to say, it was as
true as if Mr. Gulliver had spoken it."

See the title page of the first edition of *Gulliver's Travels*:
there is no mention of Swift's name as the author of a fiction, but rath-

Alberto Savinio, *Nocturne* (1950), private collection. Front cover for Lucian's *Una Storia Vera* (*True History*, Bompiani 1994)

er that of Gulliver as a truthful autobiographer. Yet readers are not deceived because, from Lucian's *True History* onward, exaggerated claims to truthfulness sound like a sign of fiction.

Sometimes readers of novels take fantasy for reality and even write letters to fictional characters, and—as happened with Goethe's Werther—many beautiful souls have committed suicide in emulation of their hero. But these are morbid cases of people who read but have not worked out the habitus of *good* readers. The good reader may also weep (as she reads) about the death of the protagonist of *Love Story*, but once the emotion of the moment has passed, she knows that the Jenny of the novel has never existed.

The veracity of fictional romance exceeds the belief in the truth or falsity of the events narrated. In real life, we do not know for sure if Anastasia Nicolaevna Romanova was murdered with her family in Yekaterinburg, or if Hitler really died in his Berlin bunker. But on reading the stories of Arthur Conan Doyle we are sure that Dr. Watson is the man who, in *A Study in Scarlet*, is called that way for the first time by a certain Stamford, and from then on both Holmes and the readers, when they think of Watson, intend to refer to that baptismal episode. The reader trusts in the fact that no two persons exist in London with the same name and the same military career, unless the text tells us so because it intends to relate the story of a dissembler or a character with a dual personality, as happens in *The Strange Case of Dr. Jekyll and Mr. Hyde*.

In 2007, Philippe Doumenc published a *Counter-Investigation into the Death of Emma Bovary*, in which he says that Madame Bovary did not die of poisoning but had been murdered. But this story acquires a certain gusto precisely because its readers know for certain that *in reality* (and by that I mean the reality of the fictional possible world) Madame Bovary committed suicide and does so every time we finish reading the book. You can interpret Doumenc's book as if it were a uchronia, in other words, the story of what *would have* happened if history had gone differently, just as you can write a novel that explains how things would have gone if Napoléon had won at Waterloo, or if Hitler had won, as in Philip Dick's novel *The Man in the High Castle*. But a uchronia is enjoyable only if you know that in reality things went differently.

All this tells us that the possible world of narrative is the only universe in which we can be absolutely certain about something, and it gives us a very strong sense of truth. The credulous believe that El Dorado and Lemuria exist or existed somewhere or other, and skeptics are convinced that they never existed, but we all know that it is *undeniably certain* that Superman is Clark Kent and that Dr. Watson was never Nero Wolfe's right-hand man, while it is equally certain that Anna Karenina died under a train and that she never married Prince Charming.

In this universe of ours, with its wealth of errors and legends, historical data and false information, one absolute truth is the fact that Superman is Clark Kent. All the rest is always open to debate.

Fanatics always hope to meet the Master of the World one day, or that the creatures of the Coming Race may emerge from an empty underworld. Visionaries have believed (and some still believe) that the Earth is hollow. But any normal person knows for sure that—in the universe of the *Odyssey*—the Earth was flat and was home to the island of the Phaeacians.

This leads us to a final consolation. Even legendary lands, as soon as they are transformed from a subject of belief to a fictional subject, have come *true*. Treasure Island is more true than Mu and, apart from its artistic value, the Atlantis of Pierre Benoit is more incontrovertible than the one sought by so many hunters of vanished lands. And when we read it as a narrative (as is proper to all mythological accounts), the Atlantis with which Plato fascinated us is just as incontrovertible and—unlike that of Donnelly— his land cannot be questioned.

We are aided by the figurative narratives that accompany the chapters of this book, which set legendary characters in an indelible reality, a part of the museum of our memory. Those heroes and those lands have disappeared (or never existed), but their imaginative representation cannot be put in doubt.

And even those who do not believe in paradise, be it earthly or celestial, if they were to take a look at Doré's image of the "candida rosa" (white rose) and read the text by Dante that it illustrates, they would understand that that vision is a truthful part of the reality of our imagination.

Gustave Doré,
*Sinbad and the Giant Roc
Bird,* from *The Thousand
and One Nights* (1865)

Sinbad and Roc the Bird

ANONYMOUS
From "Second Voyage," in The Seven
Voyages of Sindbad the Sailor,
(c. tenth century)

When I had climbed a tall tree I first
of all directed my anxious glances to-
wards the sea; but, finding nothing
hopeful there, I turned landward, and
my curiosity was excited by a huge
dazzling white object, so far off that
I could not make out what it might be.
Descending from the tree I hastily col-
lected what remained of my provisions
and set off as fast as I could go towards
it. As I drew near it seemed to me to
be a white ball of immense size and
height, and when I could touch it, I
found it marvellously smooth and soft.
As it was impossible to climb it—for it
presented no foot-hold—I walked
round about it seeking some opening,
but there was none. I counted, howev-
er, that it was at least fifty paces round.
By this time the sun was near setting,
but quite suddenly it fell dark, some-
thing like a huge black cloud came
swiftly over me, and I saw with amaze-
ment that it was a bird of extraordi-
nary size which was hovering near.
Then I remembered that I had often
heard the sailors speak of a wonderful
bird called a roc, and it occurred to me
that the white object which had so
puzzled me must be its egg.
Sure enough the bird settled slowly
down upon it, covering it with its
wings to keep it warm, and I cowered
close beside the egg in such a position
that one of the bird's feet, which was
as large as the trunk of a tree, was just
in front of me. Taking off my turban
I bound myself securely to it with the
linen in the hope that the roc, when it
took flight next morning, would bear
me away with it from the desolate is-
land. And this was precisely what did
happen. As soon as the dawn appeared

Gustave Doré, *The Master of Ringing Island* (1854), from François Rabelais' *Gargantua and Pantagruel*

the bird rose into the air carrying me up and up till I could no longer see the earth, and then suddenly it descended so swiftly that I almost lost consciousness.

Pantagruel on the Ringing Island

FRANÇOIS RABELAIS
Gargantua and Pantagruel (1532), V, 1–2

Pursuing our voyage, we sailed three days without discovering anything; on the fourth we made land. Our pilot told us that it was the Ringing Island, and indeed we heard a kind of a confused and often repeated noise, that seemed to us at a great distance not unlike the sound of great, middle-sized, and little bells rung all at once, as 'tis customary at Paris, Tours, Gergeau, Nantes, and elsewhere on high holidays; and the nearer we came to the land the louder we heard that jangling....

When we were nearer, among the everlasting ringing of these indefatigable bells we heard the singing, as we thought, of some men. For this reason, before we offered to land on the Ringing Island, Pantagruel was of opinion that we should go in the pinnace to a small rock, near which we discovered an hermitage and a little garden....

Having fasted as aforesaid, the hermit gave us a letter for one whom he called Albian Camar, Master Aedituus of the Ringing Island; but Panurge greeting him called him Master Antitus. He was a little queer old fellow, bald-pated, with a snout whereat you might easily have lighted a card-match, and a phiz as red as a cardinal's cap. He made us all very welcome, upon the hermit's recommendation, hearing

that we had fasted, as I have told you. When we had well stuffed our puddings, he gave us an account of what was remarkable in the island, affirming that it had been at first inhabited by the Siticines; but that, according to the course of nature—as all things, you know, are subject to change—they were become birds. . . .

The cages were spacious, costly, magnificent, and of an admirable architecture. The birds were large, fine, and neat accordingly, looking as like the men in my country as one pea does like another; for they ate and drank like men, muted like men, endued or digested like men, farted like men, but stunk like devils; slept, billed, and trod their females like men, but somewhat oftener: in short, had you seen and examined them from top to toe, you would have laid your head to a turnip that they had been mere men. However, they were nothing less, as Master Aedituus told us; assuring us, at the same time, that they were nei-

ther secular nor laic; and the truth is, the diversity of their feathers and plumes did not a little puzzle us. Some of them were all over as white as swans, others as black as crows, many as grey as owls, others black and white like magpies, some all red like redbirds, and others purple and white like some pigeons. He called the males clerg-hawks, monk-hawks, priest-hawks, abbot-hawks, bish-hawks, cardin-hawks, and one pope-hawk, who is a species by himself. He called the females clerg-kites, nun-kites, priest-kites, abbess-kites, bish-kites, cardin-kites, and pope-kites.

However, said he, as hornets and drones will get among the bees, and there do nothing but buzz, eat, and spoil everything; so, for these last three hundred years, a vast swarm of bigottelloes flocked, I do not know how, among these goodly birds every fifth full moon, and have bemuted, berayed, and conskited the whole island. They are so hard-favoured and mon-

strous that none can abide them. For their wry necks make a figure like a crooked billet; their paws are hairy, like those of rough-footed pigeons; their claws and pounces, belly and breech, like those of the Stymphalid harpies. Nor is it possible to root them out, for if you get rid of one, straight four-and-twenty new ones fly thither.

The Magnetic Mountain: The Eastern Tale

ARTURO GRAF
A Geographical Legend (The Magnetic Mountain) (1892–1893)

In the narrative from *One Thousand and One Nights* outlined above, an alien element of magic is superimposed on the Mountain, whereas its magnetic property is undoubtedly the original motif of the story. This dilutes the natural virtue of the Mountain, nearly rendering it an instrument of sorcery instead. How should we interpret the analogous Western tradition in which the motif of the Magnetic Mountain is combined with other forms of magic, and the Mountain is described as the dwelling grounds of sorcerers and fairies? One instance of this is the anonymous late-eighteenth- or early nineteenth-century German poem titled "Reinfrit von Braunschweig," which recounts the curious story of a powerful necromancer called Zabulon, who lived on the Magnetic Mountain and read of the coming of Christ in the stars, one thousand and two hundred years before it took place. Being the founder of necromancy and astrology, he wrote several occult books on how the birth of Christ

might be prevented. Not long before the birth of Christ, Virgil, a man of vast knowledge and singular virtue, learned of this sorcerer and his black arts, and set sail for the cliffs of the Magnetic Mountain. With the help of a spirit, he was able to obtain the sorcerer's treasure hoard and books. Then, when the appointed time came, the Virgin Mary was able to bring Jesus into the world. Similarly, a poem by Heinrich von Mügeln tells of how Virgil set sail for the Magnetic Mountain from Venice on a ship drawn by two griffins, in the company of several noble lords. On the Mountain, Virgil found a demon trapped in a vial. In exchange for his freedom, the demon agreed to show him how he could obtain a book of magic that lay there inside a tomb. Upon finding the book and opening it, eight thousand devils appeared before Virgil's eyes. He immediately commanded them to build a good, wide road, and returned safely with his companions to Venice. These legends can also be found in the *Watburgkrieg*. A prose version of *Huon de Bordeaux* describes a magnificent palace that appears on the Magnetic Mountain, home to five fairies. It is undoubtedly the same as the *chastel d'aimant* described in a later version of the *Ogier*. In a French romance in prose, which probably dates back to the fifteenth century, the Magnetic Mountain, or rock rather, is enchanted and inhabited by sorcerers. Certain inscriptions found there stipulate that in order to escape, the hero would have to take a ring that lies at the top of the cliff, and throw it into the sea. Do these stories not resemble the third kalander's tale? Many mediaeval treatises on gemology incorporate Eastern myths that

link the magnetic force closely to the so-called dark arts. ... Albertus Magnus and others do the same. In light of this, it does not seem odd that the French romance *Roman de Mabrian* identifies the Magnetic Mountain as being home not just to fairies, but to King Arthur himself; or that the *Kudrun* conflates it with the mountain Givers, or Mongibello. Another legend identifies Mongibello as Arthur's abode, home to a fortunate people who live in palaces of gold. The abundance of riches on the mountain would seem more plausible in light of the belief that the mountain had the power to draw ships towards itself from every corner of the earth.

The tradition linking griffins to the Magnetic Mountain, and using them as a means of escape for the more inventive and daring of the marooned sailors, is likely to be Eastern in origin. Benjamin of Tudela draws on this tradition in describing the sinister hazards he calls the "woes" of the Chinese seas, where ships would suddenly lose their bearings and never reemerge. Sailors would die of hunger once they had exhausted their provisions, unless they had brought bullhides on board, as the more prudent did. This meant that if they were trapped, they could wrap themselves in bullhides and allow themselves to be carried away by giant eagles that would bring them to safety. Many reached safe ground that way. The Magnetic Mountain may have numbered among these "woes": they would certainly have included magnetic rocks or shallows of magnetic rock. The giant eagles would be the rocs found in Eastern novels, which then

became the griffins in Western versions of the story.

In Western accounts, the Magnetic Mountain is often surrounded by congealing seas, as in *Herzog Ernst*, or in *Younger Titurel*, while the *Kudrun* places it in a dark sea. The motif of rough seas can probably be traced back to the Eastern versions of the story. But it is also worth noting that the imagination is naturally inclined to combine all the perils of the sea, here in the West no less than in the East—which explains why some Western versions of the story incorporate sirens.

In both East and West, the Magnetic Mountain figured in otherwise factually accurate travel accounts, as well as geographical and scientific treatises. As an extraordinary subject of fantasy or poetry, it also found its way into verse and prose romances, especially those relating tales of distant adventures. It is almost surprising that it cannot be found in the poems which might be called the epic poems of the sea: if the ancient bard who told of the trials of Ulysses and his companions had heard of the Magnetic Mountain, it would probably appear in some remote and uncharted sea in the *Odyssey*.

We have no records of when the earliest versions of the third kalander's tale was recorded; on the other hand, we know roughly when the first Western fictional account of the Magnetic Mountain was written. That would be the German tale described below, the epic poem *Herzog Ernst* (*Duke Ernst*). Although the original Latin manuscript has been lost, there is a poem from the Lower Rhine dating from between 1170 and 1180 that

appears to derive from it. Only fragments of this poem have survived, but the gist finds its way into several later texts: among them are an anonymous German poem dating from somewhere between the eleventh and twelfth centuries, from which I will cite an episode referring to the Magnetic Mountain, the Latin poem written by one Odone (prior to 1230), a tale in Latin prose, and a popular tale in German prose.

In the earliest of the medieval poems that has largely been preserved to this day, the anonymous German text, the story runs as follows: after a long and exhausting journey, Herzog Ernst and his companions sight a mountain rising steeply from the lazy waves of the congealing sea. A great forest of masts winds along its shores. One of the sailors realizes what the mountain is. He announces to the duke and his men that it is impossible to resist the mountain's attractive force, and that they are doomed: all the masts belong to wrecked ships, and death by starvation awaits the shipwrecked sailors. Upon hearing this somber news, Herzog Ernst gives himself up for lost. He addresses his men tenderly, exhorting them to commit their souls to God, to repent of their sins, and enter heaven by divine grace. While all the men do as he says, the ship speeds towards the mountain, becoming wedged between the rotting wrecks of other ships. Suddenly, it tears through the wreckage and shatters on the cliffs with a terrifying crash. Vast and indescribable riches meet the shipwrecked sailors' eyes. But of what use are riches to them? The mountain is surrounded by sea, with no land in sight. Their provisions gradually diminish; one by one they starve to death, and

the griffins steal their bodies to feed to their young. Eventually only the duke and seven of his companions remain, and there is only half a loaf of bread left among them. Then Count Wetzel has an inspired idea. He proposes to his companions that they wrap themselves in bullhides and allow themselves to be carried away by the griffins, since there is no other means of escape. The men rejoice at his suggestion. So Herzog Ernst and the Count arm themselves, and their companions wrap them in bullhides; the griffins swoop down, lift them into the air, and carry them away over the sea. When they realize they are on solid ground, the two cut themselves free from the bullhides with swords, and leap out: they are safe. The others flee the mountain in the same way, until only one man is left: with no one to wrap him in a bullhide, he starves to death. In order to escape the place where the griffins have dropped them, the survivors must board a raft that takes them down a river running underground. They find that the riverbed is covered with precious stones. Huon de Bordeaux, the Carolingian epic hero, survives nearly all the same dangers. Huon, however, is the only one of his companions to survive, so he is carried away by the griffins without being wrapped in a bullhide, and taken to an island paradise where there are springs of water and apple trees growing on the mountainside, all of which have the power to restore youth. Again, his only means of escape is an underground river like the one in *Herzog Ernst*. . . .

These Western accounts bear a striking resemblance to the sixth voyage of Sinbad the sailor, also in *One Thousand and One Nights*, as well as to

the third kalander's tale. Like Herzog Ernst's ship, Sinbad's is also drawn irresistibly toward a mountain, the foot of which is cluttered with wreckage and countless treasures. Sinbad, too, is the only one of his companions to survive. The others all die of hunger, while Sinbad escapes by boarding a raft and floating down a river littered with jewels that runs underground. I think the Western versions of the tale hint, perhaps even prove, that its Eastern versions have been adulterated, and suggest ways to restore the integrity of the original motif. Sinbad does not name the mountain where he was shipwrecked as the Magnetic Mountain, but this can be deduced from the details of his account, as compared to the other versions described above. Abulfauaris's story, also in *One Thousand and One Nights*, features a huge mountain gleaming like polished steel that attracts the ship he is sailing on; this seems to be the Magnetic Mountain too.

On the Way
to Dracula's Castle

BRAM STOKER
Dracula (1897), I

Sometimes, as the road was cut through the pine woods that seemed in the darkness to be closing down upon us, great masses of greyness which here and there bestrewed the trees, produced a peculiarly weird and solemn effect, which carried on the thoughts and grim fancies engendered earlier in the evening, when the falling sunset threw into strange relief the ghost-like clouds which amongst the Carpathians seem to wind ceaselessly through the valleys. Sometimes the hills were so steep that, despite our driver's haste, the horses could only go slowly. . . .

There were dark, rolling clouds overhead, and in the air the heavy, oppressive sense of thunder. It seemed as though the mountain range had separated two atmospheres, and that now we had got into the thunderous one. I was now myself looking out for the conveyance which was to take me to the Count. Each moment I expected to see the glare of lamps through the blackness: but all was dark. The only light was the flickering rays of our own lamps, in which the steam from our hard-driven horses rose in a white cloud. . . .

Then, amongst a chorus of screams from the peasants and a universal crossing of themselves, a calèche, with four horses, drove up behind us, overtook us, and drew up beside the coach. I could see from the flash of our lamps, as the rays fell on them, that the horses were coal-black and splendid animals. They were driven by a tall man, with a long brown beard and a great black hat, which seemed to hide his face from us. I could only see the gleam of a pair of very bright eyes, which seemed red in the lamplight, as he turned to us. . . .

All at once the wolves began to howl as though the moonlight had had some peculiar effect on them. The horses jumped about and reared, and looked helplessly round with eyes that rolled in a way painful to see. But the living ring of terror encompassed them on every side, and they had perforce to remain within it. I called to the coachman to come, for it seemed to me that our only chance was to try

Film still from Tod
Browning's *Dracula* (1931),
starring Bela Lugosi

to break out through the ring and to
aid his approach, I shouted and beat
the side of the calèche, hoping by the
noise to scare the wolves from that
side, so as to give him a chance of
reaching the trap. How he came there,
I know not, but I heard his voice
raised in a tone of imperious com-
mand, and looking towards the sound,
saw him stand in the roadway. As he
swept his long arms, as though brush-
ing aside some impalpable obstacle,
the wolves fell back and back further
still. Just then a heavy cloud passed
across the face of the moon, so that we
were again in darkness.
When I could see again the driver was
climbing into the calèche, and the

wolves had disappeared. This was
all so strange and uncanny that a
dreadful fear came upon me, and I was
afraid to speak or move. The time
seemed interminable as we swept on
our way, now in almost complete dark-
ness, for the rolling clouds obscured
the moon. We kept on ascending, with
occasional periods of quick descent,
but in the main always ascending.
Suddenly I became conscious of the
fact that the driver was in the act of
pulling up the horses in the courtyard
of a vast ruined castle, from whose tall
black windows came no ray of light,
and whose broken battlements
showed a jagged line against the
moonlit sky.

Xanadu

SAMUEL TAYLOR
COLERIDGE
Kubla Khan (1798)

In Xanadu did Kubla Khan
A stately pleasure-dome decree:
Where Alph, the sacred river, ran
Through caverns measureless to man
Down to a sunless sea.
So twice five miles of fertile ground
With walls and towers were girdled
 round:
And there were gardens bright with
 sinuous rills,
Where blossomed many an incense-
 bearing tree;
And here were forests ancient as the
 hills,
Enfolding sunny spots of greenery.

But oh! that deep romantic chasm
 which slanted
Down the green hill athwart a cedarn
 cover!
A savage place! as holy and enchanted
As e'er beneath a waning moon was
 haunted
By woman wailing for her demon-
 lover!
And from this chasm, with ceaseless
 turmoil seething,
As if this earth in fast thick pants
 were breathing,
A mighty fountain momently was
 forced:
Amid whose swift half-intermitted
 burst
Huge fragments vaulted like rebound-
 ing hail,
Or chaffy grain beneath the thresh-
 er's flail:

And 'mid these dancing rocks at once
 and ever
It flung up momently the sacred river.
Five miles meandering with a mazy
 motion
Through wood and dale the sacred
 river ran,
Then reached the caverns measure-
 less to man. . . .

The Mystery
of the Black Jungle

EMILIO SALGARI
The Mystery of the Black Jungle (1895)

Not daring to move, Tremal-Naik
waited patiently, eyes open, ears
straining to catch the slightest sound.
Towards four, the sun slowly emerged
on the horizon, illuminating the great
bronze sphere atop the pagoda, and a
ray of light projected through the
wide opening. Tremal-Naik sprang to
his feet, surprised and stunned by the
wondrous sight revealed before him.
He was standing beneath a large
dome; the great walls adorned with
murals depicting Vishnu's many in-
carnations. Above them could be
glimpsed scenes from the various
heavens: Svarga, the waiting place
for all righteous souls, Vaikuntha,
Vishnu's paradise, and Mount
Kailash, the sacred place that Shiva
calls his home. Sculptures and carv-
ings of devas, munis and asuras—di-
vine beings, sages and demons of
Hindu myth and legend—peered
down from great heights as the sun
slowly lit up the interior.
A large bronze statue of a woman

The subterranean
temples of Ellora,
in Giulio Ferrario's
Il costume antico e moderno
(1824), Florence

stood in the centre of the pagoda. She
had four arms, one held a sword, an-
other a severed head, each wrist
adorned with large bracelets. She wore
a girdle of severed hands about her
hips and a long garland of skulls about
her neck that stretched down to her
feet. A pair of skulls adorned her ears
and a dark, blood-red tongue protrud-
ed from lips parted in a fierce smile.
Her right foot rested upon the body of
a giant, who at first glance, appeared to
have been slain in battle. She had been
victorious, that was certain, for the
bloodlust was still evident in her eyes
and it seemed as if she were about to

dance on the corpse of her victim in
celebration....
"Could this be a dream?" mumbled
Tremal-Naik. "None of this makes
sense."
Barely had he uttered those words
when he heard the soft squeak of a
hinge. He swung to face the sound,
carbine in hand, but just as abruptly
stepped back, retreating to the mon-
strous statue, barely able to restrain a
cry of joy and amazement. There be-
fore a large golden door stood a young
woman of incredible beauty, her eyes
wide with terror.
She was perhaps fourteen years old, in

Front cover of the Emilio
Salgari comic book, *The
Mystery of the Black Jungle*
(1937), episode 1, A.P.I.

the flower of her youth. She was elegant and attractive with delicate rosy skin, large dark eyes and a small thin nose. Her coral lips, parted in fright, revealed dazzling white teeth. Long dark hair, adorned in the front by a cluster of large pearls, fell to her shoulders, a few jasmine flowers braided among her curls.

"Ada! The vision!" he whispered as his back struck the base of the great bronze statue.

Words failed him and for a moment he froze; he stood there, silent, breathless, dazed and uncertain, eyes fixed upon the beautiful young woman who continued to stare at him in terror.

At last she took a step forward, and as she advanced a dazzling light met the hunter's gaze, so intense he was forced to look away.

The young woman was dressed in riches. A long white silk shawl spread behind her like a cape, revealing a golden breastplate inlaid with diamonds from Gujarat and Golconda. A large Naga was engraved in its centre, its coiled serpentine body disappearing into the cashmere belt embroidered with silver bound about her waist; white silk pantaloons secured by a pair of red coral anklets ended just above her small bare feet. Strings of pearls and diamond necklaces hung about her neck; bracelets inlaid with precious stones adorned her arms. A ray of sunlight had struck that exotic attire, bathing the young woman in a blinding golden light.

"The vision! The vision!" repeated Tremal-Naik. "How beautiful she is!" ...

I'm yours to command. I have been since the first time I set eyes upon you, that night you appeared in the mussenda bush, bathed in the light of the setting sun. I thought you were a goddess come down from the heavens and my heart burst in adoration."

"Quiet, Quiet!" repeated the young woman, burying her face in her hands.

"I cannot hush, rare jungle flower!" exclaimed Tremal-Naik, his passion mounting with every word. "When you vanished, you took a piece of my heart with you. I think about you always, I see your face everywhere before me. My mind is aflame; my blood has turned to fire. You have bewitched me!"

"Tremal-Naik!" whispered the young woman.

"I could not sleep that first night," continued the hunter. "I was feverish; I had to see you once more. Why? I do not know. I could not comprehend it. I'd never felt that way before. Fifteen days passed. Every night, at sunset, I saw you behind the mussendas, and I was filled with great delight just standing there before you! You did not speak to me, but when our eyes met I knew that you . . ."

His voice trailed off, eyes fixed upon the young woman, her hands still pressed to her face.

"Ah!" he exclaimed, his voice marked with pain. "You do not wish to hear this."

The young woman raised her head; her eyes were wet with tears.

"Why speak of this," she whispered, "when it can never be! You should not have come and stirred hope in my heart! It is a false hope, nothing more; this place is cursed, deadly to those I love."

"Those you love?" Tremal-Naik exclaimed with joy. "Say those words once more, I beg you! Do you love me? Is it true? Did you return to the mussenda bush each night because you loved me?"

"You put our lives at risk, Tremal-Naik!" exclaimed the young woman, her voice filled with anguish.

"Fear not, my sweet. Am I not here to defend you? I'll tear down that monster if need be, raze this very temple to the ground. You'll never be forced to make offerings to her again."

"How do you know of that?"

"I saw you last night, when you came with that perfume."

"You were in the pagoda?"

"Yes, up there, clinging to that rope."

"But no one knows of this place, how did you find it?"

"I chanced upon it while trying to hide from those men that live on this cursed island."

"Did they see you?"

"They chased me."

"Ah, my poor love, you are doomed!" the young woman exclaimed sadly. Tremal-Naik seized her arm.

"What goes on here?" he demanded, barely able to contain his rage. "Why so much terror? Why do you make offerings to this monstrous being? Who is she? Why is there a fish swimming in that basin? Why is there a Naga engraved on your armour? Who are these men that live underground and strangle all their enemies? I want to know, Ada! Tell me!"

"Do not ask me any questions, Tremal-Naik."

"Why not?"

"I cannot escape my fate!"

"If you're a prisoner here, I'll free you. I'll fight your captors and show them no mercy."

"They'll snap your neck like a reed. Do they not challenge the might of England? They're strong, Tremal-Naik, and merciless! Legions of men have fallen before them. No one can resist them! They are invincible!"

"Who are they?"

"I cannot tell you."

"Even if I begged you?"

"I'd still refuse."

"Then you . . . don't trust me!" Tremal-Naik exclaimed angrily.

"Tremal-Naik! Tremal-Naik!" implored the young woman, her voice filling with agony.

The hunter crossed his arms.

"Tremal-Naik," continued the young woman, "Only death can free me from my fate. I love you; I love you, but . . ."

"You love me!" exclaimed the hunter.

"Yes, I love you, Tremal-Naik."

"Swear it on that monster before us."

"I swear it!" said the young woman, raising her hand towards the bronze statue.

"Swear to me you'll be my bride!"

"Tremal-Naik," she murmured sadly, "I'll be your bride if it were ever possible!"

Thugs stabbing the eyes and bodies of the travellers whom they have strangled, preparatory to throwing them into a well (c. 1829-1840), London, British Museum

"Possible? Do I have a rival for your affection?"

"Death alone may claim me."

Tremal-Naik stepped back, shaken.

"Death!" he exclaimed.

"Yes, Tremal-Naik, death. The day a man places a hand upon me those men will take my life."

"What? It can't be! This is like a bad dream."

"No, you are awake, my love, talking to your beloved."

"What a mystery!"

"A terrible mystery, Tremal-Naik. No one can bridge the abyss between us. By the heavens! What have I done to merit such misfortune? What crime have I committed to deserve such a fate?"

A sob put an end to her words and she began to cry. Tremal-Naik roared with rage.

"What can I do?" he said, moved to the very depths of his soul. "Your tears fill me with pain, my rare jungle flower. Tell me, what I must do! I'll obey your every command! Do you wish me to take you from here? I will do so, even if it costs me my life."

"No, no!" exclaimed the young woman. "It would bring death to us both."

"Do you wish me to go and never return? To protect you I would do so, though it would shatter my heart forever. Tell me, my love, what must I do?"

The young woman remained silent as tears streamed down her cheeks. Tremal-Naik gently drew her towards him. He was about to speak when the sharp notes of a ramsinga sounded from outside.

"Go, Tremal-Naik, get out of here!" exclaimed the young woman, terrified. "Go now, or all is lost!"

"Wretched trumpet!" howled Tremal-Naik.

"They're coming," sobbed the young woman. "If they find us, they'll sacrifice us to their goddess. Go! Hurry!"

"Never!"

"They'll kill us!"

"I'll defend you!"

"Go you fool! Get out of here!"

Determined to stand and fight, Tremal-Naik picked up his carbine up and loaded it.

"Please!" she begged. "They're coming."

"I'll be waiting," replied Tremal-Naik, "ready to kill the first man who dares raise a hand to you."

"Stay then. Since there's no convincing you, I'll save you."

She turned and began to walk towards the door.

Tremal-Naik rushed after her.

"Where are you going?" he asked.

"To receive their leader and prevent him from entering the temple. I'll come back at midnight. Then, if the gods are willing, we'll escape."

"I still don't know your name."

"Ada Corishant."

"Ada Corishant! What a beautiful name! Go now, Ada, I'll see you at midnight!"

The young woman drew her shawl about her, cast one last look at Tremal-Naik, stifled a sob and left.

Fedora

ITALO CALVINO
Invisible Cities (1972)

In the centre of Fedora, that grey stone metropolis, stands a metal building with a crystal globe in every room. Looking into each globe, you see a blue city, the model of a different Fedora. These are the forms the city could have taken if, for one reason or another, it had not become what we see today. In every age someone, looking at Fedora as it was, imagined a way of making it the ideal city, but while he constructed his miniature model, Fedora was already no longer the same as before, and what had until yesterday a possible future became only a toy in a glass globe.

The building with the globes is now Fedora's museum: every inhabitant

visits it, chooses the city that corresponds to his desires, contemplates it, imagining his reflection in the medusa pond that would have collected the waters of the canal (if it had not been dried up), the view from the high canopied box along the avenue reserved for elephants (now banished from the city), the fun of sliding down the spiral, twisting minaret (which never found a pedestal from which to rise). On the map of your empire, O Great Khan, there must be room both for the big, stone Fedora and the little Fedoras in glass globes. Not because they are all equally real, but because all are only assumptions. The one contains what is accepted as necessary when it is not yet so; the others, what is imagined as possible and, a moment later, is possible no longer.

The Carte du Tendre

MADELEINE DE SCUDÉRY
Clélie, a Roman History (1654–1660)

The first city located at the bottom of the map is New Friendship. As tenderness can arise from three different causes, coming about either through esteem, gratitude or inclination, three cities of Tenderness are shown on three different rivers, and there are three different routes by which they may be reached. . . . So we have Tenderness-on-Esteem, Tenderness-on-Inclination and Tenderness-on-Gratitude. However, since tenderness born out of inclination has no need of anything else in order to be what it is, there are no villages on the banks of this river, which flows so rapidly that we have no need of lodgings along its shores.

To reach Tenderness-on-Esteem, on the other hand, the situation is different, since there are as many villages as there are things both small and large that may contribute to the birth of this tenderness of which we speak through esteem. Indeed, you can see that from New Friendship, we pass through a town named Great Intelligence, because it is from there that esteem is usually born. Subsequently we visit the pleasant villages of Sweet Verses, Gallant Letters and Love Letters.... Then continuing along this road, we come across Sincerity, Great Heart, Probity, Respect, Correctness and Goodness, which lies very close to Tenderness. Next, we must return to New Friendship, to discover the route from there to Tenderness-upon-Gratitude. See how we must first of all travel from New Friendship to Indulgence, then to the little village by the name of Submission, and on to another very agreeable destination by the name of Good Care. From there, via Assiduity, we reach Dedication and Great Services. To make it clear that few people are capable of such, Great Services is smaller than the other villages. Subsequently, we must move on to Sensitivity and thence to Obedience, and finally pass through Unfailing Friendship, which is without a doubt the surest route to arrive at Tenderness-on-Gratitude.

Yet beware: by bearing a little too far to the right or to the left, it is possible to lose the way, since if upon leaving Great Intelligence we were to head for Negligence, and then, continuing on the incorrect path, make for Inconstancy and then on to Coolness, Casualness and Oversight, rather than finding ourselves at Tenderness-on-Esteem, we would arrive at the Lake of Indifference, with its cold, stagnant waters.

On the other hand, should we bear too far to the left on leaving New Friendship and continue to Indiscretion, Perfidy, Slander or Spite, rather than finding ourselves at Tenderness-upon-Gratitude, we would arrive at the Sea of Enmity, in which all ships come to grief. The River Inclination flows into what is known as the Sea of Dangers, beyond which lies the land we call Terra Incognita, because we have no knowledge of what may be found there....

The Aleph

JORGE LUIS BORGES
The Aleph (1945)

I arrive now at the ineffable core of my story. And here begins my despair as a writer. All language is a set of symbols whose use among its speakers assumes a shared past. How, then, can I translate into words the limitless Aleph, which my floundering mind can scarcely encompass?...

In that single gigantic instant I saw millions of acts both delightful and awful; not one of them occupied the same point in space, without overlapping or transparency. What my eyes beheld was simultaneous, but what I shall now write down will be successive, because language is successive. Nonetheless, I'll try to recollect what I can.

René Magritte,
The Castle of the Pyrenees
(1959), Jerusalem,
Israel Museum

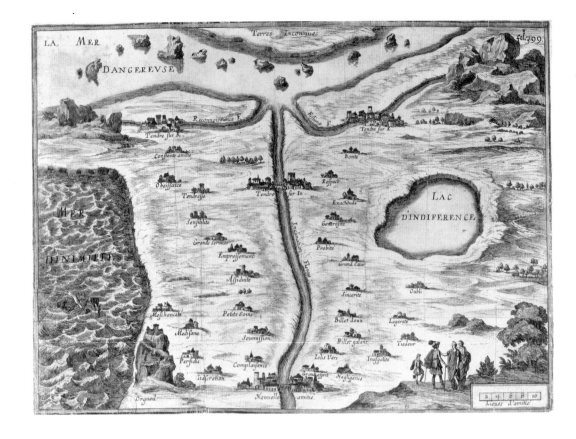

On the back part of the step, toward the right, I saw a small iridescent sphere of almost unbearable brilliance. At first I thought it was revolving; then I realised that this movement was an illusion created by the dizzying world it bounded. The Aleph's diameter was probably little more than an inch, but all space was there, actual and undiminished. Each thing (a mirror's face, let us say) was infinite things, since I distinctly saw it from every angle of the universe. I saw the teeming sea; I saw daybreak and nightfall; I saw the multitudes of America; I saw a silvery cobweb in the center of a black pyramid; I saw a splintered labyrinth (it was London); I saw, close up, unending eyes watching themselves in me as in a mirror; I saw all the mirrors on earth and none of them reflected me; I saw in a backyard of Soler Street the same tiles that thirty years before I'd seen in the entrance of a house in Fray Bentos; I saw bunches of grapes, snow, tobacco, lodes of metal, steam; I saw convex equatorial deserts and each one of their grains of sand; I saw a woman in Inverness whom I shall never forget; I saw her tangled hair, her tall figure, I saw the cancer in her breast; I saw a ring of baked mud in a sidewalk, where before there had been a tree; I saw a summer house in Adrogué and a copy of the first English translation of Pliny—

Carte du Tendre (1654), imaginary map created by Madeleine de Scudéry and engraved by François Chauveau

Philemon Holland's—and all at the same time saw each letter on each page (as a boy, I used to marvel that the letters in a closed book did not get scrambled and lost overnight); I saw a sunset in Querétaro that seemed to reflect the colour of a rose in Bengal; I saw my empty bedroom; I saw in a closet in Alkmaar a terrestrial globe between two mirrors that multiplied it endlessly; I saw horses with flowing manes on a shore of the Caspian Sea at dawn; I saw the delicate bone structure of a hand; I saw the survivors of a battle sending out picture postcards; I saw in a showcase in Mirzapur a pack of Spanish playing cards; I saw the slanting shadows of ferns on a greenhouse floor; I saw tigers, pistons, bison, tides, and armies; I saw all the ants on the planet; I saw a Persian astrolabe; I saw in the drawer of a writing table (and the handwriting made me tremble) unbelievable, obscene, detailed letters, which Beatriz had written to Carlos Argentino; I saw a monument I worshipped in the Chacarita cemetery; I saw the rotted dust and bones that had once deliciously been Beatriz Viterbo; I saw the circulation of my own dark blood; I saw the coupling of love and the modification of death; I saw the Aleph from every point and angle, and in the Aleph I saw the earth and in the earth the Aleph and in the Aleph the earth; I saw my own face and my own bowels; I saw your face; and I felt dizzy and wept, for my eyes had seen that secret and conjectured object whose name is common to all men but which no man has looked upon—the unimaginable universe.

Fantastical Places: Where Do All the Fictitious People Live?

UMBERTO ECO
Six Walks in the Fictional Woods
(1994)

Vienna, 1950. Twenty years have gone by, but Sam Spade is still trying to get his hands on the Maltese Falcon. His contact is now Harry Lime, and they are talking in secret at the top of the Prater ferris wheel. They get off and go to the Caffè Mozart, where Sam is playing "As Time Goes By" on the zither in a corner. At a table at the back, with a cigarette in the corner of his mouth and his lips curled into a bitter frown, sits Rick. He had found a clue in the documents that Ugarte showed him, and shows a photo of Ugarte to Sam Spade: "Cairo!" murmurs the private eye. Rick continues his story: in Paris, when making his triumphant entrance into the city with Captain Renault in the wake of De Gaulle, he had learnt of the existence of a certain Dragon Lady (who probably killed Robert Jordan during the Spanish Civil War), who had been put on the trail of the falcon by the secret services. She should be arriving any minute. The door opens and a feminine figure appears. "Ilsa!" shouts Rick. "Brigid!" shouts Sam Spade. "Anna Schmidt!" shouts Lime. "Miss Scarlett!" shouts Sam, "You're back! Don't put my boss through any more pain!"

From the darkness of the bar emerges the figure of a man with a sarcastic smile on his lips. It is Philip Marlowe. "Let's go, Miss Marple," he says to the woman, "Father Brown is waiting for us on Baker Street."

Abdul Mati Klarwien
(1932-2002) *Aleph
Sanctuary*, installation

Gustave Doré,
The Celestial Rose (1867),
from *The Divine Comedy,*
Dante Alighieri, *Paradiso,*
canto XXXI

The White Rose

DANTE ALIGHIERI
(1265-1321)
The Divine Comedy, Paradiso, XXXI

In semblance, therefore, of a pure
 white Rose
the sacred soldiery which with
 His blood
Christ made His Bride, revealed it-
 self to me;
meanwhile the other host, which,
 flying, sees
the glory of Him who wins its love,
 and sings
the goodness which had made them
 all so great,
was, like a swarm of bees, which
 now inflowers

itself, and now returns to where its
 toil
is sweetened, ever coming down
 to enter
the spacious Flower, which with
 so many leaves
adorns itself, and reascending thence
to where its Love forever makes His
 home.
The faces of them all were living
 flames,
their wings were golden, and the
 rest so white,
that never is such whiteness reached
 by snow.
When down into the Flower they
 came, they spread
from bench to bench the peace and
 ardent love,
which by the fanning of their sides
 they won.

APPENDICES

INDEX OF AUTHORS

INDEX OF ARTISTS

INDEX OF ANONYMOUS ILLUSTRATIONS
(in the order in which they appear)

TRANSLATION REFERENCES AND OTHER SOURCES

A note on the translations

While the translation of Umberto Eco's chapters in this book has been made by Alastair McEwen, the texts in the anthology sections of each chapter have been taken from a variety of sources in the public domain, unless otherwise indicated below. A number have been translated especially for this volume either from their original language or, where this was not possible, from the Italian versions of the texts in question. In the latter case they may differ slightly in content from the original works.

Aelian
Various Histories, translated by Thomas Stanley

Alighieri, Dante
The Divine Comedy, Paradiso, translated by Courtney Langdon

d'Alveydre, Alexandre Saint-Yves
The Kingdom of Agarttha A Journey into the Hollow Earth (1886), translated by Jon E. Graham. Reprinted by permission of Inner Traditions

Andreae, Johann Valentin
Christianopolis, translated by Felix Emil Held

Ariosto, Ludovico
Orlando Furioso, translated by W. S. Bose

Aristotle
On the Heavens, translated by J. L. Stocks; *Metaphysics*, translated by W. D. Ross

Saint Augustine
City of God, translated by Marcus Dods

Boccaccio, Giovanni
The Decameron, translation attributed to John Florio

Borges, Jorge Luis
"The Aleph" and "Tlön, Uqbar, Orbis Tertius" from *Collected Fictions*, translated by Andrew Hurley, copyright © 1998 by Maria Kodama; translation copyright © 1998 by Penguin Putnam Inc. Used by permission of Viking Penguin, a Division of Penguin Group (USA) Inc.; Penguin Group (Canada), a Division of Pearson Canada, Inc.; and Penguin Books Ltd.

Calvino, Italo
Invisible Cities (1972), translated by William Weaver. Copyright © 1972 by Giulio Einaudi editore, s.p.a. Torino, English translation copyright © 1983, 1984 by Houghton Mifflin Harcourt Publishing Company. Published in the UK by Secker & Warburg. Reprinted by permission of Houghton Mifflin Harcourt Publishing Company and The Random House Group Limited. All rights reserved.

Caesar, Julius
The Civil Wars, translated by A. G. Peskett

Collodi, Carlo (Lorenzini)
The Adventures of Pinocchio, translated by Carol della Chiesa

Cosmas Indicopleustes
Christian Topography, translated by J. W. McCrindle

de Boron, Robert
The Didot Perceval or, The Romance of Perceval in Prose, "The Castle of the Fisher King," translated by Dell Skeels.

de Troyes, Chrétien
Perceval: The Story of the Grail, translated by Nigel Bryant (Cambridge: D. S. Brewer, 1982, pp. 37-38). Reprinted by permission of Boydell & Brewer Ltd.

de Montaigne, Michel
Essays, "Of Cannibals," translated by John Florio

Diogenes Laertius
Lives and Opinions of Eminent Philosophers, translated by R. D. Hicks Diodorus Siculus, *Library of History*, translated by C. H. Oldfather

Eschenbach, Wolfram von
Parzival, translated by Jessie L. Weston

Evola, Julius
Revolt Against the Modern World, translated by Guido Stucco, from chapter 24, "The Pole and the Hyperborean Region." Reprinted by permission of Inner Traditions.

Fabre d'Olivet, Antoine
On the Social State of Man; or, Philosophical Observations on the History of the Human Race, translated by Nayán Louise Redfield

Gellius, Aulus
Attic Nights, translated by John C. Rolfe

Grimm, Jacob and Wilhelm
Fairy Tales, translated by Margaret Hunt

Herodotus
The Histories, translated by George Rawlinson

Hesiod
Works and Days, translated by Hugh G. Evelyn-White

Hippolytus
The Refutation of all Heresies, translated by Johann Peter Kirsch

Holberg, Ludvig
Niels Klim's Journey Under the Ground, translated by John Gierlow

Homer
The Odyssey, translated by Samuel Butler
Koran, translated by E. H. Palmer

Lactantius
The Divine Institutes, translated by William Fletcher

Leblanc, Maurice
The Hollow Needle, translated by Alexander Teixeira de Mattos

Lucian
A True Story, translated by Austin Morris Harmon

Lucretius
On the Nature of Things, translated by William Ellery Leonard

Manegold of Lautenbach
Opusculum contra Wolfelmum Coloniensem, translated by Robert Ziomkowski

More, Thomas
Libellus vere aureus, nec minus salutaris quam festivus de optimo rei publicae statu, deque nova insula Utopia, translated by Gilbert Burnet

Nietzsche, Friedrich
The Antichrist, translated by H. L. Mencken

Ossendowski, Ferdinand
Beasts, Men and Gods, translated by Lewis Stanton Palen

Pausanias
Periegesis ("Description of Greece"), translated by W. H. S. Jones and H. A. Omerod

Pigafetta, Antonio
Magellan's Voyage around the World, translated by James Alexander Robertson

Plato
Phaedo and *Critias*, translated by Benjamin Jowett

Pliny the Elder
Natural History, translated by Horace Rackham

Polo, Marco
The Travels of Marco Polo, translated by Henry Yule

Pseudo-Philo of Byzantium
Seven Wonders of the Ancient World, translated by David Oates

Pseudo-Callisthenes
The Romance of Alexander the Great, translated by Albert Mugrdich Wolohojian

Rabelais, François
Gargantua and Pantagruel, translated by Thomas Urquhart and Peter Anthony Motteux

Rahn, Otto
The Court of Lucifer, translated by Craig Gawler. Reprinted by permission of Inner Traditions.

Rosenberg, Alfred
The Myth of the Twentieth Century (1936), translated by Peter Peel (1982). Reprinted by Permission of Noontide Press.

Salgari, Emilio
The Mystery of the Black Jungle (1895), translated by Nico Lorenzutti. Reprinted by permission of ROH Press, www.rohpress.com.

Strabo
Geographica, translated by Horace Leonard Jones

Tasso, Torquato
Jerusalem Delivered, translated by Edward Fairfax

Verne, Jules
Twenty Thousand Leagues Under the Sea, translated by F. P. Walter

Vico, Giambattista
Principles of the New Science, translated by Thomas Goddard Bergin and Max Harold Fisch as *The New Science of Giambattista Vico*

Virgil
The *Aeneid*, translated by John Dryden
The Book of the Graal, quoted by Helinandus of Froidmont in *Chronicle*, translated by Sebastian Evans
The Letter of Prester John, translated by Sabine Baring-Gould
Perlesvaus: The High History of the Holy Graal, translated by Sebastian Evans

Translated for this edition:

by Katharina Bielenberg (from the German)
Hammer-Purgstall, Joseph von: *The Story of the Assassins*

by Chenxin Jiang (from the Italian)
Graf, Arturo: *A Geographical Legend (The Magnetic Mountain)*

by Professor Graham Loud (from the Latin)
Arnold of Lübeck: *Chronica Slavorum*

by Alan Thawley (from the Italian)
Albini, Andrea: *Atlantis: In the Textual Sea*
Álvares, Francisco: *A True Relation of the Lands of Prester John of the Indies*
Ampelius, Lucius: *Liber memorialis*
Saint Augustine: *The Literal Meaning of Genesis*
Collin de Plancy, Jacques: *Voyage au centre de la terre*
Columbus, Christopher: The Third Voyage, Letter to the Catholic Kings from Hispaniola, May–August 1498
de Boron, Robert: *Merlin*
de Foigny, Gabriel: *The Southern Land, Known*
de la Riva, Bonvesin: *On the Marvels of the City of Milan*
de Scudéry, Madeleine: *Clélie, a Roman History*
de Sède, Gerard: *Les Templiers sont parmi nous, ou L'Enigme de Gisors* (The Templars Are among Us, or The Enigma of Gisors)
Eco, Umberto: "On Perverse Uses of Mathematics"; "Six Walks in the Fictional Woods"
Frau, Sergio: *The Pillars of Hercules*
Gozzano, Guido: "The Most Beautiful"
Graf, Arturo: *The Myth of the Earthly Paradise*
Guénon, René: *The King of the World*
Henry of Saltrey: *Tractatus de Purgatorio sancti Patricii*
Iannaccone, Mario Arturo: "La truffa di Rennes le chateau"
Jacolliot, Louis: *God's Sons*
Saint Isidore of Seville: *Etymologies*
John of Hildesheim: *Historia de gestis et translatione trium regum*
Latini, Brunetto: *The Book of Treasure*
Liutprand of Cremona: *Antapodosis*
Macrobius: *Commentary on the Dream of Scipio*
Manilius, Marcus: *Astronomica*
Maximus, Valerius
Memorable Deeds and Sayings
Paris, Matthew: *Chronica majora*
Pulci, Luigi: *Morgante*
Seriman, Zaccaria: *The Travels of Henry Wanton to the Undiscovered Austral Regions and the Kingdoms of the Apes and the Dog-Faced People*
Teed, Cyrus Reed: *Koresh, Fundamentals of Koreshan Universology*
Toudouze, Georges-Gustave: *The Little King of Ys*
Vairasse, Denis: *The History of the Sevarites or Sevarambi*

Vinci, Felice: *Homer in the Baltic*
La queste del Saint Graal, from the
Prose Lancelot
Li Fabliaus de Coquaigne
The Voyage of Saint Brendan

**Translations of the following texts
are anonymous:**
De rebus in oriente mirabilibus (sixth
century)
Voltaire: *Candide*
"Second Voyage," in *The Seven
Voyages of Sindbad the Sailor* (c. tenth
century), in *The Arabian Nights'
Entertainment* (1706), ed. Andrew
Lang (1898)
Campanella, Tommaso: *The City of
the Sun*

**Permission for use of texts
originally in English:**
From *A Brief History of Time: From
the Big Bang to Black Holes* by Stephen
Hawking,
Copyright © 1998 by Stephen
Hawking. Published by Bantam Press.
Reprinted by permission of Bantam,
a division of Random House, Inc., and
The Random House Group Limited

From *Lands Beyond* (1952), L. Sprague
de Camp and Willy Ley,
Permission granted by Spectrum
Literary Agency on behalf of the
deCamp Family Limited Partnership

From *The Holy Blood and The Holy
Grail* (1982) by Michael Baigent and
Richard Leigh, published by Century.
Reprinted by permission of Dell, a
division of Random House, Inc., and
The Random House Group Limited

GENERAL
BIBLIOGRAPHY

Abdelkader, Mostafa
"A Geocosmos: Mapping Outer Space Into a Hollow Earth," in *Speculations in Science & Technology*, 6 (1983)

Adam, Jean Pierre
Le passé recomposé. Chroniques d'archéologie fantasque (Paris: Seuil, 1988)

Albini, Andrea
Atlantide. Nel mare dei testi (Genova: Italian University Press, 2012)

Andreae, Johann Valentin
Reipublicae christianopolitanae descriptio (Strasbourg: Zetzner, 1619)

Anonymous
Curious Enquiries (London: Taylor, 1688)

Anonymous
Rélation d'un voyage du pôle arctique au pôle antarctique par le centre du monde, (Amsterdam: Lucas, 1721)

Aroux, Eugène
Les mystères de la chevalerie et de l'amour platonique au Moyen Age (Paris: Renouard, 1858)

Bacon, Francis
New Atlantis (London: Lee, 1627)

Baër, Fréderic-Charles
Essai historique et critique sur l'Atlantide des anciens (Paris: Lambert, 1762)

Baigent, Michael, Leigh, Richard, & Lincoln, Henry
The Holy Blood and the Holy Grail (London: Cape, 1982)

Bailly, Jean-Sylvain
Lettres sur l'Atlantide de Platon et Sur L'Ancienne Histoire De L'Asie. Pour servir de suite aux Lettre sur l'origine des Sciences, adressées à M. De Voltaire per M. Bailly (London: M. Elmsly/Paris: Frères Debure, 1779)

Baistrocchi Marco
"Agarttha: una manipolazione guénoniana?," in *Politica Romana* II (1995)

Barisone, Ermanno
"Introduzione" a John Mandeville, *Viaggi ovvero trattato delle cose più meravigliose e più notabili che si trovano al mondo* (Milan: Il Saggiatore, 1982)

Baudino, Mario
Il mito che uccide (Milan: Longanesi, 2004)

Benoit, Pierre
L'Atlantide (Paris: Albin Michel, 1919)

Bérard, Victor
Les navigations d'Ulysse (Paris: Colin, **1927-1929**)

Bernard, Raymond W.
The Hollow Earth (New York: Fieldcrest Publishing, 1964)

Bernard, Raymond W.
Agartha, the Subterranean World (Mokelumne Hill: Health Research, 1960)

Berzin, Alexander
Mistaken Foreign Myths about Shambhala (Internet, The Berzin Archives, 1996)

Blavatsky, Helena
Isis Unveiled (New York: J. W. Bouton, 1877)

Blavatsky, Helena
The Secret Doctrine, II (London: Theosophical Publishing Society, 1888)

Blavier, André
Les fous littéraires (Paris: Veyrier, 1982)

Borges, Jorge Luis
"Tlön, Uqbar, Orbis Tertius," in *Collected Fictions* (New York: Viking, 1998)

Borges, Jorge Luis
"The Aleph," in *Collected Fictions* (New York: Viking, 1998)

Bossi, Giovanni
Immaginario di viaggio e immaginario utopico (Milan: Mimesis, 2003)

Bradshaw, William R.
The Goddess of Atvatabar (New York: Douthitt, 1892)

Broc, Numa
"Dall'Antictone all'Antartico," in *Cartes et figures de la Terre* (Paris: Centre Pompidou, 1980)

Brugg, Elmar (Rudolf Elmayer-Vestenbrugg)
Die Welteislehre nach Hanns Hörbiger (Leipzig: Koehler Amelang Verlag, 1938)

Bulwer-Lytton, Edward George
The Coming Race (London: William Blackwood & Sons, 1871)

Buonanno, Errico
Sarà vero. Falsi, sospetti e bufale che hanno fatto la storia (Turin: Einaudi, 2009)

Burnet, Thomas
Telluris theoria sacra (London: Kettilby, 1681)

Burroughs, Edgar Rice
"At the Earth's Core," in *All-Story Weekly* (April 1914)

Burroughs, Edgar Rice
"Pellucidar," in *All-Story Weekly* (May 1915)

Burton Russell, Jeffrey
Inventing the Flat Earth (New York: Praeger, 1991)

Butler, Samuel
Erewhon (London: Trübner & Co., 1872)

Butler, Samuel
The Authoress of the Odyssey (London: Longmans, 1897)

Calabrese, O., Giovannoli, R., Pezzini I.
Hic sunt Leones. Geografia fantastica e viaggi straordinari (Milan: Electa, 1983)

Calmet, Antoine-Augustin
Commentaire littéral sur tous les livres de l'Ancien et du Nouveau Testament (Paris: Emery, 1706)

Campanella, Tommaso
La città del sole, MS; "Civitas solis. Idea Reipvblicae Philosophicae," in *Realis philosophiae epilogisticae* (Frankfurt: Tampach, 1623)

Cardini, Franco
I Re Magi. Storia e leggenda (Venice: Marsilio, 2000)

Cardini, Franco, Introvigne, Massimo and Montesano, Marina, eds.
Il santo Graal (Florence: Giunti, 1998)

Casanova, Giacomo
Icosameron. Histoire d'Edouard, et d'Elisabeth qui passèrent quatre vingts ans chez les Mégramicres habitantes aborigènes du Protocosme dans l'interieur de notre globe (Paris: Imprimerie de l'École Normale, 1788)

Charroux, Robert
Trésors du monde enterrés, emmurés, engloutis (Paris: Fayard, 1972)

Churchward, James
The Lost Continent of Mu: Motherland of Man (New York: Rudge, 1926)

Ciardi, Marco
Atlantide. Una controversia scientifica da Colombo a Darwin (Rome: Carocci, 2002)

Cocchiara, Giuseppe
Il mondo alla rovescia (Turin: Boringhieri, 1963)

Collin de Plancy, Jacques
Voyage au centre de la terre, ou,

Adventures Diverses De Clairancy Et Ses Compagnons, Dans Le Spitzberg, Au Pôle-Nord, Et Dans Des Pays Inconnus (Paris: Callot, 1821)

Collodi, Carlo
"Pinocchio," in *Il Giornale per i bambini* (1880) (later, Florence: Paggi, 1883)

Columbus, Christopher
"Lettera ai Re Cattolici dalla Spagnola, maggio-agosto" (1498)

Conan Doyle, Arthur
The Maracot Deep and Other Short Stories (London: John Murray, 1929)

Corbin, Henry
Histoire de la philosophie islamique (Paris: Gallimard, 1964)

Costes, Guy and Altairac, Joseph
Les terres creuses (Paris: Les Belles Lettres, 2006)

Crowe, Michael J.
The Extraterrestrial Life Debate, 1750-1900 (Cambridge: Cambridge University Press, 1896)

Daston, Lorraine and Park, Katharine
Wonders and the Order of Nature (New York: Zone Books, 1998)

Daunicht, Hubert
"Die Odyssee in Ostasien," in *Frankfurter Neue Presse* (14 February, 1971)

DeCamp, L.S. and Ley, W.
Lands Beyond (New York: Rinehart, 1952)

Delumeau, Jean
Une histoire du Paradis (Paris: Fayard, 1992)

De Sède, Gérard
Les templiers sont parmi nous, ou, l'énigme de Gisors (Paris: Juillard, 1962)

De Sède, Gérard
L'Or de Rennes, ou, La Vie insolite de Bérenger Saunière, curé de Rennes-le-Château (Paris: René Julliard, 1967)

De Sède, Gérard
Rennes-le-château. Le dossier, les impostures, les phantasmes, les hypothèses (Paris: Laffont, 1988)

Di Carpegna Falconieri, Tommaso
Medioevo militante (Turin: Einaudi, 2011)

Dick, Philip
The Man in the High Castle (New York: Putnam, 1962)

Digby, Kenelm
Discours fait en une celebre assemblée . . . Touchant La Guerison des Playes par la Poudre de Sympathie (Paris: Courbé, 1558)

Digby, Kenelm
Theatrum sympatheticum (Nuremberg: Impresis J.A. & W.J. Endterorum haered, 1660)

Dohueihi, Milad
Le Paradis Terrestres. Mythes et philosophies (Paris: Seuil, 2006)

Donnelly, Ignatius
The Great Cryptogram: Francis Bacon's Cipher in The So-called Shakespeare Plays (London: Sampson Low, Marston, Searle & Rivington, 1888)

Donnelly, Ignatius
Atlantis: The Antediluvian World (New York: Harper, 1882)

Eco, Umberto
La ricerca della lingua perfetta (Rome-Bari: Laterza, 1993)

Eco, Umberto
"La forza del falso," in *Sulla letteratura* (Milan: Bompiani, 2002)

Eco, Umberto
"Sugli usi perversi della matermatica," in *La Matematica*, vol. 3, by Claudio Bartocci and Piergiorgio Odifreddi (Turin: Einaudi, 2011)

Emerson, Willis George
The Smoky God (Chicago: Forbes, 1908)

Eumaios
Odysseus als Afrikaumsleger und Amerikaentdecker (Leipzig: Fock, 1898)

Evola, Julius
Rivolta contro il mondo moderno (Milan: Hoepli, 1934)

Evola, Julius
Il mistero del Graal (Bari: Laterza, 1937)

Fabre d'Olivet, Antoine
De l'État Social de l'Homme ou Vues Philosophiques sur l'Histoire du Genre Humain (Paris: Brière, 1822)

Fauriel, Claude
Histoire de la poésie provençale (Paris: Labitte, 1846)

Fauth, Philip
Glazial-Kosmogonie (Kaiserslautern: Hermann Kaysers Verlag, 1913)

Ficino, Marsilio
De vita libri tres; Apologia; Quod necessaria sit ad vitam securitas (Firenze, Miscomini, 1489)

Fieux, Charles de, Cavaliere de Mouhy
Lamekis, ou les voyages extraordinaires d'un égyptien dans la terre intérieure avec la découverte de l'isle des Silphides (Paris: Dupuis, 1734)

Filippani-Ronconi, Pio
Ismaeliti ed "Assassini" (Basel: Ludwig Keimer Stiftung, 1973)

Fitting, Peter
Subterranean Worlds (Middletown, CT: Wesleyan University Press, 2004)

Foigny, Gabriel de
La Terre Australe connue (Geneva: Jaques Vernevil, 1676)

Fondi, Roberto
"Nascita, morte e palingenesi della concezione del mondo cavo" (*Arthos*, no. 29)

Fontenelle, Bernard de
La République des philosophes ou Histoire des Ajaoiens . . . Ouvrage posthume de Mr. De Fontenelle (Geneva: 1768)

Fracastoro, Girolamo
Syphilis sive morbus gallicus (Verona: 1530)

Frau, Sergio
Le Colonne d'Ercole. Un'inchiesta (Roma: Nur Neon, 2002)

Frobenius, Leo
Auf dem Weg nach Atlantis (Berlin: Vita, 1910)

Frugoni, Francesco Fulvio
Il cane di Diogene (Venice: Bosio, 1697-89)

Galli, Giorgio
Hitler e il nazismo magico (Milan: BUR, 1983; enlarged edition 2005)

Gardner, Marshall B.
A Journey to the Earth's Interior (Aurora, Il.: The Author, 1913)

Gardner, Martin
Fads and Fallacies in the Name of Science (New York: Dover, 1957)

Garlaschelli, Luigi
"Indagini sulla spada di San Galgano," convention on the mystery of the sword in the stone at San Galgano, September 2001 (http://luigigarlaschelli.it/spada/resoconto1292001.html)

Geiger, John
The Third Man Factor: The Secret of Survival in Extreme Environment (Toronto: Viking Canada, 2009)

Giannini, Francis Amadeo
Worlds beyond the Pole (Pomeroy, WA: Health Research Books, 1959)

John of Hildesheim
Historia de gestis et translatione trium regum (Cologne: Guldenschaiff, 1477)

Giuda Levita (Judah ha-Levy)
Liber cosri (Basel: Decker, 1660)

Goodrick-Clarke, N.
The Occult Roots of Nazism (Wellingborough: Aquarian Press, 1985)

Godwin, Joscelyn
Arktos: The Polar Myth in Science,

Symbolism, and Nazi Survival
(Kempton, IL: Adventures Unlimited
Press, 1996)

Graf, Arturo
*Miti, leggende e superstizioni del Medio
Evo* (Turin: Loescher, 1892-93)

Grimm, Jacob and Wilhelm
Kinder und Hausmärchen (Berlin:
Realschulbuchhandlung, 1812)

Guénon, René
"Le roi du monde" in *Les Cahiers du
Mois* 9/10, 1925 (later, Paris: Bosse,
1927)

Guénon, René
"L'ésotérisme du Graal," in *Les
Cahiers du Sud*, 1950

Grube, E.J.
"Automa," in *Enciclopedia dell'arte
medievale* (Rome: Treccani, 1991)

Hall, Joseph
Mundus alter (Hanau: Antonius, 1607)

Halley, Edmund
"An account of the cause of the change
of the variation of the magnetic needle
with an hypothesis of the structure
of the internal parts of the Earth," in
*Philosophical Transactions of the Royal
Society* XVI (1692), pp. 563-587

Hammer-Purgstall, Joseph von
Die Geschichte der Assassinen
(Stuttgart-Tübingen: 1818)

Hilton, James
Lost Horizon (Essex: Woodford Green,
1933)

Holberg, Ludwig
Nicolai Klimii iter subterraneum
(Leipzig: Jacob Preuss, 1741)

Howgego, Raymond J.
*Encyclopedia of Exploration. Invented
and Apocryphal Narratives of Travels*
(Potts Point, Sydney: Hordern House,
2013)

Huet, Pierre-Daniel
*Traité de la situation du Paradis
terrestre* (Paris: Anisson, 1691)

Introvigne, Massimo
*Gli Illuminati e il Priorato di Sion.
La verità sulle due società segrete del
'Codice da Vinci' e di 'Angeli e demoni'*
(Casale Monferrato: Piemme, 2005)

Jacolliot, Louis
Les fils de dieu (Paris: Lacroix, 1873)

Jacolliot, Louis
*Le Spiritisme dans le monde.
L'initiation et les sciences occultes
dans l'Inde et chez tous les peuples de
l'Antiquité* (Paris: Lacroix, 1875)

Jones, William
"The Circles of Gomer," in *The
Philosophy of Words* (London: Hughs,
1769)

Justafré, Olivier
*Grains de folie. Supplement aux fous
littéraires* (Perros-Guirec: Editions
Anagrammes, 2011)

Iannaccone, Mario Arturo
*Rennes-le-Château, una decifrazione.
La genesi occulta del mito* (Milan:
SugarCo, 2004)

Iannaccone, Mario Arturo
"La truffa di Rennes-le-Château," in
Scienza e Paranormale, no. 59 (2005)

Kafton-Minkel, Walter
*Subterranean Worlds: 100,000 Years
of Dragons, Dwarfs, the Dead, Lost
Races and Ufos from inside the Earth*
(Port Townsend, WA: Loompanics
Unlimited, 1989)

Kircher, Athanasius
Mundus subterraneus (Amsterdam:
Jansson & Weyerstraten, 1665)

Kuipert, Gerard
"German astronomy during the war,"
in *Popular Astronomy* LIV (6 June,
1946)

Lamendola, Francesco
"Terra Australis Incognita," in *Il Polo*
(3, 1989)

Lamendola, Francesco
"Mendaña de Neira alla scoperta della
terra australe," in *Il Polo* (1, 1990)

Lancioni, Tarcisio
"Viaggio tra gli isolari," in *Almanacco
del Bibliofilo* (Milan: Rovello, 1992)

Las Casas, Bartolome de
*Apologética historia summaria de
las gentes destas Indias* (Madrid:
Biblioteca de Autores Españoles,
1909)

Le Goff, Jacques
"Le merveilleux dans l'Occident
médiéval," in *L'imaginaire médiéval*
(Paris: Gallimard, 1985)

Le Goff, Jacques
La naissance du Purgatoire (Paris:
Gallimard, 1981)

Le Goff, Jacques
L'imaginaire médiéval (Paris:
Gallimard, 1988)

Leonardi, Claudio
"La via dell'Oriente nella *Historia
Mongolorum*," in Giovanni di Pian di
Carpine, *Storia dei mongoli* (Spoleto:
Centro Italiano di Studi sull'Alto
Medioevo, 1989)

Le Plongeon, Augustus
Queen Móo & The Egyptian Sphinx
(New York: The Author, 1896)

Leon Pinelo, Antonio de
"El paraiso en el nuevo mundo.
Comentario apologético, historia
natural y peregrina de las Indias

Occidentales, Islas de Tierra Firme del
Mar Oceano" 1656 (Lima: Imprenta
Torres Aguirre, 1943)

Ley, Willy
"For Your Information: The Hollow
Earth," in *Galaxy Science Fiction* (11,
1956)

Lloyd, John Uri
Etidorpha (Cincinnati: The Author,
1895)

Lopez de Gòmara, Francisco
*La historia general de las Indias, con
todos los descubrimientos, y cosas
notables que han acaescido en ellas,
dende que se ganaron hasta agora*
(Antwerp: Stesio, 1554)

Manguel, Alberto and Guadalupi,
Gianni
Dizionario dei luoghi fantastici
(Milano: Rizzoli, 1982/enlarged
edition, Milano: Archinto, 2010)

Mather, Cotton
The Christian Philosopher (London:
Eman. Matthews, 1721)

Mazzoldi, Angelo
*Della diffusione dell'incivilimento
italiano alla Fenicia, alla Grecia, e
a tutte le nazioni antiche poste sul
mediterraneo* (Milan: Guglielmini e
Redaelli, 1840)

Montaigne, Michel de
Les Essais (Paris: Abel L'Angelier,
1580-95)

More, Thomas
*Libellus vere aureus, nec minus
salutaris quam festivus de optimo
reipublicae statu, deque nova insula
Utopia* (Leuven: 1516)

Moretti, Gabriella
Gli antipodi (Parma: Pratiche, 1994)

Morris, William
News from Nowhere (London: Reeves
& Turner, 1891)

Nelson, Victoria
"Symmes Hole, Or the South Polar
Romance," in *Raritan* (17, 1997)

Neupert, Karl
Am Morgen einer neuen Zeit
(Dornbirn: Höfle & Kaiser, 1909)

Neupert, Karl
*Welt-Wendung! Inversion of the
Universe* (Augsburg: Scheurer, 1924)

Neupert, Karl
Umwälzung! Das Weltbild der Zukunft
(Augsburg: 1927)

Neupert, Karl
*Der Kampf gegen das kopernikanischer
Weltbild*, (Memmingen: Verlags- und
Druckereigenossenschaft, 1928)

Neupert, Karl
Umsturz des Welt-Alls

(Memmingen: Verlags- und
Druckereigenossenschaft, 1929)

Neupert, Karl
*Umwälzung der Welt-Anschauungen.
Der Sternhimmel ist optische
Täuschung* (Zurich: F. Zimmerli, 1932)

Newton, Isaac
*The chronology of ancient kingdoms
amended* (London: J. Tonson,
J. Osborn & T. Longman, 1728)

Nietzsche, Friedrich
Der Antichrist (Leipzig: Kröner, 1888)

Obručev, Vladimir Afanasevich
Plutoniia (Leningrad: 1924)

Olender, Maurice
Les langues du Paradis (Paris: Seuil,
1989)

Olschki, Leonardo
*Storia letteraria delle scoperte
geografiche* (Florence: Olschki, 1937)

Ortenberg, Veronica
*In Search of the Holy Grail. The Quest
for the Middle Ages* (London and New
York: Hambledon Continuum, 2006)

Ossendowski, Ferdinand
Beasts, Men and Gods (London: Arnold,
1923)

Pauwels Louis and Bergier Jacques
Le matin des magiciens (Paris:
Gallimard 1960)

Peck, John W.
"Symms' Theory," in *Ohio
Archaeological and Historical
Publications* (18, 1909)

Pellech, Christine
*Die Odyssee – eine antike
Weltumsegelung* (Berlin: Reimer,
1983)

Pellicer, Rosa
"Continens Paradisi: el libro segundo
de 'El paraíso en el Nuevo Mundo' de
Antonio de León Pinelo," in *América
sin nombre* (13-14, 2009)

Penka, Karl
Origines Ariacae (Vienna: Prochaska,
1883)

Petech, Luciano
Introduction to Giovanni di Pian di
Carpine, *Storia dei mongoli* (Spoleto:
Centro Italiano di Studi sull'Alto
Medioevo, 1989)

Peyrère, Isaac de la
*Praeadamitae sive exercitatio, super
versibus duodecimo, decimotertio,
& decimoquarto, capitis quinti
epistuale d. Pauli ad romanos. Quibus
inductuntur primi homines ante
Adamum conditi* (Amsterdam: Elzevir,
1655)

Pezzini, Isabella
Exploratorium. Cose dell'altro mondo

(Milan: Electa, 1971)

Piazzi Smyth, Charles
Our Inheritance in the Great Pyramid
(London: Alexander Strahan & Co.,
1864)

Pigafetta, Antonio
Magellan's Voyage Around the World
(Cleveland: A. H. Clark Company,
1906)

Pradus, Hieronymus and Villalpandus,
Joannes Batista
*In Ezechielem explanationes
et apparatus urbis ac templi
hierosolymitani commentariis et
imaginibus illustratus Opus* (Rome:
Zanetti, Vullietti, Ciacconi 1596)

Rahn, Otto
*Luzifers Hofgesind, eine Reise zu den
guten Geistern Europas* (Leipzig:
Schwarzhäupter Verlag, 1937)

Rahn, Otto
*Kreuzzug gegen den Gral. Die
Geschichte der Albigenser* (Freiburg im
Breisgau: Urban Verlag, 1933)

Raleigh, Walter
*The Discovery of the Large, Rich, and
Beautiful Empire of Guiana, with a
Relation of the Great and Golden City
of Manoa (which the Spaniards call El
Dorado)* (London: 1596)

Ramusio, Giovan Battista
"Discorso di messer Gio. Battista
Ramusio sopra il terzo volume delle
Navigazioni e Viaggi nella parte del
mondo nuovo," in *Delle Navigationi
et Viaggi Nel Quale Si Contengono Le
Navigationi al Mondo Nuovo* III
(Venice: Giunti, 1556)

Reed, William
The Phantom of the Poles (New York:
Rockey, 1906)

Restif de la Bretonne, Nicolas-Edmé
*La découverte australe par un Homme-
volant, ou Le Dédale français, nouvelle
très philosophique, suivie de la Lettre
d'un singe* (Paris: 1781)

Rider Haggard, Henry
"She," in *The Graphic* (October
1886-January 1887)

Roerich, Nicholas
Shambhala, The Resplendent (Talai-
Pho-Brang, 1928)

Rosenau, Helen
Vision of the Temple (London: Oresko,
1979)

Rosenberg, Alfred
Der Mythus des 20. Jahrhunderts
(Munich: Hoheneichen, 1930)

Rousseau, Victor
"The eye of Balamok," in *All-Story
Weekly* (January 24, 1920)

Rudbeck, Olaus
*Atland eller Manheim – Atlantica sive
Manheim, vero Japheti posterorum
sedes ac patria* (Uppsala: Henricus
Curio, 1679-1702)

Sacy, Sylvestre de
Exposé sur la religion des druses (Paris:
Imprimerie Royale, 1838)

Saint-Yves d'Alveydre, Joseph-
Alexandre
Mission de l'Inde en Europe, I & II
(Paris: Calmann Lévy, 1886)

Saint-Yves d'Alveydre, Joseph-
Alexandre
*L'Archeomètre, Clef de toutes les
religions & de toutes les sciences de
l'antiquité* (Paris: Dorbon-Aîné, 1911)

Scafi, Alessandro
*Mapping Paradise. A History of
Heaven on Earth* (Chicago: University
of Chicago, 2006)

Schrade, Otto
Sprachvergleichung und Urgeschichte
(Jena: 1883)

Seaborn, Adam (pseudonym of John
Cleves Symmes)
Symzonia. A Voyage of Discovery (New
York: Seymour, 1820)

Seriman, Zaccaria
*Viaggi di Enrico Wanton alle terre
incognite Australi ed al paese delle
scimie, ne' quali si spiegano il carattere,
li costumi, le scienze e la polizia di
quegli straordinari abitanti. Tradotti
da un manoscritto inglese* (Venice:
Targier, 1749); *The Travels of Henry
Wanton to the Terra Australis*
(London: 1772)

Shepard, Odell
The Lore of the Unicorn (London: Allen
& Unwin, 1930)

Smith, Paul
*Pierre Plantard Criminal Convictions
1953 and 1956* (http://priory-of-sion.
com/psp/ppconvictions.html, 2011)

Smith, Paul
*Bibliography on the Priory of Sion,
Rennes-le-Château, the Da Vinci Code,
Rosslyn Chapel, landscape geometry
and other modern myths* (http://www.
rennes-le-chateau-rhedae.com/rlc/
prioryofsionbibliography.html, 2012)

Sobel, Dava
Longitude (New York: Walker & Co.,
1995)

Standish, David
Hollow Earth (Cambridge, MA: Da
Capo Press, 2006)

Steuerwald, Hans
*Weit war sein Weg nach Ithaka, Neue
Forschungsergebnisse beweisen:
Odysseus kam bis Schottland* (Hamburg:

Hoffmann und Campe, 1978)

Stoker, Bram
Dracula (London: Archibald Constable & Co., 1897)

Swinden, Tobias
An Enquiry into the Nature and Place of Hell (London: Taylor, 1714)

Tardiola, Giuseppe
Le meraviglie dell'India (Rome: Archivio Guido Izzi, 1991)

Tardiola, Giuseppe
I viaggiatori del Paradiso (Florence: Le Lettere, 1993)

Teed, Cyrus Reed
The Cellular Cosmogony; or, the Earth, a Concave Sphere (Chicago: Guiding Star, 1899)

Tega, Walter
Il viaggio tra mito e scienza (Bologna: Bononia University Press, 2007)

Tomatis, Mariano
"Il gioco infinito di Rennes-le-Château," in *Query online* (http://www.queryonline.it), 2011

Toudouze, George-Gustave
Le petit roi d'Ys (Paris: Hachette, 1914)

Vairasse, Denis
The history of the Sevarites or Sevarambi (London: Brome, 1675)

Verne, Jules
Voyage au centre de la terre (Paris: Hetzel, 1864)

Verne, Jules
20.000 lieues sous les mers (Paris: Hetzel, 1869-1870)

Vespucci, Amerigo
Vita e lettere di Amerigo Vespucci raccolte e illustrate da Angelo Maria Bandini (Florence: All'Insegna di Apollo, 1745)

Vico, Giambattista
Principi di scienza nuova (Naples: Stamperia Muziana, at the expense of Gaetano and Steffano Elia, 1744)

Vidal-Naquet, Pierre
L'Atlantide. Petite histoire d'un mythe platonique (Paris: Les Belles Lettres, 2005)

Vinci, Felice
Omero nel Baltico. Le origini nordiche dell'Odissea e dell'Iliade (Rome: Palombi, 1995)

Voltaire
"Essai sur les moeurs et l'esprit des nations," in *Collection des œuvres complètes de M. de Voltaire* (Geneva: Cramer, 1756)

Ward, Cynthia
"Hollow Earth Fiction," in *The internet review of science fiction,* (http://www.irosf.com/q/zine/article/10460, 2008)

Warren, F. William
Paradise Found: The Cradle of the Human Race at the North Pole (Boston: Houghton Mifflin, 1885)

Weston, Jessie
From Ritual to Romance (Cambridge: Cambridge University Press, 1920)

Wolf, Armin & Hans-Helmut
Die wirkliche Reise des Odysseus, Zur Rekonstruktion des homerischen Weltbildes (Munich: Langen Müller, 1990)

Zaganelli, Gioia
La lettera del Prete Gianni (Parma: Pratiche, 1990)

Zaganelli, Gioia
L'Oriente incognito medievale (Soveria Mannelli: Rubettino, 1997)

Zambon, Francesco
Metamorfosi del Graal (Roma: Carocci, 2012)

Zirkle, Conway
"The Theory of Concentric Spheres: Halley, Mather and Symmes" in *Isis* (vol. 37, no. 3-4, 1947)

Zschaetzsch, Karl Georg
Atlantis, die Urheimat der Arier (Berlin: Arier-Verlag, 1922)

ILLUSTRATION CREDITS